breaking the disciplines

breaking the disciplines

reconceptions in knowledge, art and culture

edited by
*martin l. davies &
marsha meskimmon*

I.B. TAURIS
LONDON · NEW YORK

Published in 2003 by I.B.Tauris & Co Ltd
6 Salem Road, London W2 4BU
175 Fifth Avenue, New York NY 10010
www.ibtauris.com

In the United States of America and in Canada distributed by
Palgrave Macmillan, a division of St Martin's Press
175 Fifth Avenue, New York NY 10010

Copyright © Martin L. Davies & Marsha Meskimmon, 2003

The right of Martin L. Davies & Marsha Meskimmon to be identified as the authors of this work has been asserted by the authors in accordance with the Copyright, Designs and Patents Act 1988.

All rights reserved. Except for brief quotations in a review, this book, or any part thereof, may not be reproduced, stored in or introduced into a retrieval system, or transmitted, in any form or by any means, electronic, mechanical, photocopying, recording or otherwise, without the prior written permission of the publisher.

ISBN 1 86064 917 3

A full CIP record for this book is available from the British Library
A full CIP record for this book is available from the Library of Congress

Library of Congress catalog card: available

Typeset in Slimbach by Steve Tribe, Andover
Printed and bound in Great Britain by MPG Books Ltd, Bodmin

contents

List of Illustrations — vi

Acknowledgements — vii

Editorial Dialogue — 1

Section I: The Imperative to Challenge Disciplinary Orthodoxy

Thinking Practice: On the concept of an ecology of knowledge *Martin L. Davies* — 9

Becoming Academics, Challenging the Disciplinarians: A philosophical case-study *Helen C. Chapman* — 35

Section II: Hybrid Objects/Hybrid Methods

Real Milk from Mechanical Cows: Invention, creativity and the limits of anthropological knowledge *Mark T. Shutes* — 61

Clockwork Prayer: A sixteenth-century mechanical monk *Elizabeth King* — 84

The Research Methods of an Artist-Ethnographer on the Congo Coast of Panama *Arturo Lindsay* — 129

Section III: Performance, Aesthetics and Knowledge

Word of Honour *Alphonso Lingis* — 163

Reconceptualizing a Pictorial Turn: Lessing, Hoffmann, Klee and elements of avant-garde language *Beate Allert* — 187

Practice as Thinking: Toward feminist aesthetics *Marsha Meskimmon* — 223

Index — 246

illustrations

1. Automaton figure of a monk, c.1560 — 84
2. Comparison of the monk's head with an engraved portrait of San Diego de Alcalá — 91
3. Cornelius Galle, *Diego de Alcalá (vita)*, engraving, 1614 — 96
4. Components of the internal mechanism of the monk and X-ray of the interior of the monk's head — 103
5. Automaton, Cister-Spielerin; Mechanism, Cister-Spielerin; Automaton monk, c.1560; Music automaton — 105
6. Death mask of S. Giacomo della Marca — 114
7. Photograph of Archangel and angels confronting the *Diablo Mayor*, Portobelo, 2000 — 138
8. Arturo Lindsay, *Rey Bayano*, 1994 — 148
9. Arturo Lindsay, *Rey Bayano*, installation view, 1994 — 150
10. Arturo Lindsay, *Retorno de las ánimas Africana*, 1999 — 153
11. Arturo Lindsay, *Santuario para las ánimas Africanas*, 2000 — 154
12. Arturo Lindsay, *Spirit Box for Ronald Smith*, 1997 — 157
13. Paul Klee, *Hoffmanneske Geschichte*, 1921 — 209
14. Jenny Holzer, *Lustmord*, 1993–4 — 224

acknowledgements

As editors, we are grateful to many people for the efforts they invested in this project – from its inception in exciting conversations with colleagues, to its emergence and development as a viable configuration of ideas and arguments during the symposium *Reconceptions: New Ecologies of Knowledge* (1999) and finally, here, as it reaches a new audience in published form. We would like to thank, especially, the Research Committee of Loughborough University School of Art and Design, who made the *Reconceptions* symposium possible through a generous grant, all the participants in that event and Graham Seamon, who designed the promotional material for *Reconceptions* with careful attention to its conceptual framework. We would also like to thank our editorial team at I.B.Tauris, Philippa Brewster and Susan Lawson, who remained committed to the project and its potential throughout the process of publication. Finally, to our contributors, many heartfelt thanks for continuing the dialogue over these past years with such grace and eloquence.

This book is dedicated to my brother, Mark T. Shutes (1947–2001), whose life and scholarship were motivated by a determination to challenge intellectual complacency and change the future for the better. While the loss of his warmth, humour and generosity remain painful, the memory of his enthusiasm for *Reconceptions* made the editing of this volume a joyous task.

Marsha Meskimmon

I got to know Mark only for a short time. I didn't suspect how short it would be. He had a wide range of knowledge. He was fascinated by human behaviour, by ideas – and he knew how to get you thinking. His essay is poignant as a fragment of all this. His work, his public intellectual commitment, meant a lot to very many people. Then I looked forward to continuing the discussions we started. Now the regret that this will not happen is as sharp as ever.

Martin L. Davies

editorial dialogue

MM: Any edited collection emerges as the result of dialogue and negotiation over time; the editors debate a topic, invite scholars to share their views on the subject, further refine the initial premises through argument and discussion and, finally, publish the work. In some senses, *Breaking the Disciplines: Reconceptions in Knowledge, Art and Culture* followed this route, beginning life in our own animated conversations, moving forward through the work of a fascinating group of scholars, reaching a pinnacle during the Symposium *Reconceptions: New Ecologies of Knowledge* (Loughborough University, September 1999) and, now, culminating in published form. But this project is not so much linear as lateral: the varied work which has at one or another time driven our thinking and changed its parameters, cannot be contained by a narrative chronology centred on the production of this volume. Indeed, only one term has remained a constant throughout the process of discussion, debate and writing and that term is neither an origin point nor a definition, but an axis for intervention. That term is *reconception*.

Reconception is a recurrent theme in the present volume and one of the keywords of its title. Stressing the materiality of knowledge and the creative activity of thought, reconception rejects the existence of universal truths which precede articulation, arguing instead that it is in articulation itself, whether that be through words, texts, objects or images, that subjects negotiate a meaningful place in the world. Additionally, reconceptions are open to contingency and change; they are processual modes of thinking, which permit exchanges between and across conventional intellectual, political and cultural borders. Through a continual process of reconception, thought remains relevant, useful and capable of responding to the ever-changing circumstances of individual subjects in the present. In reconception, the 'knower' is located within the frame of the 'known'; participant-action research, the responsibilities of the ethnographer, the ethical implications of intellectual disciplinarity and the role of academic institutions figure prominently in the pages of this volume. These are not explored from beyond, but from within and their reconceptions have material consequences for both writers and readers.

2 breaking the disciplines

Tracing just three keynotes within this book makes the role of 'reconception' clear. First, the increasing commodification of knowledge in the UK Higher Education sector, suffering from the pervasive legacy of Tory managerialism and anti-intellectual bureaucracy, underpins some of the most powerful criticism within these essays and certainly fired our own initial determination to research against the grain. Our talks were filled with a real sense that resistance to this climate of 'student-customers' and 'subject-providers' could be found in reconceptions, in acts of discipline-breaking, self-analytic intellectual questioning focused upon the production of knowledge, rather than its products.

A very different, but equally compelling, link between many of the essays gathered here is the address to marginality and loss – from the disempowerment of culturally excluded groups to the horrors of slavery, 'ethnic cleansing' and the torture of dissidents. Again, we see a mode of reconception being posited in these texts through tactics designed to articulate difference, commemorate the nameless, bear witness to the unspeakable and give voice to the silenced. These reconceptions are not hopeless, they are not subsumed by the tragedies of which they speak, but are instead instances of resistant and resilient *agency*, determining a future fully cognisant of the past and yet not simply determined by it.

> **Agency** is constantly implied here, but not as instrumental action, or personal motive. Rather it refers almost invariably to a nexus of opportunities, occasions, motives and responses. It involves a system of occasions for individual action, which also contextualizes and governs individuals' inputs. The artist, the critic, the philosopher, the anthropologist is not outside the social, cultural or symbol-system they study; their behaviour is determined by that system. Conversely, their active personal commitment enables them to perform a consciousness-function for the totality of the system in which they are involved. They are not *agents* exerting a powerful effect, but rather a necessary point of intersection of various systems of information and reference through which the world makes sense.

Questions of historical determination are pivotal to *Breaking the Disciplines* and demonstrate yet another form of reconception mobilized by the diverse arguments collected here. Many of these essays are close readings of particular texts, images, objects and conditions which seek to challenge the brittle edifice of the presumed known through attention to the material specificity of meaning-production. They precisely do not 'take as read'; their historical intervention centres on the refusal of universal narratives in favour of situated knowledges. These historical reconceptions acknowledge

the role of aesthetics and ethics in histories and enable us to renavigate the past and map our present course.

By offering these brief thoughts on some of the reconceptions undertaken within the essays in the present volume, I am not suggesting that they can be reduced to unity. As we had always intended, the essays speak in their own, very different, voices – they articulate their arguments through wide variations of style, tone, structure and perspective. As editors, we sought to maintain their productive resonance rather than use the editing process as a means by which to mute them into consonance. I remember our own debates on this rather risky course – would this make the book incoherent, difficult to place and sell or would it permit readers to engage in the process of reconception themselves, crossing the boundaries of traditional academic disciplines and making connections between the most creative elements of the arts and humanities? We thought the latter and took the riskier decision not to tone the texts down in favour of the market and to reiterate the place of this volume as a process, an event, rather than a product or a consumer object. As an event, it is but one punctuation point within a wider, ongoing activity of reconception and its value resides in what it might inspire between and across areas of knowledge, rather than in how it might best be categorized, labelled and put on the shelf.

MLD *As you say, many common themes connect these essays in different ways. They constitute the inner coherence of this collection. But how did that come about? We said to our contributors at the outset: you should say what's on your mind. Forget the academic or disciplinary niceties; say what it is you do, what you think. We wanted to talk about what we do at present, because the only knowledge of any use deals with what is going on now. For each participant the key issue is reflexive: what are we doing when we are doing what we are doing? What am I looking at when I am looking at something? What am I saying when I am saying something? Each contributor deals with the condition of knowledge, what constitutes knowledge, how it is produced. At that moment a gap opens up between disciplinary convention and intellectual practice. And that is where reconception starts. But what underpins this reflection and the practice of reconception, relates to another issue that recurred often in our absorbing discussions: the idea of an ecology of knowledge.*

4 breaking the disciplines

> An **ecology** is a self-sustaining, self-regulating system. An intellectual ecology posits a self-sustaining, self-orientating system of thinking. According to this definition, mind is not isolated in the brain. The capacity to think is a function of the total intellectual environment. This encompasses the brain, its body, and its social and natural context. It also includes the intellectual, the professional scholar, the academic expert, the technician, their social institution, their public, their sponsors and their social and natural environment. A true intellectual ecology still needs to be developed: as yet only rudiments exist. Current epistemologies, particularly in the humanities, are narrowly entrepreneurial and technocratic. They are exclusively based on purely personal interests. They are a projection of the attitudes and personality of the individual academic expert. That is to say, the scholar's personal opinion gets promoted to the status of a science by virtue of his or her technocratic social function. The proliferation of this kind of research is what spoils the current intellectual eco-system, which is as messed up as its natural counterpart. The ecology of knowledge begins with a reflexive issue: the implications of any item of knowledge for the total eco-system of the mind. *Breaking the Disciplines* shows how the intellect is a crucial relay between social, natural and cultural systems. It suggests how an ecological conception of knowledge would work.

The concept of 'ecology' applied to knowledge reaffirms thinking as something vital – thinking not as technical problem-solving, but as reflection, thinking about the nature of thinking, about what purposes it should and should not serve. Thinking is not an activity locked inside the head, manipulating the world outside it, as if by remote control, but an activity operating within the entire cultural system. Reconceived in these terms, the cultural system becomes an ever-expanding mental space, a dynamic network of minds and symbolic forms, sustained by and sustaining the world around us – most immediately our own material, physiological existence that is situated in it and cannot last without it. This underlying ecology shows up in the fact that each essay dwells on those issues – heteronomous political, social, and economic pressures, bureaucratic regulation, exploitation, pain, torture, abjection, forms of symbolic and physical coercion – that are out to subvert thinking and prejudice reconception, that pose an immediate threat to reflective consciousness.

The concept of an ecology of knowledge also made us think about the need to see the disciplines broken, particularly in the arts and humanities. The intellectual and creative practices they incorporate should be most responsive to what is going on now. They ought to offer opportunities for reflection. But all along the line they cave in to commodification and convention. As you say, educational policy, a managerial ethos and purely instrumental priorities constantly retail knowledge already known, the same old thing. And the arts and

humanities, heavily into historicizing practices that keep on revamping the same old thing, instinctively conform to the going political and economic norms. The integrity of the knowledge-system as an intelligent structure in itself should be a reflective resource for society. But that vanishes as soon as its practitioners solicit endorsement from heteronomous political and economic values to promote their knowledge and themselves. What this means is that the disciplines, as the logistical infrastructure of commodified knowledge, are more powerful than ever, but fundamentally compromised.

Consequently, none of the essays here accepts the world and its knowledge-structures as they have become. They show that it takes nothing more (nor less) than verbal incantation, a rhetorical gesture, a splash of colour, ironic bricolage, to produce a countervailing principle of resistance. Thus they affirm the crucial function of the imagination as a life-orientating faculty. (The enemies of the imagination are enemies of life itself.) They also demonstrate the recalcitrance of reflexive consciousness. Consciousness is not just a neutral vision, a clear optic, but a complex facility for self-orientation. To be conscious is to be reserved, detached, discriminating; it means having second thoughts, being sceptical. Imagination and reservation together generate a forceful intellectual dynamic not bound by the past (by the same old thing), but forward-looking, with an 'anticipatory' function. Needing a cultural system that is not finished, not pre-determined, not acquiescent in conventional knowledge-practices, it insists on an ecological conception of mind and knowledge.

section i

the imperative to challenge disciplinary orthodoxy

thinking practice

on the concept of an ecology of knowledge

martin l. davies

I

It is a sign of the times, and it is not a very good sign, that it should be necessary nowadays – and not only necessary, but that it should even be a matter of urgency – to interest intellectuals in the fate of the intellect, in other words in their own fate.

Paul Valéry[1]

All thinking has a basic interest in the ecology of knowledge: after all, it is essentially reflective. Intellectual ecology focuses on who uses knowledge – in what ways and for what purposes. It is needed to expose the automatic habits of thinking, the technocratic nature of current knowledge-production. It is suspicious of conclusiveness. Its questioning stance is not negotiable. It insists on lucidity.

The concept of ecology beckons for want of a language to tell the difference between the knowledge already known and the knowledge society needs. There are discourses of epistemology, of the sociology of knowledge, of cognitive psychology: these are useful. There are discourses of education and of education management, but these are especially otiose. There is the late, pervasive discourse of academic self-consciousness. It expresses a diffident mentality, post-enlightenment, post-modern, post-structuralist, post-colonial, post-feminist, in which everything not a social construct must be deconstructed. It now provides (à la IKEA) self-assembly, flat-pack kits of literary, philosophical, and historical critiques to suit any agenda or situation. The post-1960s explosion of ideas which might

have drastically changed the way people look at things, has long since declined into platitude and predictability. Worse, denied any real political purchase, these ideas have become the thinking-person's ideological comforter. Nothing prevented the *de facto* depoliticization of politics pursued by politicians of all persuasions and the business sector alike: the consensus of progressive, intellectual opinion was being all the while so correctly, radically theoretical. There was no language of reflection. No wonder that 'our time, so abundant in the fruits of knowledge, should by this same token be tragic for knowledge itself': that is 'because it is tragic for reflection'.[2]

Reflection constitutes the ecology of knowledge. It is the self-consciousness of intellectual practices. It gets at what is behind them, at what they actually do and how they work. Thinking is not automatically reflexive. Thinking that occurs in terms of disciplines, does not usually reflect on itself or the wider world. A discipline can easily decline into technical formalism. It has a preconception of how its objects make sense. What makes sense is something already decided as being meaningful by the discipline. Reflection explores the relationship of knowledge to the reality it is meant to explain. It is the experience of what it is to be conscious. It dwells on the constitution of sense and the production of meaning.

The ecology of knowledge begins with thinking reflecting on itself. But thinking, when it does reflect on itself, is unhappy with its history. Thinking is averse to history. Its logical instinct puts it off anything contingent. But thinking is dismayed to find that it does have a history – that it itself might be just another product of contingency, that over time its concepts lose focus and drift. Thinking, therefore, will always find the accepted priorities unacceptable. It will always want to reorientate itself; it needs constantly to recover its autonomous coherence. The treatises reflecting on intellectual method from the seventeenth and eighteenth centuries are illustrative. More importantly, their authors – e.g. Descartes, Pascal, Bacon, Locke, Spinoza, Kant – also contribute to a language for reflection. They provide both a genre for redirecting thinking and a facilitating, ecological rhetoric. (Furthermore, the cases of Descartes and Spinoza, figures of inner exile and ex-communication, suggest the direct, political implications of intellectual ecology.) In his *New Organon* (1620), Bacon rejects 'those systems which prevailed in ancient times'. In doing so, he formulates a crucial component of intellectual ecology.

He reflects that it is 'better surely... that we should know all that we need to know, and yet think our knowledge imperfect, than that we should think our knowledge perfect, and yet not know anything we need to know'.[3] Bacon seems to be asking an open question: How do we know what we need to know? It seems indefinable. But the ecological concern for knowledge need not be positive. Instead it sustains a mental reservation. It questions the need to know what is known already.

The questionable forms of knowledge already known, identified (for example) by Bacon, Spinoza and Locke, are still current. They are: deference to authority, specialization, theorization, and commodification. Deference to authority (as Spinoza recognized) means giving up one's 'supreme right and authority of free judgment'. ('The authority of Plato, Aristotle, and Socrates, does not carry weight with me,' he wrote in 1674.)[4] Here it is necessary to distinguish between the persuasiveness of arguments *de jure* and intellectual attitudes which replicate themselves socially. Intellectual fashions, particularly when exploited commercially, exert a normative influence inimical to reflection. Constant citation and popularization enable what is already known (because it already is in the authoritative books) to make itself known. The allegedly 'authoritative' or 'influential' status of an idea is factitious. The degree to which it is authoritative or influential simply indicates how predisposed it is to being socially replicated. Its social prevalence comes from an unreflected need – it may be social-psychological, it may be simply commercial – to imitate what is *already* recognized as socially prestigious.

Further, specialization reinforces the knowledge already known by enforcing – e.g. through conventional methodologies – normative forms of behaviour. Specialization is the essence of disciplinarity. It is a technical and technocratic form of knowledge-production, a mode of intellectual conformity, alien to an ecology of knowledge. Specialization proves inimical to reflection by means of the mystique of expertise this behaviour engenders. Specialists 'reason right' (Locke acknowledges), but are let down by their parochiality: 'they read but one sort of books.' Knowledge (he says) must instead be involved in the wider world; it must connect with the social environment.[5] Certainly, disciplinary interests can be a platform for intellectual dissidence (cf. Einstein, Sakharov, Chomsky). But in these cases,

prominent status in a discipline offers a guarantee of the validity of the public use of reason and knowledge.

Locke also regards theorization as a pathological form of specialization: 'Let a man be given up to the contemplation of one sort of knowledge and that will become everything. The mind will take such a tincture from a familiarity with that object, that everything else, how remote so ever, will be brought under the same view.' The 'intellectualization' of material practice adds nothing to what is known and practised already. Locke's ecological concern, his pragmatic sense of culture, are noteworthy: 'A metaphysician will bring plowing and gardening to abstract notions; the history of nature will signify nothing to him.'[6] Theoreticians (like narrow specialists) never escape from the theoretically imposed limits of the theory they know already. Theory, in this modern sense, derives not from the Aristotelian contemplation of eternal truth. Rather it too is an intellectual technology for managing reality.[7] Ultimately it becomes predictable: 'If men are for a long time accustomed only to one sort or method of thoughts, their minds grow stiff in it, and do not readily turn to another.' To the disruptions in, and challenges from, the social and cultural environment, which would otherwise provoke reflection, theory has the answers ready made. Locke suggests eclecticism as an antidote: 'I think they [i.e. 'men'] should be made [to] look into all sorts of knowledge, and exercise their understandings in so wide a variety and stock of knowledge. But I do not propose it as a variety and stock of knowledge, but a variety and freedom of thinking, as an increase of the powers and activity of the mind, not as an enlargement of its possessions.'

Lastly, knowledge has commercial value only if it is already known, if it is inherently receivable. As a commodity it is also sustained by heteronomous, economic laws and management structures. The vocabulary in *Of the Conduct of the Understanding* (1697) is distinctly economic. Specialized, parochial minds (says Locke) 'have a pretty traffick with known correspondents in some little creek; within that they confine themselves, and are dexterous managers enough of the wares and products of that corner with which they content themselves.'[8] Locke makes a commercial analogy for the social dissemination of highly specialized knowledge. But even his commodified interests lead him to allege that too much specialized knowledge is constantly recirculated, while more valuable, but more difficult, insights remain ignored. Now, conversely, as a type of

philosophical materialism, intellectual ecology will always target the commodification of knowledge. Knowledge 'in itself' consists of 'invisibles': opinions, ideas, arguments, theories, technologies, belief-systems, ideologies and the claims made for them by the social and academic managers of knowledge. The ecological interest assesses them in terms of the underlying, bio-political or socio-economic behaviour they quite visibly sustain.

Reflection, preoccupied with how things make sense, pushes towards absolute scepticism. The process of reflection itself must realize (as Susan Sontag remarks) that 'it seems unlikely that the possibilities of continually undermining one's assumptions can go on unfolding indefinitely into the future'. It must envisage that 'all genuinely ultimate projects of consciousness eventually become projects for unravelling thought itself'.[9] But reflection does not involve the absurdity of infinite regression. Rather it is a means, the sole means, of coping with the contingencies in which we live. So much that affects us is questionable, so much needs to be questioned. Reflection is the basis of a questioning social and intellectual practice.[10]

The ecology of knowledge that reflection sustains, has one clear premise. This is: that thinking recognizes an inherent need to look after itself. Descartes, for example, reflected that, though his world could be illusory, there had still to be a subject (i.e. himself) capable of formulating that very thought.[11] Moreover, Cartesian philosophy, often taken for a dualistic, even solipsistic system, is not so far from ecological materialism. This is confirmed by the materialist (physical and physiological) hypotheses outlined in *Discours de la méthode* §5. Here, marginalizing divine intervention, Descartes speculates that matter, following inherent laws, would of itself be sufficient to create the world as we know it.[12] Certainly he demonstrates the ecological potential of purely reflective values – of self-obligation, radical reservation, the recourse to first principles, of conceptual parsimony. His thinking suggests that ecological conscientiousness is a primary, a-historical reflex of existence. It always appears as a recurrent 'historical constant' in phases of reductive scepticism. It always responds to cultural disorientation, be it European society riven by the religious and political conflicts of the Thirty Years' War, be it melancholy post-modernism, marked by the 'creative destruction' of global capitalism, cultural-psychological fragmentation and the redundancy of reality-values available 'all ways'.[13]

The ecology of knowledge is, therefore, an intellectual necessity. Thinking cannot proceed 'all ways' – not without discrediting itself, as Kant maintains in his essay, 'What is orientation in thinking?' (1786). Kant here takes the question of cognitive intention a stage further. He argues that thinking must look after itself, particularly when it ventures into those virtual – i.e. supra-sensual – realms beyond experience and intellection (i.e. beyond time and space). Kant argues that the mind has its own sense of direction – just as a person has primary orientation in a landscape or in a darkened room by means of physical location. Bereft of objective premises as it may be, reason still needs to set principles for purely subjective inferences.[14] When reason ventures into the disorientating realms beyond experience, its need exerts its right to assume as a subjective premise what it would never dare to know on an objective basis: to be guided by nothing other than its own need.[15] In this realm (says Kant) there are so many fanciful, oniric entities with which thinking need not concern itself. Nevertheless, thinking – for the sake of its own propriety – needs subjectively to assume what it cannot prove: the existence of a primordial entity, an immanent intelligence and highest good, to sustain its subjective aspiration for truth and morality.

Kant describes an ecological concept of perception: that physical, spatial structures are innate in the mind and so already predetermine consciousness. He thus states a key premise of the ecology of mind, which brings him close to Bateson's observation:

> The individual mind is immanent but not only in the body. It is immanent also in pathways and messages outside the body; and there is a larger Mind of which the individual mind is only a sub-system. This larger mind is comparable to God and is perhaps what some people mean by 'God', but is still immanent in the total interconnected social system and planetary ecology.[16]

But Kant also wants to know how thinking can reliably look after itself according to its own needs. He attributes this personal sense of intellectual assurance to 'faith in reason', a conviction deliberately insufficient in objective terms, yet subjectively adequate. Faith in reason is a compass which guides thinking in both its theoretical and practical (moral) forms. But it is also a precondition for revealed belief. Without faith in reason, it would not be possible to infer from certain, localized phenomena the larger eco-system of the mind.

Always reason must speak first, otherwise fanaticism and superstition result and it does become possible to say anything about anything.[17]

Kant alludes to a prototype theory of 'cognitive universals' in perception which guide the interaction of mind and world. He addresses those who, impatient with rational discrimination and reservation, seek alternative access to reality in the name of freedom of thought – as if these ecological universals could simply be denied. What he says is more than ever relevant now. Kant demonstrates that intellectual freedom not based on faith in reason (i.e. innate cognitive structures) culminates in an ecological crisis of the mind. Freedom of thought opposes social coercion. The ability to communicate one's thoughts freely enhances and develops what one thinks, and fortifies one's resistance to social pressures. It also opposes doctrinal (i.e. religious, social-ideological) injunctions. But, above all, freedom of thought means recognizing that thinking is obligated only by its own laws. Thinking, emancipated from its own self-legislation in the name of freedom of thought, would not be free, but lawless. Worse still, its lawless state would expose it to heteronomous legislation. Thinking would collapse into a chaos of arbitrary obsessions, exacerbated by linguistic confusion. Bereft of its own inherent dynamic, reason becomes subjugated by ready-made fact – subjected to the arbitrary, irrational rule of the *factum* (i.e. commodity thinking). Kant warns that, in the name of freedom, mind itself would be destroyed – and with it its cornerstone, the reflexive principle of the ecology of knowledge.[18]

There is, in other words, no option but to return to ecological propriety, to 'clean' thinking. As Kant argues, there is an irreducible core of intellection in human beings as bio-anthropological creatures requiring orientation in their life-world. He shows that the eco-structure of mind sustains this autonomy of reflection. For Kant, it is axiomatic that reflection cannot be coerced. It is self-legislating. Its faith in itself reveals a wider social-ecological structure of mind. It ensures that, though knowledge-production be managerially regulated (as in a knowledge economy), the mental stimulus always proves recalcitrant. Kant argues that intellectual-ecological reflection will itself find the strategies it needs to look after itself.

The recourse to reflective reason is not escapism. Rather it always returns us to where we are in the world. It also returns us to the world in which, without any other guide, we have to find our way.

Reflection is thus the inception of ecological awareness. Thinking needs to be aware as much of the particular places in which it happens as of its logical validity. The self-interrogation with which it begins, takes us back to the 'genesis of our representation of the world'. It confronts us with such fundamental issues as the construction of the image of our embodied self, hence the physiological premise of experience; moral obligations (the super-ego); the linguistic-symbolic character of human reality; and networks of social relationships. Reflection, as the consciousness of consciousness, is a product of the mental life of the organism that we are, an organism requiring its specific, meaningful, cultural eco-system.[19]

Reflection is the cornerstone of the concept of intellectual ecology. It reveals the mind itself as the product of the material, 'bio-anthropological' constitution of human beings. Reflective thought-processes derive truly from 'the reason within our bodies, our best wisdom': their veracity, their credibility, are entirely visceral.[20] The social and intellectual ecologies on which life depends, their attendant distributions of power, resources and opportunities, are – reduced to essentials – visceral matters. Current reflective strategies – semiotics, cognitive psychology, cultural anthropology, phenomenology – have attempted to define the ecological nexus of the mind. They see 'the organization of culture as a collective intellect'; that 'some degree of rationality... makes good biological sense'; that 'the cosmic Whole itself, in a certain way... is inscribed in the cerebral organization of knowledge'; that human experience in the natural situation means '[placing] ourselves in us as well as in objects, in ourselves as well as in others... to the extent that we become others and we become world.'[21] Mind, body, and social and natural environment are, therefore, in constant, reflexive neurophysiological interaction. Culture itself is a cognitive machine which, through all kinds of differentials, meshes with mechanisms of material, socio-economic production.[22]

The ecology of knowledge is a materialistic strategy for social and cultural criticism. It studies the interdependence of cultural and economic production, mind and society, through the malfunctions they cause in each other. It represents not external opposition to social processes, but a mental reservation inevitably generated by them. It works as a fail-safe, intellectual reflex. Ecological thinking, generally, doubts the sustainability of the prevailing economic system. In its extravagance it senses imminent entropy. So too the ecology of

knowledge. It occurs late – when the entire process of intellectual production becomes routinely self-defeating, when the exponential proliferation of knowledge entails, absurdly enough, the entropic disintegration of sense.[23] At this moment the intellect itself comes to recognize its own need for ecological propriety. The greatest threat to thinking lies less in censorship than in 'the rising tide of insignificance'. The manufacture of a synthetic consensus by the media, the commercialization of intellectual and cultural values and the systemic mass-production of 'surplus meanings' by the social institutions of knowledge – all this generates not only more meanings but also thereby their overall, relative insignificance to each other. With their output of technocratic ratiocination, the institutions of higher education themselves neutralize reflection. They intentionally sponsor meaninglessness: generating ideas and forms in excess of what can practically be assimilated, i.e. made meaningful, where it counts, socially.[24] Since higher education repudiates any socially or personally transformative purpose, its institutions become agents of its own trivialization. Hence the official control of intellectual dissidence becomes unnecessary. Dissidence makes itself redundant. The knowledge already known proliferates in such volumes as to be mystifying and effectively disorientating. (Multiculturalism is not so much the solution to social conflict as the liberal-minded solvent of social meaning.) Finding itself disorientated in an inimical environment, thinking must look after itself: 'the faculty of reasoning seldom or never deceives those who trust to it.'[25] Here ecological reflection comes into its own.

II

Nowadays there is a real offensive under way against thinking.

Julien Benda[26]

Reflecting on knowledge about knowledge is a practice society hardly encourages. No wonder that the rigorous geometrical method in Descartes and Spinoza, no less than the critical 'inquisition' of nature in Kant, are maligned as autocratic. No wonder that their rationalism is alleged to be self-deluding, that their reflective *logos* needs to be subverted: these are, of course, impediments to production. No wonder that their work of conceptualization looks repressive: it is,

clearly, a restraint on production. In the knowledge economy, as in the wider liberal market economy, output is all.

Moreover, reflecting on itself, thinking has reason to be disappointed with its history, with its susceptibility to drift. For example: rationalist metaphysics, viewed as a set of remote abstract essentials, would be vulnerable to ontological or situationist critique. Any logical construct would be open (as Nietzsche remarked) to being seduced by the very grammar of its language into saying more or something other than it intended.[27] But a reflective ecology of knowledge would not object to these objections. They are the very reasons for an ecology of knowledge to be reflective. Moreover, this grammatological critique should have been conducive to discrimination. That words themselves can be hostages to fortune, justifies being reserved. But here too thinking has reason to be dismayed. It finds that it never sets a precedent: it follows up or follows on. This late age, with world wars, economic collapse, genocide, nuclear deterrence, industrial-technological expansion, has *already* irremediably jeopardized not just the natural but the intellectual ecology. It is undeniable: this century has shown that 'more is real than is possible'; in this last century 'more has been produced than can be imagined'. The human world itself, as an ecological entity, has already become antiquated.[28] In this situation it would be difficult for any *a priori* sense to survive. Ontological, situationist, grammatological reflection could at least have been expected to attempt to ascertain what sense was salvageable in these nihilistic, necessitous times, what could still be said.[29] But as a social behaviour in a world where a fatal bio-politics was already institutionalized for the sake of unrestrained production, this critique in effect subverts the last formal, intellectual restraints. Paradoxically it has come to provide the 'intellectual aroma' of a shabby, neo-liberal world, a world that makes no ecological sense.

The ecology of knowledge is a way of reflecting on how sense is made. Hence, it is sceptical of what an ecologically senseless production-process produces. Knowledge itself involves verifiability, method, coherence. It stresses conceptual parsimony – the need to prevent explanatory concepts from proliferating; the stipulation that explanations should account for the maximum number of phenomena with the minimum number of causes or categories. But a system producing insignificance banishes these values. Across the human

sciences what passes for knowledge is opinion, an instrument of self-interest. It denies its own intellectual-ecological implications. It makes the very concept of critique banal. In the enterprise economy the ideal of production is unassailable: so is, by analogy, the production of opinion – private enterprise in intellectual form. In both spheres the expert is the ultimate producer. The expert – particularly in a knowledge-economy – holds the key to production. After all, the expert *is* nothing but his or her knowledge. But the ecology of knowledge also explains why inconsistencies in 'expert knowledge' appear as conflicts of 'expert opinion'. It also explains why its most specialized products (be they personal computers or academic monographs) are complex, yet expendable commodities. Where multiple, complex specializations generate overall insignificance, an ecology of knowledge aims to discriminate between knowledge and opinion, to differentiate between the knowledge society needs for its self-enlightenment from the mystifications of the opinions it is forced to listen to.

In any case, the categorical forms of rationality – in Descartes, in Kant, for example – imply that an ecology of knowledge cannot ignore social interests. Given the bio-anthropological constitution of the human being; given that, by means of the body enclosing them, the brain (and its consciousness) are enmeshed in the wider social-technical and natural environment: the ecological restoration of the intellectual environment must imply the ecological restoration of the social world. More to the point, the ecology of knowledge has to target techno-science and global capitalism as forces hostile to both local eco-systems and the total biosphere.[30] It has to expose the 'unavowed bio-politics' sustaining society and its institutions.[31] It needs to insist that our self-consciously informed, multicultural existence is in itself already ethically compromised. It needs to show that our knowledge – its scholarly objectivity, ingenious erudition, theoretical sophistication, radical perspicuity – is already incriminated. It endorses a production system which ruthlessly pursues its own interests by exploiting the producers of its raw materials and commodities in the third world and deceiving its consumers in the first.

The question of intellectual ecology arises, therefore, from within a world managed by techno-science, particularly from the normative activity it enforces, since this itself poses an ecological threat to

intellectual existence. Normativity is at odds with the intellectual eco-system which positively requires diverse and, therefore, dissident reflective practice. Normative intellectual coercion operating through knowledge-production itself, makes an ecological critique of knowledge indispensable. The point is: in a 'knowledge-society' the social function of knowledge changes drastically. Knowledge is still power, only it passes from the thinkers to the knowledge-managers. For this reason the gap between the knowledge already known and the knowledge a society needs gets ever wider. The chief agencies of obscurantism are the social institutions of knowledge themselves. They see themselves in corporate terms. They promote themselves in the wider market 'environment'. They create for themselves a 'brand image' to attract finance and investment. Their products are their courses, their consultancies. They thus create in themselves, within their institutions, a culture of marketing and commercialism. They thus proclaim that, whatever other (academic? ethical?) interests they promote, they too, like the rest of society, see making money as the most interesting thing to do.[32] But what university culture loses when it embraces the managerial culture of euphemism, is its aspiration to intellectual unimpeachibility, its commitment to veracity. What it loses in its PR gambits and publicity spin, is the behaviour which makes its alleged cognitive values real. In creating their own market-fetishism, the social institutions of knowledge contribute to the irrationalism of market forces and the mystification of the life-world. Since the social institutions of knowledge are just another economic agent in the market, higher education becomes a management strategy for assimilating young adults to the socio-economic production system. As Steiner contends, the intention of mass higher education is to 'trivialize... the cultural values and products towards which the common man is being directed'.[33] Hence, a given subject, a given course offers a set of normative constraints to reinforce a single reality principle: the priority of commercial interests. Its reflective potential is neutralized by the institutional prescription of study methods. These aim to inculcate 'entrepreneurial' practices and economic aptitudes: norms of competency in communication technologies, team-working, prescribed outcomes. The ideal of intellectual autonomy comes down to the ability to make 'informed decisions' about knowledge already known.

The 'knowledge-society', therefore, hardly produces the knowledge society needs. Moreover, the technological environment it sustains poses unique challenges as an essentially intellectual construct. These reveal the specific character of their intellectual-ecological menace. 'The mind has transformed the world, and the world gets its own back on it' (Valéry observes). Instrumental thinking has alienated people from 'the basic conditions of life itself', yet paradoxically remains the only means of solving the unprecedented problems it causes.[34] In technocratic expertise and specialized theorization there is inherent ecological blindness. The reason is, as their critics have repeatedly stressed, they require abstraction. They achieve precision, and objectivity by excluding from their conceptual scope their problematic ramifications into the social and cultural environment. And they are autotelic. They pursue their self-defined aims in their own, methodologically hygienic world, on principle shunning any intellectual confrontation with the very premises which constitute them as disciplines.[35] Furthermore, technological achievement – e.g. space exploration and the ensuing planetary perspective – itself has re-functioned human cognitive organization and the ordinary language in which it expresses itself.[36] Technocratic expertise is, therefore, unable to solve the problems it generates. The 'face-the-facts' mentality is the most resigned, the most entropic. Typical is the recent admission of an eminent professor of management that, for all the available expertise, the system of global capitalism is inherently unmanageable. Disingenuously, euphemistically, he observes: 'For at least a while we are simply going to live in a world with greater inequalities on a broad scale.'[37]

But in a knowledge society the humanities are particularly bankrupt. Ostensibly the humanities reflect on the way society runs. They are supposed to raise those issues of meaning and value the sciences avoid. That is: wherever issues of meaning and value are raised, the humanities are already involved. With this unique responsibility they keep a vigil on the fate of culture. They are the reflective force of the collective social imagination. Producing socially relevant knowledge ought to be crucial for them. Instead, they are bereft of any foundation in human sense. Rather they are founded on a sense of the human itself long since antiquated. Hence, for their articulation and relevance they are dependent on the only operative structure remaining: the structure of economic production, the liberal

market economy. They simply reiterate the socio-economic system. They just affirm the social contradictions of knowledge-production: they effectively disconnect the knowledge society produces from the knowledge it needs.

The humanities are now the enterprise culture in ideal form. Their antiquated antiquarianism betrays them. So many material resources, intellectual energies, administrative bodies exist to deal with what is over and past. It is impossible not to wonder why. The reality of the ideal of total historical recall would be catastrophically traumatic. The point of this expenditure must, therefore, lie elsewhere. Its social authorization must have another purpose. Since the only way to understand the present is to understand the present, attending to the past is a distraction on a massive scale. Each retrieved fact (as *factum*) from the past, is a lost opportunity for reflection at the forward edge of our time. This self-absorption in bygones numbs the nerve of immediate awareness.

Certainly antiquarian interests flourish in the global technoculture. The literary, philosophical, art-historical, musical canons are impeccably replicated on the latest electronic media. The major galleries and museums are thronged with the youth of the world. What do they see in these labyrinthine galleries it takes legions of expert curators to manage and maintain? The social imagination, along with its present, aesthetic potential, undergoes protracted conditioning. It is enjoined to contemplate in the past, even in the recent past, society's 'assured values'. Viewing precious, archaic objects in their showcases, visitors are invited to witness wealth directly, oblivious to how it was gained. (And this is absolute wealth, defined by the consensus of historical scholarship.) They are offered opportunities to familiarize themselves with the value of value. They learn that culture is only culture when it is socially and economically affirmative.

What explains this social behaviour is the increasingly wide availability of higher education in the humanities. In its antiquarian interests particularly, the humanities are preoccupied with understanding how social value is produced. In his studies of the Mont Sainte-Victoire, for example, Cézanne did not set out to paint 'priceless' works. Their pricelessness derives from the conversion of subsequent historical-critical appreciation into market value. Studying Cézanne now inevitably involves learning how 'pricelessness' is

produced. Even technical, formal, thematic issues in the artefacts, apparently unrelated to market values, become functions of these values. This situation obtains *mutatus mutandis* across the humanities disciplines. The humanities are the ideal form of enterprise culture, because history is the ideal production system. It has unparalleled capacity for adding value to the meanest, shabbiest item, as long as it is old and curious enough. But the production system would not function without scholars. Their research specializations, their expert skills, develop now wittingly, now unwittingly, new lines of production, new ways of adding to social-economic value. But the production system would also not function without consumers. Their informed tastes ensure a continuing demand for high-value commodities. The humanities are, therefore, the ideal form for producing the ideal consumer. The learning process enjoins consumption, not insight, nor enlightenment.[38]

But why view commodity thinking so sceptically? Surely intellectual capital is socially enhancing? Does it not generate ideas society can use? Such questions are void. The point is: what in this environment happens to thinking? The proper task of philosophy is not just to ask what is (says Merleau-Ponty). It also 'turns back on itself, to ask itself as well what asking questions and what responding mean'. Once put (he continues), this 'question to the power of two can never be erased. Henceforth nothing will be as though there had never been a question.'[39] What happens to reflective thinking? It is made redundant. The environment suppresses it: the line-management system of the knowledge institutions sees to that. The question is not asked.

So the intellectual eco-system atrophies. The situation is deceptive: scholarship proceeds 'as before', but actually finds itself irretrievably re-functioned. Irrationally enough, it becomes a 'selling-point' of the corporate university, an index of its suitability for commercial sponsorship and investment. Both the academic management of knowledge and the management of academic knowledge ensure that whatever goes intellectually sells, and whatever sells goes intellectually. This reveals that, left to its own devices, the understanding is venal. Karl Jaspers quotes Cusanus: understanding is a whore, open to any offers. He argues that, bereft of reflective self-consciousness, knowledge becomes 'interminably gratuitous, seeks to be correct on matters of total indifference. It generates

pointless activity, it becomes compliant and subservient.'[40] Insignificance inundates the intellectual environment.

This indiscriminacy arises from none other than the so-called 'hard' methods of technocratic expertise. The combination of specialization and commodification boosts the proliferation of fact. This information in turn increases the opportunities for adding value. The 'knowledge society' thus becomes the source of reflective ignorance. It passes social conditioning off as learning. It substitutes narcissistic infatuations for material analysis. Worst of all, it leaves the present alone.

Ecological concern for knowledge is nothing repressive. It faces a post-modern 'betrayal of the intellectuals'. What else are the 'humanities' but the abstract form of currently prevailing socio-economic conditions? What are the 'liberal arts' but merely propaedeutic to the entrepreneurial skills needed for perpetuating them? For what else are *universe*-ities but 'key engines of *local* economies'?[41] The managers of knowledge-production themselves have changed the purpose of learning. More crucially, they have corrupted the fabric of intellectual culture: its language. They cannot express for themselves the truth of what they perpetrate: they have to resort to euphemism. Commodity-thinking proliferates in ever-new ways. An ecology of knowledge simply recognizes that the capacity for reflection has left the system.

Ecological concern for knowledge begins where faith in the knowledge-production system ends. It grows, because intellectual belief in the system has withered. It is a symptom of the demise of intellectual trust. On those who work in it, the system imposes its duplicity. But this duplicity at least breeds scepticism. Beyond this the symbolic forms which sustain ecological reflection still exist. They are still reliable. (As 'capital', as 'heritage', they are – ironically enough – often preserved better than ever.) By definition the reflex of experience, attitude and material location, ecological concern for knowledge will not be disorientated. Philosophical reflection is always material, always attentive to its life-world, hence always demonstrative of an intellectual ecology. Reflection aims to get at what is really happening, to reveal the underlying processes at work in the world. It aims to uncover what is behind them.[42]

III

If there is no thinking for its own sake, then for this reason it has to be clean.

Ernst Bloch[43]

The ecology of knowledge offers a method and a language for relating apparently disparate phenomena with each other. It advocates reconception. This aim looks modest. But where disciplines, responding to market forces and narcissistic tastes, dissolve into proliferating sub-disciplines, the ecology of knowledge makes no sense as yet one more discipline. For the same reason, intellectual ecology must dissociate itself from that new variant of specialization, interor multidisciplinarity. This involves just the purely technical coordination of technical specializations. The emergence of interdisciplinarity is itself an acknowledgement that the proliferation of specialized scholarship leads to generalized arbitrariness. It aims to define larger, common patterns of coherence for partial interests. In fact, interdisciplinarity in this technical sense is another form of intellectual-ecological sabotage – as Kant remarked: 'To permit the frontiers of knowledge to merge into one another, does not develop the sciences, rather it disfigures them.'[44]

Instead, reflection must re-examine primary forms of symbolization and conceptualization. It works through reconception, since this is a 'principle of intelligibility which modifies the principles and rules governing theories'.[45] Reconception is the only response to the heteronomous subjection of thought. Its premise is that reality is not naturalistic, but rather conventional; that reality consists of various, interdependent 'world-versions' of meaning and sense; that reflection symbolically, semiotically analyzes and reconstitutes the 'world-versions' which structure our lives.[46] Reconception thus offers resistance to ideologies that claim that life is lived according to a single reality-principle (such as 'market forces').

Far from producing a new discipline, the ecology of knowledge is necessarily eclectic: reconception – in the interest of ecology – finds out and re-uses what knowledge is available. Eclecticism is a much-maligned intellectual stance. It is assumed to be synonymous with a lack of discrimination. Actually, it is the sole antidote to the specialized antiquarianism and the technics of multidisciplinarity that

produce the tide of insignificance. Eclecticism is, in itself, 'a polemical idea, no program'. It recognizes no intellectual authority; it rejects dogmatism.[47] The reason for this is that, in its Classical Greek derivation, 'eclecticism' involves seeing, selecting, reading, speaking, arranging, i.e. being intellectually, aesthetically discriminating.[48] The reflective practice on which the ecology of knowledge depends, reveals itself in the patterns of texts and images it creates. Reflection and eclecticism converge in a discriminating, ecological attitude. In the very logic of language, in the very act of reading and understanding, there exists already an intellectual ecology. What texts and images readers select from the world around them, how they arrange what they have gathered, the meanings they have constructed, they project onto the world they live in. They produce the necessary fictions that form their reality principle – the means of reconceiving the social situation of knowledge.

The reflective practice that constitutes the ecology of knowledge is, therefore, nothing arbitrary. The underlying idea of ecology suggests some basic lines of orientation: the need to break the disciplines and their conventional hold on knowledge that ensures intellectual conformity; an antidote to the way social and psychological space is monopolized by historicizing methods and representations that ensure the continual reproduction of the 'same old thing'.

For a start, the humanities will not be forms of last analysis. Rather, it will be important to understand their 'construction' – their articulation of 'the problem of the way in which the mind intervenes in the things of this world' – i.e. what is behind them, what they really do socially.[49] They will themselves be analyzed in terms of their 'function as metastatements about the deep structure of the system'. As 'forms of communication within the system', individual disciplines can be described as 'messages set in deep-structural code', i.e. in terms of sets of rules 'governing the permissible construction of messages in the system'. It means looking at the ways the humanities arise from patterns of relationship between the mind and its cultural environment.[50] Moreover, these patterns are metaphorical. In the humanities, men and women are studied (study themselves and each other) reflexively in the symbols from which men and women have created a meaningful world.[51] These culturally constructed symbolic orders regulate by displacement or sublimation social-ecological behaviour.

Consequently, ecological reflection will focus on 'deep structures' because, for an ecology of knowledge to exist, the mind must understand how it itself exists. Ecological reflection aims to enlarge consciousness by laying bare its social-psychological reflexes. It must, therefore, expose socially coercive, intellectual behaviour. It wants to know how thinking persuades itself. It watches for intellectually coercive, intellectual behaviour (e.g. intellectual fashions). Ecological reflection does not take the prevailing system of knowledge-production at face value. As a form of scepticism it searches for the underlying cognitive patterns, symbolic modes of consciousness, and behavioural tropes through which knowledge is constructed.

Ecological reflection sees intellectual behaviour as being as mimetic as other forms of social conduct. Intellectually mimetic behaviour produces the evolving 'institution' of knowledge, i.e. the 'knowledge already known', the product of currently recognized epistemologies, including 'the same old thing' of the historicizing mentality. Thus it reduces cognitive options, enforces identification with the going systems, and ensures within multicultural diversity the underlying standardization of mental postures. In the humanities, the mimetic conformism of intellectual behaviour is pivotal: their illusion of intellectual freedom enforces social coercion.[52]

The fact that the behaviour of 'autonomous thinkers', technocrats and experts is inherently mimetic confirms that ideas are not 'objective' 'results', 'conclusions', 'outcomes' but filters and relays connecting mind and world. That is to say, this behaviour can be reconceived in epidemiological terms, i.e. 'public representations have meaning only through being associated with mental representations.'[53] The concept of epidemiology helps to understand the distribution of cultural representations, hence to clarify the psychodynamics of self-persuasion. It studies the social-psychological construction of relevance. It holds that 'social-cultural phenomena are... ecological patterns of psychological phenomena'. It sees 'the information that humans introduce into their common environment... as competing for private and public space and time – that is, for attention, internal memory, transmission and external storage'.[54] Its implications are immense. The widespread reception of a theoretically new proposition, image, or work, the appraisals of its 'importance' or 'value', rather suggest that its real originality lies in its ability to create the social preconditions for its relevance.[55] More importantly,

both the social commerce in ideas and the intellectual commerce of society point to a reductive, ecological materialism: 'mental representations are brain states defined in functional terms, and it is the material interaction between brains, organisms and environment which explains the distribution of these representations.'[56] That is to say, the post-modern mentality may well be mesmerized by the endless play of virtualities; a social-psychological epidemiology sees instead the economic-tropological motives for their social distribution.

Ecological reflection, therefore, looks at how to uncover the cognitive patterns, symbolic modes of consciousness, and intellectual tropes that construct knowledge. It recognizes that thinking crucially happens not in an isolated human subject, but through 'conceptions of the world rooted in basic cognitive structures'. Individuals share these structures (e.g. religions, ethical values), but the structures themselves transcend them. Their content is secondary to the cognitive structures on which they are contingent.[57] Ecological thinking focuses on the underlying social-psychology of knowledge-production. It endorses the aims of a 'psychology of world views' as a way of revealing the ordinarily unnoticed conceptualizations that drive it. And so, for example, past cultural forms in themselves cease to be objects of antiquarian enquiry. They become instead components of the enlarged, ever contemporary, ecological-mental space of humanity. They are discerned as typical patterns, revealed by 'analogies of recurrent forms' detectable in them. These patterns provide an inventory of the cognitive resources of the mind. They are behind what a discipline does and the way it works.[58]

Finally, an ecology of knowledge would not work without the aesthetic dimension. The work of art is a material instance of reflective practice. Art is a form of practice that reflects on itself. As 'an elementary precondition of sensory awareness', aesthetics is indispensable to an intellectual ecology. It makes radical connections between mind, body and the social and natural environment. The material objects artistic practice creates from them become non-normative forms of evidence and reflective lucidity.[59]

The need to make art is as species-essential as are other types of human behaviour (e.g. aggression, bonding, sexuality, parenting). Art (as Ellen Dissayanake points out) should be seen not as an optional ornamentation of life, but as a biological need: i.e. 'like play, like food sharing... that is, something humans do because it helps them

to survive, and to survive better than they would do without it.' Art reflects a phylogenetic need to stress what has particular significance, an 'emotional valence', in the life-world. Art has an ecological function: through, for example, repetition, pattern, proportion, rhythm, contrast, it bestows human inflections on the otherwise unfamiliar and uncontrollable world.[60] Through the symbolic resources at its disposal art helps people to reflect on what it is to be in the world.

Conversely, art practice itself makes sense only through the ecology of knowledge. Dissayanake's concept of art is firmly rooted in ecological theory – in the conviction of the 'interpenetration of self and world' as 'a foundation for a theory of aesthetic empathy'. She herself derives this insight from the cognitive-psychological insight that 'to perceive the world is to coperceive oneself'; and that 'the awareness of the world and of one's complementary relations to the world are not separable.' As she insists:

> [This] ecological model of visual perception emphasizes the idea that we are bodies in a world, and that 'exteroception' (recognition of stimuli produced outside an organism) that contains information about the concreteness of the world is necessarily accompanied by 'proprioception' (recognition of stimuli produced and perceived within an organism) that contains information about our embeddedness in the world.

Through the ecological nature of perception the human brain becomes 'a storehouse of emotionally toned, non-verbal, perceptual memory structures' which constitute an aesthetic resource.[61] Dissayanake proceeds to review 'cognitive universals' – metaphors, patterns, repetitions, and 'cross-modal matchings' – which innately structure consciousness. These themselves rely on spatial awareness. Here Dissayanake's cognitive argument converges with Kant's metaphysical assertion of an irreducible core of intellection:

> The generality of spatial abilities, their universality, and their ease of acquisition all suggest that they are innate, part of the cognitive equipment passed on genetically as one of the important ways the brain works. One could say that spatial cognition begins (in a Kantian or Lévi-Straussian manner) as internal 'structures' of the mind that are used to model 'reality', constructing

representations of objects, patterns, and events, including the self. They are among the codes, categories, or initial states of the mind out of which more complex perceptions, conceptions, lexical structures, and sentence meanings are composed.[62]

These are three core principles guiding the eclectic practice of reflection that sustains the ecological conception of knowledge. Where they come from is a different attitude to knowledge, a preoccupation with its underlying grammar and rhetoric of motives. What they advocate, is 'clean and sober' thinking.[63] Where they lead, is reconception. Reconception does not just re-interpret the world, but *makes* different realities, engenders different patterns of behaviour. For this reason, an ecological conception of knowledge has to see its obligations clearly. It recognizes a first duty to itself. It has to be a law unto itself. It has to be reliable in heteronomous circumstances to counter cognitive passivity, to protest against the prevailing culture of euphemism. It offers the sole means of re-orientation, because if it remembers anything, it remembers this: 'the most radical scepticism is the father of knowledge'.[64]

Notes

1. Valéry, 'La liberté de l'esprit', in *Regards sur le monde actuel*, in *Oeuvres*, ed. Jean Hytier, Bib. de la Pléiade, 2 vols (Paris: Gallimard, 1957), II, p.1077. All translations, unless otherwise stated are my own.
2. Edgar Morin, *La Méthode: 4. Les Idées. Leur habitat, leur vie, leurs moeurs, leur organisation* (Paris: Seuil, 1991), p.67.
3. Francis Bacon, *The New Organon* (1620), in *The New Organon and Related Writings*, ed. Fulton H. Anderson, The Library of the Liberal Arts (New York: Bobbs Merrill, 1960), pp.31–268, pp.114–5 (§§CXXV–CXXVI).
4. Benedict de Spinoza, *A Theologico-Political Treatise: A Political Treatise*. Translated from the Latin with an Introduction by R.H.M. Elwes (New York: Dover Publications, 1951), p.119 (Chap.VII); Benedict de Spinoza, *On the Improvement of the Understanding: The Ethics. Correspondence* (New York: Dover Publications, 1955), p.388.
5. John Locke, *Of the Conduct of the Understanding*, in *Some Thoughts Concerning Education and Of the Conduct of the Understanding*. Edited, with Introduction, by Ruth W. Grant and Nathan Tarcov (Indianapolis and Cambridge: Hackett Publishing Company, Inc., 1996), pp.171–2.
6. *Ibid.*, p.192.

7. Martin Heidegger, 'Wissenschaft und Besinnung', in *Vorträge und Aufsätze*, 3rd ed., 3 vols (Pfullingen: Neske, 1967), I, pp.37–62, p.50.
8. Locke, *Of the Conduct of the Understanding*, p.170.
9. Susan Sontag, 'The Aesthetics of Silence', in *Styles of Radical Will*, first published 1969 (New York: Doubleday & Anchor, 1991), pp.3–34, pp.33–4.
10. Heidegger, 'Wissenschaft und Besinnung', pp.60–1.
11. René Descartes, *Discours de la méthode*, ed. G. Rodis-Lewis (Paris: Garnier-Flammarion, 1966), p.60 (§4).
12. *Ibid.*, pp.68–9; cf. Stephen Toulmin, *Cosmopolis: The Hidden Agenda of Modernity*, pb. ed. (Chicago: University of Chicago Press, 1992), pp.41–2.
13. *Ibid.*, p.82; cf. Jencks, p.54.
14. Immanuel Kant, 'What is Orientation in Thinking', in *Political Writings*, ed. Hans Reiss, trans. H.B. Nisbet, 2nd ed. (Cambridge: C.U.P., 1991), pp.237–49, p.240.
15. *Ibid.*, pp.240–1.
16. Gregory Bateson, 'Form, Substance and Difference', in *Steps to an Ecology of Mind: Collected Essays in Anthropology, Psychiatry, Evolution and Epistemology* (London: Intertext Books, 1972), pp.454–71, p.467.
17. Kant, 'What is Orientation in Thinking', in ed. cit., pp.245–6, p.246.
18. *Ibid.*, pp.248–9.
19. cf. Philippe D'Arcy, *La Réflexion* (Paris: Presses Universitaires de France, 1972), pp.33ff., pp.37ff., p.84.
20. Friedrich Nietzsche, *Also sprach Zarathustra*, in *Kritische Studienausgabe*, ed. Giorgio Colli & Mazzino Montinari, 2nd revised ed., 15 vols (Berlin & New York: Walter de Gruyter & DTV, 1988), IV, pp.40, p.158.
21. cf. Yuri Lotman, *Universe of the Mind: A Semiotic Theory of Culture* (London & New York: I.B.Tauris, 1990), p.36; Dan Sperber, *Explaining Culture: A Naturalistic Approach* (Oxford & Cambridge, Mass.: Blackwell, 1996), p.85; Edgar Morin, *La Méthode: 3. La Connaissance de la Connaissance* (Paris: Seuil, 1986), p.208; Maurice Merleau-Ponty, *Le visible et l'invisible*, Coll. Tel (Paris: Gallimard, 1979), p.212.
22. cf. Morin, *La Méthode: 3. La Connaissance de la Connaissance*, pp.60ff.; Morin, *La Méthode: 4. Les Idées. Leur habitat, leur vie, leurs moeurs, leur organisation*, pp.17ff.
23. cf. Paul Ricœur, 'Prévision économique et choix éthique', in *Histoire et vérité*, 3rd ed. (Paris: Seuil, 1966), pp.301–16, pp.311–12.
24. Cornelius Castoriadis, *Les Carrefours du labyrinthe: 4. La Montée de l'insignifiance* (Paris: Seuil, 1996), pp.86ff.

25. Locke, *Of the Conduct of the Understanding*, p.169.
26. Julien Benda, *Du style d'idées. Réflexions sur la pensée* (Paris: Gallimard, 1948), p.254.
27. Nietzsche, *Jenseits von Gut und Böse*, in *Kritische Studienausgabe*, V, pp.9-243, p.29, pp.34-5; §§16, 20.
28. cf. Hans Jonas quoted in Emil Fackenheim, *To Mend the World: Foundations of Post-Holocaust Jewish Thought* (Bloomington & Indianapolis: Indiana University Press, 1994), p.233; and Günther Anders, *Die Antiquiertheit des Menschen: I. Über die Seele im Zeitalter der zweiten industriellen Revolution*, 7th ed. (Munich: C.H. Beck, 1985), pp.188ff; and *Die Antiquiertheit des Menschen: II. Über die Zerstörung des Lebens im Zeitalter der dritten industriellen Revolution*, 4th ed. (Munich: C.H. Beck, 1986), pp.21ff.
29. cf. Martin Heidegger, 'Wozu Dichter?', in *Holzwege*, 5th ed. (Frankfurt am Main: Vittorio Klostermann, 1972), pp.248-95, p.248; Heidegger, 'Wissenschaft und Besinnung', p.62.
30. Edgar Morin, *Introduction à une politique de l'homme*, Coll. Points (Paris: Seuil, 1999), p.149.
31. Castoriadis, *Les Carrefours du labyrinthe: 4. La Montée de l'insignifiance*, pp.210-11.
32. George Steiner, 'The Archives of Eden', in *No Passion Spent: Essays, 1978-1996*, pb. ed. (London: Faber and Faber, 1997), pp.266-303, p.289, p.292.
33. cf. *Ibid.*, pp.293-4.
34. Valéry, 'Notre destin et les lettres', in *Regards sur le monde actuel*, in *Oeuvres*, II, p.1059.
35. Review of Georg Lukács, *Geschichte und Klassenbewußtsein* in Ernst Bloch, *Philosophische Aufsätze zur objektiven Phantasie* (Frankfurt am Main: Suhrkamp Taschenbuch Wissenschaft, 1985), pp.598-621, p.603.
36. cf. Günther Anders, *Der Blick vom Mond. Reflexionen über Weltraumflüge*, 2nd ed. (Munich: Beck, 1994), passim.
37. Lester C. Thurow, 'Building Wealth', *Atlantic Monthly*, vol. 283, no. 6 (June 1999), pp.57-69, p.69.
38. See e.g. the article, 'Your economy needs you', *Times Higher Education Supplement*, No. 1,412, 26 November 1999, pp.6-7.
39. Merleau-Ponty, *Le Visible et l'Invisible*, p.160.
40. cf. Karl Jaspers, 'Philosophie und Wissenschaft', in *Rechenschaft und Ausblick. Reden und Aufsätze* (Munich: Piper, 1958), pp.240-59, p.251.
41. cf. Lucy Hodges, 'Universities can incubate and educate. Higher education is being encouraged to change its habits and throw its weight into the development of local economies', *Independent: Education*, 3

June 1999, p.6.
42. Bloch, *Philosophische Aufsätze zur objektiven Phantasie*, pp.399-400.
43. Bloch, *Das Prinzip Hoffnung*, 6th ed. (Frankfurt am Main: Suhrkamp Taschenbuch Wissenschaft, 1979), p.1011.
44. Immanuel Kant, *Kritik der reinen Vernunft*, ed. Raymund Schmidt, Philosophische Bibliothek (Hamburg: Felix Meiner, 1971), pp.14-15 (BVIII).
45. Morin, *La Méthode: 3. La Connaissance de la Connaissance*, p.189.
46. cf. Nelson Goodman, *Ways of Worldmaking*, 5th printing (Indianapolis: Hackett Publishing Company, Inc., 1988), p.7.
47. Ulrich Johannes Schneider, 'Eclecticism Rediscovered', *Journal of the History of Ideas*, 59.1 (1998), pp.173-82, p.177, p.178.
48. cf. Pierluigi Donini, 'The history of the concept of eclecticism', in *The Question of 'Eclecticism': Studies in Later Greek Philosophy*, ed. John M. Dillon & A.A. Long (Berkeley, Los Angeles, London: University of California Press, 1988), pp.15-33, pp.16-17; Xenophon, *Memorabilia in Memorabilia, Oeconomicus, Symposium, and Apology*, trans. E.C. Marchant & O.J. Todd, Loeb Classical Library (Cambridge, Mass. & London: Harvard University Press & Heinemann, 1979), pp.1-359, p.75 (I.vi.14).
49. Valéry, *Introduction à la Méthode de Léonard de Vinci*, in *Oeuvres*, I, p.1188.
50. cf. Daniel White, *Postmodern Ecology: Communication, Evolution, and Play* (Albany: SUNY Press, 1998), pp.9-10, p.15, p.45. (White quotes here from the work of Gregory Bateson and Anthony Wilden.)
51. cf. Gianni Vattimo, *La Société transparente*, traduit de l'italien par J.-P. Pisetta (Paris: Desclée de Brouwer, 1990), p.25.
52. cf. Gillian Rose, 'The Future of Auschwitz', in *Judaism and Modernity: Philosophical Essays* (Oxford & Cambridge, Mass.: Blackwell, 1993), pp.33-36 (p.35).
53. Dan Sperber, *Explaining Culture: A Naturalistic Approach* (Oxford & Cambridge, Mass.: Blackwell, 1996), p.80.
54. *Ibid.*, p.31, p.140. (cf. Andrew Ross, 'The Ecology of Images', in *Visual Culture: Images and Interpretations*, ed. Norman Bryson, Michael Ann Holly & Keith Moxey [Hanover & London: Wesleyan University Press, 1994], pp.325-46. It may be read as a confirmation of Sperber's argument. I must thank Beate Allert for this reference.)
55. cf. Morin, *La Méthode: 4. Les Idées*, pp.137-8.
56. Sperber, *Explaining Culture*, p.26.
57. Günter Dux, *Die Logik der Weltbilder. Sinnstrukturen im Wandel der Geschichte*, 3rd ed. (Frankfurt am Main: Suhrkamp Taschenbuch Wissenschaft, 1990), p.123, p.291.

58. Karl Jaspers, *Psychologie der Weltanschauungen*, 6th ed., pb. ed. (Munich: Piper, 1985), pp.4-6, pp.12-15, pp.44-5.
59. Edgar Morin, *L'homme et la mort*, 2nd ed., Coll. Points (Paris: Seuil, 1970), p.184.
60. Ellen Dissanayake, *Homo Aestheticus: Where Art Comes From and Why* (Seattle & London: University of Washington Press, 1995), p.35, pp.54-6.
61. *Ibid.*, pp.149-50, p.155, p.156. Dissayanake quotes from James J. Gibson, *The ecological approach to visual perception* (Boston: Houghton Mifflin, 1979).
62. Dissanayake, *Homo Aestheticus*, p.159.
63. Bloch, *Das Prinzip Hoffung*, p.1016; Bloch, *Philosophische Aufsätze zur objektiven Phantasie*, p.412.
64. Max Weber, 'Der Sinn der "Wertfreiheit" der soziologischen und ökonomischen Wissenschaften', in *Gesammelte Aufsätze zur Wissenschaftslehre*, ed. J. Winckelmann, Uni-Taschenbücher, 7th ed. (Tübingen: J.C.B. Mohr (Paul Siebeck), 1988), pp.488-540, p.496.

becoming academics, challenging the disciplinarians

a philosophical case-study

helen c. chapman

One can only become a philosopher not be one. As soon as one thinks one is a philosopher, one stops being one.

F. Schlegel, *Athenaeum Fragment*, 54[1]

Introductory Remarks

For the last 12 years, I have been trying very hard to 'be a philosopher'. I have studied many of the texts of the tradition in minute detail; engaged in debates until late in the evening with like-minded friends and colleagues. I have swung wildly from the depths of frustration as texts refuse to yield any modicum of understanding to the drunken sense of euphoria that can be gained when a particularly recalcitrant piece of writing finally opens up its secrets. A few years back, I thought I had nearly got the hang of it! I passed my PhD, which focused on the role of the tragedy within eighteenth-century German Philosophy, and within six months had landed a job. The title on my office door read, 'Dr Helen Chapman: Lecturer in Philosophy'. 'At last,' I thought, 'I've made it, I am close to being a Philosopher.' However, then strange things started happening that quickly dented this optimism. I tried to get parts of my re-written PhD thesis published but all that occurred was letters of rejection. Not considered suitable for a 'philosophy' journal was the only feedback I received.

And as for re-working the ideas into a book I may as well forget it – too 'literary' and/or too 'German' I was told. Slightly puzzled by this response, I let this 'non-philosophical' work lie. Perhaps being a 'proper' philosopher involved moving away from my juvenilia, to develop more mature pursuits. As luck would have it, within my institution I was then asked whether as a philosopher I would like to contribute to cross-disciplinary teaching and research, by becoming a part of a group of staff from different disciplines who developed and taught the theory component of the Fine Art MA course. Out of this work, I further developed my own interests in thinking across disciplinary boundaries from the perspective of philosophy. Papers and a small book emerged. 'Aha,' I thought, 'perhaps now I'm slightly more mature I've got the hang of this philosophy lark, perhaps I now know what I'm doing.' Again, I was sadly mistaken. At the time of writing, all UK universities are preparing for the five-yearly Research Assessment Exercise, where funds are distributed to institutions on the basis of published evidence of the quality of their research. In discussion with colleagues, it has become clear that some of my work – in particular the cross-disciplinary research – may not be considered 'suitable' for inclusion as part of the philosophy department submission. So, in some ways, it could be seen that my attempts to be a philosopher have come to naught. While I have been masquerading under the title of Philosophy lecturer, I have been a fraud. I've been doing something, but I've not really been a philosopher.

This situation has, by turns, left me angry, frustrated and often plain confused. I've been trying my best to become a philosopher but those who are within the club – those who wear the badge of Philosopher with pride – seem hell-bent on not letting me join in. (And may I just point out I'm not the only one in this position. Many colleagues and friends whom I think to be 'budding' philosophers have also failed to come up to the mark.) So why is this? What have I been doing wrong? One way of starting to try to solve this conundrum is to return to the remarks of Schlegel which I used as an epigraph. The distinction which Schlegel draws between being a philosopher and becoming one points to the heart of the issues I want to discuss. Many of the problems I have encountered arise because those who are busy being philosophers fail to acknowledge the work of those 'becoming' philosophers. It appears that to be a philosopher one must be secure in the knowledge of who one is and what one does; so

secure in fact that one can easily pass critical judgement on all emergent 'becoming-philosophers' that one encounters. But if we take Schlegel's fragmentary remarks seriously we should question the complacency of those who apparently feel secure as to who they are and what they do. For, as Schlegel suggests, this degree of certainty is inherently unstable. In fact it acts to undermine the very position to which one aspires: 'As soon as one thinks one is a philosopher, one stops being one.' Taking heart from this suggestion I want to explore the idea that the *raison d'être* of the discipline to which I aspire is to be found in the idea of 'becoming' a philosopher rather than being one.

In what follows, I want to analyze how the 'institution' of philosophy has created the above situation. How and why does philosophy – and by inference, all other disciplines – police its boundaries and establish disciplinary rules and constraints which designate the identities of those who participate in it? This will involve briefly – and all too crudely – appraising the strengths and weaknesses of one of the more recent developments within my discipline, namely deconstruction. I shall outline how deconstructionist method is useful insofar as it enables diagnosis of how disciplinarity functions. However, although it exposes disciplinary boundaries and mechanisms, I shall argue it does not allow these boundaries to be radically challenged. It exposes why those who claim to 'be' philosophers are able to police those who want to 'become' philosophers, but it does not offer alternative paradigms for understanding the issues of disciplinarity itself. For this to happen, I will argue it is necessary to take seriously what it means to argue for a philosophy characterized by becoming rather than being. To explain this idea further, I shall turn to the work of Gilles Deleuze and Félix Guattari, and in particular their final text *What is Philosophy?*[2]. By a selective reading of this text, I shall challenge the fixed and limiting identities of the academic 'disciplinarians'. I shall show how the 'identity' which Deleuze and Guattari confer to philosophy enables the *process* of philosophizing to be recognized as such. In conclusion the efficacy of this approach will be assessed by turning to the ecological metaphor which is one of the leitmotifs of this book. I shall suggest that while the metaphor is useful to think through the process of challenging existing orthodoxies and disciplinary constraints we must not allow it to be read as a new conceptual

'paradigm'. For, as my argument throughout will demonstrate, it is precisely this solidification of thought into fixed motifs and ideas which the becoming-academic should challenge.

Instituting Disciplinarity

When researching the issue of the disciplinary boundaries of philosophy, it is telling that often I had to turn to discussions outside the discipline itself in order to find appropriate models and debates. While philosophy seems happy to allow discussions of its own identity in relation to specific historical determinations of the philosophical canon, it rarely confronts its status as a discipline among others within the institutions of academia. A number of reasons can be suggested for this lack of discussion. It could be because such a debate is not deemed to be philosophical – i.e. it is tainted by politics or by cultural concerns and thus cannot be considered to be a 'correct' subject of study for the philosopher. (Already here we can see how the implicit assumptions of disciplinary identity come into play whenever the question of the identity of a discipline is raised.) Alternatively, it is as though philosophy does not need to question its own disciplinary presuppositions because those who 'do' philosophy already know what they are up to, therefore such a discussion would be redundant. However, as my introductory remarks have shown, there are quite a few people who think that they are engaged in philosophy, only to be told by those who are 'properly' doing it, that their particular pursuit does not quite hit the mark. In this case also, implicit assumptions are drawn upon in order for the 'accepted' model of philosophy to be able to define its own identity and exclude others. Therefore it is necessary to investigate the actual mechanisms by which the process of disciplinary boundary formation occurs.

One of the most interesting and influential discussions of the 'institutionalization' of knowledge is offered by Samuel Weber in *Institutions and Interpretations*.[3] Weber draws on deconstructionist methodologies to explore how the 'institution' of literary studies has been set up and promulgated within the academic community. While the focus of much of Weber's work directly relates to the discipline of literature, I would argue that the processes he describes and analyzes have direct relevance to philosophy as it is understood from within the confines of the academy. In his essay 'The Limits of

Professionalism', Weber argues that the increasing 'professionalization' of academic disciplines within the university has led to a solidification and demarcation of what is counted as the 'correct' object of study. He argues that within the academy professionalism is 'construed not merely as "a set of learned values", as an integral system, but more to the point, as a set of habitual responses'. These 'habitual responses' are the already established sets of beliefs and practices which constitute the 'correct' functioning of the profession in question. Importantly these responses, while drawing on the ideas of impartiality and objectivity which are implicit in the idea of the 'professional', do not necessarily have any *a priori* claim to 'fact' or 'truth'. Rather, precedent and tradition are called upon to substantiate the claims that are made.[4]

The academic professions' claim to objectivity and neutrality is further backed up by the fact that, particularly within the disciplines of the humanities, 'knowledge' is understood to have use value but not an exchange value. Hence the idea within the academy that the dissemination of knowledge is purely altruistic. The 'professional' works and distributes knowledge for the sake of society at large. A distinction develops between the 'knowledgeable' professional and the ignorant lay-person, who becomes dependent upon the ministrations of the profession. As Weber points out this means that the notion of professionalism builds and sustains its dominance on a structure of anxiety understood from a Freudian perspective.[5] Society is 'told' it needs the knowledge of the professional to protect itself from potentially being dangerously duped. Furthermore, professional structures are internally regulated by anxiety. Being a 'professional' entails conforming to and upholding the internal norms and beliefs of the profession. Internal structures develop which reward those who conform to the profession's precepts – hence the idea for example of 'career progression'. The modern university is the paradigm location for this instituting institutionalization of the professional disciplines of knowledge. As Weber remarks:

> The university, itself divided into more or less isolated, self-contained departments, was the embodiment of that kind of limited universality that characterised the cognitive model of professionalism. It instituted areas of training and research which, once established, could increasingly ignore the founding limits

and limitations of individual disciplines. Indeed the very notion of academic 'seriousness' came increasingly to exclude reflection upon the relation of one 'field' to another and concomitantly, reflection upon the historical process by which individual disciplines established their boundaries.[6]

The institution thereby creates and polices disciplinary boundaries. Commenting on this aspect of Weber's analysis, Diane Elam remarks that it exposes how: 'Disciplines amount to a containment strategy designed to prevent conflict and promote the uncritical acceptance of the institution. That is to say, disciplinarity is the regulatory mechanism which assures the continued success of the institution itself.'[7] Weber's analysis shows how the institution's natural and unquestioned givens (i.e. the content and methodology of disciplinarity) are built on a logic of exclusion and differentiation. First, to establish what constitutes the 'subject-matter' of a specific discipline it is defined in relation to what it is not. Precedent and tradition develop through the increasing 'specialization' and 'professionalization' of the discipline which cover over this 'founding moment'. Gradually the discipline instigates the debates and themes which constitute its internal content. The discipline is self-regulating with regard to its 'other' insofar as what is considered new and innovative is not even allowed a foot in the door. Institutions and disciplines are therefore inherently conservative. However, this conservatism ultimately means they are also inherently unstable and open to challenge. For if, as the deconstructionist analysis exposes, there is no foundation for the claims that the discipline makes, its truth claims must be seen purely as normative and regulatory.

To return to the 'case-study' under question here, the discipline of philosophy itself can be exposed to this form of analysis and questioning. For it could be suggested that those who insist on its current disciplinary integrity do so only by virtue of precedent. There is no *a priori* reason why philosophy should not consider itself in terms of innovation and change rather than having recourse to what it always was. To use the language of my opening remarks, those who insist on 'being' philosophers are displaying disciplinary anxiety that is at root unfounded. Instead, as Schlegel suggests, what could and should characterize the philosophical enterprise is an understanding of philosophy as process. This is to be seen as the desire to continually question and stretch the limits of modes of

thinking rather than retreating back behind the barricades which institutional neurosis erects.

What form, however, should this questioning take? For some, deconstructive methodology is seen to be most appropriate because it enables the mechanisms of the limit to be exposed. However, it remains open to question whether the acknowledgement of limit can also act to transform the limits. Is deconstructive analysis able to approach the issues from a radically new perspective? At first sight, it could be supposed that the answer is affirmative. Deconstruction is premised upon the logic of the binary, of exposing that which has been marginalized but upon which the dominant term is dependent. Thus it could be argued that the distinction between 'being and becoming' fits these requirements perfectly. In other words, all that is necessary is to show and acknowledge what is excluded and to allow its qualities to be reappropriated into the discipline. However, this presupposes that the qualities that are being discussed are capable of being assimilated into a new 'whole' discipline; i.e. that the meanings of the terms being and becoming are mirror opposites that mutually define one another. As I shall argue later on, such assumptions are flawed in that thinking from the perspective of 'becoming' radically disrupts any possibility of reappropriation by the dominant economy. The terms 'being' and 'becoming' as I shall employ them denote very different, antithetical economies and modes of thought. Furthermore, a problem inherent in the deconstructive approach is that it does not disrupt the logic of the binary entirely. It exposes and alters the limits of the discipline, in order to incorporate what was excluded, but does not disrupt the logic of the limit itself. Just as disciplinarity is marked by an inherent conservatism and a desire to return to a steady state, so too is deconstruction. Its analyses are always marked and tainted by the economy and thought from which it is derived because it is unable to question the fundamental starting points of the theory which it employs.

I want to suggest that if we are serious about challenging disciplinary constraints we need to think differently from the beginning. Rather than seeing 'being' or 'becoming' a philosopher as an either/or choice between two mutually defining and complementary viewpoints we should instead understand them as indicating radically different approaches. To talk of philosophy in terms of 'becoming' is to indicate a completely different approach to

the subject which transforms not only the methodology of how philosophy is to be 'done', but also radically alters its content. In fact, as I shall go on to argue, it is an approach which ultimately calls either/or distinctions such as method or content into question. It is here that I now want to turn to Deleuze and Guattari, for, as I will argue, their work introduces a different paradigm to employ in the debates we are undertaking.

Deleuze and Guattari and Becoming-Philosophy

In what follows I am not calling for us all to 'be Deleuzian' in our approach to thinking about the discipline of philosophy, rather I want to demonstrate what 'becoming Deleuzian' may mean for the debate with which we are engaged. The distinction between being and becoming runs throughout Deleuze and Guattari's work. In *A Thousand Plateaus*, this distinction is exemplified by contrasting the image of thought as a tree with the idea of thinking as a rhizome. Exploring these metaphors in more detail will enable us to establish how the 'discipline' of philosophy can be thought of differently.

Traditional thinking – what is termed an 'arborescent' system – is characterized by a desire for origin/ground, genealogical teleology, stasis and transcendence.[8] In *What is Philosophy?* Deleuze and Guattari argue that this approach has corrupted and misled the practice of philosophy because it creates objects which are taken to be the 'subject-matter', the products of philosophy. The knowledge created by these processes generates Universals which are taken as the solution, the once-and-forever answer to a particular problem. This way of thinking has two effects. First, it helps to engender and promulgate a hierarchy of thought whereby philosophy deems itself to be 'grounding' or 'primary' precisely because it makes claim to instantiating Universals. It provides the schemas to which all other modes of thinking must acquiesce. I would suggest that it is this inbuilt disciplinary 'superiority complex' which has made philosophy particularly blind to examining its own presuppositions. It also helps to explain why philosophy as it is practised within most institutions is less willing than most disciplines to contemplate innovation and change.[9]

Secondly, because the methodology of traditional philosophy – identified as contemplation, reflection and communication – engender

Universals, what becomes valued are the products of thinking – the Universals – rather than the process itself. This means that philosophy opens itself to dealing in commodities – Universals – rather than concentrating upon questioning and renewing itself in relation to the new situations and aporias that it confronts within the world. For Deleuze and Guattari, this idea of philosophical debate as a marketplace of ideas whereby you bargain and choose the 'philosophical commodity' that best suits the particular debate in which you are engaged is anathema.[10] The tendency of philosophy toward commodification also sheds light on the earlier discussion of the boundaries of disciplinarity. It is not surprising to find that the ways of 'doing' philosophy which are accepted and embraced by the academy are those which are easily commodified. This is because the approach creates 'objects' (Universals) which are set up as that which must be learned and discussed by the discipline. These objects provide the discipline with a focus for its debates – they become the 'objects' of study which, because they are defined as 'universal', already have a 'truth-value' of their own. Defining philosophy as an agreeable commerce 'of the mind' engenders an approach which the disciplinarians demand. Any attempt to 'do' philosophy differently is ruled out of court precisely because it has the potential to disrupt and challenge the self-generating and self-serving market of ideas. This is a market which 'knows what it likes and likes what it knows' – it knows its customers well and thus the constraints of the discipline remain in place.

In contrast to the Universalist arborescent, commodificatory philosophy of being, the philosophy of becoming is described in rhizomatic terms. A rhizomatic system is continually spreading, diverging, splitting. What is emphasised here is the process and creation of thinking, rather than the products of thought itself. Therefore, at the beginning of *What is Philosophy?* Deleuze and Guattari argue that 'philosophy is the art of forming, inventing, and fabricating concepts'.[11] What is important here is that philosophy is defined as a practice, an art. Philosophy is not about conceptual thinking understood as a body of knowledge to be digested; rather it is the art of creating concepts. It has an event-like quality, where the practice of making, 'creating' concepts is equal in value to the actual concepts, the finished products themselves. Furthermore, 'concepts' are described as 'fragmentary totalities'. In other words, the concept

must be understood as open-ended, provisional, and as always potentially in relation to other modes of thinking. The metaphor which Deleuze and Guattari use to describe the relation of the concepts to each other highlights this element:

> As fragmentary totalities, concepts are not even the pieces of a puzzle, for their irregular contours do not correspond to each other. They do form a wall, but it is a dry-stone wall, and everything holds together along divergent lines. Even bridges from one concept to another are still junctions, or detours, which do not define any discursive whole.[12]

These remarks suggest that the task of philosophy is not to construct closed 'systematic' models of understanding. Rather philosophy proceeds and develops through disjunction and diversion. There is no 'answer' that the philosopher can provide if she manages to get the pieces to fit together. Rather Deleuze and Guattari are suggesting that philosophy has to be understood as inherently fragmentary, provisional and potentially always unstable. In other words it privileges becoming over being.

The contrast between the two approaches to philosophizing is 'a question of a model that is perpetually constructing or collapsing and of a process that is perpetually prolonging itself, breaking off and starting up again'. However, what is also important is the fact that the introduction of this understanding of becoming further strengthens our earlier claim that the approaches of being and becoming are not mutually complementary. It is not an either/or choice between the perspectives. Rather, as Deleuze and Guattari state, 'we invoke one dualism only in order to challenge another. We employ a dualism of models only in order to arrive at a process that challenges all models'.[13] By adopting the perspective of becoming, one is immediately challenged to think differently. Thought – philosophical or otherwise – is a process which makes connections and operates materially and mediately. Furthermore, it is not the destination, the end point or the idea in itself that is of importance; rather it is the process in and through which ideas are engendered and collide, elide or multiply with each other.

How can this discussion of philosophy as the art of creating concepts and the distinction between a philosophy of being and a philosophy of becoming be used to inform and guide the debate which I earlier

introduced? How can it be used to challenge the disciplinary police who want to maintain an 'accepted' conventional understanding of the 'discipline' of philosophy? As I shall now go on to argue, Deleuze and Guattari's work has the potential to transform 'doing' philosophy precisely because it confounds the accepted disciplinary definition of the subject and offers a different understanding which enables the idea of 'becoming a philosopher' to flourish.

Transforming How to Do Philosophy

To illustrate the possible implications of this discussion, I want to highlight three of the main transformations which this approach can effect. These are the role of criticism in philosophical thinking, the relation of the 'discipline' to its history and the relation between philosophy and other 'creative' forms of thinking. Throughout, my focus will be to show how Deleuze and Guattari's ideas change the role of 'being a philosopher' from an identity behind which one hides, to a practice which allows creation and change to occur.

The Role of Critique

Often it is asserted that the function of philosophy is to criticize the assumptions of a particular point of view in order to reach a consensus as to the 'most' correct reading or interpretation of an idea. This presupposes that such a consensus is both achievable and desirable. This approach is useful for the philosophical disciplinarians, because it enables the boundaries of a subject to be policed. If you can be shown to disagree with the criteria for consensus or if your mode of reasoning or articulation is considered to be faulty you can easily be dismissed out of hand. However, using Deleuze and Guattari's work, this viewpoint becomes problematic because any idea of knowledge being about consensus and discursive agreement is antithetical to an approach to philosophy characterized by event or creation. To say a concept is 'better' than another is simply to show how a concept has evolved that is more appropriate for the Event which it engenders. For example, Kant's criticism of Descartes' formulation of the *cogito* does not invalidate the latter's theory entirely. Rather it is to see that 'to criticise is only to establish that a concept vanishes when it is thrust into a new milieu, losing some of its components, or acquiring others that transform it'.[14] Following the above example, this means

that Kant's work is not to be read as the solution to a flaw in Descartes, but rather that each is appropriate to the specific problems it confronts. Criticism is valid in that it is a creative activity, bringing forth new concepts in which understanding is reconfigured. Simply to criticize in order to maintain the status quo is the methodology of those who see philosophy in static terms as the maintenance of a given set of problems.

Similarly, as Deleuze and Guattari point out, when philosophers identify themselves with a particular thinker or movement they are potentially engaging in a reactionary and non-philosophical approach to the discipline.[15] Here, again, the difference between being and becoming a philosopher is played out. The names Kant or Descartes should not be used as disciplinary battle-lines behind which the philosopher retreats in order to engage in pedantic and sterile analyses of points of scholarship. Rather philosophy and its history are of value because of the way in which these 'famous names' can be evoked in order to generate creativity within present thought. As Deleuze and Guattari suggest, to be a Kantian is to renew the concepts generated by this thinker in order to create different figurations. It is not simply to be able to quote 30 pages of the *Third Critique* at one's detractors, or as Schlegel pointed out in 1798, 'according to the school definition, a Kantian is only someone who believes that Kant is the truth, and who, if the mail coach from Königsburg were ever to have an accident, might very well have to go without the truth for some weeks.'[16]

These arguments show that philosophy is characterized by 'doing'; it is a practice that cannot be reduced to a body of knowledge. It is not to set up one's stall behind a given thinker and to defend your 'correct' interpretation of their work at all costs. This is why, at the beginning of the previous section, I was careful to argue that I wanted this discussion to be understood as not simply being an advocacy of 'being Deleuzian'. Rather it should be seen as an exploration of what 'becoming Deleuzian' may entail. I am not intending to set up Deleuze and Guattari's arguments as offering an alternative 'system'. Rather I am arguing that it is precisely this sense of 'systematicity' against which their thought reacts. There is no 'model' that will emerge out of this discussion. Instead this work is intended as a provocation, a challenge, a questioning of accepted positions.

This work is itself provisional. It is a transition, a bridge to future thoughts and interventions. At the present time, I am unsure as to

how one can entirely embrace 'becoming' a philosopher. I am finding a voice through these ideas, finding a way in which I can talk of the process that this entails. As I remarked in the introduction, I have for a long time tried to 'be' a philosopher. That has entailed immersing myself in the details of this identity. Just as disciplinary boundaries are maintained at all costs, disciplinary identity is also comfortable and comforting and is difficult to throw off. Risk-taking of the sort I am exploring and advocating here is difficult and takes practice. It is made all the more difficult by the fact I know this present discussion is haunted by the disciplinary anxiety I discussed earlier. ... *Am I doing it right... is this part of the essay still philosophical? ... Am I clearly responding to the problems which I identified at the beginning of the paragraph? ... Have I answered my critics? ... Will I still be accepted as a philosopher if I show my weaknesses and doubts... but remember that's not what you want to be anymore – you're happy becoming one... aren't you? ... I never considered myself to be a nervy or phobic philosopher – so just pull yourself together, say what you want to say, remember lines of flight not points, you can be the pink panther!*[17] I find it immensely difficult to become philosopher on my own. I need my companions, the other voices in the debate that help me to say what I want to articulate. Thus my 'voicing' of Deleuze's work is a means through which I can advocate both the dilemma I am facing and offer a productive route forward. For, unlike Alphonso Lingis elsewhere in this volume, I have not yet got the confidence to exclaim 'I am a dancer' with all that this exhalation contains. I'm getting there – as perhaps this part of the text shows – but it will take time. And, as is ably demonstrated in Deleuze's work, becoming a philosopher doesn't necessarily mean entirely going it alone. Collaboration, assemblage, alliance are all possible strategies. And you too can dance with the pink panther... or Kant or Hölderlin...

Becoming-philosophy and its relation to its history

Several important consequences emerge from understanding the history of the discipline in terms of creative renewal and engagement. A way of thinking about the relation of the history of philosophy to philosophy understood as a contemporary practice is offered which both acknowledges this history while simultaneously freeing it from slavery and reverence towards its doctrines. It may be thought that in defining philosophy as the art of creating concepts

Deleuze and Guattari would be in danger of separating philosophy from its history entirely. This move would suggest that philosophy is an abstract practice that is removed from the materiality of thought. This argument is used by some disciplinarians when they want to try to differentiate philosophy from cultural history or history of ideas. (My own research has sometimes come up against this distinction when I have been told that my work on the eighteenth century is history of ideas rather than philosophy.) In fact, the opposite is true. Deleuze and Guattari criticize philosophy understood purely as a form of logic as unphilosophical precisely because it tends to deny any relation to history. Instead, the view of philosophy that they explore has a more complex relation to its history. In order for the 'becomings' of philosophy to have 'content' it must draw on history. It is not tied to this history but rather uses it as a resource.[18] In Deleuze and Guattari's work, the metaphor of geology is juxtaposed with genealogy in order to clarify the relation of philosophy to its past; the task is to replace 'genealogy with geology'.[19] This move into a language of place rather than linear time is confirmed by the statement that we:

> must give up the narrowly historical point of view of before and after in order to consider the time rather than the history of philosophy. This is a stratigraphic time where 'before' and 'after' indicate only an order of superimpositions... Mental landscapes do not change haphazardly through the ages: a mountain had to rise here or a river to flow by there again recently for the ground, now dry or flat, to have a particular texture.[20]

This move to the language of place disrupts traditional disciplinary beliefs. There is not a linear development of Western modes of thought from Ancient Greece to the present day. The narrative of philosophy is not fixed and unchanging. Rather, visualizing philosophy in 'stratigraphic' terms reveals links and relations which the linear conception deems inadmissible. The terrain which one surveys from the present bears the traces of previous interventions and engagements. As Deleuze and Guattari suggest in their metaphor of the mental landscape of thought, our current concepts bear traces of what has passed. However, there is no fixity to the current determination; there is no possibility of predicting when and if a small seismic shudder will occur which will disrupt the present

terrain. This shift may expose previously hidden concepts and bring them into new configurations with current concepts, thereby creating the possibility of new becomings emerging. In this move the old concepts may again be buried or partially submerged, thereby transforming the landscape of philosophy. It is this sense of indeterminacy and incipient play which is characteristic of becoming-philosophy and what makes it possible for Deleuze and Guattari to claim: 'Philosophy is becoming not history; it is the co-existence of planes, not the succession of systems.'[21]

Furthermore, these remarks problematize the philosophical project for the disciplinarians because it questions what counts as the correct object of study. There is no predictability about either the route through the landscape that is to be taken or even what the landscape will look like. Becoming-philosophers do not abide by the way-marker posts that the disciplinarians place through the landscape which tell us where to go and how to think. Rather, they are precisely those who stride off into the distance without the map, following their desires and transforming how the landscape is to be read on the way. From the perspective of the disciplinarians, this is nothing short of vandalism – 'they don't keep to the paths or keep off the grass' – but the becoming-philosopher does not care. Their interest lies ahead, in seeing what new experiences lie over the horizon. But in striding forth, these thinkers are not aiming towards some preset goal. Their motivation is experimentation and experience not colonization. The task is not to recreate old configurations; there is no longing to return to the 'mother country'. Rather the motivation of this approach is to creatively engage with past.

One area where I would suggest this process can be seen to be happening is within certain areas of recent feminist philosophy. Here the history of philosophy is creatively encountered. The impetus of this approach is not simply to negate – the knee-jerk reaction of 'spit on Hegel' (tempting though this sometimes still may be) has been tamed.[22] Rather the 'past' of philosophy is creatively re-engaged in order to bring forth new configurations and new alliances. This approach can be seen for example in the work of Irigaray, where she not only shows up the 'blind-spots' within Western thinking of Woman but also simultaneously allows the lacunae and fissures of the tradition to be revealed. In so doing, her work could be described as generating the kind of 'stratigraphic' alteration to which Deleuze and

Guattari refer. Voices are uncovered which the 'disciplinarian' tradition has covered over, enabling different configurations to be exposed. In so doing, new alliances are formed, new discussions are started. Who would have thought either Spinoza or Kierkegaard would have anything useful to say to today's women?[23]

Becoming-philosophy and its relation to other disciplines

I now want to turn to the relationship of philosophy to other disciplines. In traversing the mental landscape, the philosopher often encounters others on the way. As I argued earlier, philosophy often adopts a very elitist stance towards those whom it considers to be 'non-philosophers'. To be a philosopher seems in part to be complicit in upholding an implicit value judgement about other disciplines. Philosophy 'may not boil cabbages' (to quote one of my old philosophy professors), but it does claim a position of power and privilege with respect to all other disciplines. How then can we assess Deleuze and Guattari's understanding of philosophy in relation to other disciplines? Does their work help to free us from disciplinary constraints and boundaries? On first sight it may appear that the answer to this question is negative, because in *What is Philosophy?* rigorous distinctions appear to be drawn between disciplines. While philosophy is the 'art of creating knowledge through concepts'; science is defined as 'knowledge through functions and reference' and art is 'knowledge through percepts and affects'.[24] Thus apparently *a priori* boundary lines are drawn up. How can this degree of rigidity be squared with the claim that a 'becoming' philosophy is characterized by experimentation and creativity? In order to respond, we first have to note that all different disciplines, philosophy, science and art, are involved in creating knowledge. Thus 'knowledge' is not the exclusive preserve of the philosopher. This breaks with the traditional view of the distinctive nature of each discipline, because, for example, traditional philosophy would be very reluctant to allow that art is capable of making knowledge-claims at all. However, Deleuze and Guattari make clear that each discipline has a distinct, non-hierarchical role to play in relation to another. Each discipline has a mode of exploration which is appropriate to it. Philosophy does not hold exclusive rights to making knowledge-claims, rather what is specific is the method deployed. This method is no better or worse than the

other approaches, it is simply that which is appropriate. Furthermore, it is not that there is a 'specific' domain of knowledge to which philosophy has exclusive access and rights: 'The exclusive right of concept creation secures a function for philosophy, but it does not give it any pre-eminence or privilege, since there are other ways of thinking and creating.' Rather, as Deleuze and Guattari suggest, there is interbreeding and cross-fertilization between disciplines. An idea which has been understood from the conceptual perspective in philosophy may equally be taken up by either art or science and viewed through the processes and configurations which that discipline deploys. Relationships do and must exist between the different approaches: 'the concept as such can be the concept of the affect, just as the affect can be affect of the concept.'[25]

Deleuze and Guattari's argument shows how different disciplines have their own distinct approaches which are valid on their own terms. To criticize one for not doing what another does is to fail to recognize the necessary specificity of the disciplines. On this one point Deleuze and Guattari and the disciplinary police concur: it is necessary to hold onto some sense of identificatory specialization, for otherwise knowledge-claims would be reduced to utter relativism. However, where the two part company is both over the way the content of the discipline is to be understood and also how the discipline is to be practised. The terms philosophy, science and art do not denote a fixed 'subject' for study or contemplation. Rather as Deleuze and Guattari write: 'To think is to experiment, but experimentation is always that which is in the process of coming about – the new, remarkable and interesting that replaces the appearance of truth and are more demanding than it is.'[26]

In these remarks, the breakdown of the rigid distinction between method and content begins to emerge. For although I am stressing the different approaches which different 'disciplines' utilize, it is also important to realize that what is meant by 'a discipline' is being reworked and revived. The discussion of art, science and philosophy do not solely refer back to a set of preset 'knowledges' or systems which constitute these disciplines. Each term also denotes the processes by which 'knowledge' is configured by their particular approach. One of the reasons why philosophy has maintained a distance from other disciplines is that it has been unwilling to confront the relation between process and content. It does not like

to consider the materiality of thought, that knowledge is not independent of the processes by which it is configured. In fact it has maintained its elitist position precisely through preventing contamination from process. Ideas, systems are seen to be transcendent of the particular; they organize, configure, determine the latter but they do not come into contact with it. Traditionally, philosophy is the theory that intervenes into materiality like a *deus ex machina* but does not allow itself to be touched. However, by approaching philosophy as a form of 'doing', as a becoming rather than a being, one is forced to confront the processes whereby ideas are engendered. It leads to questions being raised about the presumed separation between the idea and the process that creates it. Thinking can start to become reconceptualized as a making where the process is indistinguishable from the product.

Furthermore, considering philosophy as a type of 'doing' or 'process' makes it easier for it to be brought into dialogue with other forms of 'knowledge' experimentation such as art or science. For example, philosophy traditionally offers a theoretical explanation of the nature of the artwork; i.e. the artist simply 'creates' and then the aesthetician 'explains' the product. However, viewed from the perspective of becoming, the philosopher undertakes a process that is analogous to the maker. Thus dialogues can and should begin between these different makers as to what occurs in the making. In a certain way this is what is occurring in this book via the relationship between the different papers. Each discusses how knowledge is 'made' and generated out of the processes with which they engage. Thus this paper should be read as being in dialogue with the others. However, this dialogue is not intended to effect a synthesis; rather it is to offer a different assemblage, a productive engagement between approaches. This can only occur though when the hierarchies are removed; for example, when I as a philosopher do not 'talk down' to the visual artist, but rather meet on a plateau formed out of common concerns. In so doing, dialogue and new configurations, new 'knowledges', emerge. For while disciplinary restraints are in place, the tendency is always to remain in one's corner or to try to appropriate the specificity of the other's approach back onto one's own territory. 'Becoming' here has the effect of deterritorialising disciplines and that allows creative dialogue to begin.

Concluding Remarks

Where do we now go with this? These concluding remarks may seem a strange place to start to introduce new 'concepts'. However, in order to assess the possible impact of this discussion I want to link it to the motif around which this book is organized, namely the idea of 'ecologies' of knowledge. Deleuze and Guattari's work fits perfectly into this motif in that it emphasizes process over stasis, becoming over being etc. In much work within ecology there is a constant reminder that what lies at the heart of any successful eco-system is its ability to adapt and change. While the system may always tend toward equilibrium this is not a fixed state. A balanced ecology is not one where everything is in place, where all niches are occupied by species that are adapted to the specific conditions of the moment and are ill equipped to deal with change. While this state of affairs may look tranquil and settled to the outsider it is a system in imminent decline. For unless an ecology is flexible and able to respond to unexpected events, it will be threatened with destruction. What keeps an eco-system vibrant is diversity and flexibility; it must be able to monitor and adapt to change in all forms. A successful ecology needs a constant throughput of energy, whereby each part feeds into the other, thereby creating a living, vibrant and self-sustaining community. To transpose these ideas back into the discussion I have developed here, I want to suggest that the approach offered by Deleuze and Guattari is precisely that of the flexible ecology, it maps out a way of approaching and understanding philosophy as a practice characterized by innovation and development. The calls of the philosophical disciplinarians are eventually self-defeating because they create a system which is fossilized and moribund. It is not a system which constantly renews itself, which is in flux and development. Instead it relies on the existing amount of energy it has contained within its boundaries, which it constantly recycles. However, just as stale air in a closed system will eventually become rancid and suffocating so too will the philosophical disciplinarians become tired and jaded. Philosophy – and by inference any discipline – needs renewal, in the same way that any ecology needs an inbuilt mechanism that ensures adaptation and change.

A danger in this argument is that it could be read as calling for a re-generation of the eighteenth-century model of thinking as a form of organic unity. For example, the 'bright young things' of the late

eighteenth century established a manifesto for a 'symphilosophy' where all parts of thought are brought together and 'all art should become science and all science art; poesy and philosophy should be made one.'[27] Similarly linking the notion of 'becoming-academics' with the metaphor of ecology could be interpreted as a call for some new form of synthesis and holism within thought. However, as I have argued throughout, we must be wary of any attempts to 'systematize' this way of thinking. In fact, as I have shown, such a resistance to the move towards systematization is inbuilt in the structure of 'becoming'. For when we 'observe' the ecologies of thought we have to be aware of the role which we are playing in the process. We are not passive observers 'viewing' the species under our gaze nor are we even to understand ourselves as being an 'observer' of the processes of becoming. Rather we need to recognize ourselves as participants in the flows, the becomings in which we are immersed. As Deleuze and Guattari suggest, this is one of the most difficult tasks which confront us: 'The question is directly one of perceptual semiotics. It's not easy to see things in the middle, rather than looking down on them from above or up at them from below, or from left to right or right to left: try it you'll see everything changes.'[28] The ecologies which are offered by 're-conceptions' are concerned precisely with the challenge of 'seeing things from the middle'. The task is not to establish new 'theories' that offer systems or a bird's eye view of the problem. (The problems that are caused by this approach are amply illustrated and investigated by Mark Shutes' paper in this volume.) In thinking from the perspective of becoming we are concerned not with establishing 'points', 'ideas' or definitive explanations. Rather our focus is how new configurations, alliances and coalitions in and of themselves have the potential to transform the idea of disciplinarity. To consider a discipline from the perspective of becoming is not to clearly establish which ecological niche it inhabits, but rather it is to explore the processes by which a specific 'disciplinary niche' interacts, feeds off and offers succour to other disciplines. It is to see how the relations and processes which maintain the discipline occur but it is also to acknowledge the transformations and mutations which each must undergo. Thinking of disciplines in terms of becoming insists on their status as provisional and open.

Several consequences arise out of advocating this approach. First, as this discussion has shown throughout, the task is difficult and

fraught. It potentially exposes the participant to ridicule and anxiety in the face of one's disciplinary peers and masters. However, it is a challenge and risk which I consider to be worth taking. Furthermore, as I showed in the introduction to this essay, many of us have not much to lose anyhow. We were never considered to 'be' philosophers in the first place, and so we should not retreat from exploring new approaches to the discipline just because those who legislate the boundaries don't like it. Also, as Deleuze and Guattari argue, what is often most effective in challenging disciplinary boundaries is the guerrilla raid which is unexpected, the seismic shudder which occurs in the discipline which is caused by the intruder or the person who is least likely to be a troublemaker: 'It's the quiet ones you have to watch, you know.' We need to be constantly questioning the 'limits' which the discipline sets up for itself so as to harry and provoke movement and change. As the above analogy indicates, this doesn't mean we have to adopt a full-frontal attack on the academy and its institutions. In fact, the mechanisms of disciplinarity are so ingrained in the structure of institution as to make such an attack ineffective. Rather what is needed is to undertake subtle interventions when we can, to cooperate and liaise with those who are working to question the complacency and fixity of disciplinary norms and boundaries.

Second, those of us who are within the discipline, who occupy privileged positions as part of the academy, must be wary of not succumbing to the pressure to conform. We must try to prevent the replication of the structures which we ourselves have encountered. This imperative has ethical implications both for pedagogy and research. If we are serious about exploring what it means to 'become academics' we must be open and responsive in our teaching and working with students and our dealings with our peers. As I have argued, this does not mean that we commit ourselves to some liberal mishmash of accepting anything and everything which is placed before us. Disciplinary identity is still important, as are the traditions and practices which this contains. However, the disciplinary identity of a becoming-philosopher or becoming-anthropologist is necessarily and importantly reconfigured by their commitment to working from 'within' the processes that such an identity endows. This disciplinary 'identity' is less to be understood as the battle armour which one displays to maintain the honour of one's subject at all costs, than the signal one emits to potential interlocutors as to the perspective –

and prejudices – from which one is speaking. Thinking of one's discipline in terms of a practice – as something which I do rather than something I am – enables one to be more responsive both to the nuances of the work one is undertaking and to the encounters with others that occur. It is to be open to innovation and collaboration rather than immediately hostile and defensive. In the long run I would argue that this creates a much more productive environment for all.

It may be argued that the viewpoint I am advocating here is hopelessly utopian and naïve. Academic institutions and the disciplines they contain have a vested interest in maintaining the status quo, all the more so in a climate when all forms of knowledge are increasingly called to account both financially and in terms of their 'exchange-value'. However, if my argument has been of value at all, it should be clear immediately that what is at stake is a refusal to become complacent or resigned in the face of difficulties. It is necessary to question and challenge the vested and arcane interests of the disciplinarians in order that knowledge and learning do not become another 'commodity' among all others whose value is simply that which the market will sustain at a particular time. As this discussion has shown, the call to 'become academics' is one that is inherently political. It means that we must be wary and responsive to the increasing 'institutionalization' of knowledge. We need to find creative ways of maintaining and developing open links and debates both within and across disciplinary and institutional barriers. While the dominant political climate is one which increasingly discourages such moves, it is essential that we find ways in which such collaborations and the debates they engender may continue.

Interestingly, as I think I have shown through my reading of Deleuze and Guattari's work, the amount of adaptation that is necessary to start to effect these changes is, on the surface, not that great. The call to 'become philosopher' is not a call for totally new beginnings (if such an idea were ever possible in the first place). The 'philosopher' like myself does not necessarily have to entirely give up their beloved foraging within dusty tomes nor do they need to instantly develop a radically new mode of thought or address. Rather, what is necessary is to be more open and responsive to what it is that they are already doing. Not merely to think, but to think creatively with a mind that is open to hearing the awkward questions. Finally, and perhaps most astutely, it is to stop wanting to be a philosopher

and to be contented with the process of becoming one. For, as this discussion has hopefully shown, this is the most exciting and most challenging stance that one can adopt. To sway toward the position of 'becoming' philosopher may not be safe and cosy, it may not secure tenure, but it enables philosophy to maintain the radical edge which it should and must have if it is to have any purpose.

Notes

1. *Friedrich Schlegel's Lucinde and the Fragments*, trans. Peter Firchow (Minneapolis: University of Minnesota Press, 1971), p.167.
2. G. Deleuze and F. Guattari, *What is Philosophy?*, trans. Graham Burchell and Hugh Tomlinson (London: Verso, 1994).
3. Samuel Weber, *Institutions and Interpretations* (Minneapolis: University of Minnesota Press, 1987).
4. Weber, *Institutions and Interpretations*, pp.25, 28.
5. *Ibid.*, pp.28–31.
6. *Ibid.*, p.32.
7. Diane Elam, *Feminism and Deconstruction: Ms. en Abyme* (London: Routledge, 1994), p.97.
8. G. Deleuze and F. Guattari, *A Thousand Plateaus: Capitalism and Schizophrenia*, trans. Brian Massumi (London: Athlone Press, 1988), pp.16, 233–309.
9. e.g. the row that erupted in Cambridge over Jacques Derrida's credentials as a 'philosopher'.
10. Deleuze and Guattari, *What is Philosophy?*, p.99.
11. *Ibid.*, p.2.
12. *Ibid.*, p.23.
13. *Ibid.*, p.20.
14. *Ibid.*, p.28.
15. *Ibid.*, p.28.
16. Schlegel, *Athenaeum Fragment*, 104, in *Friedrich Schlegel's Lucinde and the Fragments*, p.173.
17. Deleuze and Guattari, *A Thousand Plateaus*, p.11: 'The pink panther imitates nothing, it reproduces nothing, it paints the world its colour, pink on pink; this is its becoming-world, carried out in such a way that it becomes imperceptible itself, asignifying, makes its rupture, its own line of flight follows its own "aparallel evolution" through to the end.'
18. Deleuze and Guattari, *What is Philosophy?*, p.96.
19. *Ibid.*, p.44.
20. *Ibid.*, p.58.
21. *Ibid.*, p.59.

22. This is the title of Carla Lonzi's influential article on the main theoretical assumptions of the Italian feminist group *Rivolta Femminile*. See Paulo Bono and Sandra Kemp (eds), *Italian Feminist Thought: A Reader* (Oxford: Blackwell, 1991), p.40.
23. e.g. Luce Irigaray, *Speculum of the Other Woman* (Cornell University Press, 1985) and *An Ethics of Sexual Difference* (London: Athlone, 1993). See Moira Gatens, *Imaginary Bodies: Ethics, Power and Corporeality* (London: Routledge, 1996) on Spinoza; and Christine Battersby, *The Phenomenal Woman* (London: Polity Press, 1998) on Kierkegaard.
24. Stephen Arnott, 'In the Shadow of Chaos: Deleuze and Guattari on Philosophy, Science and Art', *Philosophy Today*, 43.1 (Spring 1999), p.49.
25. Deleuze and Guattari, *What is Philosophy?*, pp.8, 66.
26. *Ibid.*, p.111.
27. Schlegel, *Critical Fragments* 115 & 116, in *Friedrich Schlegel's Lucinde and the Fragments*, pp.157, 175.
28. Deleuze and Guattari, *A Thousand Plateaus*, p.23.

section ii

hybrid objects/
hybrid methods

real milk from mechanical cows

invention, creativity and the limits of anthropological knowledge

mark t. shutes

It was to be a surprise visit. As I entered the farmyard, I saw Declan and two men I did not recognize standing around what looked to be a life-sized model of a Frisian-Holstein cow. Before I could move closer, Declan saw me and moved in my direction. Now, I had not seen Declan for three years, and I must confess that I expected a very warm greeting, but this was not to be the case. He greeted me with a question: 'Can you still weld, boy?' Years ago he had showed me how to spot-weld metal, and, although I was doubtful that I could still do it, I replied in the affirmative. Without another word, we moved off towards the small storage barn/workshop, where I was equipped with the huge gloves and helmet of a welder. I was to join some small pieces of steel bracing that looked to be part of the base of a transport trailer of some kind. 'It's for the mechanical cow, you see,' said Declan over his shoulder, for he was already moving towards the doors. 'Now just follow the bead of metal, boy, and you'll be fine.' Well I didn't see. And I wasn't fine. And as I knelt on the dirty ground of the shop in my best clothes, I shouted from under the heavy welder's mask: 'Why are you doing this? Why are you building this cow?' 'All in good time, boy,' he said, 'sure, you've only just arrived.' [from fieldnotes, Ireland, Summer 1986]

Introduction

On a summer's day in 1986, a local farmer from a small parish in southwestern Ireland found himself the subject of a front-page story in the *Irish Times* and a 60-second news spot on Irish national television. He and a few associates had constructed, from scratch, a strikingly realistic and life-sized model of a Frisian/Holstein cow, complete with nodding head, switching tail, sound effects, and, most important, a mechanical udder that was capable of delivering stirred and warmed cow's milk to real calves through a set of rubber teats. The farmer brought this model to a regional agricultural fair in County Cork, where he set up the cow and had two calves feed from it. It was a last-ditch effort to advertise and market the calf-feeding device, which was his own invention.

It was the novel simplicity of the situation that captured the attention of the Irish media on that day: a mechanical cow that gave real milk to hungry calves. But as an ethnographer who has lived and worked with this farmer and his fellow parishioners for over 20 years, my attempts at the anthropological analysis of this event have proved it to be anything but simple. Even the most casual reader of the above would be able to frame the questions crucial to an understanding of the event: What were the circumstances that led the inventor to believe that a calf-feeding device was necessary for his future survival as a farmer? Why did this particular individual initiate a process of innovation and not some other parish farmer? Why did he decide to build a mechanical cow to market the device? Did his efforts succeed or fail, and why?

It is in finding the answers to these questions, however, that the complexity emerges. First, the analysis must utilize multiple domains of inquiry, including the historical, ecological, political-economic, cultural-ideological, linguistic-symbolic and idiosyncratic, since the phenomenon to be explained is clearly not reducible to a single domain. Second, these domains of inquiry are circumscribed by particular theory/method/data requirements, which are, in many ways, incompatible with each other, thereby confounding any analysis which seeks a cross-domain solution.[1] Given this kind of domain-limited thinking, a truly incorporative anthropological explanation of such an event is difficult, if not impossible, to realize. We become, in effect, trapped by our self-imposed epistemological boundaries.

Under these circumstances, therefore, two kinds of analyses typically emerge: either (1) the anthropologist reduces the explanation to a single domain and ignores, or views as irrelevant, the large range of issues that cannot be resolved by reference to it, or (2) the anthropologist combines those domains of inquiry that are more closely compatible, thereby reducing, but never eliminating, the range of issues that must be ignored by such a combination. Since neither a solution-by-reduction nor a solution-by-partial-addition can offer a fully satisfactory explanation of a phenomenon, we seek to legitimize our choice of domains by reference to prevailing disciplinary standards for inquiry, which fluctuate according to the relative power of the adherents of the various competing domains. The result is an endless and often politically heated debate over the wrong issues. Rather than seeking a reconceptualization of our epistemological boundaries so as to accommodate a more comprehensive explanation of human behaviour, we ceaselessly argue the relative efficacy of one limited domain over another, or of one combination of compatible domains over another combination.

This work examines the phenomenon of the mechanical cow from the perspective of three competing analytical domains within anthropology: the Political-Economic, the Cultural-Ideological and the Linguistic-Symbolic, demonstrating that, while each domain contributes a legitimate 'chunk' of information that proves crucial to the final analysis, a full understanding of the event cannot be accomplished through their use alone, either as single components or in some additive or reductive combination. Rather, what is required is a fundamental re-conception of the individual as both the recipient and maker of meaning and culture, simultaneously.

For example, the farmer Declan is, without doubt, the recipient of pre-existing structural constraints, like polity, economy, culture, language and geography, which shape, in significant ways, the manner in which he views the world and behaves within it; and he shares the general outline of such constraints with those around him. For this reason, traditional anthropological analyses, which emphasize structural constraints of various kinds, are useful for the identification of Declan's shared group boundaries and the manner in which they impact on his behaviour.

But Declan is also an active participant in the process of making meaning. He continuously re-shapes and re-negotiates and re-makes

those pre-existing boundaries into a system of meaning that, while still intelligible to those around him, is more in accord with his own particular circumstances. The circumstances surrounding the creation of the mechanical cow form simply one example of this process at work. Moreover, the other members of his 'community' are also engaged in similar processes, as are we all. For this reason, an analysis of how an individual actively participates in creating culture and negotiating meaning is crucial to our full understanding of individual behaviour.

The structural constraints, therefore, can best be conceptualized as the opening set of reasonable options available to individuals who are mutually dependent upon each other for their survival. They do not determine individual behaviour, but rather point the individual to the behavioural paths that are least likely to invoke conflict and resistance from others. Nor is it likely that all individuals are aware of all the possible constraints. Individuals may rigidly follow such suggested paths in some situations and radically re-invent them in others, but almost always with imperfect knowledge of the parameters involved. It is the task of anthropological analysis, therefore, to document the structural constraints in order to understand how, and under what circumstances, individuals re-negotiate them. It is not the task of our analysis to reify the constraints themselves, and to offer them as competing explanations for individual behaviour, although that seems to be exactly what we have done. Oddly enough, such a re-conception is not totally new in anthropology. Nearly 60 years ago, Murdock offered the following:

> Society... with the environment, poses problems for the individual, teaches him time-tested cultural solutions, and enforces his observance of them. The solutions themselves, or culture, reside only in the habit systems of individuals, constituting such of their habits as the members of a society or group share with one another. Of itself, therefore, culture can exert no influence upon an individual; expressions like 'the coercion of custom' and 'cultural compulsives' are meaningless and misleading. Culture is merely the lesson to be learned; the teacher and disciplinarian is society or its agents – parents, associates, wielders of authority, etc. ... Interpersonal relationships constitute the cement of society. Whenever two persons come into face-to-face association they adjust their behaviour to one another, in part by bringing into play cultural

norms with which they are already familiar, and in part by developing new reactions through the learning process.²

Clearly, we have lost our way. And nowhere is this more apparent than when we are confronted with finding explanations for individual acts of creativity and invention, like the mechanical cow, for here the active role of the individual in re-negotiating meaning and culture is most painfully evident.

Background

The events herein described took place in a small farming parish in County Kerry, Republic of Ireland. The parish has a total population of approximately 380, the vast majority of whom (55 families) are engaged in farming and live on their holdings. The village centre contains three shops, four pubs, a post office and a collection point for the Kerry Coops dairy cooperative, to which all of the local farmers belong. The average size holding within the parish is approximately 50 acres, with most farms falling into the 30 to 50-acre category. Only about 30 per cent of the farms are larger than 50 acres, with the largest being 110 acres. They are dairy farmers, relying chiefly upon the sale of milk to meet their cash needs. There is no cereal grain production of any sort nor any significant tillage, save an occasional small garden consisting of potatoes, turnips and cabbages. The vast majority of farm families now purchase such root crops from local stores.³

The farmer mentioned above, whom we shall call Declan to mask his real identity, is married and has three grown sons, the youngest of whom is on the farm with him. Fifty-five-year-old Declan has farmed 75 acres of good-quality valley land since inheriting the farm from his father over 30 years ago. Declan's family has held this same acreage for over 400 years.

Like most of the farmers with larger holdings in the parish (known locally as 'big fellahs' or 'strong' farmers), Declan had always relied upon both the sale of milk and year-old cattle as the two sources of farm income. For over a hundred years this two-product strategy had protected local farms from the vagaries of the market place. Although milk was their primary product, they always kept some number of cattle to meet emergency expenses or as a hedge against bad weather and/or disease, which could severely curtail their income from dairying. In this manner, they maintained control over their farming

decisions, and this control was a vital and important component of their self-image.

In the early part of 1983, nearly ten years after Ireland's entry into the European Community (EC), Declan began to feel that he and his neighbours were losing that control. For reasons which shall be discussed shortly, they were being forced to abandon cattle raising entirely and concentrate exclusively upon the production of milk as the sole source of their income. Except for those calves intended as replacements for older dairy cows, most were now sold a month after birth (called 'sucks'), and the money earned from the sale of these 'skinny little fellahs' was hardly equal to that which was previously earned through the sale of yearling cattle. Indeed, it was barely enough to pay for the artificial feed that they had consumed since their birth. In addition, because all of these calves were marketed at about the same time, the glutted market worked in favour of continually lower prices.

Declan believed that it was very dangerous for him to rely solely upon milk sales, since the market price was heavily subsidized by the EC, and quotas on production seemed inevitable. He began to look for a way to regain a two-product strategy in order to maintain his control over his enterprise. This concern led him to invent the calf-feeder. His reasoning at that time can be summarized as follows:

(1) His goal was to use his primary product, raw whole milk, in such a way as to provide him with more than one source of income.

(2) The market for sucks was depressed, and they could be bought at well under their real market value, quickly fattened, then sold at a later period when there were fewer calves on the market and when their greater weight brought a price comparable in total to that previously gained by the sale of cattle.

(3) Feeding raw whole milk would increase the calves' weight far faster and less expensively than feeding artificial formulas, but the feeding process had to be automated or the labour time spent hand-feeding them would be cost-prohibitive.

(4) Automated feeding could be accomplished in a very small area and would not necessitate a reallocation of prime grass fields used to graze milking cows and produce winter silage. The size of the dairy herd, therefore, could remain constant.

(5) The whole process could be initiated slowly, with only minor reductions in the amount of whole milk delivered to the creamery, and the loss of that income would be more than made up by the profits from the sale of the older calves.

(6) In this manner, Declan reasoned, he would regain control over his short-term production decisions. If the price for whole milk declined or if the EC initiated quotas on milk production, then Declan could shift more of his whole milk into calf-fattening and increase his calf herd accordingly. If the price for calves declined, he could sell more of his whole milk to the creamery. Only if both markets collapsed simultaneously would he be in trouble, but that was a familiar risk.

Declan enlisted an unemployed engineer and an underemployed machinist from the market town of Tralee to assist him in carrying out the design he had in mind. The machine had to be able to keep the milk at a constant warm temperature and had to continuously stir the raw milk to prevent separation. In addition, it had to be able to deliver the milk to calves through rubber teats so that the calves would be able to feed themselves on demand. The only human labour involved would be to keep the tank of the machine filled with raw whole milk. In effect, the machine would operate much like a real cow, and whole milk delivered in such a fashion would assure that the calves would gain substantial weight in a minimum amount of time.

After about a year of tinkering with various designs, Declan and his friends came up with a prototype that seemed to accomplish all of the above objectives. Declan immediately set up three of the new machines in his own farmyard, using part of a small field that was formerly used to fatten a few sheep, but that was not part of his dairy herd fields. He began with a modest purchase of 15 sucks and devoted part of his milk product to their feeding. It took a few days for the calves to respond to the feeding system, but they fed vigorously afterwards. Declan kept careful records of their weight gains over the next six months, and sold them for a profit that was more than he would have made had he sold the extra milk to the creamery.

The next year, 1985, Declan increased the number of sucks purchased to 30, since this was the first year of the EC-imposed quota on milk, and he would have had to cut production in his dairy herd if he did not have this other option. The profits from that year's

calves were about the same as the first, and Declan's invention accomplished what he had intended. But Declan was being encouraged by his two assistants to market the device. Declan finally agreed, partly because doing so would help him to recover the initial construction costs, but also because he sincerely believed that the device would be of great benefit to dairy farmers like himself.

Declan spent the winter of 1985–86 travelling to other parts of Ireland, trying to get a few farmers with larger holdings to independently test his invention, and thus verify the weight-gain results that he had attained. At least two farmers agreed to do so and got very similar results to Declan's. In the spring of 1986, Declan tried to interest both governmental agencies and the local cooperative in his invention, using both his own statistics and those of the two outside farmers as evidence of the efficacy of the device. His attempts were a failure, with the agencies either choosing to ignore his evidence altogether or claiming that a much larger sample was necessary to validate the evidence. It was then that Declan decided to build the life-size mechanical cow in order to market the device in its innards at the regional agricultural fair in County Cork.

The media success of the mechanical cow at the fair enabled Declan to make a few sales that very day, and today he continues to market them with great success. He still uses the device himself and is pleased with the results. Other local farmers have also begun to experiment with it as well, which pleases him even more than sales to outsiders.

Analysis

Given the basic details of Declan's activities, certain questions crucial to the analysis arise: (1) What caused the community-wide shift from a two-tiered production strategy based upon milk and cattle sales to a one-tiered strategy based solely upon milk production? (2) How did Declan's perceptions about his role in the community and about the community itself affect his reactions to these changes? and (3) Why did Declan conclude that the mechanical cow would be a successful strategy for marketing his device?

Finding answers to each of these questions is essential in order to understand fully the change-event that has been described above, and yet each demands a different sort of analysis. Question 1 requires

the kind of analysis to be found under the general heading of Political-Economic: an empirical, quantifiable account of the changes in political and market forces that lead to a shift in local production strategies. Question 2 requires an analysis of the cultural ideology held by community members with respect to 'strong' farmers and their importance to community life, and is referred to as the Cultural-Ideological component. Question 3 involves what might be referred to as the Linguistic-Symbolic component of the analysis, wherein we examine the manner in which Irish small farmers may manipulate, or be manipulated by, the language and symbols of power. Let us review each component in turn.

A. Political-Economic component

Ireland's entry into the EC (then called the European Economic Community) in 1973 introduced dramatic changes to the farms throughout Declan's parish. Milk price subsidies, grants and low-interest loans made available through EC membership and administered by a local dairy cooperative transformed the two-tiered income system based upon milk and cattle into a one-tiered system based solely upon milk production.

Now, on all but the smallest of farms, dairy herds have increased dramatically. Non-milking stock is regularly sold a few weeks after birth in order to accommodate the increased herds. Outside contractors prepare the vast majority of the winter feed as local farmers attempt to increase the efficiency and reliability of food production for their dairy herds. And tillage of any sort is practically non-existent because of the labour-intensity of such activities. The parish farmers have become specialized milk-producers, more or less, with all of the positive and negative elements that such a transformation implies. Indeed, agricultural producers throughout the EC have experienced similarly dramatic social, economic and political changes in their rural communities as a result of their participation in the Common Agricultural Policy (CAP) of the EC.[4] The planning and implementation of the CAP has, for the most part, been governed by development theory, which pays little or no attention to the active role played by the rural producer in the acceptance or rejection of change elements.[5] The results of the CAP have, therefore, been uneven at best, and potentially disastrous at worst, particularly in the smaller, more peripheral areas.[6]

From the standpoint of a political-economic analysis, the reasons for these changes can be readily identified. First, the continuing downturn in the world demand for beef throughout the 1970s, coupled with EC milk price subsidies that nearly doubled the amount per gallon received by the farmer between 1973 and 1986, forced the local farmers to reduce their cattle herds and replace them with milking stock. In 1976, the total number of cows in the community numbered 938 head. From 1977 to 1986, the cow herds have expanded nearly 30 per cent to 1,323 head. In 1976, the total number of cattle (over one year old) was 994. In the past ten years, however, that number has decreased to 318 head, a reduction of 68 per cent. Now, 90 per cent of all calves are sold one month after birth, with the money being used to purchase fertilizer and possibly feed concentrates for the cows should the weather prohibit their 'going out to grass' in the early spring.

Second, the increase in the size of dairy herds placed an excessive strain upon the labour supply available to community farms, necessitating an unprecedented increase in the acquisition of labour-saving equipment and processes, which were acquired through EC-subsidized grants and low-interest loans. For example, in 1986, nearly all the farms were using the central road and paddock system, which allowed a farmer to drive the cows to and from the milking parlour to pre-selected and fertilized grazing plots while continuously re-fertilizing plots used on previous days. Only one such system was operating in 1976. In 1986, nearly all the farms were hiring contractors to cut and prepare self-feeding grass silage. In 1976, only about 21 per cent of the farms had such a feeding system. In 1976, only 14 per cent of the parish farms had milking parlours. By 1986, nearly 80 per cent of the farms had some form of automated milking equipment and parlours. In 1976, only 21 per cent of the farms used bulk milk refrigeration and transport tanks, compared to 80 per cent in 1986. The bulk of these expansions and acquisitions took place during what the local farmers call the 'boom period' between 1977 and 1981.

Third, the move to single-commodity production was greatly facilitated by the fact that the community was already involved in an increase in milk production prior to Ireland's entrance into the EC, and thus saw these latest changes as part of an already familiar pattern. Since a large part of the expansion was fuelled by grants

and low-interest loans that could easily be met by the increased price received for their milk, no farmer believed that they were taking any kind of unwarranted or unfamiliar risk. They saw themselves as following the same sort of pragmatic, short-term strategy that they had always followed, which was, in the words of one farmer, 'taking it all into account and doing what we thought was best for us in any one particular year'. No one dropped an entire stock of cattle overnight. They simply reduced it gradually over the ten-year period between 1976 and 1986. As far as they could see, it was merely an extension of the process in which they had already been involved prior to 1973, and they thought that they could always increase their cattle production at some later time when the market recovered.

Fourth, the 'boom period' was quickly replaced by the bust cycle of the early 1980s, which saw the emergence of EC milk quotas, which fixed the price at 1984 rates in order to recover from the massive milk and butter surplus that the EC nations had produced. In addition, the community suffered from three years of excessive rainfall between 1981 and 1984, which severely curtailed milk output and fixed the 1984-based production quota at rates well below their normal capacity. In addition, in each of the three years of 'the flood' the local farmers were obligated to the silage contractors through arrangement made the previous year, even though most of their fields were too wet to be cut. This meant massive losses in income over the three-year period and the establishment of an unprecedented debt among local farmers, who were forced to purchase foodstuffs for their milking herds. Finally, the inflationary cycle that had been developing over the 'boom period' severely curtailed any further increases in labour-saving techniques and equipment, and forced a number of farmers that were in the middle of their expansion to more than double their payments for the work-in-progress.

Fifth, given the reduced production rates imposed by the quotas, few farmers in the community escaped the debt cycle, with the luckiest having only a short-term debt repayable within five years. Others were faced with repayment, which would require ten years or more. No farms were lost during this period, but their debt structure necessitated that they concentrate all of their energies upon milk production, which was now their sole stable source of income. Effectively, they became producers of only one commodity: milk.

B. Cultural-Ideological component

Between 1850 and 1950 two apparently disparate yet internally consistent ideological notions were strongly felt and collectively held by parish members: (1) the importance of the 'strong' farmer and (2) that all relationships within the community were based upon strictly egalitarian principles, or, as one farmer put it, the notion that 'we're all Indians here, there are no chiefs'. Let us examine each in turn.

(1) The 'strong' farmer: These were the farmers that were then at the centre of parish life. In charge of highly labour-intensive farming enterprises that included a mixture of tillage, cattle and hand-milked cows, these 'big fellahs' traded the use of their equipment and breeding stock, their expertise and knowledge with the market outside of the parish and their general patronage and goodwill to the 'small' farmers in exchange for labour at crucial production junctures. They also hired agricultural labourers, who were dependent upon such employment to gain 'the price' of their emigration. The volume of their purchases at local shops kept such places open and available to all. And their celebrations of birth, death and marriage were memorable in terms of available food, beverage, and entertainment.

During that period, the farm enterprises of these individuals differed only in scale from that of their smaller neighbours. They had more acreage and hence a higher volume of productive output. That volume was just high enough, however, to make a difference in terms of the quality and quantity of life that could be gained by other parish members through participation in their activities. In a very real sense, the success of these farms defined the success of the entire parish.

Being 'strong', therefore, meant being able to maintain a viable enterprise under outside market conditions that seemed incredibly complex, unpredictable, and dangerous. The ideal 'strong' farmer was seen as being a shrewd bargainer, an excellent judge of men and livestock, a worldly wise individual who could not be duped by outsiders, and, most important of all, a cautious, conservative and knowledgeable evaluator of the marketplace. Such a farmer would never be the first to experiment with new techniques, unless the benefits were virtually certain or no other options were available, and would avoid any kind of long-term debt that might threaten the loss of the land. In addition, they would be, as one local expressed it, 'moral and serious men, devoted to the work and with no time for foolishness'.

The fact that any real individual was unlikely to possesses all of the above characteristics, or that farmers classed in that category often acted in ways that were inconsistent with the ideal pattern, in no way diminished the notion itself, for, as Geertz suggested long ago, it acted as both a model 'of' and 'for' the world of this rural parish.[7] As a model 'of' the world, it identified the need for extreme caution in the marketplace and a careful year-by-year appraisal of their farming strategies. As a model 'for' the world, it identified the behavioural guidelines that parish members must attempt to follow to remain in control of their lives, given the uncertainty and power of the outside world. By focusing upon those few farmers that both bridged the gap between local parish and marketplace and were essential to the quality of life within the parish, the notion of the 'strong' farmer tapped the perfect source for both of these aspects.

Guided by this ideological model, the larger farmers felt constrained to exercise extreme caution in their economic decisions, and could be subject to extreme local criticism should they deviate too far from this conservative strategy. They also truly believed that they were ultimately responsible for the parish's welfare. Their rewards for proper behaviour included both prestige and the access to cheap labour that guaranteed them higher profits than their smaller neighbours. This same model constrained the smaller farmer to both yield respect and sacrifice labour to the larger farmer, but in the process they gained access to the equipment and expertise that allowed them to base their own economic decisions upon those of the larger farmers, without substantial risk or the need for increased knowledge on their own part.

(2) Egalitarian relationships: The linchpin of the entire process just described was labour. The larger farmers were ultimately dependent upon access to the 'donated' labour of the smaller farmers if they were to maintain the scale of their labour-intensive enterprises. The threat behind a small farmer's criticism of their parish behaviour was the withdrawal of their labour support. For their part, smaller farmers could not afford to lose access to the equipment and knowledge of the larger farmers for any length of time. The threat behind the larger farmers' criticism of any aspect of their parish behaviour was the withdrawal of these things. In addition, small farmers relied upon each other's labour for certain activities (called 'cooring') and geographically proximate farms, regardless of size, depended upon

each other's labour for collective activities such as threshing (these groups were called 'meithal'). Clearly these delicate dependencies precluded the development of any sort of ideological system that would base social interaction within the parish strictly upon differences in wealth and prestige, in what is typically referred to as a system of social stratification. Something more subtle was required.

It was precisely at this point that the idea of egalitarianism came into play. The strongly held notion that all parish members are equals, and ought to be treated as such, provided the perfect guidelines for social interaction under these circumstances. No farmer, large or small, risked a potentially dangerous misinterpretation of their motives or economic goals when their behaviour to each other in public was carefully egalitarian. Indeed, such public statements as 'we're all Indians here...' or 'we all only work to pass the day' or 'the only difference between a big fellah and a small fellah is the size of their hats' or the use of the common greeting 'lads' between males of all ages and statuses are all indications of the constraints of this egalitarianism.

The necessity and efficacy of an ideology of egalitarianism also led to an elaborate separation of public and private behaviours. Farmers would rarely directly discuss their own farming enterprises and plans in public, nor those of any other parish member. Agricultural workers could be fired for discussing their employers actions in public, and those that became permanently attached to one farm and allowed to build a house on that land (called 'cotters') were referred to as being 'like one of the house, who never carried tales'.

Their use of indirect questions and negative inquiries also reflects this concern to mask private feelings and motives while trying to discover those of others. And there was also the commonly expressed local fear of being 'caught out', which in general referred to the highly undesirable state of having revealed your private feelings or motivations in public. This is not to say that individuals could not be direct and forthright as regards their private behaviour, only that there were strong ideological commitments to the opposite. It was safer and sounder behaviour to keep the public and private domains separate.

Finally, it is certainly not correct to interpret these locally expressed ideological ideas of the 'strong' farmer and egalitarianism as somehow being indicative of a 'peasant' parish, wherein commitment to traditional values prohibits or impedes necessary economic change.

The whole purpose of these ideas was to allow change to take place within the framework of local control, specifically through the gradual changes in strategy made first by the 'strong' farmers and eventually borrowed 'in scale' by all the rest. They were culturally transmitted behavioural guidelines that provided all members of the parish with the ability to resist lack of control over change, and not change itself.

Too frequently, the older ethnographic literature concerning rural Ireland has either emphasized these ideological aspects without examining the economic history of the groups in question,[8] which has sustained the 'peasant' model, or, less frequently, the opposite emphasis had been offered, which leads to an equally inappropriate class-analysis model based strictly upon differences in wealth and prestige.[9]

Between 1950 and the present, both an earlier, locally induced change to the mechanized dairying part of their strategy and the later EC-induced change to the single commodity production of milk have all but obliterated the labour dependencies which characterized the previous 100 years. Insufficient time has elapsed to accommodate a major change in ideology and, as a result, the older notions of the 'strong' farmer and egalitarianism still prevail, although their contextual relevance is rapidly changing.

Faced with these growing inconsistencies between ideological perspective and economic reality, the most common reaction, particularly among the 'strong' farmers, has been to resist total commitment to the single-income strategy, even though they stand to gain from it in the long run, while desperately seeking alternatives to it; alternatives that will give them back control over what their farms will produce. Not surprisingly, their most commonly stated reason for this resistance is their fear that the parish itself will rapidly decline and, eventually, disappear.

C. Linguistic-Symbolic component

Given the ideological components discussed above, it should not be surprising that the use of irony dominates the communication styles of local parishioners. Consider the relationship between the two major notions of the 'strong' farmer and the egalitarian parish. On the one hand, we are presented with the idea that some individual farmers are unique from all the rest in terms of their skills and abilities, and that they are, therefore, deserving of much higher levels of respect and prestige than would otherwise be given to an ordinary

farmer. On the other hand, we are given the notion that no such individuals exist within the parish, and that all members are inherently equal and to be treated with the same level of respect and prestige. And so when a farmer is identified as being 'strong', it doesn't necessarily mean that he is worthy of more respect than any other parish member, and when parish members insist that there are no chiefs among them, it doesn't necessarily mean that there aren't individuals that have more influence than others because of their superior skills and abilities.

Irony is also clearly evident in the everyday speech of parish members. Under the ideological constraints of strict separation of public and private behaviours, what is said in public typically contains such ironic elements. Even the very structure of questions permits the individual to speak from the other's point of view so that, for example, asking someone for a ride into town on the following day would be framed as 'You wouldn't be going to town tomorrow, now would you?', or 'I don't suppose you'll be in town tomorrow?'. In this fashion, the style of interrogatory communication protects the speaker from being 'caught out'.

The solution to these ironic elements in speech lies in the fact that all those who use such conventions are intimately familiar with each other's history, habits, behaviours and emotional tendencies. There is a real exclusionary power to such uses of irony, for, although outsiders may share the very same conventions, only those with such intimate knowledge really understand the complete message, with all of its subtle nuances. In this sense, then, the use of irony serves as a mechanism for bonding parish members to each other in a conspiracy of uniquely shared meanings.

From the perspective of the urban, bureaucratic world outside, such ironic uses are often interpreted as genuine dissimulation, wherein the speaker is seen as feigning ignorance and self-effacement in order to gain some advantage. Rural people who use such patterns of speech are often referred to as being 'crafty' or 'shrewd'. Whether or not the dissimulation is always intended, the use of irony does give locals an edge in their dealings with bureaucracies since it tends to invoke a sort of begrudging respect in an individual that would otherwise have the total upper hand.

Discussion

Let us now return to the original set of questions that arose from this analysis. (1) What caused the shift in strategy? As we have seen, the shift from a two-tiered to a one-tiered economy was the direct result of changes in the international markets for cattle and milk. At the local level, however, the gradual change from more milk to fewer cattle was never seen as a shift away from cattle altogether, but rather as the same kind of careful yearly decision-making that had always typified their strategies. Since the market was strong for milk, they shifted more of their energies to the production of milk, but always prepared to shift back if the milk market weakened.

The debt incurred by this shift could easily be handled by the increase in milk income, and so, from their perspective, it was business as usual, wherein they would pit their local expertise against the market. Because their strategies were necessarily made for the short term, it was impossible for anyone to foresee that two years of the worst weather in the history of the County followed by the imposition of a milk quota could eliminate their two-tiered strategy entirely, and force them into production for the maintenance of debt. Almost everyone was trapped by the situation. The market strategy that had sustained them through much more bleak times than the present had failed and they were no longer in control of their production decisions.

(2) How did Declan's perceptions about his role in the parish and about the parish itself affect his reactions to these changes? No group was more embarrassed and shocked by these changes than 'strong' farmers like Declan. They had done everything correctly. They had proceeded cautiously in expanding their dairy herds since the initial years of EC membership. They were not, as far as they could see, incurring any meaningful debt in the process, taking advantage of grants and relying upon loans only where the debt could be repaid out of their present income. Indeed, most of them were quite proud of the fact that they had been able to lead their parish into the prosperous times of the EC without any severe disruptions of parish life. The smaller farmers who, as always, followed them into this series of gradual changes were also prospering, in scale, and privately praised the initiatives taken by the 'strong' farmers throughout the 1970s. In spite of all this, the bottom fell out in the early 1980s.

Declan, in particular, felt in some way responsible for the plight of his parish. He had always been a solid, if cautious, supporter of the EC system, and he had been a leader in the early 1970s in mechanizing his dairying operation, prior to Ireland's entry into the EC. Although severely criticized for these actions then, most of the other farmers did likewise after EC membership was accomplished, and his private prestige was very high throughout the 1970s. It is important to understand that Declan, like most of the 'strong' farmers, was probably in an excellent position to weather these debt and quota problems and come out the other end in a sounder economic position than before. But Declan and the others didn't just view their enterprises from an economic standpoint. He was a member of a parish, and he was a 'strong' farmer. And he felt the responsibility of that position. He and the other 'strong' farmers also felt the harsh criticism of smaller farmers, with comments like 'well they're (larger farmers) free of us now,' and 'the big fellahs won't have the time of day for us now, you'll see'.

Declan's entire plan for recapturing some form of two-tiered income through the invention of a calf-feeder was motivated by this sense of responsibility to all of the farmers in the parish, and by his own conviction that his strength and value as a farmer in that parish rested in his own ability to control his production decisions. Were he and his fellow 'strong' farmers motivated solely by concerns for their own economic gains, such an invention would not have been forthcoming, for time was on their side in a single-income situation.

(3) Why did Declan decide upon a mechanical cow as a way of marketing his invention, and why did this succeed? It is interesting to note that when Declan was encouraged by his urban-based co-workers to market his device, the initial strategy involved getting the facts and figures to support the claims of weight-gain. Without such evidence, reasoned his allies, the attempt to sell the device would fail. In fact, this evidentiary approach failed miserably, and Declan could interest none of the powers in his device. Declan had very little advantage in presenting bureaucratic data to bureaucrats, and the invention he was offering had the potential to take the control over the milk supply out of their hands and put it back into the hands of the farmers. It was a question of power, and the data Declan offered could easily be managed to their advantage, by saying that there was simply not enough of it, or by ignoring it altogether.

But, by hitting upon the idea of the mechanical cow, Declan recreated the image of the 'crafty' farmer on a grand scale, and his message had a poignancy that could not be ignored. Who could not respect, even begrudgingly, the image of an 'uneducated' farmer not only having the skills to produce such a perfect mechanical model, but the device that was in its innards? And who could miss the irony of a farmer having to produce mechanical symbols of his livelihood in order to be able to make better use of the real objects? He attained the small advantage that irony has always given the members of his parish and was able to market his device and recover his investment in his own strategy.

Declan himself is uncertain as to exactly when and how the idea occurred to him, but, once he committed to it, it became his overwhelming passion and obsession. His friends and family became genuinely concerned for his wellbeing, as he worked tirelessly to replicate a cow in perfect detail, ignoring or postponing much of his usual daily work in the process. Much like an artist, he became consumed with the project, and, as the cow gradually took shape, he became more and more animated and energized by the results of his labours. Clearly he was drawing upon some powerful symbolic resources, rooted deeply in his own experiences, and the effect upon his behaviour was transformational in nature. Equally as clearly, the mechanical cow had a powerful symbolic impact upon others who saw it, with its ironic portrayal of both the problem and the solution to the plight of western Irish farmers: maintaining control over their lives and work.

The answers to each of our questions were gained by reference to separate analytical components, and each component contributes information which is invaluable to our understanding of the event. But it is only by reference to an individual, Declan in this case, and the manner in which that individual negotiates the meaning of such components, that the event is understandable in its totality. Any attempts at reduction to one component or the other excludes details that are essential to the understanding of the event. And any combination of components robs the event of its most significant aspect; that is, that it plays itself out in the mind and behaviour of a single individual. The event is unitary, whereas each analytical component is compartmentalized and competitive. Are we to imagine that Declan actually thinks and makes meaning according to these differential components? Can we, in other words, re-construct the actions of a three-dimensional human simply by pasting numerous

theoretical 'paper suits' upon a two-dimensional image, and hoping that the very 'thickness' of our description will resolve the difficulties?

Conclusions

By way of conclusion, let us imagine the total relationships between an individual and the set of structural constraints that shape that individual's behaviour in a more general fashion. These relationships can be viewed in the form of a diagram:

```
                    Reinforcement of Meaning
        ┌──────────────────────────────────┐
        ↓                                  │
   ┌─────────┐   ┌───────┐   ┌──────────┐  ⊕
   │ Symbol  │──▶│Culture│──▶│Individual│──▶◇ Environmental
   │ Sources │   │       │   │Behaviour │   ◇ Constraints
   └─────────┘   └───────┘   └──────────┘   ⊖
        ↑                                  │
        └──────────────────────────────────┘
                    Renegotiation of Meaning
```

The diagram contains four elements labelled 'Symbol Sources', 'Culture', 'Individual Behaviour' and 'Environmental Constraints' respectively, and defines the dynamic relationships between them. Symbol Sources can be defined as the total storehouse of meaning available to a group, including language. This element would be much like the Linguistic-Symbolic component referred to above. Culture is defined as the currently operative set of meanings utilized by a group which establishes the guidelines for acceptable individual behaviour, and which are unconsciously encoded into a set of shared beliefs and values through the process of socialization. This element would incorporate what we have referred to above as the Cultural-Ideological component. Individual behaviour, then, is defined as the manifestation of those shared symbols, beliefs, and values in the actions and activities of individuals as they attempt to make meaning of the world. This is the 'stuff' of negotiation for the individual. Finally, every individual takes this package of meaning that initially defines their behaviour and evaluates it in terms of their own ability to succeed in a world defined by specific ecological, technological, economic and

political parameters, which are labelled in the diagram as Environmental Constraints. These are akin to the Political-Economic component described above.

Those encoded meanings that individuals find to be consistent with their own ability to successfully carry out their lives are replicated in the next generation through socialization. This process is identified in the diagram as the 'Reinforcement of Meaning'. Those encoded meanings that individuals find to be inconsistent with their ability to successfully carry out their lives undergo a complex process of re-evaluation of meaning that involves a return to the storehouse of symbols for redefinition or new definition. In this manner, the individual re-makes meaning, and new elements enter the Cultural-Ideological domain. This process is identified in the diagram as the Renegotiation of Meaning.

It is crucial to view the entire process described above as being in a state of perpetual motion, as it were, with individuals constantly making and re-making meaning and creating continuous possibilities for change within their respective groups. Human cultural systems endure, therefore, not by being isolated from changes, but through continuous exposure to them. The cultural system shared by Declan and his fellow parishioners, it would follow, has endured because it has been in a constant state of modification.

The answers to the three questions about Declan and his mechanical cow are, in fact, understandable in terms of this kind of process. Declan's dilemma was the result of changing political and economic forces (Environmental Constraints), which challenged his way of life and his view of himself as a 'strong' farmer (Culture). This dysfunction led Declan to draw from the storehouse of meanings available to him (Renegotiation of Meaning) and to eventually hit upon the powerful ironic image of the mechanical cow giving real milk (Symbol Sources). The act of creating the mechanical cow gave new meaning and energy to Declan, while the visual image of the finished product invoked strong responses from those who encountered it. Thus, new ideas about the lives and possible strategies of small farmers entered the realm of shared meanings to be passed on to the next generation (Reinforcement of Meaning), since the calf-feeding device offered them very real chances of regaining control of their productive enterprises and, perhaps more importantly, demonstrated that their way of life could endure and succeed.

The message throughout this essay has been that anthropological research must initiate an ongoing process of thinking outside of the boxes into which our theory-method conflicts have placed us, if we are to adequately understand human behaviour in all of its complexity. At issue in this particular study has been the inability of current anthropological approaches to offer a satisfactory explication of individual creative acts, such as the mechanical cow. We have been more adept at studying human beings as objects determined by broad social patterns than we have been at seeing them as individual subjects who are the very makers and re-makers of those patterns. As a result, we have frozen human beings within in the object-constructed space of our theories and methods, and cannot easily account for their most fluid and flexible individual actions.

One way to rectify this problem with our disciplinary boundaries is to renew our efforts to place the individual at the heart of our analysis, as we have done in the case of Declan and his mechanical cow. This sort of 'micro-historical' critique of the limits of anthropological knowledge, based upon the creative acts of one individual subject, also offers us the very real opportunity to open a dialogue with arts and humanities disciplines interested in the acts, thoughts and motivations of individual actors and creators. Indeed, the critique of disciplinary boundaries in pursuit of a more open dialogue between them is the unifying theme of this volume. But it also presents us, as ethnographers, with the humbling yet invigorating notion that, thus far at least, we may have been asking the wrong questions. To paraphrase the words of Declan: All in good time. We've only just arrived.

Notes

1. Paul Friedrich, 'Language, Ideology, and Political Economy', *American Anthropologist*, 91 (1989), pp.295–312.
2. George Peter Murdock, 'Anthropology and Human Relations', *Sociometry*, 4 (1941), pp.141–142.
3. For a more thorough general description of this parish, see Mark T. Shutes, 'Production and Social Change in a Rural Irish Parish,' *Social Studies*, 9, iii/iv (1987), pp.17–28.
4. cf. Ian R. Bowler, *Agriculture Under the Common Agricultural Policy: A Geography* (Manchester: Manchester University Press, 1985); Rosemary Fennell, *The Common Agricultural Policy of the European Community: Its Institutions and Administrative Organisation* (London, Toronto, Sydney & New York: Granada Publishing Ltd., 1979).

5. cf. Hugh Clout, *A Rural Policy for the EEC?* (London & New York: Methuen, 1984); Chris Curtin, 'The Peasant Family Farm and Commoditization in the West of Ireland', in Norman Long, Jan Douwe van der Ploeg, Chris Curtin and Louk Box (eds), *The Commoditization Debate: Strategy and Social Network*, Papers of the Department of Sociology, 17 (Wageningen: Agricultural University, 1986), pp.58–76; David Goodman and Michael Redclift, *From Peasant to Proletarian: Capitalist Development and Agrarian Transitions* (New York: St. Martin's Press, 1982); Norman Long, J.D. van der Ploeg, Chris Curtin and Louk Box (eds), *The Commoditization Debate: Strategy and Social Network*, Papers of the Department of Sociology, 17 (Wageningen: Agricultural University, 1986); Nicos P. Mouzelis, *Modern Greece: Facets of Underdevelopment* (New York: Holmes & Meier Publishers, Inc., 1978); and Mark T. Shutes, 'Changing Agricultural Strategies in a Kerry Parish', in Thomas Wilson and Chris Curtin (eds), *Ireland From Below: Social Change and Local Community* (Galway: Galway University Press, 1989), pp.186–20.

6. Brian E. Hill, *The Common Agricultural Policy: Past, Present and Future* (London & New York: Methuen, 1984); C. Kelleher and A. O'Mahoney, *Marginalization in Irish Agriculture*, Economic and Rural Welfare Research Centre of the Agricultural Institute, Socio-Economic Research Series, 4 (Dublin, 1984); Mark T. Shutes, 'Kerry Farmers and the European Community: Capital Transitions in a Rural Irish Parish', *Irish Journal of Sociology*, 1, i (1991), pp.1–17; and Shutes 'Rural Communities Without Family Farms? Family Dairy Farming in the Post-1993 EC', in Thomas M. Wilson and M. Estellie Smith (eds), *Culture Change and the New Europe: Perspectives on the European Community* (Boulder, San Francisco, Oxford: Westview Press, 1993), pp.123–142.

7. Clifford Geertz, 'Religion as a Cultural System', in William A. Lessa and Evon Z. Vogt (eds), *Reader in Comparative Religion*, (New York: Harper and Row, 1965), pp.78–89, p.81.

8. cf. Conrad M. Arensberg, *The Irish Countryman* (Gloucester, Mass: Peter Smith, 1959), pp.35–107; Conrad M. Arensberg and Solon T. Kimball, *Family and Community in Ireland* (Cambridge: Cambridge University Press, 1968), pp.31–58; Nancy Scheper-Hughes, *Saints, Scholars and Schizophrenics: Mental Illness in Rural Ireland* (Berkeley: University of California Press, 1979); Damian Hannan, 'Peasant Models and the Understanding of Social and Cultural Change in Rural Ireland', in P.J. Drudy (ed.), *Ireland: Land, Politics and People*, Irish Studies, 2 (Cambridge: Cambridge University Press, 1982).

9. cf. Peter Gibbon, 'Arensberg and Kimball Revisited', *Economy and Society*, 2 (1973), pp.479–498.

Plate 1. Automaton figure of a monk, South Germany or Spain, c.1560; National Museum of American History, Smithsonian Institution, Washington, D.C.

clockwork prayer
a sixteenth-century mechanical monk

elizabeth king

'El movimiento se demuestra andando,' we say in
Spanish: You demonstrate movement by moving.

Carlos Fuentes[1]

Introduction

In the Smithsonian Institution is a sixteenth-century automaton of a monk, made of wood and iron, 15 inches in height (plate 1). Driven by a key-wound spring, the monk walks in a square, striking his chest with his right arm, raising and lowering a small wooden cross and rosary in his left hand, turning and nodding his head, rolling his eyes and mouthing silent obsequies. From time to time, he brings the cross to his lips and kisses it. After over 400 years, he remains in good working order. Tradition attributes his manufacture to one Juanelo Turriano, mechanician to Emperor Charles V. The story is told that the emperor's son King Philip II, praying at the bedside of a dying son of his own, promised a miracle for a miracle, if his child be spared. And when the young prince did indeed recover, Philip kept his bargain by having Turriano construct a miniature penitent homunculus. Looking at this object in the museum today, one wonders: what did a person see and believe who witnessed it in motion in 1560? The uninterrupted repetitive gestures, to us the dead giveaway of a robot, correspond exactly in this case to the movements of prayer and trance.

In the history of European clock technology, the monk is an early and rare example of a self-acting automaton, one whose mechanism is wholly contained and hidden within its body. Its uncanny presence

separates it immediately from later automata: it is not charming, it is not a toy, it is 'fearfully and wonderfully made' and it engages even the twentieth-century viewer in a complicated and urgent way.[2] It has *duende*, the dark spirit Federico García Lorca described.[3] Myself a sculptor, negotiating competing ways of representing human substance and spirit, I wanted to know more about this object, and the legend connected to it.

The monk had arrived in Washington via Geneva in 1977, into the care of Smithsonian Conservator W. David Todd, who has made an extensive study of its mechanism. Conversations over time with Mr. Todd, together with research of my own, have helped me learn a little more about the monk.[4] What is the source of the story about how the monk came to be made, a story a curious viewer inevitably hears if he or she presses anyone at the museum? (David Todd mentioned it to me one day on the telephone in response to my early queries.) By what authority can we connect the monk to the court of Philip II, and who was Juanelo Turriano? In the history of the mechanical arts of the Renaissance, how unique was this little artificial man? Where was the line between religion and magic in such an object? What can be said about it within the contexts of sixteenth-century Catholicism, science and alchemy? Who operated the monk and who would have seen it? Above all, *how* was it seen, and what beliefs might have been crucial to its effect on spectators? This essay narrates the backwards search for the origins of the monk; and I have permitted the search itself to be visible as a part of my subject. Driven both by the object charisma of the automaton, and by the thaumaturgical legend of the bedside promise, this study is ultimately an artist's homage to the human attempt to model an act of the spirit.

Part I: An Illness

The young prince Don Carlos is perhaps best known today as the romantic hero of Giuseppe Verdi's great opera *Don Carlo*, first performed in Paris in 1867. Based on the eighteenth-century play of the same name by Friedrich Schiller, Verdi set to music the story of a noble and defiant crown prince of Spain, destroyed by his jealous father King Philip II, in a tale of empire, rebellion, doomed love and Inquisition. The historical record reveals a real-life sixteenth-century Spanish prince, king and court of a very different order, although

even today remnant contention clings to the subject of Don Carlos' short and strange life. Born in 1545, he was the first of eight children by four successive wives to King Philip II. His mother, María of Portugal, died at his birth, at the age of 17. Heir to the Spanish throne, Don Carlos was himself 17 years old in 1562 when, perhaps on an illicit errand, he took a fall down a flight of little-used stairs in his royal lodgings in the university town of Alcalá de Henares, and struck his head against a closed door in the passageway below.

The great historian William H. Prescott, in his 1874 *History of the Reign of Philip the Second*,[5] describes what happened to Don Carlos after the fall:

> He was taken up senseless, and removed to his chamber, where his physicians were instantly summoned, and the necessary remedies applied. At first, it seemed only a simple contusion on the head, and the applications of the doctors had the desired effect. But soon the symptoms became more alarming. Fever set in. He was attacked by erysipelas; his head swelled to an enormous size; he became totally blind; and this was followed by delirium. It now appeared that the skull was fractured. The royal physicians were called in; and after a stormy consultation, in which the doctors differed, as usual, as to the remedies to be applied, it was determined to trepan the patient. The operation was carefully performed; a part of the bone of the skull was removed; but relief was not obtained.[6]

All accounts of this illness, including one in the recently published volume *Philip of Spain* by Henry Kamen,[7] describe a grief-stricken king rushing to Alcalá from Madrid with his Councils of State and the best physicians in the land, among them the great anatomist Andreas Vesalius, to attend Don Carlos. Prescott continues:

> Meanwhile, the greatest alarm spread through the country at the prospect of losing the heir-apparent. Processions were everywhere made to the churches, prayers were put up, pilgrimages were vowed, and the discipline was unsparingly administered by the fanatical multitude, who hoped by self-inflicted penance to avert the wrath of Heaven from the land. Yet all did not avail.

'Putting Don Carlos Together Again: Treatment of a Head Injury in Sixteenth-Century Spain' is the title of a spirited recent article in the

Sixteenth Century Journal. Written in 1995 by L.J. Andrew Villalon, it takes us through day by appalling day of the ordeal, from 19 April to 9 May, quoting from the written accounts of the prince's surgeon and his personal physician.[8] On the afternoon of 9 May, as Villalon tells it, in the aftermath of an attempt to trepan the patient's skull (a full trepanation was not in fact carried out), the townspeople of Alcalá gathered at the Church of Saint Francis.

> With Franciscan friars in the lead, they marched toward the palace, carrying with them the remains of a fifteenth-century member of the order, Diego de Alcalá, for whom they had long hoped to win sainthood. They entered the sickroom, and, in the presence of their kneeling monarch, they set down beside the patient the remains of Brother Diego. Although Carlos was only semiconscious and blinded by infection, he asked for his eyes to be forced open in order to see the blessed remains. The chief steward, hoping to spare the young man further pain, refused to allow this; however, the desiccated corpse was moved close enough for Carlos to reach over and touch it, after which he drew his hands across his diseased face. (p.356)

Prescott transmits the story a little differently, having the king himself and his court fetching 'the mouldering remains of the good father, still sweet to the nostrils, as we are told.' Laying the corpse on the prince's bed, they removed the cloth that wrapped the dead man's head and placed it on Carlos' forehead. (p.469) And yet another account – more about this one later – refers to the *mummy* of the friar being placed in the sick boy's bed with him.

So certain did Don Carlos' death seem on the evening of 9 May, that the king took his closest advisors and departed at midnight for the Jeronymite monastery outside Madrid, to await the final news. But that night Don Carlos slept peacefully for the first time in weeks. And the very next day commenced a sudden, extraordinary recovery. He regained his sight a week later, his fever disappeared soon thereafter, and within a month, he was completely healed.[9]

In the aftermath of Don Carlos' stunning recovery, Villalon tells us, there was no small controversy about how the cure was brought about. Vesalius was praised by some, and among the ten attending physicians who had laboured so hard over the prince there were a few who felt they were due the major part of the credit. But very

soon attention came to focus on Fray Diego de Alcalá, with a groundswell of feeling that here was the agent of a miracle. We ourselves can look back and be sure that the physicians' prodigious efforts, complete with the usual bleeding and purging and the continual probing of the wound with non-sterile instruments would have accumulated more against than in favour of the chances for survival. ('[The doctors] went on placing upon the exposed portion of the skull a powder made of iris and birthwort, and on the lips of the wound a mixture of turpentine and egg yolk.'[10]) But the most dramatic evidence came from Don Carlos himself. According to his surgeon, Dionisio Daza Chacon, when the prince regained his senses he reported an apparition appearing to him the very night of 9 May, when death was closest. A figure dressed in Franciscan habit and carrying a small wooden cross had entered the sickroom and spoken to him, saying he would yet regain his life. Don Carlos was certain that this visitor had been Brother Diego himself. He convinced his father, and together they vowed to bring this miracle formally before the Pope.[11]

In Counter-Reformation Spain, a physician would risk heresy to contest such royal testimony to divine intervention.

Part II: Don Carlos and the Two Monks

Is it quixotic, in searching the descriptions of the secular and religious celebrations following Don Carlos' return to health, to hope for a mention of a small promised clockwork automaton? Yet there is a direct clue, albeit only a recent one. A volume in Spanish by José A. García-Diego, *Los relojes y autómatas de Juanelo Turriano* ('The Clocks and Automata of Juanelo Turriano') was published in Madrid in 1982, by Albatros Ediciones, in the series 'Tempvs Fvgit, Monografías Españolas de Relojería'. Among the plates are photographs of two small automata associated with Turriano, one a dancing lady with a lute (plate 5) now in the Kunsthistorisches Museum in Vienna, and the other the figure of the monk now at the Smithsonian.[12] García-Diego writes: 'this second automaton represents a friar. In contrast with the musical woman, I would say that its personality is, for me at least, considerably unpleasant'.[13] Regarding the monk's attribution, he cites two catalogue entries for it, from sales exhibitions, one in Geneva and another in Zurich in 1976, prior to the Smithsonian purchase. The Zurich source speculates a south German origin. But

in 1980 the Smithsonian Institution, having acquired the monk, included it in the ambitious show 'The Clockwork Universe' – the golden age of German clock-making, 1550 to 1650, and here the monk is labelled as being of either German or Spanish origin.[14] García-Diego comments: 'The affirmation that it could be of Spanish origin is based on the conception and realistic modelling of the head of the monk"; that to my understanding is only mediocre and (although I am not an expert) without special connection to the art of our country.' (p.105) Then he adds this:

> But in the cited catalog of Geneva a hypothesis was given about when the figure of the religious one could have been fabricated, of which I think I should record mention. It is supported in an announcement by Father Servius Gieben, Director of the Historical Institute of the Capuchins in Rome. According to him, it would represent San Diego de Alcalá, a Franciscan who died in 1463. That would permit connecting it to the Spanish Court, since the episode of how his mummy was placed in the bed of Prince Don Carlos was known, wounded in the head in a supposedly fatal fashion, having fallen down stairs (1562); which had the effect of an immediate cure and later, upon petition of Philip II, the canonization of the friar. Father Servius continues and I copy: 'In this climate of religious exaltation – processions, public prayers, pilgrimages for obtaining a cure for the Prince – it is in that which the fabrication of the automaton found itself as a kind of votive offering and – why not? – in order to urge the young prince to a more serious life (he was very capricious). The date should be 1562 or a little later, and the author Juanelo Turriano (or de la Torre, dead in 1585) who was chief engineer for Philip II.' (pp.105–6)

Here in print is the very story, or almost the very story, that I had heard from David Todd at the Smithsonian: an automaton fabricated as an act of gratitude, a votive offering – if not precisely the fulfilment of a promise. But who is Father Servius Gieben? And when did he write his hypothesis: is this a contemporary source or a historical one? García-Diego at least footnotes the Geneva catalogue, the source for the hypothesis, and the footnote is interesting. Acknowledging that he himself is cited in this sales catalogue, he reprints the paragraph in which his own authority is presented as an important basis for the

attribution of the automaton to Turriano. But now he has changed his mind, he says in the footnote. And he indeed concludes his book's section on automata by stating that he cannot agree with either the attribution or the date for the monk's manufacture. In fact, he groups several automata linked to Turriano, the monk included, and places them instead in the eighteenth century, 200 years later! According to this author, only the beautiful lady with the lute in Vienna is spiritual enough to remain in Turriano's name. (p.109)

But he includes another plate, taken from the same Geneva catalogue, apparently provided by the mysterious *historiador capuchino*: a close-up photograph of the face of the monk is paired with an engraving depicting, we're told, the head of San Diego de Alcalá (plate 2).

Plate 2. Comparison of the automaton's head with an engraved portrait of San Diego de Alcalá, from the auction catalogue *Très importante collection de tableaux Espagnols du XIIIe au XVIIIe siècle...* (Geneva, 1976), p.84; rpt. in José A. García-Diego, *Los relojes y autómatas de Juanelo Turriano* (Madrid, 1982), p.LXI.

A Letter

José A. García-Diego's book on Juanelo Turriano, not a work of careful scholarship, is nonetheless an invaluable effort to assemble the fragments of the life of a sixteenth-century engineer about whom not enough has been written. To interpret his portrait of Turriano, and his conclusion about the automata, one first wants a proper introduction to Sr. García-Diego himself. He was a civil engineer who later became interested in the history of science and technology in

Spain, with a particular focus on the history of hydraulic engineering. Working with historian Alexander Keller of the University of Leicester, he arranged for the publication of transcriptions of several important historical manuscripts, including *The Twenty One Books of Engineering and Machines*, long thought to be the work of Turriano, and a volume entitled *Giovanni Francesco Sitoni: Ingeniero renacentista al servicio de la Corona de España*, a forgotten Renaissance treatise by an Italian engineer on the principles and practice of hydraulic technology (with the sounding title 'Trattato delle virtù et proprietà delle acque, del trovarle, eleggerle, livellarle, et condurle...'). García-Diego founded the Fundación Juanelo Turriano in 1987, for the purpose of furthering the study of the history of civil engineering.[15] He passed away in his native Madrid in 1994 at the age of 75.

In spite of the title of García-Diego's book on Turriano, the chapter on automata is a brief one, entitled 'Interlude on Automata'. It comes across more as an engaging aside, though clearly he was fascinated with the figures. He later produced a second edition of his book – for he changed his mind yet again – this one translated into English, with the title *Juanelo Turriano, Charles V's Clockmaker, The Man and His Legend*.[16] Though only four years apart, there are further differences between the two books in addressing the subject of automata, as we will see, and the second book drops the word altogether from its title.

The catalogue for the sales exhibition in Geneva that García-Diego cites (and is himself cited by) is titled straightforwardly by the list of items to be auctioned, at L'Hotel Richemond in Geneva on 21 June 1976: *Très importante collection de tableaux Espagnols du XIIIe au XVIIIe siècle, un chef-d'oeuvre de Martin Van Heemsckert, un automate de Juanelo Turriano ingénieur de Charles Quint*. The entry on the monk on pages 83–6 quotes José Antonio García-Diego, 'le grand spécialiste de l'oeuvre de Turriano'. The automaton, he says:

> could be attributed to Juanelo Turriano who surely made it when he accompanied the Emperor Charles V in his retreat at San Yuste. This by reason of the mechanics and the resemblance to the automaton in Vienna that is considered by Bedini as the only one made by Juanelo Turriano. (p.83)

In the opinion of a second and very different specialist, Turriano is named again, this time with the connection to San Diego de Alcalá:

> Research subsequently undertaken at the Historical Institute of
> the Capuchins in Rome, concerning the identity of the individual
> represented by the monk, permits us to come closer to the
> problem. After engravings from the sixteenth century, one dating
> from 1588, the year of the canonization of Saint Diego d'Alcala,
> it would appear to be a representation of the saint, a lay brother
> of the order of Saint Francis of Assisi, who died in 1463. Here
> we encounter again the Spanish court, but several years later, in
> 1562, four years after the death of Charles V. (p.84)

And the full quote follows, as we've seen from García-Diego's own later translation in his book (where he misdates the engraving as 1558). The research was performed by Père Servus Gieben ('Servus' here spelled without the 'i'), Directeur de l'Institut Historique des Capucins de Rome. It is taken from 'a communication of November 16, 1975'. Printed next to Father Gieben's statement are the paired images of the automaton's face and the 1588 engraving of the saint. And the Geneva catalogue entry concludes:

> The automaton would have thus belonged to the unhappy prince
> Don Carlos, who after having plotted against his father, was
> imprisoned in the Alcázar in Madrid where he died on July 25,
> 1568, very probably from the effect of a poison administered
> him by order of Philip II, after a long and painful trial.
>
> The paternity of Juanelo Turriano seems to be without any doubt
> and, as for its intent, one sees that the automaton well favors
> Saint Diego de Alcala, the hypothesis of Father Gieben seems to
> us perfectly coherent. Regarding the automaton itself, which has
> come down to us marvelously well preserved, is it necessary to
> emphasize the principle importance of an object nearly unique,
> living testimony dare one say of the technological preoccupations
> of the Renaissance and of the inventive genius of the men of
> that era?[17]

This is, after all, a sales catalogue. What a pitch! Although the monk was not sold at auction that day, the Smithsonian's purchase took place the following year as a direct transaction via a private dealer in the same city.

A copy of the Geneva catalogue is among the documents in the accession records for the automaton in the Registrar's Office of the

Smithsonian Institution. Also in the file is a letter to Otto Mayr, then curator and head of the Department of History and Science at the Smithsonian's National Museum of History and Technology, dated 4 April 1977, from a Monsieur Georges Sedlmajer, in Geneva, paraphrasing much of the catalogue copy. 'With this letter,' Sedlmajer writes, 'I send you the complete dossier that I have assembled on this automate. The only letter which is missing is of Father Servus Gieben of the Institut in Rome, photocopy of which I can send if you wish.' And Mayr must have asked for it, for indeed the photocopy is here too. Written in French, and dated 16 November 1975, it is the precise 'communication' quoted by the Geneva catalogue and later by García-Diego.

'Monsieur Sedlmajer,' it begins:

> Our research to identify the personage represented by your interesting automaton has resulted in the following conclusion.
>
> After searching in vain among the priests of the epoch, the iconography of the image, to find a Franciscan brother with the attributes of the cross and the rosary, we have settled on St. Didace, or Diégo d'Alcalá. This is a lay brother of the order of Saint Francis of Assisi, who died on November 12, 1463 and was canonized in 1588. As a lay brother [*frère convers*], he does not wear the full tonsure, but presents instead a shaved head. His attributes are precisely the cross, often made of reed, and the rosary...
>
> Regarding the resemblance between the antique engravings of San Diego (one thinks a little idealized, of course) and the expression of your automaton, I won't excessively insist. You will find enclosed with this letter two photocopies of engravings, one from 1588 and the other a little later, for making a comparison. For my part, the likeness is more than sufficient.
>
> But I have further motives for bringing this lay Franciscan saint into a royal Spanish milieu, and precisely in the year 1562. They are as follows:
>
> In April of 1562, the prince Don Carlos (1545–1568), son of Philip II, King of Spain, was found in the palace at Alcalá, gravely ill. In falling down a flight of stairs (19 April, 1562) he had suffered a wound to the head that the surgeons judged fatal. Attempting the extreme, they brought to the prince's room the intact remains of the body of the saint, and at once he was perfectly cured.

Philip II, King of Spain, father of Don Carlos, set out to immediately solicit, in recognition, the canonization of a Servant of God. Sixtus V placed him in the company of Saints in 1588. (On the miracle of the cure, see Fr. Lucio María Nuñez, Documentos sobre la curación del príncipe D. Carlos y la canonización de San Diego de Alcalá, in the review *Archivo Ibero-Americano* 2 (1914) 424-446.)

It is in this climate of religious exaltation – processions, public prayers, pilgrimages for obtaining the prince's cure – that one must locate the fabrication of the automaton, as a kind of ex-voto and – why not? – as an exhortation to the young prince to a more serious life (he was very capricious). The date should be 1562 or a little later, and the author Juanelo Turriano (or de la Torre, dead in 1585) who was chief engineer to Philip II...

As you understand, we are always very interested in all other documentation that you succeed in obtaining on this interesting piece of Franciscan art.

I beg you to accept my best regards, for yourself, your wife, and all your family,

Servus Gieben

Directeur de l'Institut Historique des Capucins

The photocopies of the two engravings both show the figure of San Diego, with cross and rosary, surrounded by a cycle of images from the life and death of the saint (plate 3). Each engraving includes in its cycle a panel depicting Don Carlos' sickroom, complete with a kneeling king, and a group of three Franciscan priests lifting a composed and haloed figure onto the bed.

A Servant of God
Brother Diego de Alcalá was born in the small village of San Nicolás del Puerto, near Seville, around 1400; he died in 1463 in the monastery of Santa María de Jesus in the town of Alcalá de Henares. He lived a life of uninterrupted poverty, first as an anchorite hermit, then as a Franciscan lay brother known for the perfection and asceticism of his practice. He remained illiterate his life long; perhaps this may have prevented him from advancing beyond a lay affiliation to the

Plate 3. Cornelius Galle, *Diego de Alcalá (vita)*, engraving, first published 1614; Museo Francescano, Istituto Storico dei Cappuccini, Rome.

Franciscan Order. Attempts to bring him to Papal notice in the fifteenth century were lost in the welter of political power-struggles during the declining reign of King Henry IV and the rise of Ferdinand and Isabella. Historian L.J. Andrew Villalon, who provided the bedside description of Don Carlos' illness quoted above, has also given us a clearer portrait of Diego himself, through his recent discovery of a copy of a forgotten manuscript in the archives of El Escorial, the original (now lost) written between 1463 and 1467 in the four years just after the monk's death.[18] The copy, made a century later at the orders of Don Carlos, transcribes the compiled testimony of witnesses of miracles attributed to Fray Diego, observed at his deathbed and afterwards in the chapel where his remains were preserved. Compiled by the Archbishop of Toledo and by Fray Juan de Peñalver, the guardian of the monastery of Santa María de Jesus, the testimony had been recorded in formal language in the presence of a notary. This remarkable document, which Villalon has dubbed 'The Miracle Book of Diego de Alcalá', gives us our first contemporary glimpse of San Diego. Some 159 individuals, 18 of whom had known him personally, had come forward with depositions. We learn, for example, that Fray Diego died of an immobilizing ulceration of the left arm and that at the moment of death he overcame his paralysis to raise, with both hands, a small wooden cross, speaking a prayer in Latin, 'a language he had never been heard to use'. That night, the monastery cook, Fray Pedro de Maturaba, holding vigil over the body in the church, 'saw such a great light surrounding the corpse of Brother Diego that it appeared to him lighter than the sun and rendered the chapel as light as day'. The corpse never stiffened into rigor mortis, but preserved the flexibility of life. Following Diego's burial in the small monastery cemetery:

> the guardian Peñalver [according to his later testimony] was so distraught that he could neither eat nor sleep for several days. There is even some hint that given the remarkable condition of the body, he worried about the possibility of a premature burial. In this distracted state, and apparently acting without permission from his ecclesiastical superiors, Peñalver ordered the body disinterred.
>
> On Tuesday [two days after burial], in the dead of night, he sent a young brother out into the cemetery with instructions to lock

the doors behind him and dig up Diego. In his hurry to complete the macabre task assigned him, the young man struck the corpse a blow with his shovel, thereby severing the left hand from the body, at which moment, he later told the guardian, he had felt the monastery walls tremble. (The severed hand would thereafter be preserved separately in the sacristy.) Badly shaken by the experience, the young friar finished the digging with only his hands, after which he hurried to inform Peñalver...[19]

Moved to the altar of a side chapel in the church, the corpse lay on display for six months, appearing yet so alive that one visitor, Villalon tells us, tried to take its pulse. And there now began a steady procession of pilgrims with ailing relatives and dying children, come for miraculous cures brought about by virtue of contact with Diego's body.

Over a century after his death, Brother Diego was canonized as a saint by the Roman Catholic Church. It took Philip II, the Franciscan Order and the Spanish people 26 years of respectful petitions to four consecutive popes to bring about the institutional confirmation of the miracle of Don Carlos' cure.[20] San Diego is the first Counter-Reformation saint. His symbols, humble ones, are a small wooden cross and a rosary. His life is portrayed in religious paintings by Francisco de Zurbarán, Bartolomé Estéban Murillo, and Annibale Carracci. (San Diego de Alcalá mission was established in the New World in 1769, and later became San Diego, California.) His remains are still in Alcalá de Henares, moved now to the Iglesia Magistral, a cathedral first built in the twelfth century. A side chapel is devoted to the display of the small tomb. Over it, a recent inscription appears on the wall:

CAPILLA Y ALTAR

DE SAN

DIEGO DE ALCALÁ

CUERPO INCORRUPTO

†1463 1975

But Don Carlos died in suspicious circumstances in 1568, only six years after his ordeal. In truth plagued by ill health since birth, he had drawn up a will in 1564 and in it asked his father to continue their campaign to recognize Brother Diego, should his own life end before it could come to pass.[21] Yet even as Philip worked to establish

the credibility of one myth, another was unfolding around him. The story of infanticide reaches its extreme form in Verdi's opera *Don Carlo*. But that is another tale! Let us return to Turriano.

Juanelo Turriano

Juanelo Turriano is a mysterious figure. 'La selva juanelesca' – the jungle of juanelo – a phrase from the editor's preface to José A. García-Diego's book about him. As García-Diego declares, we have had to track down the facts of Turriano's life through a maze of indirect reference and surmise. He is variously credited with the design and construction of one of the finest astronomical clocks of the Renaissance; a role in the calculation of the calendar reform of Pope Gregory XIII in 1582; the engineering of the great waterworks which provided water from the River Tagus to Toledo and the Alcázar; the invention of history's first known gear-cutting machine; and a close friendship and association with Juan de Herrera, chief architect of the great palace and monastery of El Escorial.[22]

The best part of our knowledge of Turriano dates from the time he enters the employment of Emperor Charles V. For the following sketch I draw from two works from the 1960s by the historian Silvio A. Bedini, Curator and later Assistant Director of the Museum of History and Technology at, indeed, the Smithsonian Institution.[23]

Gianello Torriano, as his name is spelled in his native country, born between 1500 and 1515 in Cremona, was an Italian engineer and master clockmaker. He was brought to the attention of Emperor Charles V at the time of Charles' coronation at Bologna in 1530 as King of Lombardy. A printed edict had been sent out by the emperor to the major cities of north Italy, calling for a skilled clockmaker who could repair the famous astrarium built in the fourteenth century by Giovanni de' Dondi in Padua. Celebrated as one of the greatest astronomical clocks ever built, it remained, even in disrepair, state-of-the-art technology in sixteenth-century Europe. Could Turriano have conceivably still been a teenager when his reputation carried him forward for this extraordinary task? (García-Diego places Turriano's birth date in 1511.) Moreover, in examining the remains of the clock, he found that corrosion had caused irrevocable damage, and he thus undertook to build a new and similar machine for the emperor in the ensuing years. And this machine in its turn, like de' Dondi's, was considered an almost superhuman technical accomplishment. Bedini cites contemporary accounts that praise

Turriano's innovations to its mechanism: the great Girolamo Cardano concluded a 1554 description of the clock, saying 'so that the machine really depicts the whole universe'.[24] In a 1570 reference to the clock, the English alchemist John Dee exclaims over the fact that one of its wheels takes 7,000 years to make a full revolution.[25] Ambrosio de Morales, court annalist to Philip II, professor at the University of Alcalá de Henares and close friend and admirer of Turriano, wrote in 1575 in his great historical opus, *Las antigüedades de las ciudades de España*, that it took Turriano 20 years to design the clock and three and a half years to fabricate it by hand: 'The clock had all of 1800 wheels, without [counting] many other things of iron and brass that are involved.'[26] As García-Diego has written, 'the astronomer who at the same time worked with his hands... was then, and also later, a rare phenomenon'.[27] Turriano signed his clock with an engraved inscription in Latin as follows: 'QVI. SIM. SCIES. SI. PAR. OPVS. FACERE. CONABERIS', which can be very roughly translated as 'you will know who I am if *you* try and make this'.

When the infirm Charles V abdicated his throne in 1555 and retired to the monastery at San Yuste, Turriano accompanied him and:

> devoted himself to averting the Emperor's moods of depression by creating little automata for his diversion. Tradition relates that Turriano's little figures often appeared on the dinner table after the Emperor's meal in the form of armed soldiers which marched about, rode horseback, beat drums, blew trumpets, and engaged in battle with lances. At another time Turriano is said to have released little birds carved of wood which flew about the room, out of the windows and returned, to the great disapproval of the Father Superior, who considered them to be works of the devil.[28]

One can trace this story back to a seventeenth-century text by Famianus Strada, *De bello Belgico*,[29] here paraphrased by Sir William Stirling-Maxwell, in his 1891 book *The Cloister Life of the Emperor Charles V*:

> Other puppets were also attributed to [Turriano]; minute men and horses which fought, and pranced, and blew tiny trumpets, and birds which flew about the room as if alive; toys which, at first, scared the prior and his monks out of their wits, and for awhile gained the artificer the dangerous fame of a wizard.[30]

Here is the original, translated into English in 1650 by Sir Robert Stapylton, reproduced intact:

> For often, when the Cloth was taken away after dinner, he brought upon the board little armed figures of Horfe and Foot, fome beating Drums, others founding Trumpets, and divers of them charging one another with their Pikes. Sometimes he fent wooden fparrows out of his chamber into the Emperours Dining-room, that would flie round, and back again; the Superiour of the Monaftery, who came in by accident, fufpecting him for a Conjurer.[31]

And thus the scene is reset by successive generations of historians. By the time Bedini recreates it, it is tradition speaking. García-Diego quotes Strada too, calling it 'a short passage full for wonders'.

When the emperor died in 1558, Turriano entered the service of Philip II, in Toledo, where he further distinguished himself with works of hydraulic and civil engineering. Turriano died around 1585. García-Diego in his book demonstrates that King Philip did not share his father's interest in planets and clocks, and Turriano's life after the emperor's death was difficult. This is the first of García-Diego's reasons for disbelieving the story of the automaton monk, that it would have been an unlikely assignment to his engineer from this king.[32] But to this day, the street in Toledo where Turriano lived is called *calle del hombre de palo*, 'the street of the wooden man':

> in memory, says tradition, of a puppet, of his making, which used to walk daily to the archiepiscopal palace, and return laden with an allowance of bread and meat, after doing ceremonious obeisance to the donor.[33]

The Attribution of the Monk

In none of the historical sources we've found is there any reference to the mechanical monk, nor apparently does the monk appear in the royal inventories of the emperor or his son. On the other hand, an automaton very similar to the above-mentioned lady lute player in Vienna was described in 1575 by, again, Ambrosio de Morales as being made by Turriano, and this has provided a continuing hypothesis for *her* attribution.[34] In 1966, the historian Silvio Bedini, whom I paraphrased at length above, referred to her in the context of the pieces Turriano made in the emperor's final years at San Yuste,

but said that if she was made by Turriano, she is the only surviving specimen of his automata.[35] (This is the reference cited by García-Diego in the Geneva catalogue.) Indeed, not even Turriano's great planetary clock survives, although a modern reconstruction of the de' Dondi clock was completed in 1960 for the Smithsonian. As far as we know at this point, the monk seems to surface only in the twentieth century, in the 1970s, with José A. García-Diego among the first to write about it. One longs to trace it back further, for the backwards journey earns us a view of each of the landmarks from both directions. It appears that the weight of the story of how and why the little machine came to be made seems to rest on Father Servus Gieben's 1975 letter. Under what circumstances did he come to perform his research, and did he know how his hypothesis was to be utilized? He doesn't mention any other automata, or the Morales passage on Turriano – did he know of these connections? Certainly this 'history of the history' of a thing, shows us a little of what happens when a mysterious object makes its appearance on the world antiquities market. But the proprieties of that market can deeply mock the historian's attempt to trace the journey an object has travelled through time.

At present the Smithsonian register reads simply 'Automaton figure of a monk: south Germany or Spain, c. 1560' and, in smaller print, 'Figure: head of poplar wood; head and limbs rendered naturalistically; modern habit. Movement: iron; height: 39 cm. (15 3/8 in.)'.

Part III: A Sixteenth-Century Mechanical Masterpiece

W. David Todd is himself a consummate clockmaker. When he became Conservator of Timekeeping at the Smithsonian's National Museum of History and Technology in 1978, he took up the care of the newly acquired monk and produced a complete set of diagrams of its internal mechanism, parsed out the exact play-by-play of the movement cycle, and then built a fully working model for the museum to display next to the original.

He found that he could not open the head to observe the machinery inside without damaging the fragile carved and painted wood, so he had it x-rayed (plate 4). And throughout this scrupulous examination, he searched for signs, cleaning marks, any signal that would give a clue to the automaton's history. He found no such thing. Its history

would have to be gleaned solely through material and design comparison with kindred clockworks. The immediately distinguishing features: the mechanism is made almost entirely of iron (later mechanisms of similar design are brass); and the parts are assembled largely with pins, not screws. These features, together with a particular decorative style of workmanship in the internal mechanism, point to the second half of the sixteenth century, according to Todd, who compares the monk's anatomy with the clocks of this period.

Plate 4. (left) Drawing by W. David Todd: components of the internal mechanism of the monk, 'Mechanism for the eyes and jaw'; National Museum of American History, Smithsonian Institution, Washington, D.C. (right) X-ray of the interior of the monk's head, revealing the mechanism of the eyes, mouth and neck; National Museum of American History, Smithsonian Institution, Washington, D.C.

Todd has helped us to appreciate the complexity of the monk's movements. The performance is initiated with the winding of the mainspring with a key. The internal mechanism propels the figure forward on three hidden wheels, its two feet stepping forth from beneath the cassock. The figure takes 12 steps, travelling a distance of approximately 19 inches, and turns to its right, a bit more than a right angle, to walk in a new direction. Fully wound, the monk will make seven such turns. The head is moving now to the left, now the

right, now straight ahead; the eyes roll right and left independently of the head but they also look towards the cross when it is raised. The mouth is opening and closing as if repeating the *Mea Culpa* or the Hail Mary: either one, for the right arm is beating the breast (slowly: once very four steps) and the left arm is raising and lowering the rosary with its cross. Head, mouth, arms and eyes thus moving, the automaton executes its first turn. Midway along the new path, or once each straight-line leg of its journey, it lifts the cross higher and inclines its head for the admonitory kiss. This last gesture involves a more complex motion of the left arm and shoulder, together with the lowering of the head and an abrupt motion of the mouth. The clockwork that generates all these actions, housed inside the wooden body, is a self-regulating assembly of iron cams and levers approximately the size of your open hand.

Today we know of the existence, around the world, of two other monk-like automata and four lady musicians, all sharing the same basic chassis design and body mechanism and all dated to the second half of the sixteenth century. Of the two monks, one arrived in the Deutsches Museum in Munich in 1985; the other is found in the Iparművészeti Múzeum (Museum of Applied Arts) in Budapest, purchased in 1915 (plate 5).[36] These two figures differ from the Smithsonian monk in appearance and gesture. Instead of the cross and rosary, both automata hold in their hands small bells, shaking them and appearing to make them ring. The actual bell sound comes from a tiny glockenspiel within the body, still functional in the case of the Budapest figure.[37] The Budapest museum lists its figure not as a monk but a saint, for framing the head is a gilded halo, and the body was dressed in ornamented damask robes (the cloth considered an eighteenth-century addition). Moreover, this one is a stationary, not a walking figure. Yet the internal iron clockworks of the three automata are strikingly similar and have been dated accordingly to the mid-century. Head, mouth and eye movements are comparable, and the overall sizes of the three figures are almost exact: 39 cm. in height for the two monks; the saint is 2 cm. taller – perhaps that is his halo? Such similarities could suggest a single maker, or perhaps one figure became a prototype later copied by others. Significant mechanical differences appear in the motions of the arms, and only the Smithsonian monk interrupts what he is doing to bow his head to the cross. Neither the Munich nor the Budapest figure performs

Plate 5. (top left) Automaton, Cister-Spielerin [Lute-Player], Spain (?), middle or second half sixteenth century; Kunsthistorisches Museum, Vienna. (top right) Mechanism, Cister-Spielerin; Kunsthistorisches Museum, Vienna. (above left) Automaton monk, South Germany or Spain, c.1560; Deutsches Museum, Munich. (above right) Music automaton, figure of a male saint, Juanelo Turriano (?); Museum of Applied Arts, Budapest.

the act of prayer. One might point out that the ringing of a bell signals a call to prayer, or marks the sacred moments of the Catholic Mass; yet this is not, strictly speaking, a personal enactment of solitary entreaty or worship, the defining labour of a monk. The very word 'monk' derives from the Greek word *monos*, alone.

Photographs show the carved wooden heads and faces of these two figures to be stylistically different from the one in the Smithsonian and from one another as well. Yet one wonders, could this carving be from the same hand? A serious comparison would require determining, as with any sculpture, whether or not these components had suffered repair or restoration in the centuries since they were made. The Smithsonian monk shows no sign of significant alteration to either body or mechanism, and only the garment, cross and rosary are more recent. The painted face is cracked and peeling, but David Todd has identified the paint as demonstrating full age. On all points, it would be productive to bring these three figures together in one laboratory for a more detailed comparison. That all three have appeared only in the last century, and without documents or provenance, would render a close comparison all the more welcome.

And the much-referenced Vienna lady? The most famous of the several lady musicians, she is displayed in the Kunstkammer of the Kunsthistorisches Museum in Vienna.[38] She too came to light only in this century, in 1934, from a private collection.[39] She is taller than the monk, 44 cm. to his 39; but the iron clockwork dates her to the same period. The mechanism design appears similar in principle, though with major differences in the layout, axes and workmanship of the components. Though no longer able to actually function, she is said to move with small tripping steps, strumming the lute with her right hand, and turning her head from right to left. She can advance in a straight line, or follow the path of a circle.[40] Numerous accounts have linked her to Turriano, and one can trace one author quoting another all the way back to the 1575 text by Ambrosio de Morales, resulting in a kind of momentum of proof by repetition.[41] Like the monk, she is so splendidly made that she deservedly inspires such historical rumours. The Morales passage itself appears in his great opus on the history of the antiquities of Spain, just following his description of the famous astrarium:

> Juanelo as a diversion also wanted to create anew the ancient statues which moved and, on that account, were called automata

by the Greeks. He made a lady more than one *tercia* high who, placed on a table, dances all over it to the sound of a drum which she meanwhile beats herself, and goes round in circles, returning to where she started from. Though it is a toy and fit for mirth, it is nevertheless a great proof of his high intelligence.[42]

A drum rather than a lute... but everything else resoundingly similar.

José A. García-Diego must be credited with beginning the work of comparing all these automata.[43] By the time he had finished the newer English edition of his book in 1986, he had seen at auction the monk later to be acquired by the Deutsches Museum in Munich and he had learned more about the Budapest figure. The chapter, still titled 'Interlude about automata' in the updated book, now discusses all three monk-like figures, as well as the Vienna lady and the several similar musician figures. Gone, to his credit, is the opinion that the date of the Smithsonian automaton be advanced to the eighteenth century. But he now removes ('once and for all') the attribution to Turriano of the Vienna lady, declaring that Ambrosio de Morales is 'not a very trustworthy author on points of detail'. He concludes that *none* of the automata can be the work of Turriano, and we've seen that the newer book drops 'autómatas' from its title. As intrigued as he is by these figures, García-Diego bases his conclusions on an underlying belief that such objects were only 'toys', presumably beneath the genius of Turriano, the dignity of the emperor and the tolerance of the king. (Morales uses the word *juguete* too, but in one translation of his description of Turriano's works, the astrarium is also referred to as an ingenious toy.)[44] A disappointing conclusion, not because of its withdrawal of the automata from Turriano's oeuvre, but because it misses the fact that such objects – biological automata, Silvio Bedini calls them – spring from the same ambitious impulse as the great astrarium itself: the ancient human urge to understand by imitation the works of nature. The mechanical principles of the clock were paradigmatic in Descartes' philosophy of the workings of the living body and mind – are we driven from without or from within? – and the automaton forms an important chapter in the histories of philosophy and physiology and, now, the modern histories of computer science and artificial intelligence.

A Short History of the Relations Between Machines and Divinity (Deus ex Machina)

An automaton is defined as a machine that contains its own principle of motion. Strictly speaking, a clock is an automaton. The notion of an artificial human figure – an 'android' as it has come to be called – derives in part from the tradition of the striking jack in the great medieval town clocks, in which the hour would be sounded by a mechanical figure springing into motion with a hammer and gong. That this employment once fell to a living person, the town watchman,[45] suggests that here were our first labour-saving robots. But the animated figure, or moving sculpture, can be traced back to ancient Egypt. 'At Thebes accordingly, there were statues that spoke and made gestures. The priests made the heads and arms move by devices not as yet clearly explained' we are told by Egyptologist Alexandre Moret,[46] invoking the same combination of mystery, divine intervention, human ingenuity, and mechanics of deception our own monk exhibits. Theatre has always been the partner of religion.

The sixteenth century was a period of tremendous mechanical sophistication: the dawning of the scientific revolution. Clockmaking was to become a profession in its own right, separate from its origin in the blacksmith's art, and its former association with gun- and locksmithing. Precision timekeeping in centuries to come would become crucial to the world shipping trade for its use in determining navigational longitude.[47] But, in its early form, clockmaking was driven less by the problem of measuring time than by the astronomer's efforts to model the locations and motions of 'the fixed and moving stars', that is, to capture the animating principle of the universe.[48]

A significant development – perhaps *the* significant development – from the medieval town clock, driven by enormous systems of weights, was the emergence of the spiral spring combined with the 'fusee'. A fusee is an ingenious device for making the driving force of a spring constant. Once attributed to Leonardo da Vinci, earlier examples of the fusee have now been found. When wound, a mainspring could now deliver a steady application of tension, rather than a stronger and then progressively weaker force as it ran down.[49] An early fusee made of wood is found in the mechanism of the monk.

The other important development in the mechanical arts was the 'cam'. An ancient device attributed to Archimedes, the cam reached broad use in the fifteenth century in the striking trains of clocks. A

cam is simply a barrel or disk of metal rotated by the gear train. Its outer edge is either studded with short pins or cut to a calculated profile and, as it turns, one end of a lever, riding against that uneven edge, is set in motion. Called a 'following-arm,' this lever translates the cam's calculated profile into reciprocating movements that can be highly precise and carefully timed. Such levers operate, for example, the spring-tensioned linkages to the monk's arms, legs, head, eyes. The cam that generates the movements of the monk's mouth is a disk with six low slanted teeth and one sharp spike cut into its edge. The following-arm, linking cam to jaw, thus transmits a regular opening and closing of the mouth, as in speech, punctuated once each revolution by the arrow of a kiss! The cam is thus the memory of the machine, and its profile is the analogue information base for generating the exact movements of a given part.[50]

But even though the spring and fusee consolidated the drive system of a device into a much smaller area, and the cam could store a great deal of information in one component, the early clockmakers did not strive for portability per se. Of the automata that appeared with the rise of clockmaking, most were mechanical elaborations of the striking jack. Or, if they were not connected to a timepiece, they performed in elaborately constructed settings, or on ornate bejewelled pedestals. One of the virtues of the monk, and the few automata like it that have come down to us from the past, is that the animating mechanism is entirely contained in the body of the figure. The automaton moves in *our* world, of its own accord, and not in a miniature world apart, or upon a console we know is full of hidden cams and gears. There is no intermediary prop or set for our imagination, assuring us of the boundaries of what we are about to feel. And of course this is a more difficult technical feat for the clockmaker.

Further still, the monk's motions unfold over time and are compounded, i.e. the automaton continues to do new things from one moment to the next: this would intensify and prolong the duration of its confrontation with a spectator.

For all the lack of any identifying information inside this machine, Todd's drawings of its parts show us the work of a master mechanic with a restrained sense of style. Many components are decoratively chamfered and shaped beyond the necessity of function. The complex design of the monk's left arm, with the elbow moving independently of the shoulder, alone is worth respect, and here it is done with an

elegance only God was meant to see. There are, in fact, two orders of concealment, for the spectator was not meant to observe the act of winding the drive spring. Todd points out a hidden lever to be used secretly by the operator of the automaton: once wound, the machine would only begin moving after the release of this lever. We must envision a scenario, Todd advises us, where a powerful person, or an emissary from that person, is seen to hold the miniature man in his hands, then set it down on the table or floor. Whereupon, very slowly, very deliberately, it would set out on its own.

Part IV: For Whose Sake?

Why was this monk made? My early questions – who operated this small machine and who would have seen it, how would a spectator in the sixteenth century have interpreted its performance – hang on the influence of the legend surrounding it. A dying boy, a holy corpse, the royal promise, the brilliant clockmaker... but we've seen that the story is only a hypothesis, though one with a sure life of its own. The possibility that the monk is a portrait of San Diego de Alcalá, or bears some commemorative relation to the saint, is more within reach. But this too eludes certainty. And if the automaton hardly resembles the contemporary image of the saint (a complaint of José A. García-Diego), then perhaps he resembles San Diego's remains! He is, himself, now no more than a set of remains, with his cracked paint and clouded eye... but like the saint's, an effective set, a working set. Was he made by Juanelo Turriano? It seems that even this must remain a tantalizing conjecture.[51] Whoever made the monk, he certainly wasn't cheering anyone up. The other two male figures seem beneficent by comparison, with bell and glockenspiel. Our monk looks dead set. And if the Smithsonian dating is correct, he is made during the great upheaval of Reformation and Counter-Reformation, where definitions of divinity, authority, heresy, and the line between religion and magic were often matters of life and death.

By comparison, the lady with the lute might very successfully have made an after-dinner appearance at any number of royal occasions, drawing a mixture of amazement and delight. There is a long tradition of later automated figures that played musical instruments and imitated other courtly graces. Perhaps the monk was meant for a single viewer, as suggested by the image of Turriano diverting the

emperor's declining spirits at San Yuste. Maybe he was to appease the Father Superior, though the simulated act of prayer carries some fearful implications.[52] In posing the question of audience, we enter a complex caste system of potential spectators, from educated to merchant to labouring classes of persons, secular and religious contexts, public and private display. Those artfully made hidden levers and cams inside the monk are gestures seen by no one but its maker. One appeal of Father Gieben's theory – that the monk was a votive offering – is that God himself becomes the intended audience. As is the case, ultimately, for the act of prayer the monk mimes. But then one remembers the lever David Todd pointed out, to permit the winding to be done out of sight.

A Monk's Opinion

Father Servus Gieben responded to my letter with miraculous dispatch. Alive and well, the President yet of the Istituto Storico dei Cappuccini in Rome and the Director of its Museo Francescano, he wrote saying 'I certainly will be pleased to read your paper on the "Mechanical Monk" of which I preserve nice photographs and curious memories.'

Born in the Netherlands in 1924, Servus Gieben entered the Capuchin novitiate in 1942 and was ordained in 1949.[53] He completed a PhD at the Università Gregoriana in Rome in 1953, and in the same year was made associate of the Istituto Storico dei Cappuccini, itself founded in Assisi in 1930, and moved to Rome during the Second World War. The Institute's mandate is the pursuit of scholarly research on the history of the Franciscan Order, and in particular its Capuchin Family, formed during the sixteenth-century Counter-Reformation. Father Gieben was President of the Institute from 1970 to 1977, as he is again at present (since 1999). For 25 years, as a specialist in the depiction and iconography in art history of the lives of the saints, he has been responsible for developing the collections now housed in the Institute's Museo Francescano. He is a scholar of medieval theology and has written in depth on the life and works of the thirteenth-century Oxford scholar Robert Grosseteste, contemporary of Saint Francis. Among Father Gieben's published works are numerous editions of primary manuscripts from the history of Franciscan thought. He is fluent in Dutch, German, French, Italian, English and Latin.

How did the Father come to perform his research on the small automaton in 1976? I quote his own words, from his letter to me of 25 September 1999:

> In the summer of 1975 I was approached by the antiquarian Georges Sedlmajer from Geneva, who had a problem. Thinking that his monk represented a Jesuit preacher, he had approached the Jesuits in Rome. But they pointed out to him that his automaton was wearing sandals, which was not a Jesuit but a Franciscan fashion. So they sent him on to our Museo Francescano. His letter was accompanied with good photographs. His question was: who is this monk and what is the meaning of his movements. The intense expression of the face convinced me at once that it must be the portrait of a famous preacher or of a Saint, probably a Spanish one. Iconographic indications (cross and rosary, shaved head) pointed to San Diego, a lay brother, not a priest. But I racked my brains for finding a motive that might have cause to represent San Diego in that way. On the 12th of November arrived the feast of San Diego and reading about his life I struck upon the miracle which caused his process of canonization to be completed. The article in Archivo Ibero-Americano 2 (1914) 424–446 depicted, in my opinion, the right setting for the origin of the automaton as an admonition to the unruly young Carlos... I could not think of anybody else who could have made this automaton unless Juanelo Turriano the Emperor's mechanician. Hence my attribution of the monk to him. There is no tradition of this kind of automata in the Franciscan Order and I would exclude that the monk could have been made for the friars.

An astonishing letter in its entirety, not least for the sharpness of memory, 25 years after the fact. The sartorial forward from the Jesuits to the Franciscans and the Feast Day of San Diego heralding the moment of insight... it's almost too good a story! Father Geiben's conviction that the figure was a portrait of a particular individual, both from likeness and iconography, is significant, given his expertise in the pictorial history of the lives of the saints. Yet why 'probably Spanish?' Had Monsieur Sedlmajer mentioned the Vienna automaton and Turriano in his letter to Father Gieben? I wrote and asked Father Gieben this. He replied, 'Mr. Sedlmajer certainly did not give me the link to the automaton in Vienna. I learned about its existence only from your paper.' His opinion that the monk represented a Spanish

figure was based on the physiognomy of the carved face, he wrote me, a judgement resulting from his search through the Museo Francescano print archives and the match, not just with the person of San Diego, but with the saint's symbols, lay status and gestures. Father Gieben also mentioned in this reply that he had no idea of how his research was to be used, or of its later consequences in identifying the automaton. He later sent me good photographs of the two engravings of San Diego. One is dated between 1595 and 1600; the other, from which the detail was cropped for comparison to the automaton in the Geneva catalogue, is 1614 (both dates slightly later than those indicated in his original letter to M. Sedlmajer).[54]

It is significant that Servus Gieben arrived at his conclusion without an awareness of the attribution to Juanelo Turriano of any similar automaton figures. His opinion comes not from the history of technology, but from the history of theology. That these two separate tracks converge upon so close an explanation of the monk's origin is remarkable.

Father Gieben sent me something else: a photograph of a death mask kept in the Church of Santa Maria La Nova in Naples, identified as being the face of S. Giacomo della Marca, who died in 1475 at the age of 84 (plate 6). The mask, cast in wax, was a private gift to the Church at the end of the nineteenth century. Could this truly be the face of a man of 84, known to have lost all his teeth, Father Gieben wondered? Noticing a remarkable resemblance to images of San Diego, and to the carved face of the automaton, he allowed himself to speculate on the possibility (however remote) that the mask could have been used as the model for the automaton.[55]

Part V: Looking at the Monk Now

The monk is, like all automata, a recording, a kind of artificial memory. What can *he* tell us?

David Todd winds the mainspring and we watch the monk perform on a table in Todd's workshop. While we both agree that this is a serious object, a haunted object, Todd believes his purpose was to intimidate and warn. I believe he instructs by example. Todd thinks the eyes and head move to make confrontational contact with onlookers, 'You! You! And you!' I think the eyes are rolling in the head in trance. Though I have to admit, when he advances in my

Plate 6. (left) Death mask, wax, identified as that of S. Giacomo della Marca, 1391–1475; collection of Convento S. Maria La Nova, Naples. (right) Photograph by W. David Todd; National Museum of American History, Smithsonian Institution, Washington, D.C.

direction – comes at me – it is with such steady and unswerving forward momentum that my animal flight urge stirs. Just when I ruefully smile, he turns away, finished with me. I nervously postulate that the square path of the walk is the invisible cloister around which the monk shuffles in prayer. Todd thinks this is the clockmaker's device to 'keep the fellow from falling off the table and knocking his head(!)' He reminds me that some of the musician automata walk in squares too. The monk moves slowly – unnaturally so. But the fusee keeps his progress steady. (How much does he weigh, I suddenly wonder, this 15-inch tall homunculus? When the play is over, I ask Todd if I may pick up the actor, a bold request to make with so antique a clockwork. Over a cushion, with museum gloves, and absolute concentration, I lift him with both my hands by the torso, like a baby... just for the space of a second. He is heavy! But not in the way of an organic thing, more like a little tank.) Would the measure of the monk's power have come from the sight of a king setting him in motion? But Todd and I agree the power flows in the opposite direction, so that once the tiny man is

seen to move independently, the operator's status takes a leap, *he* becomes a kind of god. Either way there is a mutual transfer of authority and magic. Todd, jesting only a little, likens the possession of the monk to owning the Pentium chip a couple of years ago. Who commands the highest technology possesses the highest power. But who possesses whom, given the nature of the monk's hold on us?

Sigmund Freud's now famous definition of the uncanny: ambiguity about the extent to which something is or is not alive.[56] The notion of a sliding scale is a useful one, marking a greater or lesser degree of doubt. We are biologically driven by this distinction, which we can observe every time a coat rack in our peripheral vision startles us as an unexpected guest. It can be of a very tiny duration, this uncertainty, and still register a measurable shock. Might an unsuspecting viewer long ago have believed it to be alive, this small figure moving on the table? This is not a question with a hard yes or no answer. It is a rolling question.

But perhaps one could ask it differently. To what extent would a viewer's response to the monk be an emotional response and, as such, a response *as if* to a living thing? We are reminded of the puppet's power to enchant us, not only by the illusion of autonomy and agency, but also by the illusion of *personality*. Even if just a crude bit of wood and cloth, a puppet's movement transforms it into something with a psyche. We read intent, but more compellingly, we read its emotional tone and inflection.

A storyteller once said, to secure the immediate attention of children, begin a story with a contradiction. It hypnotizes them. The puppet itself is a contradiction: while one part of our mind carefully observes the techniques of the illusion, another part involuntarily participates in the masque. The monk offers several overt contradictions. 'It' or 'he'? The monk is a *thing* one moment, a *being* the next. Further, he has the shape of a man, and a very individual one at that, with delicate, protruding ears and direction-finding nose – but he's much too small. He moves by himself and, as an animate thing, the gestures of arms and legs and head are familiar, but they are too slow, unnervingly slow. This is what the monk possesses that the Hollywood robot or the wax museum figure lacks: something seriously wrong right away. The paradox is that this holds our attention longer. In fact, the very constraints on the clockmaker, which include things like limits on speed and range of motion to preserve

centre of gravity and stability on three wheels: these very limitations give rise to qualities we interpret on a completely different level. The slowness becomes loaded, as if the figure marshals a kind of extreme concentration. Once we are willing to invest a thing with independent agency, and this is where the starting shock ignites our credulity, our very faculty of rational thought, once ready to detect the deception, suddenly skips a beat and is arguing instead for the quite implausible. The mechanical repetition? But the monk enacts something that is repetitive by mandate, by definition. It is when the monk turns, for here the motion is its most three-dimensional to our eye, that he is most uncanny. As he turns away from us, it is with the most profound disdain. He is not real, and yet we are wanting to believe and believing he is real. Just for the moment, to want is to have. And now it is we who are in the trance.

In her recent book, *Art and Ritual in Golden-Age Spain*, Susan Verdi Webster examines the great Spanish tradition of penitential processions during Holy Week, occasions in which elaborately dressed and decorated wooden figures of patron saints – some even with hidden mechanisms for animating the arms and heads – were carried through the streets, in a commingling of theatre and devotional passion. Among classes of objects remotely connected to the monk, these articulated sculptures – *imágenes de vestir* as they are called – offer productive comparison. Webster describes the powerful emotional responses they drew from onlookers, and of particular interest is the contrast she marks in comparing the figures as they were seen throughout the year in repose in the churches, with their animated appearance in the street during Holy Week.

> The spatial and temporal status of the sculptures in procession significantly enhance their mimetic effects, and their unique kinaesthetic character allows them dramatic entrance into the realm of human experience. They are able to move both physically (through articulated limbs) and spatially (through the streets of the city). Furthermore, the incorporation of sculpture within a processional context acts to change a most fundamental aspect: the sense of time. No longer static, eternal images of altars and *retablos*, their temporal state is extended so that they merge with the spectators' own experience of space and time.[57]

Our emotional engagement with the monk, as he performs in our

own time, bears comparison with Webster's portrayal of this penitential spectacle. The distinction between the moving and the still effigy is crucial in understanding the nature of its claim on our attention, especially in the case of an object that is first or primarily seen to be immobile, and which then begins to move. Such a transformation irrevocably alters essential relations between all parties. The great difference between the *imagen de vestir* and the monk is size: the former is defined always as being carved to human scale. The monk's miniature height, coexisting with the immediacy and purpose of his motion, may be the most disturbing contradiction of all, for the combination of 'small' and 'moving' holds ancient, almost primal anxiety for us. He can play to only so large an audience, but his relation to a spectator is *personal*.

Part VI: Looking at the Monk Then – Some Historical Speculations

The story of Don Carlos gives us a glimpse of sixteenth-century Roman Catholicism, as well as a glimpse of the contemporary relations between religion, politics, magic, and medicine. In the period of the Reformation, the high Catholic Church recoiled both from corruption within its own orders and from the onslaught of the Protestant revolt. The Counter-Reformation, with the founding of the powerful new Jesuit Order, the Council of Trent and the new Inquisition provoked a reinvigoration of Catholic doctrine, tightening strictures against heresy and reinscribing the authority of the sacraments.

This was an age in which physical objects and inanimate things were believed by many to possess supernatural powers. The Mass itself, and the central belief in the transubstantiation of the Host, enacts the penultimate miracle of the quickening of inanimate substance. Keith Thomas, in his 1971 book *Religion and the Decline of Magic*, locates in the power of the Mass 'the magical notion that the mere pronunciation of words in a ritual manner could effect a change in the character of material objects'.[58] Literalism, metaphor and symbol in the liturgy were zealously debated, but always with the Church attempting exclusive jurisdiction over the realm of miracles. Yet the ur-science of alchemy, winding itself through medieval Christianity, was also flourishing in the sixteenth century: Paracelsus wrote his most famous treatises on metallurgy, theosophy,

anatomy, medicine, astronomy, among which the work *De Natura Rerum* ('Of Natural Things') was completed in 1537. This text contains the controversial recipe for making a homunculus, a very different method for generating body and blood from 'material objects'.[59] The intermingling of alchemy and orthodox religion is magnificently laid out in Marguerite Yourcenar's historical novel *The Abyss*.[60] Yourcenar's central character, Zeno, a fictional portrait based on aspects of the life of Paracelsus, pursues knowledge of body and universe under the constant threat of heresy, as he moves from city to city through the Europe of the sixteenth century's second quarter. Indeed, the auto-da-fé – the public burning of heretics at the stake – is seen to be a routinely attended state event in the court life of King Philip II. When we remember that alchemy, for all its long association with forbidden knowledge, is the mother science of modern chemistry, and that Paracelsus was among the first to propose a theory of metabolism against the entrenched 'four humours' view of the body, we understand something of the paradox and complexity of this transformative period in history. (And we wonder what kind of gentler treatment Don Carlos might have received from the great Swiss physician.) The alchemist moreover, sought equally a knowledge of the cosmos and an understanding of the living organism: these truths would be elementally interwoven. The astrarium and the automaton could likewise be seen as linked works in the technological sphere: the search for the *Primum Mobile*.

The monk shares with the alchemist's homunculus his small size, self-animation and intended role as servant. For us, he particularly shares with the homunculus his artificiality as a 'man-made man'[61] capable of performing the most complex and distinctly human transactions, and perhaps possessing some superhuman abilities as well. In literature, the fabrication of the homunculus is always a forbidden act, Part Two of *Faust* being the best-known example.[62] And, likewise, we have some record that automata too roused the disapproval of the Church, as when Turriano gains 'the dangerous fame of a wizard.'

Keith Thomas, quoted above on the magical transformation of the Host, speaks in his book about how such changes could be effected *mechanically*, and the following passage has a peculiar ring to it in the context of the monk [italics mine]:

> For the essential difference between the prayers of a churchman and the spells of a magician was that only the latter claimed to

work *automatically*; a prayer had no certainty of success and would not be granted if God chose not to concede it. A spell, on the other hand, need never go wrong, unless some detail of ritual observance had been omitted or a rival magician had been practising stronger counter-magic. A prayer, in other words, was a form of supplication: a spell was a *mechanical* means of manipulation... In practice, however, this distinction was repeatedly blurred in the popular mind. (p.41)

But Thomas also uses the word 'mechanical' in discussing the Church's assurance of the cumulative power of a repeated prayer: 'Salvation itself could be attained, it seemed, by mechanical means, and the more numerous the prayers the more likely their success.' One could even hire members of the clergy to repeat prayers on one's behalf. (pp.41–42) The rosary, to this day, is an abacus for counting prayer repetitions. The mechanical monk, with his rosary, is thus a doubling of repetitive devices. In this light, his clockwork performance becomes a petition and re-petition to Catholic eternity, a conjunction of two systems of timekeeping.

The monk, an object which has been invisible to all these histories as they have been written, has something to tell us about each. He walks a delicate line between church, theatre, magic, science. He circulates among – murmurs about – all of them. He is a synapse, transmitting a host of simultaneous signals. Here is a machine that prays. Is it a divine machine? Or, man-made, a miracle in its own right? Or again, as a votive offering, a machine made if not for God alone, then one meant to *appear* to be made for God alone? Certainly the same beliefs that animated the corpse of a friar with the power to heal could likewise animate a miniature man seen to be performing the authorized and orthodox gestures of the faith.

What did a person see and believe who witnessed the monk in motion in 1560? We, who see him today in a glass case at a museum, must imagine him less securely confined and named. I think, finally, that it is the touching of the two wires – religion and magic – that might generate an unstable definition of aliveness and spark a response of shock in a viewer to a miniature man who is moving, who is coming in your direction.

Judging the quick from the dead: all three bodies we have examined in this story are ambiguous. Unconscious Don Carlos with his suppurating head wound, hovering near death; Brother Diego's life-

giving corpse, 'still sweet to the nostrils'; and an automaton whose own head, x-rayed, shows us an image of the machine in the ghost. In each case, we can roughly compare a sixteenth-century with a twentieth-century definition of aliveness, discovering our own uncertainties in the balance. What is living stuff made of? All the players here are busy with ideas about the hidden matter within the *corpus*.

> And if the automaton hardly resembles the contemporary image of the saint, then perhaps he resembles San Diego's remains. He is, himself, now no more than a set of remains, with his cracked paint and clouded eye... but like the saint's, an effective set, a working set.

Epilogue

Now, just a few threads to tie up.

What *was* Don Carlos doing on those little-used stairs? He was certainly not on his way to a clandestine rendezvous with his father's new wife, the young Elizabeth of Valois, who was Don Carlos' same age. Nor was he preparing to depart for the Netherlands to lead an insurrection against the Spanish Crown. These are Verdi's conceits, and Schiller's before him, and before Schiller the seventeenth-century French writer César Vischard de Saint-Réal, and yet other legends before that.[63] In fact, according to William H. Prescott, Don Carlos was sneaking down to a tryst with the daughter of the garden porter.[64] And King Philip's well-documented grief over the fall: how do we reconcile it with his arrest of his own son six years after the miracle, for which he was in the midst of efforts to win sainthood for Friar Diego? Only now are we beginning to extricate truth from myth concerning the death of Don Carlos.

In 1980, the Smithsonian changed the name of its National Museum of History and Technology. It was to be called the National Museum of American History. And some changes started to take place, subtle ones at first, but in recent years shifts in institutional priority have alarmed many historians and scholars. For one thing, the monk, as of December 1997, is now removed from view. The old instrument and timekeeping displays have been redesigned with a new theme in mind: the meaning of time to Americans and its influence on American life. But it isn't just politics as usual: not only is the monk un-

American, he slips through all kinds of identification parameters. He isn't a clock, he isn't a computer, he isn't a sculpture, he isn't an icon, he isn't a plaything: he doesn't fit anywhere! We still don't know how to look at him. And he troubles us.

Notes

An early version of this essay was published in the debut issue of *Blackbird: An Online Journal of Literature and the Arts*, Spring 2002, www.blackbird.vcu.edu.

1. Carlos Fuentes, 'Velázquez, Plato's Cave and Bette Davis', *New York Times*, 15 March 1987.
2. 'I will praise thee; for I am fearfully and wonderfully made', Psalm 139, Verse 14. My phrase 'in a complicated and urgent way' is borrowed from Michael Baxandall, *The Limewood Sculptors of Renaissance Germany* (New Haven: Yale University Press, 1980), p.153.
3. Federico García Lorca, 'Play and Theory of the Duende', in *Deep Song and Other Prose*, ed. and trans. Christopher Maurer (New York: New Directions, 1980).
4. I first saw the monk in 1989, when Christopher Furman, then a student in my advanced sculpture class at Virginia Commonwealth University, arranged a trip to the Smithsonian to see it and meet David Todd.
5. William H. Prescott, *History of the Reign of Philip the Second, King of Spain*, ed. John Foster Kirk, 3 vols (Philadelphia: J.B. Lippincott, 1874). It is interesting to compare this publishing date with the first performance of Verdi's opera in Paris in 1867.
6. Prescott, vol. II, pp.467–8. *Erysipelas*, also called St. Anthony's fire, was a spreading inflammation of the skin, now understood to be caused by a streptococcus.
7. Henry Kamen, *Philip of Spain* (New Haven: Yale University Press, 1997), pp.91–2.
8. L.J. Andrew Villalon, 'Putting Don Carlos Together Again: Treatment of a Head Injury in Sixteenth-Century Spain', in *Sixteenth Century Journal*, 26.2 (1995), pp.347–65.
9. *Ibid.*, pp.357–8.
10. *Ibid.*, p.354.
11. *Ibid.*, pp.361–2.
12. José A. García-Diego, *Los relojes y autómatas de Juanelo Turriano* (Madrid: Albatros Ediciones, 1982), pp.LV–LX, figs 6.3–6.9. The photographs I reproduce here – my own plates 1 and 5 – although they are closely similar, are not taken from García-Diego, but instead come directly from the respective museum archives.

13. *Ibid.*, p.104. I thank Adam Meuse and Carlena Kirkpatrick for translating this and the following quotes from García-Diego's book.
14. Klaus Maurice, Otto Mayr (eds), *The Clockwork Universe: German Clocks and Automata 1550–1650* (New York: Neale Watson Academic Publications, 1980), p.170.
15. The Fundación, according to its recent website, preserves García-Diego's library, publishes papers on the history of engineering, produces facsimile editions of historical scientific manuscripts, and promotes the protection and reconstruction of historical engineering works as cultural monuments. The website address is http://filemon.mecanica.upm.es/juanelo/principali.htm.
16. José A. García-Diego, *Juanelo Turriano, Charles V's Clockmaker, The Man and His Legend*, trans. Charles David Ley (Sussex: Antiquarian Horological Society; Madrid: Editorial Castalia, 1986).
17. *Très importante collection...*, pp.85–6. All translations from the French my own.
18. My sketch of Brother Diego's life, drawn initially from the *Bibliotheca Sanctorum*, vol. IV (Rome: Città Nuova Editrice, 1995), pp.605–9, has been deeply informed by Professor Villalon's works: 'San Diego de Alcalá and the Politics of Saint-Making in Counter-Reformation Europe', *Catholic Historical Review*, LXXXIII.4 (October 1997), pp.691–715; 'Conflicting Views on Sainthood and the Canonization of Diego de Alcalá: A Working Paper', presented at the Sixteenth Century Studies Conference in Toronto, Canada in October 1998 and available on Villalon's website, Wire Paladin, http://www.geocities.com/Athens/Parthenon/9507; and 'The Miracle Book of San Diego de Alcalá, or, The Fifteenth Century Failure to Canonize the First Counter-Reformation Saint', forthcoming from *Mediterranean Studies*. See also Thomas E. Case, *La historia de San Diego de Alcalá. Su vida, su canonización y su legado* [bilingual edition in Spanish and English], (Alcalá de Henares: Universidad de Alcalá, 1998).
19. Villalon, 'The Miracle Book...'
20. Villalon, 'Putting Don Carlos Together Again...', pp.361–2.
21. *Ibid.*, p.362.
22. Among the recognized historians whose works have included accounts of Turriano are Sir William Stirling-Maxwell, *The Cloister Life of the Emperor Charles V*, 4th ed. (London: John C. Nimmo, 1891); Ernst von Bassermann-Jordan, *Alte Uhren und Ihre Meister* ['Old Clocks and Their Masters'], (Leipzig: Verlag Wilhelm Diebener G.M.B.H., 1926); Enrico Morpurgo, *Dizionario degli orologiai italiani (1300–1880)* (Rome: Edizioni 'La Clessidra', 1950); Ernest L. Edwardes, *Weight-Driven Chamber Clocks of the Middle Ages and Renaissance*

(Altrincham: John Sherratt and Son, 1965); Hans von Bertele and Erwin Neumann, *Die Kaisermonument-Uhr, Monographie einer historisch bedeutungsvollen Figurenuhr aus der Spätzeit Kaiser Karls V (1500-1588)* ['Monograph of a Historically Significant Figure Clock from the Time of Emperor Charles V...'], (Lucerne: Buchdruckerei Keller & Co. AG, 1965); and Silvio A. Bedini, who is cited below.

23. Silvio A. Bedini and Francis R. Maddison, *Mechanical Universe: The Astrarium of Giovanni De' Dondi* (Philadelphia: The American Philosophical Society, 1966), pp.56-8; and Silvio A. Bedini, 'The Role of Automata in the History of Technology', in *Technology and Culture*, 5 (1964), p.32.
24. Bedini and Maddison, p.37. Girolamo Cardano, *De subtilitate...* (Lyons: 1554), pp.611-12.
25. Bedini and Maddison, p.38, note 120.
26. Ambrosio de Morales, *Las antigüedades de las ciudades de España* (Madrid: 1575), pp.91-3; quoted by Bedini and Maddison, p.40.
27. García-Diego, *Juanelo Turriano*, p.65.
28. Bedini and Maddison, p.57.
29. Famianus Strada, *De Bello Belgico... ab excessu Caroli V imp.... ad an. MDXC* ['Concerning the Belgian War... from the abdication of the Emperor Charles V... to the year 1590'], 2 vols (Rome: 632-47).
30. Stirling-Maxwell, p.180.
31. Famianus Strada, *De Bello Belgico: The History of the Low-Countrey Warres*, trans. Sir Robert Stapylton (London: Humphrey Mosely, 1650), Book 1, p.7.
32. García-Diego, *Los relojes y autómatas*, p.108.
33. Stirling-Maxwell, p.444. Comparison here with the Jewish Golem is irresistible.
34. Morales, p.93, quoted by García-Diego, *Los relojes y autómatas*, pp.99-100.
35. Bedini and Maddison, p.57.
36. The information on the Munich monk comes from Peter Frieß, 'Restaurierung einer Automatenfigur', in *Alte Uhren und moderne Zeitmessung*, 4 (August 1988), pp.40-50. For the Budapest figure, I thank curator Ágnes Prékopa, formerly of the Museum of Applied Arts in Budapest, for providing me with information via private correspondence. A detailed account of the restoration of this figure, published by the two conservators who performed the work, is: Katalin Soós and Jenö Rácz, 'Eine Automatenfigur in Budapest', in *Zeitschrift für Kunsttechnologie und Konservierung*, 4 (1990), pp.207-14.
37. One can even hear a recording of it over the internet from the *Phonogrammarchiv* of the Austrian Academy of Sciences: http://www.kfs.oeaw.ac.at/DLI/mech/turriano.htm.

38. The three other ladies are: an extensively reconstructed lute player, smaller in height (34 cm.), whose iron clockwork is dated to 1550, in the Conservatoire National des Arts et Métiers, Paris; another smaller lute player in the Smithsonian Institution whose clockwork is of brass, this one dated to 1600; and the clockwork only (also brass and also dated 1600) of a lute player in the Bavarian National Museum in Munich, which has been given a head, arms, etc. in the last century. Note the dates of the last two: because of their brass works they must be considered to be later technology, for the metallurgical development of the brass alloy as a non-corrosive, very machinable preference to iron was only then becoming affordable.

39. She is described in 1926 by Ernst von Bassermann-Jordan, *Alte Uhren*, pp.66–9, and in Alfred Chapuis and Edouard Gélis, *Le Monde des Automates*, 2 vols (Paris: 1928; reprinted Geneva: Editions Slatkine, 1984), pp.215–17. My thanks to Dr. Rudolf Distelberger of the Kunsthistorisches Museum in Vienna, for correspondence about this automaton. She may be seen on the Museum's website: http://www.khm.at.

40. The choice of a linear or circular movement path is mentioned in Chapuis and Gélis, vol. 2, p.215.

41. A partial list: 1988 Peter Frieß, p.42; 1982 García-Diego, *Los relojes y autómatas*, pp.99–100; 1966 Bedini and Maddison, p.57; 1965 Edwardes, pp.99–100; 1926 Bassermann-Jordan, p.68; 1891 Stirling-Maxwell, pp.179–80.

42. Morales, p.93; translated from the old Spanish and quoted by García-Diego, *Los relojes y autómatas*, pp.99–100. This English translation in turn, from García-Diego, *Juanelo Turriano, Charles V's Clockmaker*, p.101. A *tercia*, about 11 inches, is one-third of a *vara*, or rod, a Spanish linear measure of 84 cm.

43. For a more recent comparison, see Adelheid von Herz, 'Androiden des 16. Jahrhunderts', Universität Hamburg, unpublished MA thesis, 1990.

44. Edwardes, p.99.

45. Bedini, 'The Role of Automata...', pp.29–30, note 15. See also Edwardes, pp.1–69; and Daniel J. Boorstin, *The Discoverers* (New York: Random House, 1983), pp.26–53.

46. Alexandre Moret, 'Les statues d'Égypte', in *Revue de Paris* (May 1914), pp.130 et seq.; as quoted in Alfred Chapuis, Edmond Droz, *Automata: A Historical and Technological Study* (Neuchâtel: Editions du Griffon, 1958), p.15. This book, together with the original two-volume edition in French by Alfred Chapuis and Edouard Gélis, *Le Monde des Automates* (see above note 39), constitute the most comprehensive

history in print of the automaton in all its myriad forms. To my mind, the finest short history of the automaton is the above noted work by Silvio Bedini, 'The Role of Automata in the History of Technology'. A recent volume by Horst Bredekamp, *The Lure of Antiquity and the Cult of the Machine*, trans. Allison Brown (Princeton: Markus Wiener, 1995), initiates a welcome and broad multi-disciplinary interpretation of the automaton in the European *Kunstkammer* tradition.

47. A story made popular in the book *Longitude* by Dava Sobel (New York: Walker, 1995).

48. Bedini, 'The Mechanical Clock and the Scientific Revolution', in Maurice, Mayr (eds), *The Clockwork Universe*, pp.19–26.

49. Peter Honig, 'History and Mathematical Analysis of the Fusee', in Maurice, Mayr (eds), *The Clockwork Universe*, p.114:

 The solution was developed in the form of the combination of a cord or chain... with a sort of cone called a fusee. Qualitatively it works in the following manner. When the clock is unwound, the chain or cord is wrapped on the outside of the mainspring barrel with one end of the cord anchored in a slot in its side; the other end is anchored in the fusee. As the timepiece is wound, the chain becomes wrapped along the spiral grooves of the fusee as it is unwrapped from the spring barrel. While this is happening, the tension in the chain increases as a result of the growth in spring force. Since the fusee is the first member of the gear train, the torque or twist which it develops must be constant if timing is to be accurate. As the tension in the chain increases, the radius of the fusee where the chain makes contact decreases to compensate theoretically for force changes. A lot of force acting on a small radius is equivalent to a little force on a large radius. That is why the fusee possesses its unusual shape.

50. For an interesting discussion of the cam as an ur-computer memory, see James M. Williams, 'Antique Mechanical Computers, Part 1: Early Automata', in *BYTE Publications, Inc.*, 3.7 (July 1978).

51. The possibility that the monk was made not on the occasion of Don Carlos' recovery, but instead to mark the 1588 canonization of the friar who cured him, deserves consideration. Turriano died in 1585. Moreover, south Germany must continue to be considered a potential alternative to Spain for the manufacture of any of the automata mentioned here. Augsburg and Nuremberg were important centres of clockmaking development in the sixteenth century. Traffic between the lands of the Austrian Habsburgs and the Spanish holdings at the time of Philip II – all earlier united under Charles V – was steady enough that it may even be that the monk was made in Spain *and*

Germany, or otherwise commissioned in Spain and constructed in Germany.

52. An outstanding recent essay, on the imitation of the sincerity of prayer in both Church and Theatre in the sixteenth century, is by Ramie Targoff, 'The Performance of Prayer: Sincerity and Theatricality in Early Modern England', in *Representations*, 60 (Fall 1997), pp.49–69.

53. The biographical sketch in this paragraph is based on information published in Vincenzo Criscuolo (ed.), *Quarant'anni di servizio nell'Istituto Storico dei Cappuccini (1953–1993): Isidoro da Villapadierna, Mariano D'Alatri, e Servus Gieben* (Rome: Istituto Storico dei Cappuccini, 1993), pp.69–84. The website for the Istituto Storico dei Cappuccini in Rome is http://istcap.org/home/htm.

54. Quotes here are taken from correspondence with Father Gieben between July 1999 and January 2002.

55. The photograph is reproduced in Daniele Capone, *Iconografia di S. Giacomo della Marca nell'ambiente napoletano lungo i secoli* (Naples: S. Francesco al Vomero, 1976), p.39. San Diego's age at death was approximately 63.

56. In fact, this definition was first formed by Ernst Jentsch in 'Zur Psychologie des Unheimlichen', in *Psychiatrisch-Neurologische Wochenschrift*, 22 (1906), p.197. See Robert Plank, 'The Golem and the Robot', in *Literature and Psychology*, XV.1 (Winter 1965), p.25. The Freud essay is 'The "Uncanny"', in *On Creativity and the Unconscious*, ed. Benjamin Nelson (New York: Harper, 1958), pp.122–161, see p.132.

57. Susan Verdi Webster, *Art and Ritual in Golden-Age Spain* (Princeton: Princeton University Press, 1998), p.167. I thank Fredrika H. Jacobs for pointing me towards this book.

58. Keith Thomas, *Religion and the Decline of Magic* (New York: Scribner's, 1971), p.33.

59. Paracelsus' recipe can be found in Arthur Edward Waite, *The Hermetic and Alchemical Writings of Aureolus Philippus Theophrastus Bombast, of Hohenheim, Called Paracelsus The Great* (London: James Elliott, 1894), p.124. I first encountered the recipe in John Cohen's book *Human Robots in Myth and Science* (London: George Allen and Unwin, 1966). There has been debate about whether the specific work, *De Natura Rerum*, is authentic to Paracelsus. Its attribution is discussed in William Newman's recent excellent essay 'The Homunculus and His Forebears: Wonders of Art and Nature', in Anthony Grafton and Nancy Siraisi (eds), *Natural Particulars: Nature and the Disciplines in Renaissance Europe* (Cambridge: MIT Press, 1999). The recipe reads:
 Let the semen of a man putrify by itself in a sealed curcurbite (gourd

glass) with the highest putrefaction of the venter equinus (horse dung) for forty days, or until it begins at last to live, move, and be agitated, which can easily be seen. After this time it will be in some degree like a human being, but nevertheless, transparent and without body. If now, after this, it be every day nourished and fed cautiously and prudently with the arcanum of human blood, and kept for forty weeks in the perpetual and equal heat of a venter equinus, it becomes, thenceforth a true and living infant, having all the members of a child that is born from a woman, but much smaller. This we call a homunculus; and it should be afterwards educated with the greatest care and zeal, until it grows and begins to display intelligence. Now, this is one of the greatest secrets which God has revealed to mortal and fallible man.

60. Marguerite Yourcenar, *The Abyss*, trans. Grace Frick and the author (New York: Farrar, Straus and Giroux, 1976).
61. Cohen, Chapter 3, 'A Man-made Man', pp.36–49.
62. Plank, 'The Golem and the Robot'. This essay elegantly articulates the links between the alchemy, folklore, and technology of artificial beings. See pp.17–19 for his discussion of Goethe's homunculus. For a synopsis of the *Faust* homunculus scene itself, see Walter Kaufmann, *Goethe's Faust* (New York: Anchor Books Edition, Doubleday, 1963), pp.35–37.
63. Villalon, 'Putting Don Carlos Together Again...', pp.348–9.
64. Prescott, p.437, note 16.

Acknowledgements

I am indebted to W. David Todd, Conservator of Timekeeping at the Smithsonian Institution, for his input at every stage of this story, in many ways his story. I began this work while a Fellow at the Bunting Institute at Harvard University in 1997, where I had the help of two capable research assistants: Harvard students Syau-Jyun Liang and Bulbul Tiwari. The following year, Virginia Commonwealth University student Adam Meuse worked for me, and it was Adam who found the article 'Putting Don Carlos Together Again: Treatment of a Head Injury in Sixteenth-Century Spain' by L.J. Andrew Villalon. German translation and help in understanding German sources was provided by Susanne Böer. Mary Flinn, writer and editor, articulated for me the notion of a link between two kinds of time: Catholicism's perpetuity, and technology's clockworks. The historian Jane Kamensky, whom I met at the Bunting Institute, closely read an early draft and helped me detect the assumptions behind my own twentieth-century definition of prayer, directing me to Keith Thomas' book *Religion and the Decline of Magic*. Fredrika H. Jacobs, art historian at VCU, offered crucial

suggestions about the interrelationship of Church and theatre. L.J. Andrew Villalon, whose work on Don Carlos and San Diego is central to this essay, read my final drafts, and gave essential criticism. I am grateful to historian Alex Keller at the University of Leicester for his view of aspects of the work of Juanelo Turriano. I must thank Teresita Fernandez for helping me find Father Servus Gieben. My suspense on sending Father Gieben this manuscript was met with impeccable scholarly generosity. His theory about the monk is as astonishing a thing as the monk itself. My own father, physicist John S. King, helped me create a sense of structure in this (as he calls it) dendritic tale. For Evelyn Lincoln, as ever, my daily gratitude. As I completed the manuscript, I felt I finally knew enough to telephone the distinguished historian Dr. Silvio Bedini, now retired from the Smithsonian Institution, to ask him if he still believes the lute playing lady in Vienna is the only automaton that may have come from Turriano's hands. 'No,' he said, 'I think there's a chance the monk is made by Turriano.'

the research methods of an artist-ethnographer on the congo coast of panama

arturo lindsay

> *Anthropologists and artists can show us the importance of shifting views and embracing multiple perceptions. And it is anthropologists and artists that can hold up a mirror so that we can see oppressive acts within ourselves... Artists and anthropologists: kindred souls that we are, we can also show the world the dangers of ethnocentrism, of provincialism, of isolationism – indeed all of the isms that shackle us.*
>
> Johnnetta B. Cole, 1994[1]

As an emerging artist during the 1970s, I was in search of a path that would lead me to making meaningful art. I had become disenchanted with the art I was seeing in the major museums and prestigious galleries in New York City. Essentially, I wanted to make art that would serve as a catalyst to bring about positive social change. I found that path when I met anthropologist Johnnetta B. Cole who taught me how to look at contemporary art through the lens of an ethnographer. This ability has not only shaped the way I make art today, but afforded me an opportunity to serve as a social change agent on the Congo Coast of Panama.[2]

During the 1960s and 1970s, while the United States was grappling with critical issues of social change, modern art had lost its avant-garde edge. The term avant-garde originates in the mid-nineteenth-century French military: 'to refer to a unit of a regiment whose respons-

ibilities included advancing ahead of a regiment to encounter the enemy, for reconnaissance, and the exploration of uncharted terrain... The uncertainty and challenge of their tasks required new, innovative and nontraditional methods'. Renato Poggioli defines the term avant-garde at the beginning of modernism as 'not only the idea of the interdependence of art and society, but also the doctrine of art as an instrument for social action and reform, a means of revolutionary propaganda and agitation'.[3] At the beginning of the twentieth century, modernists were not only interested in an aesthetic revolution, they also sought social change. But by mid-century, a new generation of artists had shifted away from venturing into 'uncharted terrain' for 'social action and reform', to merely searching for new forms to challenge the prevailing Western aesthetic canons. Modern art had become elitist, egocentric and self-serving, with late modernists creating art that was based on self-referential inquiry.[4] The adage 'art for art's sake' became the criterion that governed their work. Modern art was no longer avant-garde, as the efforts of formalist critics and theoreticians like Clement Greenberg, to make abstract and non-objective art 'as acceptable as the art of the old masters' were successful. By becoming acceptable to the power elite, late modernism had become part of the 'Establishment'; however, the price of 'success' meant turning a blind eye to the events unfolding on the streets. For late modernism, 'prestigious' museums became mausoleums.

Avant-garde artists a generation later, many of whom spent their formative years during the turbulent 1960s and 1970s, chose a different path. Rather than venturing into uncharted terrain, politically committed artists from marginalized communities chose to explore familiar territory in search of sources through which to depict themselves and their communities more accurately. In so doing, they challenged the prevailing evils of racism, ethnocentrism, sexism and homophobia. Artists who shared the political sentiments of the Black Panther Party, Student Non-Violent Coordinating Committee (SNCC), Students for a Democratic Society (SDS), and the Young Lords Party chose a leftist path following Lenin's axiom 'Art belongs to the people'. In Chicago, AFRICOBRA, an Afro-North American group of artists, was established to create a new Afro-centric aesthetic reflective of the values of their community. The Mexican muralist movement earlier in the century and the Cuban poster art movement of the 1960s influenced the development of community art workshops in ghettos

and barrios throughout the United States that later produced black and Latino 'revolutionary art.' Additionally, the growing Feminist movement became attractive to many women artists who wanted to address socio-political issues related to women in their art. Groups such as the Guerrilla Girls began to challenge the sexist and racist exclusionary practices of mainstream museums and galleries. In 1971, Judy Chicago and Miriam Shapiro established the Feminist Art Program at the California Institute of the Arts (Cal Arts) with the express purpose of training young women artists. The art of this period, therefore, became self-reflective, i.e. reflective of the reality of the general populace. I found this practice of producing self-reflective art appealing.

During this period ethnic minority communities in the United States turned to their artists for assistance in redefining their identities away from negative stereotypes. As a result, the role of the artists in these communities became crucial in building positive self-empowered images. However, the education and training of these artists at predominantly Euro-American institutions with art teachers grounded in late modernist self-referential art and aesthetics was insufficient. While their teachers were interested in abstraction and non-objective art, ethnic minority art students were interested in content-based art with a narrative that reflected the concerns of their communities. As a result, most ethnic minority art students chose sociology, anthropology and political science courses to learn more about themselves and the critical issues affecting their communities. For Latino artists of African descent, the task often meant exploring several communities in the United States and in their native countries. In cases where Latin American or Caribbean courses were not offered, these students became self-taught native sociologists and/or anthropologists initiating their own ethnographic research projects. Such was the case with me.

I was born in the seaport city of Colon on the Caribbean coast of the Republic of Panama during the post-Second World War baby boom era. Along with my parents, I immigrated to the United States in 1959 and settled in black and Latino communities in Brooklyn. During the late 1960s and early 1970s, the philosophical underpinnings and goals of self-determination of the Civil Rights and the Feminist movements, coupled with the self-destructive nature of the war in Viet Nam, the race riots in the United States and the covert 'military operations' in Latin America and Africa, made an indelible impression on me. I

became committed to raising my voice in protest against oppression and working towards bringing about positive social change. I decided to commit myself to fighting not only those cases where I was a member of the group being oppressed, but also when I was an oppressor. This required a great deal of self-examination and confrontation, and the purging of my own ethnocentric, sexist and homophobic tendencies.

Given the deplorable conditions of race relations in the United States, I decided to focus my energy on the causes of peoples of African descent. Like many other Latino and Caribbean art students of that era it became vital to my psychological survival, if not my physical existence, to begin unravelling ontological questions surrounding issues of race and ethnicity in the United States. As a result, I began studying history for the 'official' story, then with the assistance of Johnnetta B. Cole, turned to ethnography for the stories of the people woven in the poetry of oral history and performed traditions. My intellectual development led to my becoming engaged in the post-modern discourses around identity, pluralism, and self-representation. As a young artist during the 1970s and 1980s, the 'familiar terrain' I chose to venture into was the African diaspora.

In order to conduct epistemological investigations in the vast topography of knowledge in the African diaspora, it became essential for me to delimit my study and develop a reliable method of investigation. To this end, I developed a hybrid experimental research method that I have used over the last decade in Latino, African-American and Caribbean communities in the United States, as well as in Central America and the Caribbean. For the purpose of this paper, I will focus on the work I am presently doing on the Congo Coast of the Republic of Panama. This investigation, which began seven years ago primarily as a scholarly and aesthetic inquiry, was prompted by an encounter with a Congo some four decades earlier and has now become a transformative catalyst in my life and my art. My first visit to the Congo Coast was in February 1993 during carnival. Adolfo, my godfather, and my Tía Soñia accompanied me from the city of Colon to the hamlet of Cuango. Literally, we travelled as far as the road would take us on the Costa Arriba – the northern coast of the Province of Colon where Congo traditions are practised. While I enjoyed my visits to the many small villages, I really connected with the Congos of Portobelo. Portobelo today reminds me a great deal of the Colon of my childhood memories.

History, Culture and Customs of the Congos

The Congos mainly inhabit the northern coast of the Isthmus of Panama and are the proud cultural inheritors and, in some cases, the actual descendants of the *cimarrones* – Africans who escaped slavery by fleeing to the mountains and rainforests. Once free, the cimarrones established *palenques* – fortified villages, which they defended and from which they set out on raiding parties to attack the Spaniards in their cities and towns, as well as their caravans that traversed the isthmus.

During the colonial period, the term Congo was used more as a generic term for African than a definitive term referring to a specific ethnic or cultural group. Africans from almost every region of the continent from which people were abducted passed through Panama on their way to forced labour in the gold and silver mines of Peru and other parts of the 'New' World. According to Roberto de la Guardia G. and Jorge Kam Ríos in *Los Habitantes del Istmo de Panama*, captured Africans from the following cultures and countries arrived in Panama during the colonial period: Vaí, Monrovia (Liberia); Mina, Bañon (Guinea); Arará, Ewe, Fon (Benin); Congo, Cuango (Zaire); Mozambique (Mozambique); Mandinga, Jolofo, Berbesí (Senegal); Lucumí, Yoruba, Carabalí, Biafra (Nigeria); Angola (Angola); Balunta (Portuguese Guinea); Fula (Sudan); Gana (Ghana); Bula, Capi, Yolongó, Bram (Sierra Leone); Terranova (Santo Tomé); Soso (French Guinea); and Cancan, Popo, Cremoní, Casanga, Gago, and Chalá.[5] It is believed by some in Panama, however, that the majority of Africans who settled in Panama may have come from the region of the Congo and Guinea in Africa. For the most part, however, the cimarrones were culturally mixed, descended from Africans from various parts of the continent who intermarried. Additionally, they married other blacks and mulattos born in the Americas, as well as indigenous people. While the *lingua franca* was Spanish, both enslaved Africans and the cimarrones employed a jargon consisting of double meaning and reversals. This language served to confound the Spaniards yet assisted the cimarrones and enslaved Africans in organizing acts of subterfuge. This intricate system of communication made it possible for them to develop and manage an elaborate system of espionage, in order to plan escapes and coordinate raids. Very often the cimarrones, adhering to the adage 'my enemy's enemy is my friend' collaborated with the pirates in wars

against the Spaniards. After several defeats, the Spaniards were forced to sign truces with the cimarrones recognizing their freedom and sovereignty over parts of the country. Having attained their goals, the cimarrones attempted to live normal lives and raise families in their palenques. The result of these acts of subterfuge is that Congo history, culture and customs are layered with idiosyncratic symbolism, paradigms, tropes and metaphors.

Oral historians on the coast differ in their accounts of the origins of Congo traditions however, and at least two popular versions seem credible and can be substantiated by recorded data. The first theory links the present day Congo celebrations to those held by the cimarrones commemorating their freedom won in the wars against the Spaniards. According to ethnomusicologist Ronald Smith:

> [Panama] city, after being founded in 1673, saw mock battles between youths who would dress like pirates and proceed to 'sack' the city during carnival celebrations. In the historical literature of Panama there are references which deal with the collaboration between cimarrones and the English pirates who preyed upon the Spanish gold fleets which sailed from Portobelo which is near the cimmarón stronghold known as Palenque.[6]

These youths, probably of African descent, were simply using the altered state of carnival in order to pay homage to the heroism of their parents and grandparents.

A second theory suggests its origins are in the festive dancing and singing performances of enslaved Africans who assumed the role of court jesters, wearing European clothing backwards to entertain the Spaniards during carnival. Unbeknownst to the Spaniards, these Africans were mocking them, their customs and lifestyle. According to oral history, the enslaved Africans wore the clothing of the Spaniards backwards as a way to ridicule them without their knowledge.[7] While Congo traditions may have many points of origin, newspaper accounts suggest that by the nineteenth century they were an integral part of the carnival in Panama.[8] The difficulty in dating the beginning of Congo traditions is due in part to an absence of histories of the cimarrones, who, for some time, were thought to be a shameful and marginal segment of Panamanian society. Additionally, many valuable documents have been lost in the numerous raids on Panama City and Portobelo by pirates, the

humid climatic conditions of the isthmus and fires in public buildings over the last four centuries.

Congo customs today are a 'living art tradition', reaffirming the identity of a poor but proud people and bringing to life their oral history. Congo traditions consist of an informal social structure, unscripted traditional performances with mythological personages, buffoonery, a language, music, dance, the culinary arts and material culture. These traditions, however, are only practised during carnival season or on special occasions. Except for those instances, Congos are not a separate or distinct cultural group in Panama today.

Social Organization

The Congos are a tightly knit, queen-centric society. Although the queen is elected, she is unquestionably the sovereign ruler of the group and is responsible for resolving all disputes among the Congos and acts as the intermediary between the Congos, the police and the general public. During Congo season, queens extend invitations to other Congo groups in neighbouring towns and villages to visit her. These visits, which can last from a few hours to a few days, are centred on eating a communal meal that is prepared according to Congo tradition and serves as an important opportunity for Congo bonding regionally. While queens enjoy a great deal of power, they can be voted out and replaced by a new queen if they become corrupt.

The Congos are not an exclusionary group, they do not have a royal family, an autonomous political system, a distinct religion, rites of passage or secrets to be learned and protected. Virtually anyone in the village can become a Congo by simply donning a Congo costume and adhering to some simple rules of conduct. The term *vestir de Congo* – dress like a Congo – is used to describe an ontological transmutation of being from 'self' into Congo. By dressing and acting like a Congo, one becomes a Congo. Their social structure resembles that of a mutual aide society that binds friends, members of a family and a community together with the express interest of preserving their history, values, and customs while entertaining themselves and the general public.[9]

The three most important characters in Congo society are the queen, who is named *María Merced*, the king, named *Juan de Dioso*, and *Pajarito* – little bird, who carries a whistle. These are the only characters that wear crowns. Other characters who are part of the

activities include: *las meninas* – maids of honour; *el Diablo Mayor* – the major devil; *el Diablo Segundo* – the devil who is second in command; *los diablos* – the devils; *el Arcángel* – the archangel; *los ángeles* – the seven angels; *la cantalante o revellín* – the principal singer; *el coro* – the chorus; *los tamboleros* – the drummers; *Mama Guarda* – the maternal guardian; *el sacerdote* or *cura* – the priest; and the Congos.[10]

Unscripted Traditional Performances

Beginning on 20 January, the feast day of Saint Sebastian, with the raising of the Congo flag over the *palacio*, and ending on Ash Wednesday with the *bautizo de los diablos* – the baptism of the devils – material reality is suspended in favour of mytho-reality. During this period, belief in the order of the material world is bracketed as spirit beings and ancestors take human form and rule the day. In Portobelo, Congo performances take place in the centre of town in the plaza, and on a large open field that is divided by the main road. These performances are referred to as the *juego de Congo* – Congo play – and are manifested in two significant ways. First, as impromptu street performances where the Congos use the licence of carnival to assert their authority over the land. This is a reminder to all that their ancestors had dominion over themselves and their territory. They may stop cars and demand a tariff to pass through 'Congoland'. They may demand that you buy them a bottle of beer, *seco*,[11] rum or maybe contribute food to the communal meal. Should you refuse or insult them, you may be arrested and taken to the queen for a trial, all in good carnival humour. Mostly, however, they clown around with each other making a spectacle of themselves.

Secondly, as sacro-secular rituals. At exactly midnight on *martes de carnaval* – Shrove Tuesday, the Diablo Mayor will leave his home in search of the Congos. Pajarito, who has been standing vigil at the Diablo Mayor's house will immediately run to the palacio very excited, blowing his whistle warning the Congos that the devil is approaching. This is the first appearance of a mythological being, the Diablo Mayor. He always carries a whip and is dressed in a black costume with red accents, a huge red and black mask, a pointed tail and jingle bells sewn on the legs of his costume. He will enter the palacio backwards, as is the custom, begin to dance, and proceed to whip anyone he sees. He is only appeased when he dances with the Congo queen.

Another significant dramatic event takes place on Ash Wednesday when all of the devils appear in the village. Carnival 2000 in Portobelo saw as many as 34 devils, who have the right to whip anyone they wish in the village, but especially the Congos. They also attempt to capture the angels, who are young men dressed in white tunics and headbands. The angels are tied together at the waist by a rope and led by an archangel who carries a wooden cross. The Congos, who along with the angels are the benevolent figures in this drama, chase after the diablos encircling them, capturing them and later delivering them to the 'priest' to be baptized. The devil must have a *madrina* – a godmother – in order to be baptized. As they approach, the 'priest' will ask the devil if he wishes to denounce Satan and become a Christian. After hesitating and 'acting up', the devil will finally answer 'yes'. He is then asked to say *Dios* – God, to which he replies *arroz* – rice.[12] The 'priest' will ask the devil three times to say Dios and he will respond *arroz* each time. The 'priest' will finally give up and bless the devil, who must remove his mask. This ritual 'baptism' is in part an exorcism. Once the mask is removed, according to tradition, the devil is to return to normal life. However, this is not the case in Portobelo today. With their masks removed, the devils, mostly unmindful young boys and men, will continue whipping people even after they have been blessed, and they usually begin by whipping their madrina.

Finally, the Diablo Mayor is captured, he renounces evil, and he too is baptized and removes his mask. He then dances his final dance known as the *Diablo Tun Tún*. He is then tied up once again and taken through town to be 'sold'. This sale is a way for the angels to raise money, food and drinks for themselves and the Diablo Mayor (plate 7). This ritual, which highlights the struggle of good against evil, ends the carnival season. The Congo flag is lowered and the village settles down to 40 days of self-denial during Lent.

Buffoonery

Throughout history and in most world cultures the oppressed have used buffoonery as a tool for survival or as a weapon of resistance. In the folklore of many West African cultures there exists a character that is a trickster or a charlatan. Throughout the Yoruba diaspora, he is known as Elegba, Elegbara or Eshu. Among the Akan speaking people of Ghana he is known as Anansi the Spider. In the Americas,

Anansi has become Brother Nanci in the Caribbean and Brer Rabbit in the United States. In the countless stories of these characters, the theme that appears most often is that of pretext. In Portobelo, a great deal of male Congo behaviour is dominated by pretext. On my first visit to Portobelo, I met Mangera. As soon as he saw my camera he laid down on the ground and requested to be photographed. When I asked him to stand, he jokingly said that Congos could only be photographed lying down. He proceeded to act like an 'idiot' making silly sounds and giggling while posing. After a couple of photographs, he asked me to buy him a drink. Fearing that I would have to purchase drinks for all of his friends, I refused. He then became so loud as he begged for a beer that I was embarrassed and quickly relented. For the Congos, alcohol plays a significant role in this pretext of buffoonery and, unfortunately, because of the amount of drinking done by the Congos during festivals, many people dismiss the subversive play as nothing more than drunkenness. I am convinced, however, that the Congo buffoonery we are witnessing today is simply a retention of the ruse enslaved Africans employed in order to be perceived as non-threatening.

Plate 7. Photograph of Archangel and angels confronting the *Diablo Mayor*, Portobelo, 2000.

Language

Congo 'language' developed when enslaved Africans realized they could communicate with each other by speaking Spanish with very thick African accents that their enslavers found difficult to understand. In order to really confuse the Spaniards, who gave them little credit for intelligence, they further bastardized Spanish, reversed the meaning of words and added a sprinkle of African words and phrases creating a new jargon understood only by them. This language is preserved today and used during Congo celebrations. A Congo might greet you in the morning with *buenas noches* – good night. He might offer to shake your hand, then when you extend your hand he will extend his foot. Playing with the language is a favourite form of entertainment for the Congos. While a Spanish speaker who is familiar with the reversals, the bastardized Spanish words and basic rules of the language may begin to understand a little of what is being said, it is difficult to follow an entire conversation. The Congos have an uncanny ability for non-verbal communication. An outsider can begin to get a grasp of a conversation and without a verbal cue the Congos can change the rules of communication leaving the outsider confused. While I am now able to follow a Congo conversation fairly well, when they want to prove to me that I am really not all that good, they will do reversals on reversals, pick up the rate of speech and slur their words even more. They are able to follow each other through several patterns of reversals, rates of speed and slurring that I simply cannot. My friend Ariel enjoys seeing me struggling to understand what he is saying.

Music

Congo musical instruments are limited to the voices of the singers and the drum. A main singer known as the *cantalante* or *revellín* and a chorus performs Congo songs. The *cantalante* engages in a call and response with the chorus. A song's refrain is repeated over and over again until the group gets tired or the *cantalante* or the queen begins a new song. The songs the women sing vary from the very traditional to contemporary songs that may contain political satire. Improvisation is an important aspect of Congo songs. The ability to improvise is also a determining factor for selecting a *cantalante*. Only women participate as singers while men are drummers. Although Smith has documented the use of four drums in his research, I have only seen three in use in the seven years I have been working on the coast.

According to Nicanor, an important Congo drummer and the only drum-maker in Portobelo today, there are only three drums – two *secos*, which are large, and one *requinto*, which is small. I have been told that there is a tradition of using four drums in other villages along the *Costa Abajo* – the low coast.

Dance

Dance is at the centre of all Congo performances. I have been told by dance researchers in Panama that Congo dance is the precursor of *El Tamborito Panameño*, which is centred on *coqueteando* – a somewhat flirtatious play between a man and a woman. Congo dance differs, however, in that the man makes very overt sexual overtures while attempting to steal a kiss from the woman who gracefully and skilfully avoids his advances. The woman holds the hem of her skirt and waves her arms as she dances, at times making sensuous gestures to entice her male partner only to reject his advances when he approaches.

The Congos are very open to and encouraging of others participating in Congo dance. A *congada* – Congo performance – will begin with only one couple dancing at a time. While dancers, both male and female, will be replaced by others during a song, there will only be one couple on the floor at a time. However, as soon as several songs have been played they will select a member from the audience to join them in dancing. Congadas generally end with both Congos and audience members dancing into the wee hours of the night.

An important aspect of Congo tradition is centred on play and, in particular, making a spectacle of audience members as they attempt to dance Congo. In 1993, the first year I began this study, I went to Isla Grande where I encountered some of the Congos of Portobelo I had met and befriended the previous evening. We spent a good portion of the day talking about Congo culture, telling jokes, and drinking beer and seco. The combination of beer, seco and the hot tropical sun quickly made me quite inebriated. My newfound friends realizing my impaired state summoned the queen who invited me to dance with her. This was a royal invitation I dared not refuse. Judging from their laughter as I attempted to dance Congo for the first time, I must have been their major source of entertainment that day. I am still teased about my first Congo dance performance. Often it begins with a backhanded compliment. Someone will make a comment about how well I dance Congo, *now*. This is only a ruse to begin retelling a

plethora of stories about how awful my drunken performance was on Isla Grande, which have become more exaggerated with time.

Culinary Arts

The Congos maintain the same diet as other inhabitants of the coast. The main Congo meal however, is a soup called *sancocho de Congo*, or *sopa de Congo* in Spanish and *macocho* in Congo. This is an improvised communal meal made up of whatever food can be collected. The main ingredients are root vegetables cooked in a broth with bite-size pieces of meat, fish or fowl added. It is generally cooked in a very large soup pot outdoors on an open hearth. Ironically, the macocho of today probably does not differ much from the meals the cimarrones must have eaten, since they too depended on whatever they were able to acquire each day. Although the queen seldom does any of the cooking, she generally supervises the cook, determines what ingredients should be purchased and who is able to partake of the meal. Like the kings of the cimarrones, during carnival the king of the Congos must lead his men on raiding parties into the vegetable gardens and farms of the villagers to steal food for the communal meal. This is the king's main responsibility.

Material Culture

The material culture of the group consists of a flag, a palacio, costumes and musical instruments all of which have symbolic meaning in Congo history. In recent years a new tradition in the visual arts is being developed at Taller Portobelo[13] and is slowly becoming part of the material culture of the group in Portobelo. The Congo flag is composed of two equally sized black and white panels that date to the colonial period. It is intended to represent the peace and equality that was attained by the cimarrones. Today it represents the peace and equality that continues to exist among their descendants in Panama. The palacio is an open-air architectural structure made of poles that support a thatched roof. The palacio is meant to represent the palenque. It is at times still referred to as palenque. Traditionally, this structure was dismantled at the end of each carnival season and reconstructed the following January. However, in Portobelo today, the roof is made of zinc and the present palacio has been there for at least two years owing to the increased number of requests they have received for performances. Congo traditions have experienced a

resurgence in recent years and many tourists have been visiting the town. As a result, the Congos of Portobelo have been performing *congadas* for tourists arriving by boat and cruise ships, or by land in buses and cars. These performances are singing and dancing only. The devils and angels will rarely appear for a performance any time other than during the pre-Lenten celebrations of carnival.

The Congo male costume consists of old clothing worn inside out, referring to the practice of reversing meaning and reality, a theme also found in their language. The practice of wrapping themselves with ropes and chains is a reference to the ropes and chains that once bound their ancestors in slavery. Ropes and chains also served as a device to tie stolen items to the bodies of the cimarrones leaving their hands free to defend themselves while escaping or on raids. Large bags are also a significant part of the male Congo costume. These bags reference the bags the cimarrones used to carry personal items and food during long periods away from home while hunting, spying on the Spaniards or raiding their caravans or towns. Congo men wear conical hats made of the fibre of the coconut tree that are decorated with feathers, cloth, and trinkets of the designer's choice. Their costumes are completed with *bastones* – walking-sticks. These bastones recall the walking-sticks their ancestors used during the colonial period as weapons to defend themselves against the Spaniards, or wild animals, as well as to climb hills and to walk in the rainforests. Congo women wear a plain blouse and the *pollera montuna* – a colourful, floor-length, fully flared skirt that is gathered at the waist. Peasant and enslaved women originally wore this type of pollera during the colonial period. Congo women also wear elaborate make-up, fancy jewelery, straw hats and flowers in their hair.

El tambor – the drum – is unquestionably Africa's major contribution to Panamanian culture. According to Panama's pioneer folklorist Manuel F. Zárate, the drum is integral to Panama's most popular and ancient dance that unifies the sentiment of native soil. So vital is the drum to Panama's cultural identity, it is the name given to the national dance *El Tamborito Panameño*. Congo drums are made of the trunks of different trees depending on the desired sound. Once the trunk is dried, the bark is removed and the drum-maker will then proceed to ream a hole using a hammer and chisel or a machete. He will skin a deer, wild pig, goat, cow, or wildcat and leave the hide in salt water to make it pliable. Once the hide is ready

and the hole is the appropriate size the hide is stretched over the trunk and tied with strips of hide, twine or cord. Wooden pegs are inserted between the strips and used to tighten the hide to the drum and for tuning. The drum is then placed in the sun for several days to cure. Congo drums are very similar to those made along the west coast of Africa.

Congo painting is the newest tradition, which mirrors their customs and will be discussed more fully in the next section of this essay. Congo painting adheres to two general tendencies – chronographic and portraiture. The chronographic tendency documents events such as congadas, mythological stories, history and fables. The portraits depict contemporary Congos, elders, and ancestors.

The Method

Structurally, my research method relies on two important sources, Don Ihde's *Experimental Phenomenology* and James P. Spradley's *Participant Observation*. In order to apply this method my first move was to turn to ethnography in order 'to discover the cultural knowledge people are using to organize their behavior and interpret their experience.'[14] While I am a trained artist, I consider myself a self-taught ethnographer. Johnnetta B. Cole writes:

> In studying others the anthropologist is seeing, feeling, knowing for the first time what it is to be a part of a particular culture. In studying ourselves we learn to see, feel, and know anew as we systematically examine and analyze those institutions, processes, and emotions of which we are a part.[15]

By being a janus-headed artist-ethnographer, at times my art and I are placed in the same landscape as the artists and the art I study. While there are many advantages to being a 'native anthropologist' there are some inherent challenges in doing this type of investigation since the landscape can at times become muddy as quick shifts are made from being 'objective' to 'subjective' and from participation to observation. Delmos J. Jones writes:

> The problem at this point is that there are native anthropologists, but there is no native anthropology. By this I mean there is little theory in anthropology which has been formulated from the point

of view of tribal, peasant, or minority peoples. Thus, the whole value of the inside researcher is not that his data or insights into the social situation are better – but that they are *different*.[16]

I will add that there is also no theory that has been formulated from the point of view of contemporary tribal, peasant, or ethnic minority artists – the visionaries and makers of material culture. In order to avoid some of the pitfalls inherent in conducting 'native' anthropology I have incorporated the phenomenological move of epoché into my research method with some degree of success. It should be noted that in spite of the best intentions, there are inherent problems in any form of cultural investigation since there is no such thing as pure cultural objectivity. Every investigator is affected by the native cultural soil in which she or he is rooted. Given the above, I have been documenting the results of my research method in hopes that it may prove useful in contributing to the development of a theory from a different point of view, that of contemporary tribal, peasant, or ethnic minority artists.

Prior to beginning the field study, my only experience with the Congos was becoming an unwitting victim of a diablo's whipping during carnival as a child in Colon. When I was about seven years old I was caught by a diablo in an alley during the carnival season, who proceeded to whip me. According to tradition, the diablo has a right to beat children during carnival.[17] Shortly after, a Congo appeared almost miraculously and placed himself between the diablo and me, absorbing the blows intended for me. His intervention provided me an opportunity to flee. Essentially, I was rescued by this unknown Congo. Remembering the experience some 40 years later, as I was 'venturing into familiar terrain' for concepts to inform my art, prompted me to begin field research on the Congos.

In 1994, I was awarded a Lila Wallace-Readers Digest International Artist Award to live and work in Portobelo for six months. When I first arrived in the village to set up my studio I was greeted with a great deal of suspicion. While the children, in particular 'Don' Rodrigo, Gordo and Gino made me feel very much 'at home', many of the older townspeople were not so hospitable. After living in my studio for a couple of months I asked Meli, my housekeeper, what people were saying about me in the village. With much prodding, Meli said with a smile *'Señor Arturo, algunos en el pueblo dicen que eres un agente de la DEA'* ('Mr. Arturo, some of the people of the

village say that you are an agent of the DEA [United States Drug Enforcement Agency].') I went on to assure Meli that I was not a DEA agent or an agent of any other governmental agency. I explained that I was simply an artist interested in the Congos and planning to do a major art exhibition on their history and culture. Meli then told me that her neighbour was Sandra Eleta, an internationally renowned Panamanian photographer, and insisted that we should meet. I informed her that I had briefly met Sandra the previous year, but had not seen her since arriving in town. Meli promised to let Sandra know that I was now living in Portobelo. That weekend Sandra invited me to lunch and soon after my neighbours began to say 'hello' to me and I began to feel a great deal more comfortable in town.

By the end of my residency in Portobelo, Sandra and I became very good friends. Today we refer to each other as *hermanito* or *hermanita* – little brother or little sister. Virgilio 'Yaneca' Esquina, a leading Congo, and I also became close friends. We refer to each other as *Compa* – godfather of my child.[18] For my Lila Wallace exhibition at the Museo de Arte Contemporaneo, Sandra and Keith Wilcox, a Canadian friend, arranged for a busload of Congos to go to the opening reception to perform traditional Congo dances and songs. Their performance turned into a late-night party, and many of them spoke to me during the course of the evening expressing their pleasure and heartfelt gratitude for the work I had done. Many of the Congos who performed that night are today some of my closest friends. The bringing of Congo culture, which is still somewhat marginalized, to the centre of Panamanian 'high' culture was considered a triumph.

Just before my Lila Wallace grant ended, I was invited to a meeting at Sandra's home to discuss the growing drug problem that was plaguing the village. The United States invasion of Panama in December 1989, on the pretext of extricating General Manuel Noriega, intentionally destroyed the National Guard and resulted in the eradication of law and order. Drugs that once passed through Panama to feed the habits of street addicts and yuppies in the United States and Europe while making Colombian and United States drug lords and businessmen wealthy, were now staying in Panama. Poor villagers and indigenous people on the Caribbean coast of Panama replaced, sometimes by force, Noriega's corrupt officials.

The meeting lasted for several hours with a great deal of name calling and finger pointing. As the meeting was coming to an end, I

was invited to offer my opinion. I suggested that from my point of view the problem in the village did not appear to be drugs. Although culturally and historically rich, Portobelo is an economically depressed village. I thought that drugs were simply a symptom of the real problem – poverty. I went on to say that I was willing to help develop a painter's workshop that could serve to both preserve Congo traditions and to provide much needed hard currency. A few years earlier, Sandra had developed a women's cooperative that fabricated high fashion clothing for women at Taller Portobelo. These clothes were sold internationally and provided a great deal of income for the women and their families. That evening Sandra, Yaneca and I committed ourselves to developing a painting workshop for Taller Portobelo. So began a new Congo tradition in the visual arts.

The following year I invited Sandra and Yaneca to Spelman College as Artists-in-Residence. Sandra did a photography workshop with some of my students in Reynoldstown, an African-American community in Atlanta, and Yaneca worked with my painting students, teaching them how to make Congo *bastones*. Sandra and Yaneca's visit to Spelman piqued my students' interest in the Congos and the village of Portobelo. In order to provide my students and other college students in the United States, Latin America and Europe an opportunity to experience some of the wonders of Portobelo and to continue working with the Congo artists of Taller Portobelo, I developed the Spelman College Summer Art Colony in the summer of 1997. That year four students travelled with me from the United States to join nine artists from the village to establish the first summer art colony. At the end of the three-week project, we were invited to exhibit our work in the education gallery at the Museo de Arte Contemporaneo and El Aleph Cafe in Panama City. This was the first time that the new tradition of Congo painting was exhibited in Panama. The success of the exhibitions and the Spelman College Summer Art Colony over the years encouraged me to purchase 13 acres of land directly across the bay from Taller Portobelo to build Taller Arturo Lindsay as a permanent art colony.

The construction of Taller Arturo Lindsay and the programs it will sponsor will provide new jobs for the community and a steady flow of bright young artists and students into the village each year. The community has greeted this positively. In December 1998, I began a Fulbright Fellowship, in part to build the administrative

infrastructure of Taller Portobelo. I arrived with a gift of two computers from Spelman College to facilitate organizing the business of Taller Portobelo, register the paintings, prepare invoices and place photos of the paintings on the Internet for sale. These computers have also been used by children in the village to do homework, a football team to design their uniforms, a pensioner to write an official letter to the Social Security Administration complaining about missing cheques and a musical band and local fisherman to advertise their services, etc.

The Artistic Interpretation

To date, the art I have created based on my research and experiences in Portobelo falls into two categories – documentary and spiritual. The documentary work, which is the early work, tends to be very didactic. In these works my intent was primarily pedagogical. I was alarmed at how little the Panamanians, and to some degree the Congos themselves, knew about the history and traditions of the Congos. As a result, my teaching instincts became the muse that guided the production of this body of work. In 'Faces for the History Without History', Gerardo Mosquera wrote of this body of work:

> Lindsay imagines the faces of the lost heroes of slave insurrections, deifying them through art. These works bring together a pop language associated with advertising and the media with traditional African inspired sculptures, religious Catholic and Afro-American votive objects, video, soil, and offerings. With all these elements Lindsay designs the iconography of an official history that is lacking images. He harmonizes the aura of art with the religious power of altars to legitimize the history of the marginalized of his country of origin.[19]

In order to provide what Mosquera would call the 'lacking images' for the history of the Congos, as well as to honour the heroic deeds of their ancestors, I decided to create a series of portraits of the kings and leaders of the cimarrones. The first portrait was that of Bayano (plate 8). Bayano was a prince in his homeland before his abduction. Shortly after arriving in Panama he escaped with a band of men and women and established a palenque. It is said that his kingdom at one time extended from the Atlantic coast to the Pacific and that he

was the wisest and fiercest of all kings. His name, unlike that of any other cimarrón leader, is still preserved in Panama today as the name of a river and of several businesses. The other portraits of cimarrón leaders I created include Filipillo, Antón Mandinga, Juan de Dioso, El Negro Madagascar and Domingo Congo.

All of the portraits in this series were modelled on individuals I met in Portobelo in 1994; they were not intended to be realistic representations. In a number of portraits I commingled facial features of different individuals to create new faces. The negative spaces in each painting were filled with iconography that retold the stories of the wars fought by the cimarrones, their lives, and the presence of mythological beings. I intentionally portrayed the leaders of the cimarrones as proud and noble men, in part to counter the prevailing media depiction of young black men as hoodlums or thugs. I also hoped that, although the paintings were not realistic representations of a specific Portobeleño, they would resemble the people in the village. The eyes were made slightly oversized to suggest the spiritual development of these individuals, somewhat like the angels in the ancient sacred scrolls and illuminated manuscripts of Ethiopia.

Plate 8.
Arturo Lindsay,
Rey Bayano,
1994.

Six installations were later created for each portrait. Although each work is different each time it is installed, the design structure remains consistent. The portrait is mounted on the wall and directly in front of it is a mound of dirt. On top of the mound is a chair/throne with a sculptural figure representing a spirit-being emanating from the seat. An offering of fruits and vegetables on a tray surrounded by flowers and candles is placed in front of the mound and the chair/throne. The overall intent of these installations is to create a spiritual space that will inspire a feeling of awe. I want the viewer to have a phenomenological experience of being in the presence of the majestic or sublime (plate 9). This type of installation is representative of a series of homage installations I have been producing for the last decade and a half. A few years ago when my Tío Adolfo took me to Mount Hope Cemetery in my hometown of Colon to visit the graves of my younger brother Luís and my grandparents, I was stunned when we entered the cemetery and I saw the design structure of the graves. It was then that I realized my installations are paradigmatic of the burial traditions of my hometown. Ironically, I had not been in that cemetery in over 30 years.

The mystical and miraculous qualities of life in Portobelo shaped the art created in the spiritual category. The presence of the Cristo Negro de Portobelo – the Black Christ of Portobelo, renowned for healing; the apparition of the Virgin Mary in El Valle de la Media Luna, a nearby valley; the remnant of the auction block where Africans were sold into bondage now in the middle of a haunting old cemetery; the watery grave of the notorious English pirate Sir Francis Drake; the ruins of seven Spanish colonial forts dating to the sixteenth century; the pageantry of Good Friday and 21 October, the feast day of the Black Christ; and the appearance of devils and angels during carnival all blur the line between natural and supernatural realities. Living in this blurred reality zone has nourished the creation and production of a body of work that can best be described as sacro-secular. *Ancestral Mothers and Fathers Known and Unknown* (1994–8) is one of the first works in the spiritual series to include actual photos of my grandparents, other deceased relatives and deceased artists whose lives and work have greatly impacted me (cover image). As family members nurture and influence our lives, older artists nurture and influence the creative lives of younger artists. As a result, they become the mothers and fathers of our vocation. When they

Plate 9.
Arturo Lindsay,
Rey Bayano,
installation view, 1994.

die, like blood ancestors, they continue to nurture us and we continue to learn from them. I consider artists such as Wifredo Lam, Käthe Kollwitz, Andy Warhol, Romare Bearden, Frida Kahlo and Ana Mendieta, among many, my ancestors.

As soon as I completed the installation, I instinctively poured libations on the soil. At that moment, I immediately realized that that act shifted the installation from an object of aesthetic contemplation to a functional aesthetic phenomenon. The work in this series deals with the process of memory and the nature of memorials. When I first lived in Portobelo, I established a studio in a section of town known as Guinea. I later discovered that my studio was located in the middle of an area where abducted Africans were quartered as soon as they arrived in the village. I now work in a studio at Taller Portobelo that faces the bay. From the veranda of the studio, I can see the remnants of the docks where abducted Africans were disembarked. It is impossible for me to live in Portobelo without feeling the presence of its tortured past. I hasten to add, however, that this experience is not a depressive one. I have never felt angry, vengeful, or malevolent spiritual forces in the village. On the contrary,

there is a calm and peaceful energy that permeates life in Portobelo, and as a result, the images in my work appear positive and benevolent.

While the plight of the Africans who arrived in Portobelo has figured prominently in my work for many years, and more so since I have been living in the village, the souls of the millions of Africans who perished at sea during the middle passage of the transatlantic slave trade have become a major source of concern for me. What troubles me most is the lack of interest or attention historians have granted them. There are no major public monuments for them, no national day of mourning, and no special ways of memorializing them. As a result, I have created a series of installations that are intended to memorialize these individuals. Seminal to these installations is the notion of reconciliation and healing. I believe that art, like religion, can serve as a vehicle through which the process of spiritual healing can take place.

The first installation to address the middle passage saga was done at the Museo de Arte Contemporaneo in Panama City in 1994 and entitled *Middle Passage Memorial*. This work consisted of 11 sculptural effigies each representing one million beings standing on a sand- and seashell-covered floor reminiscent of the bottom of the sea. Scholars are not in agreement as to how many people actually perished during the middle passage since accurate records were not kept. Nevertheless, we are sure that the number is in the millions. I chose 11 million for this installation as a conservative guess. In subsequent installations on this theme I have used other numbers. The sculptures included a pregnant woman, children, tall and short people, twins etc. In a somewhat Warholian act of repetition, a large white canvas with dozens of black line figures hangs on the wall at the rear of the installation. This installation was recreated in Atlanta two years later when my solo travelling exhibition, *Arturo Lindsay: Animas, arcángeles y antepasados*, opened at Nexus Contemporary Art Center.[20]

In 1998 I created a second memorial installation entitled *Middle Passage Memorial II* for *Percosi dello Spirito* ('The Shape of the Spirit'), an exhibition at the City Museum of Cagliari for the Centro Culturale Man Ray in Sardinia, Italy. In this work, I used two sculptures from my spirit boxes series surrounded by a large quantity of broken bottles in the shape of a boat. I began using broken bottles in my work a few years earlier, influenced, in part, by the ritual of breaking bottles and jars at the grave sites found in some indigenous American and African

cultures. Metaphorically, broken bottles allude to the contents, in the case of humans, souls, being freed from the vessels that once contained them. Once again, I relied on Andy Warhol's practice of repetition and multiples in this work to compel the viewer to contemplate the quantity of perished souls as they view the number of broken bottles.

In 1999, I created *Retorno de las ánimas Africanas* ('The Return of the Tortured African Souls'), which was installed in Peru at Galeria Pancho Fierro as part of the Second Biennial Art Exhibition of Lima (plate 10). I was offered three galleries for my contribution to the *Bienal*. The work included a *cayuco* – a dugout canoe I purchased from a local fisherman in Portobelo. This installation was first constructed at Taller Portobelo with the assistance of students from the Spelman College Summer Art Colony and the University of Panama, as well as Congo painters and friends. Amy Sherald, my studio assistant, helped me reinstall the work at the Pancho Fierro Gallery in Lima. The entire gallery was filled with sand and the cayuco, with a chair/throne in the middle, was suspended from the ceiling. Adhered to the bottom of the cayuco were pieces of broken mirror that reflect the light from the candles in the sand below giving the gallery the impression of sunlight glimmering at the bottom of the sea. On three walls, I reproduced black and white schematic drawings of slave ships that might have visited Portobelo with abducted Africans. In front of the cayuco was a small altar dedicated to Yemaya, the Yoruba orisha of the sea.[21] The altar included a small plaster cast of La Virgen de Regla, Yemaya's Roman Catholic representation. Also on the altar was a Yoruba bronze casting of Yemaya Olókun, the manifestation of Yemaya who rules the deepest part of the ocean. Standing next to the altar were two spirit boxes. I attempted to approximate the sensation of walking on the floor of the ocean for the gallery visitor. By providing the visitor with an aesthetic experience of the space where the souls of captured Africans who perished at sea now reside, my intent was to create a closer identification for the viewer by personalizing the experience. I was very pleased during the opening reception as a number of people who were visibly moved approached me to congratulate me on the work, or to discuss the fate of those perished souls. I am always amazed whenever I create a middle passage installation at how few people have ever given any thought to the plight of the millions of Africans who died at sea.

Plate 10. Arturo Lindsay, *Retorno de las ánimas Africana*, 1999.

In June 2000, I was invited by *La Fundación Calicanto* and the *Dirección National de Patrimonio Histórico* in Panama to participate in an outdoor exhibition of installations entitled *Altares* (altars) in the ruins of the Santo Domingo monastery, popularly known as the *Arco Chato* in the old colonial section of the city. The installation was entitled *Santuario para las ánimas Africanas* – 'Sanctuary for the Tortured African Souls' (plate 11). Once again, the installation was conceived and developed in Portobelo in collaboration with participants of the Spelman College Summer Art Colony and the Congos of Taller Portobelo, in addition to an artist/friend Imna Arroyo, a Puerto Rican printmaker and Professor of Art at Eastern Connecticut State University and Rafael Ocasio, a colleague from Agnes Scott College. We decided to use the motif of a floating cayuco again, this time enclosing it in a Congo palacio wrapped with gauze. We located the installation in the former cloister of the monastery creating a feeling of being in a sanctuary.

Fidel Castro was once asked why he was sending Cuban troops to fight in liberation struggles in Africa. He replied 'nuestra impagable

deuda', referring to the unpayable debt owed to millions of Africans who worked under the most inhumane and deplorable conditions to develop the Americas and, in so doing, enriched Europe. In 1994, also as part of the exhibition for the Museo de Arte Contemporaneo in Panama, I created *Nuestra impagable deuda*. This installation also adheres to the style of the homage series with a large painting that hangs on the wall with soil, chair/throne and candles before it. The painting, although black and white, reverses colour in the figure ground relationship seen in the other works. In this case the background is black and the line drawings are white.

The presence of mythological and spirit beings in Portobelo is not alarming or out of the ordinary for Portobeleños. The *Cristo Negro* ('Black Christ'), for instance, has several nicknames, as do most Portobeleños. He is referred to as the *Naza*, short for the *Nazareno* ('Nazarene'), *el Negrito* ('little black man'), etc. Puerto Rican *salsero* Ismael Rivera describes the relationship many of his devotees have with this life-size sculptural figure of a black Christ in his song *El Nazareno*. He sings '*El Nazareno me dijo, que cuidará mis amigos. El Negrito lindo de Portobelo me dijo, que cuidará mis amigos*' – 'The

Plate 11. Arturo Lindsay, *Santuario para las ánimas Africanas*, 2000.

Nazarene has told me he will take care of my friends. The little black man of Portobelo has told me he will take care of my friends.' Often when something really special happens to me Sandra will say, *'Fuga, Fuga, el Naza si te cuida'* – 'Fuga, Fuga [my nickname in Portobelo], the Naza really does take care of you.' When referring to this figure, people speak as if they are talking about someone who lives in the village. Virtually no critical issue is addressed or important action taken by devotees of the Naza without consultation.

While spirit beings do take human form during carnival, their ethereal presence is felt and sometimes seen at other times in the village. At dusk one evening in 1998, while I was taking a walk on the coast with Tosha Grantham, an artist/curator and Ahijada Fellow of the Spelman College Summer Art Colony, we encountered a young woman on the road who began to walk with us. As a car was approaching, I turned to alert the young woman, but she had disappeared. I turned to Tosha who had the same look of disbelief on her face. We verified to each other that we had in fact seen this young woman. While we could describe in great detail her hair and clothing as well as the sound her slippers made on the pavement, neither of us could describe her face. It was a straight road, no curves, and no houses nearby. She simply vanished. When we returned to town our concerns were casually dismissed. We were told that that 'spirit' is always on the road at dusk. I no longer walk after five o'clock.

Supernatural experiences such as these led to a body of work entitled the *Guardian Angels* series. The first painting in this series was of my own guardian angel entitled *Retrato de mi angel guardian* ('Portrait of My Guardian Angel'), completed in 1997. This work was created for the Salón Internacional de Estandartes ES97 travelling exhibition in Mexico that originated at the Centro Cultural Tijuana. The painting measuring five metres by one and nine-tenths metres (approximately 15 feet by six feet) is acrylic on paper and painted on both sides. The subject is of male and female versions of my guardian angel, or maybe two guardian angels. I am really not sure. In this painting I began working with the idea of rendering portraits in a realistic style while filling the body with symbols, icons, and iconography. This body of work is highly influenced by my wife Melanie's Eastern Orthodox icons that fill one half of our bedroom wall, Yoruba and Congo iconography, Roman Catholic symbolism, Ethiopian sacred art and personal designs. In 1997, students of the

first Spelman College Summer Art Colony reported having strange experiences, seeing apparitions as well as each others auras while in the dungeon in the San Jerónimo fort. Those experiences led me to another series of paintings that adheres to the style of the guardian angels series with the exception that I have begun adding feathers and other trinkets to the paintings. This practice is borrowed from Congo costumes and in particular their hats.

Another important work in this sacro-secular series is *Ana Vive* ('Ana Lives'). This work is dedicated to Ana Mendieta, the young Cuban-American artist whose life was eclipsed as her art career was beginning to soar. In this installation, I recreate some of Ana's drawings on the wall. A sculptured mummy with her eyes exposed and open lies on the gallery floor encircled by sand in the form of one of Ana's drawings. Facing the sculpture is La Virgen de Monserrate, the Roman Catholic representation of the Yoruba orisha Yewá who inhabits the cemeteries and whose principal responsibility is to deliver the dead to Oyá. Yewá is also known to be protective of the souls of battered women, many of whom end up in her care because of abusive husbands and boyfriends. Mendieta's work so impressed me and has influenced my work so greatly that in spite of the fact that she was my contemporary, I always include her photograph as an ancestor in my installation *Ancestral Mothers Known and Unknown*.

Finally, *Spirit Box for Ronald Smith* is my way of honouring and thanking Dr. Ronald R. Smith, whose advice, friendship and scholarship helped make my work on the Congo coast of Panama a great deal easier (plate 12). Ronald died of AIDS in 1998. He is not my first nor regrettably my last friend to die of this dreadful disease. When not in use as an installation, his dissertation sits in his spirit box in my home. I really miss Ronald.

Conclusion

My original intent in researching and documenting the Congos was to honour a people who have experienced one of humanity's worst atrocities, yet have survived with dignity and self-respect. I expected to conclude my work in Portobelo after touring my exhibition and publishing a coffee-table book on the Congos. However, the recognition that the community needed my expertise and skills for a

longer period of time made me realize that I could not just leave. I felt a calling that I am still unable to ignore. Anthropologists and in particular, 'native' anthropologists all face very critical, albeit ethical questions once they become insiders. What do you do when the information and knowledge you acquired from your research indicates that your skills or expertise can help remedy a problem in the community you are investigating? Is it the job of a cultural investigator or artist to get involved in problem solving? Is it our responsibility to assist an individual or community attain self-determination? I am not sure what the appropriate answers are. I only know that I could not just observe without becoming involved. While doing this work I have become enamoured of the mystery, beauty and warmth of the Congos of Portobelo. While I still observe the Congos in order to better understand their culture and to enrich my art, today my emphasis is on participating in the culture to help bring about positive

Plate 12.
Arturo Lindsay,
Spirit Box for Ronald Smith, 1997.

social change, somewhat in keeping with the intent of the avant-garde at the beginning of the last century, creating art 'as an instrument for social change and reform'. In so doing, my life and my art have been dramatically altered for the better.

Acknowledgements

I am greatly indebted to Dr. Johnnetta B. Cole, President Emeritus of Spelman College and now President of Bennett College in North Carolina. It was Dr. Cole, then a professor in the W.E.B. DuBois Department of African American Studies and the Anthropology Department at the University of Massachusetts, Amherst, who taught me how to look at contemporary art as cultural material while I was a graduate student. Dr. Cole continues to be my teacher, my mentor and my friend. I am also deeply indebted to several grants and fellowships that funded this research over the years including the Lila Wallace-Reader's Digest International Artist Award, the Fulbright Foundation, the Bush Foundation, and the Merryl Foundation.

Notes

1. Johnnetta B. Cole, 'Creativity and Culture: An Urgent Call For Community', a lecture given for the PEW Fellowship in the Arts Awards, 1 November 1994.
2. The term Congo Coast is of my invention. While not a term popularly used in Panama, I find it useful to describe the region that the Congos inhabit.
3. On the avant-garde see Renato Poggioli, *The Theory of the Avant Garde*, trans. Gerald Fitzgerald (Cambridge: Harvard University Press, 1968).
4. On the concept of 'self-referential' inquiry, see Jonathan Harris, 'Visual Cultures of Opposition', in *Investigating Modern Art* (New Haven and London: Yale University Press, 1996).
5. K. José Colón Garcia, F. Jorge Luis Macias, 'Notas para el estudio de los Congos en Panamá', Master's thesis (University of Panama, 1977), pp.78–79.
6. Ronald R. Smith, 'The Society of Los Congos of Panama: An Ethnomusicologist Study of the Music and Dance-Theater of an Afro-Panamanian Group', Ph.D. dissertation (Indiana University, 1976), p.109.
7. I obtained this information from Sr. Morrocho, an elderly gentleman in Portobelo whom I interviewed in August 1994. This story has been verified several times by other elders in the town.

8. Ronald R. Smith, 'The Society of Los Congos of Panama: An Ethnomusicologist Study of the Music and Dance-Theater of an Afro-Panamanian Group', Ph.D. dissertation (Indiana University, 1976), p.110.
9. *Ibid.*, p.107.
10. *Pajarito* is the son of the queen, *María Merced*, and the king, *Juan de Dioso*. His primary role is that of messenger for the group: he carries the queen's invitation to Congos in other villages. He also keeps vigil at the home of the *Diablo Mayor* and alerts the Congos when the devil is out and about. *Pajarito* at times is a trickster, betraying sleeping Congos by alerting devils to their location. *Meninas* are usually daughters or nieces of the reigning queen and the *Mama Guarda*, who is at times the treasurer, is generally an elderly woman related to the queen.
11. Seco Herrerano is an inexpensive alcoholic beverage popular in Panama.
12. It should be noted that although *Dios* and *arroz* are not homonyms, they are phonetically similar. It is the play on words that the devil uses to avoid saying God.
13. *Taller* is Spanish for an artist's studio.
14. James P. Spradley, *Participant Observation* (Forth Worth: Holt, Rinehart and Winston, Inc., 1980), pp.30-31.
15. Johnnetta B. Cole (ed.), *Anthropology for the Nineties: Introductory Readings* (New York: The Free Press, A division of Macmillan, Inc., 1988).
16. Delmos J. Jones, 'Towards a Native Anthropology', in *Anthropology for the Nineties: Introductory Readings* (New York: The Free Press, A division of Macmillan, Inc., 1988), p.37.
17. The whipping of children by the devils is not child abuse – no one is injured and its theatrical nature is well defined. However, the appearance of the devil is often used by parents as an instrument for social control – having been visited by a devil during childhood, I can verify that the experience does encourage a child to alter bad behaviour.
18. *Compa* is an abbreviation of *compadre*, the term used to refer to the godfather of one's child. In Latino culture, the role of godparents is extremely important and parents and godparents develop a special bond. The use of the term with a friend implies a special relationship – that you trust that person with your children's lives.
19. Gerardo Mosquera, 'Faces for the History Without History', in *Arturo Lindsay: Animas, arcángeles y antepasados*, exhibition brochure (Nexus Contemporary Art Center, Atlanta, Georgia, 1996).

20. Nexus has changed its name to the Atlanta Contemporary Art Center.
21. An *orisha* is a deity in the Yoruba tradition. On Yoruba and Santeria art and religion see Arturo Lindsay (ed.), *Santeria Aesthetics in Contemporary Latin American Art* (Washington, DC: Smithsonian Institution, 1996).

section iii

performance, aesthetics and knowledge

word of honour

alphonso lingis

To Say *I*

I am a dancer. I am a mother. I am young still. When, alone or in the presence of others, she utters *I*, this word goes back to the heart of the speaker. She impresses it upon herself, and her substance retains it. She is committed to it, and the next time she utters *I* this subsequent *I* corresponds to and answers for the prior one.

The *I* that seemingly only reports her past commits her to it. *I was there, and I saw that there was going to be trouble. I got mad when my petition was just ignored... I am so happy I quit my job.* With these words the present *I* puts the past *I* in the present *I*.

The word *I* goes back to the heart of the one who utters it, to specific traits in himself. *I am on my own now. I am a dancer.* Already to say *I am a man...* is to commit oneself to manly behaviour; to say *I am a woman...* is to commit oneself to womanly deeds. To say *I am young still* is to put one's forces outside the roles and role models.

The utterances *I say..., I do..., I am a...* are not simply reports of a commitment, but the actual enactment of the commitment. A very fundamental power is involved. The power to fix one's own word in oneself is a power that leaps over the succession of hours and days to determine the future now. One day, deep in the secrecy of my own heart, I said *I am a dancer, I will be a dancer*, and it is because and only because I uttered those words that I am now on the way to becoming a dancer.

The remembering of these words one implants in oneself is made possible by a brushing off of the thousands of impressions that crowd on one's sensory surfaces as one moves through the thick of the world. The *I* arises in an awakening, out of the drowsy murmur of sensations. It especially requires an active forgetting of lapses, failures and chagrins – which persist as cloying sensations that mire down one's view into the past itself and into the open path ahead. There is a

fundamental innocence in the *I*, which stands in the now, and from this clearing turns to the time ahead and the time passed. To say *I* is to commence. *Now I see! I will go!* There is youth and adventure in the voice that says *I*.

Now I see! These words, which fix the future, leave me free, once I fixed them in myself, to observe the passing scene without tentatively arranging it around one centre and then around another. *I will go* leaves me free for whatever interruptions, distractions, momentary amusements the day brings. Through innumerable interruptions, contraventions, invitations, and lures to do other things, I felt the uncanny power of these words. I felt the power in them which was the sole evidence that they would prevail. I do not, before every new distraction, repeat *I saw! I will go!* These words settle into my nervous circuitry, my muscles, my glands, become one with the posture and direction of my movements. They become an instinctual direction of my hours and days.

Word of Honour

Now I see! I am still young. The word *I* is a word of honour, a pledge to honour those words. Nobility characterizes, in someone in high station or in low, the man of his word, the woman of her word. Noble is the man who is as good as his word, the woman whose word is a guarantee. With her words she commits herself; she stands in her word, her body stands, her life stands. His words are his honour. One's word *I, I say..., I am going to..., I am a ...* is the first and most fundamental way one honours oneself.

I am a dancer is a commitment one puts on oneself; one will seek out dance classes, one will train every day with exclusive resolve, one will endure being left out of company selections, dancing in troupes that got miserable reviews by the critics, one will never act on the basis of failure. It is oneself, and not dance, one dishonours if one does not do these things.

The word of honour one has fixed in oneself is the real voice of conscience. Already *Now I see!* and *I have no idea what to do with my life* are words of conscience. These words remain in me, an inner voice that orients and pledges. One's dancer conscience is not at all a critical function, a restraining force, like the daimon of Socrates, which speaks only to say *no* to the instincts. To have a dancer

conscience is to utter words of honour and pride that consecrate one's instincts, words that settle into one's nervous circuitry, one's sensibility, one's muscles, and become instinctual. One's artist conscience does not torment one with guilt feelings. In the words *I am a dancer! I am a mother! I am young still!* one feels instead upsurging power, and the joy of that power. One's pride in oneself is a trust in the power of these words. *Now I see! I am young still. I am a dancer* – there is a trembling pulse of joy in those words, and a foretaste of joy to come. One trusts one's joy, for joy is expansive, opening wide upon what is, what happens, and it illuminates most broadly and most deeply.

The word one has fixed in oneself is fixed in one's sensibility, one's nervous circuitry, one's circadian rhythms, one's momentum and one's tempo. It vanishes from the conscious mind which can fill itself with new words and scenarios. One no longer has to recall, in the midst of morning concerns that require one's attention, that word *dancer* uttered in oneself; one instinctually heads for the dance studio and feels restless and tied down if one is prevented from going.

Now I see! I have no idea what to do with my life: these words position my body in the field and position myself in that body. The one who says *I am a dancer* or *I am a mother* finds the reality of the dancer or mother he or she is in his or her body. To say to oneself *I am a dancer* is to commit one's body to travail and labour and pain and injury, is to commit one's body to sleep in a garret for years. To say to oneself *I am a mother* is to commit one's body to sleepless nights and exposure to diseases one's child picks up at school and to anguish worse than incarceration when one's son is arrested. To say to oneself *I am a doctor* is to commit one's body to total mobilization for hours and at any hour and to the daily proximity to deadly diseases.

I say to myself *I am a dancer! I am a mother!* I say *I am an adventurer!* And how much more strength is required to say *I am an explorer of myself by being an explorer of a hundred towns and lands!* How much more rigorous is the conscience of the one who affirms: *I am one who risks all that I am in every new land and adventure!*

But to say *I am a dancer! I am a mother!* is not to fix my life to do one thing, to be one thing, and it is not to ensure my life will be without risks. To be really a dancer is to be a runaway youth on an unknown road, to be, like Martha Graham, a beginner at the age of 80. To be really a mother is, like Celia de la Serna, to be dragged out

of the cancer ward to be thrown into prison in Buenos Aires for being the mother of her son, being the mother of Ernesto Che Guevara.

To say *I* is to disconnect oneself from the others, the crowd, the company, the system. It is to disconnect oneself from their past and from their future. *For my part, I think... Here is what I am going to do...* Throughout our lives, something in us understands that certain ways of action, certain ways of speaking, certain ways of feeling are just not ours. It may well not come from a sense of the continuity of our lives; it may instead come from the sense of the youth, the newness of our lives. To sense one's youth is to sense all that one has to do that is not found in the role models of adult society nor of youth culture, not found in what can be learned by lesson and paradigm. The runaway youth, dropped out of school, hitchhiking, refusing to anaesthetize the poet in himself and become a notary, understands the imperative urgency of *what I have to do* and *what I have to say*.

Because the utterance *I* is a commitment it is also the power to disconnect and decommit oneself from a past experience, undertaking, or commitment. *I didn't see what was going on. I was drunk. Oh I was so much older then. I'm younger than that now.* And because the utterance *I* is a commitment, it is also the power to disconnect and decommit oneself from one's own future. *I shall not answer or even read the critics of my book. I will leave college next week, and have no idea what I will do next.*

To say *I* is to disconnect oneself from the others, and from discourse with others. *I am a dancer. Well, I am young still* – the performative effect of these words is inward. They are not the sort of thing one goes around saying to others. In fact the one who goes around saying to everyone *I'm going to be a dancer* is seeking their permission and support, and there is cause to suspect that he has not really or not yet fixed these words on his heart. There are those who have never told anyone, and who are driven by their secret intoxication with this word. *Now I see*, I say in the middle of a discussion, and I may stay in the discussion to argue for what I see and try to affect the subsequent movement of their thoughts and decisions. But more likely the main effect of my insight will be to determine the line of my thoughts and decisions after I leave the others. My word of honour does not get its meaning from a dialectic and its use is not primarily in a language game with others.

The typical secrecy of those words *I am a dancer, I am young still*

can function in several ways. The secrecy sets them apart from the profane common talk; it sacralizes them. It maintains for oneself a space for giving free play to doubts, second thoughts about what one has said to oneself, as well as giving free play to fantasy about it. It can function to preserve affable and non-confrontational relations with others who have different commitments and those who have different plans for oneself. The walls of secrecy fragment our social identity. The one who has said in his heart *I am a dancer* will not be the same person among his fellow pre-law students in the university, before his parents, when seeking private lessons from a renowned teacher, when playing football with cousins at the family reunion.

And within ourselves, walls of non-communication separate different and autochthonous psychic structures. To say *I am a dancer* is not to impose upon oneself a molar or molecular unity. In the heart of myself I am a dancer; but the whole of what I am is a singular compound of fragmentary systems of knowledge, incomplete stocks of information and discontinuous paradigms, disjointed fantasy fields, personal repetition cycles, and intermittent rituals. The non-communication between different psychic structures can function to maintain the identity and solidarity of one's dancer self, to exalt and consecrate it; it can function to establish a division of labour between being a dancer and being an employee at some job and being an affable family member, each in its own sphere and time. It can function to maintain an intra-psychic space for different compounds of knowledge, fantasy, and repetition compulsions. Inner walls of secrecy maintain a space where quite discontinuous, non-coordinated, non-communicating psychic systems can coexist. A space where episodic systems can exist, where phases of one's past and of one's future can be still there, untransformed and unsublated.

How do I understand that I came to believe that I am a dancer, am destined to be a dancer? How do I explain it out of the chains of information I acquired about the social environment about me, the successive role models that I fixed in memory, the fantasies of my childhood, the resentments and rebellions I accumulated against my parents, the ways I came to disdain pragmatic judgments and occupations? But I may wish to maintain a non-confrontational co-existence of different sectors of myself. I may value an affable relationship with the Dionysian demon within myself. I may not want to penetrate behind those walls about my dancer destiny, I may choose

to be astonished at the primal dancing drives contained within myself. Let this word *dancer!* be separated and secret – sacred. I may want the enigmas and want the discomfiture within myself.

To Honour Another's Word

The word of honour one puts on oneself is not a term of a dialectic; it is not a response to a question or demand another puts to one, and it is a word not essentially addressed to anyone outside. Yet the *I* of *I am a man, For my part, I think...* makes itself understood. *Here I am! I saw, I heard, I did... I say, I tell you...*: to say *I* is to take a stand. Others understand these words and understand this *I*, this word of honour. When they hear me say *I say, I tell you...* they turn to an instance that will answer for what is being said, that can and would answer the questions and objections they put to it.

The power to fix a word in oneself, to fix oneself with a word makes one responsible, able to answer for one's word, able to answer for what one says and does. It is what makes one also able to make promises, to undertake commitments to another. Others can take the words of a man of his word as a guarantee, because the words with which he utters a commitment to them are words he fixes on himself. To say, facing others, *I am a dancer. I am a man. Here I am.* commits me to attend to what they ask and answer it.

How the words of the interlocutor go to the heart of the speaker! I know that in my own case. How *Hey man!*, *Hey buddy!* cut through the image and role I had been holding up! I may well sense immediately that the one who stands before me and addresses me has a mistaken idea of what I am and what I have done, but how his word *you* touches the real me to arise behind that mistaken idea!

The word *I* with which I present myself is not simply an empty shifter. It sets me apart from the others with distinguishing, distinguished traits. *I will be right over...*, I say to a friend in distress, putting forth my resources and my loyalty in that word *I*. *I will take care of your mother... I am going with you on the search... I am your lover and I say...* Whenever I say *Here I am*, I expose my body, put it at risk, give it to others, sacrifice that body.

I address, in the human body before me, someone who says within himself *For my part, I think..., What I see is...* This someone is not an alter ego, is not simply another mental being like I am that is capable

of viewing things and situations and reporting on them in statements. The you I address is a power that addresses the me who says *Let me tell you...*, questions the me who says *I will go*, makes demands on the dancer I say I am, contests the youth I say I still am, puts me and my situation in the midst of the common world in question. *You* – you for me are a power that can deny, refuse and can assent, confirm, consecrate. The response I make to someone as you I address to him or her for his or her judgement.

The one I address disconnects himself from the view I have of him and the image I have constructed of him, and from the interpretation I have elaborated of what he said. The one I address also disconnects himself from my past encounters with him. *Yes, I did say I would clear up the place before the social worker got here. So what? I am no longer the suburban housewife you knew.* He also disconnects himself from his own future. *The troops are already shelling the village and you say they are going to level it? Well, I am a doctor and I am staying right here to tend to the dying.*

Our eyes are not turned to and held by a man or woman of honour only in order to call upon him, question her, make demands on him. Our eyes are turned to and held by him and her to honour him and her. To turn to the one who says *For my part, I think...* is to honour the one who is as good as her word. The attention paid to the one who says *I am a dancer* is an honour paid to him. That is why it is with words that one dishonours someone.

The one I address can also disconnect himself from his *I* – from his *I think..., I am telling you...* – as I can, when speaking with him, likewise disconnect myself from what I am saying and from the *I* that is saying *I think..., I am going to...* I – and from my interlocutor – can be insincere, can dissimulate, can lie. It is the one who stands in his words when he says *Let me tell you...* that I will answer when he questions the me who says *I will go*; it is the one who is a dancer whose demands on the dancer I say I am that I will recognize; it is the one who has never sold out – Che Guevara at 40, Nelson Mandela at 80 – and who contests the youth I say I still am that I recognize I have to answer.

A man or woman of honour will not tolerate insult; he or she will stand with his or her body, his or her life against him who impugns his or her honour. It is with her body on the dance floor that the dancer will answer the sneers of critics. It is with his body in the

rioting slums, and not with arguments in the clubs and salons, that the doctor answers the insults of the racist ruling class. But she and he disdain to answer those who do not stand in their words.

Servile Self-Consciousness

Here I am! I am a dancer. I saw, I heard, I did... Here the *I* arises, with its strengths, takes a stand. Its word of honour, become instinctual, is a password which opens a path and a destiny extending to remote distances ahead. It is the most un-selfconscious of utterances.

Self-consciousness is depicted as an inner mirror upon which the processes of the mind are reflected. But that is only a metaphor. In fact one becomes self-conscious with words, by carrying on an inner dialogue: *I am bored with this lecture, I am going to try to make a good impression, I am hungry, This traffic is getting on my nerves, I feel really stressed out, I really should not be watching this television trash, I wish I could start studying and pass the exam.* The language of self-consciousness is a language of intentions, appetites and volitions. It is not an observation of something else behind all that, which would be one's *self*. Instead, it ascribes intentions, appetites, discomforts, volitions, and boredom to the *I*. The *I* is a stand taken in those intentions, hungers, cravings. This *I* is something quite different from the *I* that rises as a power to determine the future, the *I* that is a word of honour.

It is only the 'worst and most superficial part of ourselves', Friedrich Nietzsche said, that can be formulated in the language of self-consciousness.[1] Self-consciousness is the inner dialogue with oneself about one's needs and wants, that formulates the self as a bundle of needs and wants. It only concerns what is intermittent and superficial in oneself.

This inner dialogue is not formulated, however, in a private language. How is it that one's own intentions, appetites, and volitions are articulated in words, general terms, which others can understand?[2]

As infants we needed no words for our romping animal energies and exuberances, accompanied with cries and laughter. The words we had to learn were words for our needs, our hungers, our discomforts – words others could understand. We learned to formulate our own needs, hungers and discomforts in the general words of public language, so that others could understand them

and attend to our needs and wants. It was the original form of self-consciousness. Self-consciousness formulates our life for ourselves as needy and dependent.

And the others do understand and want to hear about our needs and lacks. Our needs and wants are apprehended by the others as appeals to themselves, expressions of dependence on them, declarations of subservience, invitations to subjugation. *You're bored? You're tired. Then come up to bed,* says the mother, looking forward to an uninterrupted movie on television. It is through our needs and lacks that we appeal to the will in the others – the will to power in the others, the will to dominate. *You want to get out of the house – you want a motorcycle? Then go get a job.*

It is in becoming self-conscious, in articulating ourselves as needs and lacks, that we become servile. All the instincts of the servile are to make themselves weak; in all their talk they ask to be mastered. Expressing oneself in the (common) signs of language is debilitating and capitulating.

Self-consciousness is a consciousness turned back from the world to what is needy and wanting in oneself; it is critical and guilty. It is the critical words of others that induce us to turn back upon ourselves. Their words of blame isolate an action or an omission, which they identify to be voluntary: you could have done otherwise. Blame singles out our carelessness, our lack of deliberation, our impulsiveness, our thick-headedness. It assumes that we had a reason to act otherwise – a reason available in the discourse of the community, which we had already made a reason for ourselves.

The language of self-consciousness is an itemization of needs, wants, appetites, a language of dependence and parasitism, a critical and guilty language. Self-consciousness produces servility, submission, obedience, the virtuousness that has to be distinguished from the *virtu*, the availability and reliability, of the man of honour. Despite Socrates and his slogan, 'An unexamined life is not worth living', despite Kierkegaard replacing love with the unending examination of the intentions involved and motives for love, we do not admire and do not trust actions that issue from a critical and guilty self-consciousness. We do not trust our children, or even her own, to a mother who pursues an interminable psychoanalysis of her conscious and unconscious motives. It is that woman with the big heart, the farm woman beaming over calves, piglets, chicks, the aging

prostitute longing for nothing more than to give tenderness and love, the woman in the old folk's home watching the children play in the park across the street and caring for her old cat, that we trust.

But the one who engages in this language ends by making his words true. In expressing oneself as a bundle of needs and cravings an individual makes himself common, and dependent, parasitical. One lives to acquire commodities with which to nourish, refurbish and protect oneself, and to fill up the space and the time. One feels threatened by all that is ephemeral, transitory, fragmentary, cryptic, all that eludes the rapacious nets of common reason and utility.

Believing One's Own Word

The word one implants in oneself – *I am a dancer, I am an adventurer* – is not put there by critical self-consciousness. Is it implanted by pure force of will? Is the content of the term *I* prescriptive rather than descriptive?

One will not become a dancer unless one says *I am a dancer*; one will not become an adventurer unless one says *I am an adventurer*. But one will not become a dancer or an adventurer unless one believes what one says in one's heart. By an act of will one may want to be a dancer, but one does not by an act of will make oneself believe that one is a dancer.

Is not belief in oneself one of those states that cannot be brought about intentionally or wilfully? I can make myself eat with an act of will, Leslie Farber pointed out, but cannot with an act of will make myself hungry; I can make myself go to bed, but cannot make myself sleepy; can wilfully bring about self-assertion or bravado, but not courage; meekness, but not humility; envy, but not lust; commiseration, but not sympathy; congratulations, but not admiration; reading, but not understanding; knowledge, but not wisdom. One cannot by an act of will make oneself be amused; one cannot make oneself laugh by tickling oneself.

To believe something is to believe that one is compelled to hold that belief because there is evidence that it is true, and not merely because holding that belief may be useful. A patient is told she has cancer. Believing that there is no hope will certainly depress the immune system. So she has to believe that there is hope. But how to make oneself believe there is hope? In the end is there any other way

than to find reasons to believe that chemotherapy and radiation treatments are effective?

To say *I*, to say *Here I am* is to see lucidly where and what here is; to say *Now I see...* is to see something in the clear light that illuminates what it really is; to say *I am a dancer* is to know what dance is, is to know dance taking possession of oneself and activating one's nervous circuitry and musculature with its own rigorous dynamics. In uttering *I*, I make myself present – present to things and events where and as they are. For what could be the value of the words *I am a dancer*, *I am a doctor*, *I am a man of the sea*, if nothing of what one's words present about the music and the choreographer, about the efficacy of antibiotics and the effects and risks of surgery, of the movements and feeding habits of the great white sharks is reliable?

The Word that Generates Understanding

This power to fix one's own word in oneself generates the power, Nietzsche said, 'to see distant eventualities as if they belonged to the present, to decide with certainty what is the goal and what the means to it, to distinguish necessary events from chance ones, to think causally, and in general to be able to calculate and compute.'[3] How many are those about us who do not distinguish what is essential to them and what incidental, who do not see what possibilities are within reach and do not even see goals! How many are those who do not think, whose minds are but substances that record what baits and lures the mass media broadcast at large! They do not commit themselves to the systems of thought that track down the causes of injustice and sociopathic behaviour, the causes of environmental deterioration, the causes of literary and artistic achievement.

Compelling insights, foresight, purposive thought, causal thought, calculative thought – thought in general – do not, then, arise from contact with the regularities of nature passively recorded by the mind. The rows of trees and the daily movement of clouds overhead, the birds that chatter in one's back yard, the landmarks and the paths one takes every day, the tasks that are laid out for one every day, the patterns of conversation with acquaintances, the concepts that exist to classify these things and the connections between them – these lull the mind which glows feebly in their continuities and recurrence; they do not make it thoughtful. Instead, thought results

from language, thought arises out of the word one puts to oneself – a word of honour. This word interrupts the continuities of nature and silences the babble of others in oneself. It is the power one feels in oneself when one fixes oneself with a word, stands and advances in that word, the feeling that one is making one's own nature determinable, steadfast, trustworthy, that makes one look for regularities, necessities, calculable forms in the flux of external nature. Once I have said *I will be a dancer*, I begin to really determine what the things about me are, I begin to understand anatomy, the effects of exercise, of diet, the effects of great teachers and grand models, the workings of a whole cross-section of urban society. It is the man or woman of his or her word who is thoughtful. How thoughtful Ernesto Guevara became when, saying 'I am a soldier of America!', he left medical school to hitchhike the length of the continent, earning his food by doing manual labour on plantations in Argentina, spending nights in ranch-hand shacks in Chile, in Indian hamlets in Peru, in miner's shanties in Ecuador, in jails in Colombia, in leper colonies in Venezuelan Amazonia!

Things True to Their Word

Nietzsche speaks of those who do not have the right to make promises because they do not have the power to keep them.[4] There are those who do not have the inner force to fix one's own word in oneself, to leap over the succession of hours and days to decide the future now. They are self-conscious, identifying *I* with intentions, appetites, volitions, with needs and wants. It is piecemeal, letting oneself be captivated by small pleasures and gilt and chocolate bait that one finds one day that one has sold out, a commercial artist, a comfortable bourgeois. But there are also those who do not have the right to make promises nor the power to keep them because they do not have the strength to get into the heart of things.

Veracity designates a will to put forth the truth, but also an ability to do so. To tell the way things are with a painting by Botticelli, a temple in Cambodia, a willow tree in one's back yard, one has to have dwelt long and intimately with them. To tell the ways things are with the great white sharks, one has to have dwelt long with them, in their waters. How many are those whose words we dismiss because we sense they have only picked up their words from others,

they never go to the heart of things, they skim over things, they have only a tourist's rap to tell, having spent but 15 minutes before the Botticelli, having spent but a week in Guatemala! It is the one in whom we sense a word has been fixed – *I am a dancer, I am a man of the sea* – whose words about the possibilities and talents there are in the city, about the great whites we take seriously. The word of honour one implants in oneself is a word of honour addressed to things. The words with which things become present to us as they are come from things faced with honour, words that answer to and for them.

To know things. To get to the heart of things. This means to reach at the core of each or any thing something that is, that is itself, that is singular. The thought that goes to the heart of things is not a spontaneous, self-launching activity. Thought is not really a succession of initiatives relating, connecting, elaborating concepts, elaborating phrases. There is a phase of raw exposure to things and events, a phase of bewilderment, of hesitation, of being disconcerted, when thought is in suspense, immobile.

When thought turns to the heart of things, then, it runs up against the raw fact that they are there, it ponders. It weighs down on the things, and the weight of things weighs down on thought. This pondering is not an intentionality, and not a reflexive movement. It is a letting oneself undergo the impact of this thing or event.

There is in the heart of a thing a concentration, there, where it is. But at the same time to be there is to be exposed. A stone is there, posited, in position, posed, positive. A tree, rising from the ground, is exposed – exposed to the sun and to the winds and the storms and chainsaws. Its roots in the ground are exposed to the moisture, the fungi, the rocks that shift, the moles, the spade that cuts. An orchid flower blossoming in a crotch of that tree is at the disposal of the orchid plant, of its inclination to nourish that blossom, its inclination to propagate itself. The blossom is inclined toward the light. It spreads its throat and frilly petals.

There it can make sense. Something that takes place, that comes to pass, diagrams a certain direction. And this direction, this sense, is in the thing itself, before it can be linked up by the discursive mind to other things as a means to an end, before it can acquire significance in some context or project or enterprise or evolution. There is innocence, youth, and adventure in things.

We use our voice to make contact with persons – and with things. To enter into contact with someone is not to conceptually grasp his or her identity and respect his or her boundaries and inner space. We greet someone with 'Hey man!' The vibrant tone of those words hail in that individual a man, not a child, a student, or a writer. We address and answer someone in the words and forms of speech which are hers. We catch up the tone of the one who addresses us, her voice resounds in our own. We catch on to the urgent, frantic, panicky, exultant, or astonished tone. To answer the frenetic tone of a young person with the stentorian tone of officious and sedentary life is, before we refuse to understand really what she will tell us, to refuse her tone – to refuse her. It is to refuse her *I*, her word of honour.

Likewise, we catch on to the level of the purring kitten, the frantic cries of the bird, the snorting of the distrustful horse, the complaint of the caged puma. We catch on to the tone of the blackbird marsh, of the hamlet meditating in the Himalayan mountainscape, of the shifting dunes under twilight skies. Our words form; in them the tone of these things and events resounds in our voice. It expresses the muffled calm or the frenetic movement, the rhythm and periodicity or jerks and explosions of the things and events. What we say is interspersed with rejections of inappropriate currents, ways of speaking and categorizing: *No, it's not that...* And our words locate what is not clear and distinct, what is not immediately seen; they invoke the latent and the hidden.

Words issue out of an intimate acquaintance with things and events. Words articulate the agitated tone of a column of ants, the syncopation of the Balinese dance, the purple majesty of the Pacific ocean under dawning Madagascar skies. Words articulate the tone of a cave, a cathedral, a dance, the pacing, the rhythms, the reticence, the silence.

Words are things. They are things that have the marvellous and enigmatic power to express, to formulate, to set forth things – to concentrate and expose things.

Each of us lives and speaks in the conviction that our words do indeed say, set forth, what the things themselves really are. None of us is a radical nominalist. In words things present themselves. *Come, I'll take you out to meet the great whites!* the old fisherman tells us. As he speaks to us, our attention is not fixed on images in his mind, nor images in our mind, but drawn to the sharks themselves. When we go out to the ocean with him, he shouts: *There they are!* and his

words make us see them, shadows deep in the turbulent waters. He recognizes individual sharks whose bodies, whose ways he knows; he recognizes a shark he has not seen before. We descend into the ocean with him, and meet those very sharks that his words on the boat have introduced to us and presented to us. And when, now, we speak of them, it is not concepts nor images in our minds, but those very sharks that our words make present again to us. The one who says with conviction *I am a dancer!*, *I am a doctor!* has the conviction that the words that put forth what the things and events about her or him are, are words that can be counted on about things that can be counted on. The properties and behaviours of things are retained in words. With words we stay in touch with things. Because of words the real world lays open to us, beyond the narrow confines of what our eyes now see.

Yet at the same time, whenever we consider words that say what things are, we become aware of an inexpressivity in those words. At the kitchen window we see and say: *A spider is spinning its web.* There is no question but that these are the right words. But at the core of those words – spinning, web – is there not an opacity? – where the words are not simple windows upon the spider out there and its web, where the words do not simply diagram the inner structure of those things, but where the words themselves take form, like opaque things. *L'araignée file son étoile.* There is something inexpressive in the words as things. The thought that ponders over the things words present ponders over the secrecy in the heart of things.

The Important and the Sublime

It is not an act of will to make whatever happens to oneself and about oneself necessary to oneself that makes one commit oneself to one's own word. It is instead compelling insight into what is important, urgent and immediate to be done and to be said that makes one's word of honour necessary to oneself. It was the epiphany of the important – the transcendent importance of dance, the grandeur of the wilderness, the majesty of the oceans – that first called forth the word that said: *I will be a dancer, I will be a forest ranger, I will be an oceanographer!* But it is this word that gives me the power to distinguish the important from all the lures of the fatuous concerns illuminated on neon signs and television screens.

In the measure that we become intimate with persons, other animals, ecological systems, artworks or buildings, we develop perceptual and conceptual sensitivity, logical acumen, breadth and depth of comprehension and the capacity to distinguish the important from the trivial. Understanding is all that.

There is no understanding – no compelling insights, foresight, purposive thought, causal thought, calculative thought – no thought in general, without the capacity to distinguish the important from the trivial. It is part of the understanding of the nurse in the emergency room, the automobile mechanic, the pilot, the Scuba-dive master. It is part of every practical understanding. It is also part of all theoretical understanding – that of the nuclear physicist, the astronomer, the microbiologist.

The word of honour arises before the grasp of the important and the sublime.

Martin Heidegger replaced a substantive account of things with a relational account – things, he said, do not have 'properties', that is, traits that belong to them; instead they have appropriatenesses – concrete ways they fit into or resist other things about them and fit into our projects. But the sublimity of things and events is recognized in the way they exceed concepts that measure their appropriateness to our projects. Their size, force, beauty, wild freedom, nobility make them insubordinate to the uses we may devise for them. *That's not just timber – that's a sequoia forest!* declares the utter disproportion between the concept which subordinates the trees to human uses and the perception of all their reality. *Hey put that broom down; that's a hummingbird that got into the living room.* Things and events reveal themselves as sublime when they demonstrate that before them man is not the measure of all things. That which one has to ponder, go back to, in things is not the opaque, but the sublime.

To be struck by the importance of dance, of mothering a child, or of freeing the rivers of pollution is to see the urgency of what has to be brought about, protected, rescued, or repaired, and to see that I am the one who is there and who has the resources. It is then that the noble heart gives his word of honour, to them and to himself.

To say *I am an adventurer!* is to honour a hundred towns and lands. The runaway youth, dropped out of school, hitchhiking, honours the poet in himself by giving his word of honour to all the open roads. Saying proudly 'I am Che Guevara's mother,' Celia de la

Serna was dragged out of the cancer ward to be thrown in prison in Buenos Aires.

Deluding Oneself

It is because she said I am a dancer, and believed it, that she could become a dancer. Can she be deluded? Can she even be lying to herself?

Here is this man or woman who has fallen ill with a strange illness, or fallen into a deep depression. He or she suffers, longs to be healed. But strange illness, depressions, hallucinations are part of the initiation of every shaman. What might happen is that he or she become a healer. How to know that this is one's destiny? I.M. Lewis and Georges Devereux reclassified shamans as neurotics. But neurotics are dysfunctional in our culture and shamans do heal dysfunctional individuals in their cultures. Field researchers have long observed shamans performing tricks – apparently pulling out of the sick person's body the cause of the sickness, an object which the shaman has put there with prestidigitation. To what extent then does the shaman believe in his shamanistic powers, and to what extent is he shaming? This theologian teaching in a renowned university – does he really believe the dogmas about the Virgin Mary – the virgin birth and the physical assumption of her body into heaven upon her death? This pastor in Ireland or Rwanda – does he really believe that all things are in the hands of an omnipotent and benevolent Divine Providence? Is he then really a Christian? This man – does he really believe he is normal? Is he not instead passing as straight, as law-abiding, as socialized? Is it not by passing as heterosexual that one quits one's bisexual preadolescence or indeed nature? Is not the noble in Nietzsche the one who always goes masked, masked as noble?[5]

Shamans recognize that there are charlatans, all of whose healing is a sham. And shamans who do believe in their healing also practise prestidigitation. But they see people getting well and believe in a healing power that works through them. They believe the healing works through other channels than the tricks they recognize they perform. The shaman who apparently pulls the disease out of the sick person's body in the form of a bloody organ is lying to the onlookers but not to himself.

David Abram was a young American who worked his way through college putting on magic shows. When he finished, he applied for

and received a number of small grants to study magic in old cultures. He went to Sri Lanka, Bali and Nepal. In fact there are no magicians in those places; there are shamans and healers. In Bali he formed a relationship with a healer. She revealed to him some of the power objects and rituals of Bali. But she also intimated that he share some of his powers with her. He tried to explain to her that he had no power; all he had was prestidigitation, was tricks. But the concept of a magician in the Western sense was alien to her and her culture. Finally he realized that if he did not share something, she would shut him out and he would lose the person from whom he was learning most. This woman had some time back broken her thumb, which had set badly, so that it had lost mobility. This was a serious impediment to her, because it was by the practice of massage that she earned her income – the healing was, in the culture, done without charge. One night, things came to a head; David had to do something. He improvised a ritual over her hand, using some of the power objects of the culture. To his consternation, the next day she showed him how her thumb was beginning to regain mobility, and insisted he repeat the ritual. To his horror, in the days that followed the thumb recovered complete mobility.

Doubt depends on an experience of the reliable, the credible, and in order to really doubt one needs reasons to doubt. If doubt arises, it is because I find reasons and evidence for those reasons to think that I cannot be a dancer. Out of fear of the truth, one can hold back from looking for those reasons and that evidence. Later, one says one was deluding oneself. Lies are effective only when they are believed. Masking over the reasons to believe one will never be a dancer and believing one's own masquerade is possible by finding reasons to believe one is a dancer.

Paul Gauguin abandoned his family in order to pursue his art. 'I am moving next month to Fatu-iva, a still almost cannibalistic island in the Marquesas. There, I feel, completely uncivilized surroundings and total solitude will revive in me, before I die, a last spark of enthusiasm which will rekindle my imagination and bring my talent to its conclusion.' He did have reason to believe that he had talent. He did not know if he could bring that talent to its conclusion. If the ship, sailing long through stormy seas, would not arrive, if he had succumbed to fatal disease on the way, no one would ever have known.

Yet do we not honour the word of honour of someone who lives by

his word, though totally deluded? It is not only historians who work to recuperate the honour of all the losers of history – Brutus and Moctezuma, Gandhi and Che Guevara. It is the victors themselves, who do not desecrate but bury in military graves their fallen enemies and receive with full military honours the officers who, their cause lost, come to surrender.

In reality there is no honour in delusion. One will not be able to continue, having one day recognized that one has no talent, that one is not a dancer, that one has been dishonest with oneself. In the Congo, seeing the men with whom they had come to fight were not liberators, Che Guevara evacuated his men. It is not true that in Bolivia, having understood that they were surrounded, Che led his men on only to die in a hopeless cause. In reality, he was seeking to escape the encirclement – and though he was captured and murdered, a quarter of his men did escape. And we now know he was right to believe that thousands of Bolivian miners would have come to fight with him. How savagely he reproached himself for believing those who pledged to contact and organize those miners! That he could not have known in time that they were liars is tragic. That Moctezuma could not have known in time that Cortez and his men were liars is tragic.

There is no honour in delusion. If one continues to fight a cause one knows is lost, one does so to demonstrate to oneself, and to one's comrades and to those as yet unborn, that the cause that is winning is ignoble.

The Representative and His Honour

The discourse of an established community determines what could count as observations, what standards of accuracy in determining observations are possible, how the words of common language are restricted and refined for use in different scientific disciplines and practical or technological uses. Further, the discourse of our community determines what could count as an argument – in logic, in physics, in history, in literary criticism or in Biblical scholarship, in economics, in penology, jurisprudence and military strategy, in medical treatment. Establishing what can and must be said about things requires a community with institutions, which set up and finance research teams and laboratories to gather information and

observations according to community standards of accuracy and repeatability, institutions which select and train researchers, and certify and evaluate the researchers and technicians. Establishing what can and must be said about things requires institutions which select what research is to be published, and how it is to be judged.

Every established discourse also determines what does not make sense at all. The grammar of English determines what combinations of English words do not make sense; the symbol system and axiomatics of geometry determine what combinations cannot be mathematically functional; the vocabulary and grammar of mechanics determine what explanations can only be nonsense. The fundamental community decisions as to what could count as observations, what standards of accuracy in determining observations are possible, what could count as an argument determine what statements and what actions do not make sense at all.

An established discourse is not simply a body of statements that circulates, that is taken up by speakers and passed on. It is addressed to individuals and puts demands on them.

Individuals are subjected to an established imperative to formulate what they see and experience in the established concepts of the language and in forms that can be verified. The most intimate and living impulses and insights of individuals lose their individuality in being so formulated. Then an individual speaks as one in whose statement is implicated the logic and theories and cognitive methods of his culture; he or she speaks as a representative, equivalent to and interchangeable with others, of the established truth. She speaks as a veterinarian, an electrician, a computer programmer, a public health nurse. He speaks as a citizen, informed about the traffic code, the banking practices, the dress codes of restaurants and public beaches. Her or his very body sees and feels as an ophthalmologist, a ferryboat captain, a lab technician, a British or Hong Kong subject. He formulates his anxiety attacks in terms of contemporary psychiatry; she names her aches and pains with the terminology of scientific medicine.

An individual presents himself or herself as a representative of a community of knowledge and practice. It is as a representative that he is called upon to honour his word. She is called upon to answer for what she does with words and deeds from the bodies of discourse established as true. There would be no physics, history, literary criticism or Biblical scholarship without speakers who commit

themselves to answer for their statements. There would be no economics, penology, jurisprudence, military strategy, or medical treatment without speakers who are as good as their word.

To speak as a mouthpiece of the established body of information is not to decline to present oneself and answer for one's own words. For one answers with the words of the institution, but stands in those words, puts one's body and one's life in one's response. To be there, in the building, as the electrician is to commit oneself to repair any blown circuit at any hour and wherever it is and in risk to one's body. There are risks an ophthalmologist, a ferryboat captain, or a public health nurse expose their clients to, but they expose themselves to risks that may well be still greater. It is one's honour to be a representative, and it is with a word of honour that one presents oneself as a representative of the established community and the established discourse.

Words of Dishonour

The established discourse discredits as incompetent and unfit and also as charlatans and impostors those who do not represent well and with honour the established truth.

Every established discourse excludes what some individuals say and what they do as inassimilable, intractable. For these individuals the established discourse as a whole functions for them as an utterance. It declares: *You are mouthing nonsense. You are delirious and deranged. You are demented.*

Those found within the community and excluded were identified in the Middle Ages as heretics and also as mystics. They are identified today as psychotics and as religious fanatics. Those outside the community and with whom that community could not communicate were identified in the Enlightenment as barbarians and cannibals. They are today identified as terrorists.

They are not simply dissidents, and may not be dissidents at all. It could well be that one finds oneself excluded, rejected outside, by the body of statements whose veracity one has no doubts about. Mystics and psychotics may nowise contest the rigour and truth of the established religion or the body of psychiatry. But the established discourse is not addressed to them as an utterance soliciting their contribution to truth. It addresses to these individuals but one utterance: *You are incapable of truth!*

Today the community discourse that identifies some as religious fanatics, terrorists, psychotics relegates to nonsense all they may say about things and the world, and in addition silences their utterances, the words with which they put themselves forth, with their words of dishonour.

Individuals outside the community can hear an utterance addressed from another community – or from a community of non-humans. The Enlightenment identified as savages people with whom one could not share an informative discourse about things. They do not answer for what they say and do to our community, but communicate with one another in ways irrational to us, or communicate with beasts and demons. In our societies people who do not speak as representatives of responsible civic discourse, but strike out against interlocutors, are named criminals. Those who do not question or respond to but strike out against the established truth and established institutions are identified as terrorists.

The ravings of the fanatic and the terrorist can be excluded by silence. But it is not only the words but also the deeds of the fanatic and terrorist that do not make sense. Silence is not enough to neutralize their raving bodies. These bodies will have to be isolated, interned, chemically or electrically tranquilized.

The procedures of isolation, internment, physical constraints and tortures aim not only to insulate the community from the ravings of fanatics and terrorists, but also to make them utter words of confession.

It is true that the methods of police interrogation and the theatre of the trial aim to induce the captive to confess to the truth of the politico-juridical discourse that has identified him or her as fanatic and terrorist. And the methods of counselling and psychoanalysis, in most cases imposed under court action or latent threat of court action, aim to induce the fanatic to confess to the truth of the psychiatric-juridical institution that has identified him or her as psychotic.

But neither the politico-juridical institution conceives the fanatic or terrorist nor the psychiatric-juridical institution conceives the psychotic as one who has a part to play in the constitution of the truth. And has a part then to play also in the structure of power, which would be constructed out of the truth established in the community. Instead, what is demanded is that the fanatic, terrorist and psychotic confess that he or she speaks nonsense, that he or she does not have a mind capable of contributing to or verifying the truth of the institution.

What is expected is that he or she avows to being incapable of truth, confesses her or his mind is corrupt, her or his body corruption.

Torture demands this confession and torture demonstrates that the body of the fanatic and terrorist is incapable of truth. The technology of torture works to tear away at his or her body and prove to him or her that he or she is a raving coward. Torture works that the fanatic, terrorist, psychotic put these words of dishonour on himself and herself.

The instruments and techniques of torture do have the power to render a body incapable and brutish, by tearing away at its integrity, proving it cowardly and craven. This demonstration is made with sleep deprivation and shaking in Israeli prisons, with beatings, electrical shocks, burnings in Third World prisons, with incarceration in Maximum Security cells in First World penitentiaries, with confinement, electric shocks and drugs in insane asylums.

The Honour of Savages

The body of the victim, reduced to corruption and decomposition, is still the locus where something resists. What resists giving in to utter the confession the torturer demands is not the character or will of the captive; militants carry vials of arsenic because they know that torturers can crush all character and break any will. Rather what resists in her or him is the relationship with something other than himself and which nowise depends on him – the word of honour given to her comrades who are not rotten, his cause which does not depend on him, the suffering and anger that is born and reborn with every generation of repression, the struggle which did not depend on oneself and will survive one, the mute utterance of the suffering from which one could no longer protect the others and of their anger from which one could not expect anything. Invoking these struggling comrades, invoking this silence and anger, the captive presents himself in the darkness of isolation cells and maintains his honour. Even in the extremity of physical and moral decomposition, even in being reduced to rot and carrion, even in being irremediably separated from his comrades, his cause, the suffering and the anger of the oppressed, his God, the degraded body of the captive, in its pain and despair, presents itself.

In the darkness of dungeons, the fanatic and terrorist hears the utterances of those dead and buried in unmarked graves, the troubles

and agitations of beasts and reptiles, the storms and the geological strata shifting and creaking. The pain and the decomposition of her or his body hears the reverberations of the technological machinery of torture in the empty skies into which her or his screams and sobs are lost, in the cement of the dungeon walls in which they are muffled, in the rock strata of the silent planet into which they sink. He hears also the whine of the mosquitoes and the rustling of the cockroaches and the strident clamour of the night insects outside. Her own gasps and sobs are intermingled with the clamour of insects and the reptile hubbub in the swamps. Even as she and he confesses her and his dishonour, her and his presence utters her and his word of honour to the rats and rocks and stars.

Notes

1. Friedrich Nietzsche, *The Gay Science*, trans. Walter Kaufmann (New York: Vintage, 1974), p.354.
2. *Ibid.*
3. Friedrich Nietzsche, *On the Genealogy of Morals*, trans. Walter Kaufmann (New York: Vintage, 1969), p.58.
4. *Ibid.*, p.60.
5. Friedrich Nietzsche, *Beyond Good and Evil*, trans. Walter Kaufmann (New York: Vintage, 1966), p.40.

reconceptualizing a pictorial turn

lessing, hoffmann, klee and elements of avant-garde language

beate allert

I

Do we live, as Fredric Jameson has already warned us, in a 'prison-house of language'?[1] How can we express thoughts that are not already precoded by the use of language itself? Is the use of language inevitably tied up with deeply engrained power structures? This question has troubled writers and critics from a wide variety of perspectives, including post-structuralism, Marxism, feminism, post-colonialism, and eventually all those concerned with finding a voice for themselves that is not imposed on them, is free from manipulation and void of all censorship. But this is not only a question of the verbal but also of the visual.

I agree with Barbara Stafford, who argues that the so-called 'visualists' in our culture have mainly been dominated or marginalized by the so-called 'textualists' and that in this age of rapidly evolving imaging devices and simulation techniques we must turn to the artists and experts of visual culture for ways of theorizing and critically engaging with such developments.[2] This essay is a contribution to a new ecology of knowledge that will challenge both logocentrism as well as imagocentrism. At the same time, I will try to avoid what I consider a dangerously simplistic trap, namely a forced equation between texts and images.

We may also want to ask ourselves to what extent we are – given our media-driven culture today – the victims of a 'panoptic vision',

one that filters and assimilates all our news, fantasies, and perceptions?[3] The notion of difference was initially a threat until it became widely used and apparently lost its critical edge. We may now be living in an era of globalization in which the notion of egalitarianism plays a similarly charged but changing role. While we are trying to overcome binary thought patterns and either/or modes of thinking, forced symmetries and simplistic generalizations are not alternative ways out. In order to leave reductive forms of knowledge and reflection behind us, it is not enough to switch from the verbal to the visual or to think that we should juxtapose written texts with new images.[4] Although we are accustomed to the notion that what we see with our own eyes is more true than what we read or hear, new forms of image production also require new forms of 'visual literacy'.[5] Visual modes of expression also depend on complex power structures, as has been shown by Martin Jay and others.[6]

While, in antiquity, Horace took *ut pictora poesis* for granted, Gotthold Ephraim Lessing in his *Laokoon* questioned such a symmetry. While the priority of pictures in the formation of language and art has been asserted since the Enlightenment, images were simultaneously reduced for the use of visualization in a limited sense, especially when it was for illustrative or didactic purposes. While exploiting the visual for the textual, the translatability among the senses and disciplines has often remained under attack. Lessing's question whether the poetic could incorporate both what painting and plastic art can do with space and what music can do with time, seems meanwhile discarded. While he may have already anticipated a critique of the Enlightenment discourse while contributing to its formation, his warning may now have to be taken more seriously in our time at the beginning of the twenty-first century. If Lessing argued that images could not be translated into texts, or that poetry and literature had very different tasks in their attempts to incorporate images into their own media, he may have said something that has become even more relevant today.

I intend to explore examples in the histories both of literature and visual art where new modes of expression manifest themselves. Hans Blumenberg has already argued that metaphors may be indicative of substructures of thinking; they may be elements of unfinished thought, not yet fully captured or textualized by the domain of Logos and dominant reasoning. They can therefore hold precious material,

unfinished potential.[7] He suggested a so-called 'metaphorology', the study of metaphor, an archaeology of knowledge in the realm of broken and incomplete images as they emerge in narratives, poetry or in fiction. In doing so, he broke down the binary between image and text and emphasized the dimension of time that governs them both. He believed that images precede discursive logic and that therefore they are the ones that capture the avant-garde potential, even in the broken and fragmented remnants of the metaphoric. Walter Benjamin's 'science of thresholds' was a similar search for elements that can be used towards the construction of heuristic tools.[8] Such tools have much to do with reading and language and they must differ from those Audre Lorde warned us not to use for any counter-cultural purposes when she wrote 'The Master's Tools Will Never Dismantle the Master's House'.[9] The new tools will have to be created from scratch, only with the diverse elements that have already been offered to us by our cultural histories, perhaps as they are being read against the grain. In any case, such readings will require new applications and, as the title of this essay suggests, reconceptualizing.

How to break out of given thought patterns is really a question at the core of all avant-garde art. And, I would claim, it is a question that can perhaps only be answered in the multi-faceted medium of art itself, perhaps indirectly, by the use of metaphor, by the images of children, or by those to whom art is not only superstructure but a basic need and an ongoing search for truth.[10] Children expand their world by combining words they know for things that are new to them or by expanding their vocabulary. It is a feature of metaphoric expression in distinction to discursive writing that words and signs are not used in a way that is lexically already defined but rather newly defined by their specific contexts in very specific situations.[11] Such specificity is crucial for my approach here and so is attention to the temporal aspects of art and aesthetic production.

In February 2000, a symposium entitled 'Art, Music, and Education as Strategies for Survival: Theresienstadt 1941–45' was held at Moravian College, Bethlehem, Pennsylvania, at which were present several survivors of the Terezín concentration camp. They and others are witnesses to the fact that producing art, both pictorial and written, was for them, even under the most extreme and adverse conditions of the Holocaust, a strategy for survival, and a reminder to us that the debate between the 'verbalists' and the 'visualists' is about

matters which can have important consequences in the lives of individuals. There was an exhibition of paintings by the children of Terezín and their teacher Friedl Dicker-Brandeis who studied with Paul Klee at the Bauhaus from 1921 to 1923.[12] Dicker-Brandeis and Klee were both curiously interested in the artistic expressions as they are found in the paintings by children. They shared with children the ability to connect things in unexpected ways, they used lines and colours as part of a rhythm, a process that is not finished with the act of painting but must continue in the act of viewing it. And they were interested in an inner kind of vision, in nature as it is unfinished and continuously created and redone with each of its apparent reproductions. A new ecology of images and ways of reading emerges once we become aware of the ongoing dynamics of artistic production. We were drawn into the creative processes of these paintings as we were drawn into the powerful chamber music that was also played at the symposium, works composed by Pavel Haas, Gideon Klein, Hans Krasá and Viktor Ullmann.[13] Their art has truly survived them and continues to live and energize us today.

My essay here will be limited to three specific case studies on works that belong perhaps to mainstream European culture from the eighteenth to the twentieth centuries. My 'readings' of these well-known works or artefacts will be, however, with a perspective from the margin. I will explore the above question on the potential of avant-garde art, first, in the context of Lessing's *Laokoon*, subtitled 'On the Limits Between Painting and Poetry', a treatise on sculpture with vast art-theoretical consequences, including the production and semiotics of theatre and film. I will critically address two strands of culturally engrained reception patterns of this essay that gained momentum during the twentieth century and especially in the context of recent visual-verbal debates.[14] In particular, I challenge the dominant interpretation of *Laokoon* as a text that has been said to advocate not only a clear distinction between poetry and painting, the verbal and the visual arts, but also to block the interflow between them.[15] It is a text that has - by mistake I believe - been made into one of the cornerstones for the disciplinary divide in Western culture.[16] It seems to have been the classical locus where the visual and the verbal arts became split in terms of their spatiality and temporality. I will dismantle this notion, thus contributing to an interdisciplinary debate on visual-verbal dynamics. I am about to challenge the

interpretation of *Laokoon* as an alibi to separate the arts. I will also challenge the false claim that the visual must turn verbal in order for it to be understood.[17] Neither binaries, nor equations nor metonymic erasures are stable in Lessing's *Laokoon*. I should mention that Lessing's essay has recently become highly politicized in the context of gender studies.[18] My own reading of it asserts that indeed this is a semiotic work with the end result open and the readers/viewers drawn as active participants into the productive process.

The second case study will focus on E.T.A. Hoffmann's *The Golden Pot*, a work of fiction belonging to the genre of the artistic fairy-tale by a writer whose work was a primary source for Sigmund Freud's notion of the Uncanny.[19] The text I am concerned with here allows insights into the auto-referential process of poetic production that places multi-sensory perception at the core of writing. This text, while belonging to Western culture and German Romanticism, offers a critique of logocentrism and ocularcentrism. It questions intentionality as primary force in the production of texts and images. It ridicules the life of normality with the bourgeois and Philistine types, such as Sub-Rector Paulmann and Registrary Heerbrandt, but it also makes fun of the paradise-like yet artificial and grotesque studio of the Archivist Lindhorst where the trees, birds, and flowers may either consist just of paper and belong to the tapestry or be dangerously alive and bewitched. There are multiple levels of the plot. Anselmus must enter the territory of the Archivist and gets drawn into a struggle that is gendered on a higher plane and that involves the mundane as well as the supernatural. Anselmus encounters animals and animated figures or forces with whom he must learn to communicate before he can actually find his own role as a writer and contribute to the process that will lift the spell. He must master fears that are reminiscent of those evoked in Lessing's *Laokoon*, and he is prone to various mishaps, such as stepping into the basket of the old apple-woman at the market place. Then all of her apples roll out of the basket and he feels as if for each displaced apple more eyes were staring at him. But it is not only seeing he must conquer, but multi-sensorial perception. The key to the dilemma seems to be a subtext about Lily and Phosphorus and about the splitting of senses which separated the current world from that of Atlantis.[20] Binaries between the real and the imaginary, the male and the female, the normal and supernatural, become extremely problematic and sometimes

boundaries get blurred in the process of this complex narrative. Imagination acts as a constructive force. What can rescue the situation is an open, childlike spirit like that of the student Anselmus, the power of the poetic. Although in Hoffmann's text it is the male world of the Salamander, or of the Archivist, who in the end seems to win the battle over the dangerous world of the apple-woman and her associated creatures, it is the feminized snake Serpentina who, on a more concrete level, mediates the current solution.

Further aspects of the genesis of artistic production and the interfaces between the arts are examined in the context of my third case study on three works by Klee in which he explicitly makes reference to E.T.A. Hoffmann. The pictures I will discuss have features that can – in my view – be better understood intertextually. Jürgen Glaesemer has documented that Klee actually went to the première of Jacques Offenbach's opera libretto 'Hoffmanns Erzählungen' at the Stadtheater in Bern on 7 February 1904, which may have been the first contact Klee had with Hoffmann's work.[21] We know that Klee went to this opera libretto more than once and that he commented on reading Hoffmann in his diary and letters. So far, very little has been done with Glaesemer's important information.[22] There is a specific context in which Klee expressed his own affinities to what he termed 'cool Romanticism.' He wrote in his diary:

> One deserts the realm of the here and now to transfer one's activity into a realm of the yonder where total affirmation is possible.
>
> Abstraction.
>
> The cool Romanticism of this style without pathos is unheard of.
>
> The more horrifying this world (as today, for instance), the more abstract our art, whereas a happy world brings forth an art of the here and now.
>
> Today is a transition from yesterday. In the great pit of forms lie broken fragments to some of which we still cling. They provide abstraction with its material. A junkyard of unauthentic elements for the creation of impure crystals.
>
> That is how it is today.
>
> But then: the cool crystal cluster once bled. I thought I was dying,

war and death. But how can I die, I who am crystal?

I crystal.[23]

In *The Golden Pot*, the word 'crystal' also plays a key role. On one level, it is associated with the spell that separates the current age from that of Atlantis. There is also the curse of the apple-woman on the market place that shouted Anselmus would 'fall into crystal'. Crystallizing and freezing are ways to visualize stagnation. Anselmus has to overcome this curse before he can become a writer and enter the poetic realm. Notions of crystallizing and freezing invoke also their opposite, liberation and dynamism. Klee's outspoken affinity with 'cool Romanticism' has puzzled many Klee scholars.[24] I suggest that we consider the clues we already have in order to gain new insights into his and into Hoffmann's work. Klee did not use more readily available tools, such as realism, representational art, or explicit political speech. Instead, he pictured the realm of metaphor and elements from far away, the past and the supernatural, in order to make his own statements. His art has energized generations to come in amazingly avant-garde ways.

My approach to these works is political in a sense, as is my initial question about border crossing beyond given norms. How do these works reflect interdependency, as well as individuality and freedom of artistic production? Why have certain aspects of them been so grossly misunderstood in their reception histories? How do these works entail visual and verbal aspects both and negotiate certain themes and constellations between them? How do their approaches differ? What gender implications are there? What theoretical consequences can we draw? I hope to address these and other questions in my case studies on Lessing, Hoffmann and Klee and as they also arise in current discussions about the limitations and potentials of our visually oriented time. For example, in German the word *Verfilmung* has been regarded in terms of a loss from texts to images, as if literature was better than its filmic counterpart since it allows apparently for more imagination. I will challenge this concept as a by-product of the split between academia and art, or literary studies and popular culture. A new ecology of knowledge will perhaps operate on the basis of careful intertextual studies between the visual and the verbal but on assumptions that no longer adhere to outdated hierarchies among the senses and disciplines.

II

Laokoon by Gotthold Ephraim Lessing has been the basis of an aesthetics that acknowledges the importance of the medium for the message, the significance of signs in terms of their effects rather than their ontological status, and the open-endedness of semiotic projects.[25] In connecting *Laokoon* with such diverse artists as E.T.A. Hoffmann and Paul Klee, it is my thesis that their works contribute to the semiotics of art where meaning is not given, but always created in the process of reception. Lessing draws attention to the materiality of the signs, the media-specific meanings of messages, and a split between the sayable and the seeable, as became important later in the theoretical reflections of Foucault and Deleuze.[26] Lessing shows the key role of imagination in both realms, the verbal and the visual and explores gaps and contiguities between them.

In order to contextualize *Laokoon* in Lessing's time, one should remember that Aristotle in his *Poetics* had already made a distinction between the 'rhythmic arts' such as dancing, poetry, and music and the so-called 'arts of the rest' such as painting and sculpture.[27] This distinction was apparently long forgotten. The Greek poet Simonides of Ceos called poetry a speaking picture and painting a mute poem, thus emphasizing their correlation rather than their distinction.[28] As Edward Allen McCormick noted in his introduction to his translation of *Laokoon*, in the Middle Ages painting was considered the nobler art and the poets attempted to borrow from the painters by visualizing their thoughts. The Renaissance seemed to establish equality in terms of *ut pictora poesis* and, for example, Lodovico Dolce stressed that the poet is at the same time a painter.[29] What links the two is the concept of 'imitation' and while the painter imitates by lines and colours, the poet imitates by words. This approach remained valid through Dryden, Milton, Pope and others. Abbé Jean-Baptiste Dubos found it most significant that the two arts arouse emotion and that poetry and painting are copies of real passions that can affect us in just the same way as would the objects imitated.[30] In such a view, art has in a sense obtained an equal status with reality, a notion which has gained new currency not only for Jean Baudrillard, but also in the context of Klee, where abstraction is unavoidable and not a matter of mimetic deductions.[31] It has its own right.

Dubos pointed out, as similarly did Lessing, that painting represents

only one single moment and its signs are coexistent, whereas poetry produces its effects in a linear series of instants. The verbal arts share many features with music in contrast to the spatial arts. Dubos claimed superiority of poetry over painting in the representation of the sublime, thus suggesting a dangerous hierarchy among the disciplines.[32] There were other contemporaries with related arguments, mostly critical of the neo-classical literary norms of their times, such as the Swiss writers Johann Jakob Bodmer and Johann Jakob Breitinger in their *Discourses of the Painters*, advocating the admission of the supernatural and the acceptance of emotion in art, thus challenging normative poetics in similar ways as Lessing did.[33] Lessing's *Laokoon* is a work with multiple sources and references and perhaps therefore, as some critics think, with limited originality. But there is no doubt that Lessing's text had powerful effects for generations to come. Lessing was not only one of the most prolific authors of Enlightenment discourses but also one of its most articulate critics and ahead of his time, at least as certain features of its dominant discourse are concerned. There are aspects belonging to marginalized discourses of the Enlightenment to which Lessing also contributed, but these have been repressed in the reception history for a long time and are only now beginning to emerge in scholarship.

Lessing's *Laokoon* is a theoretical treatise on the limits of painting and poetry, the visual and the verbal, with particular focus on the famous statue. It is a masterpiece of rhetoric with its brilliant use of metaphor, irony and poetic self-reflection. The statue is a representation of the Trojan priest of Apollo, who, in trying to save his two sons from being strangled by monstrous serpents, is fatally entangled by them.[34] What we can see in the statue is three bodies under attack, and there is tension and subdued emotion. Laokoon attempts to rescue his sons and himself while he must already feel the firm grip of death. As the spectators know from the surrounding script, this is a futile struggle against the snakes. To what extent emotions are actually shown, or rather projected by the viewer or reader on the artwork, is a matter of discussion in much scholarship even today.

First, Lessing's commentary on this famous topic shifted attention away from the literary sources, especially from Virgil's account of the story (*Aeneid*, Bk. 2, ll.199–227), according to which the central figure was crying out in agony. Lessing reminds us that the mouth of the figure is not that of a loud scream as Virgil's text would have it.

In contrast to Winckelmann, who argued that the figure was silent because that had to be consistent with the classical Greek ideal of restraint or subdued emotion for the sake of 'quiet grandeur', Lessing (chapters 16 to 22) rejected any such arguments that are not based on the specific art work itself.[35] He also questioned the classical ideal of apparently undisturbed harmony in all circumstances and introduced the idea of a 'silent scream', a notion that has been influential in the works of theatre and film, including the works of Bertolt Brecht and Sergei Eisenstein.[36] While drawing attention to the pragmatic medium of the sculptor and the presence of the art work, Lessing argued that the statue simply could not show any scream due to the limits of its visual media. The statue must limit its account of the action to one single moment in the flux of time. Visual art requires something of a performance and the sculptor must apparently arrest time and catch one moment that is most fruitful for the action surrounding the statue. Lessing introduced also the notion of a most 'pregnant moment' into art-theoretical debates.[37] By subtracting the notion of development out of the image into the realm of the textual temporarily, he did not exclude the verbal from the visual once and for all. He also raised new questions for the observers to solve.[38] Although the spatial and the temporal have important roles both in painting and poetry from today's point of view, Lessing experimented with these binaries for the sake of something else. Lessing does not present his solution to the readers in any ready-made form. By pointing out that visual art is silent, that it has signs that need deciphering regardless of any possible underlying texts, he contributes to the emancipation of the visual from the verbal and to a concept of speaking images which has meanwhile been developed and used for feminist criticism by Mieke Bal.[39]

By pointing out that the verbal lacks spatiality in one context, Lessing makes perhaps the first step towards what Gaston Bachelard subsequently called the 'poetics of space'.[40] It is the observer having to make choices and to create meaning. While the Laokoon statue in Lessing's time was mostly interpreted on the basis of a story that has numerous versions in classical literature, Lessing had the statue speak for itself. By drawing attention to 'the most pregnant moment', he pointed out that images are not given but created in a process.[41] And as Carol Jacobs shows in her essay 'The Critical Performance of Lessing's *Laokoon*', Lessing's text makes use of insights it does not

really say but rather demonstrates. It is a dramatic performance if you will, an illustrated reading of a statue that involves us in an unfinished debate. It is not only about the three figures that are about to be strangled by the snakes. There is another trio at stake: 'The textual situation in this essay "Über die Grenzen der Mahlerey und Poesie" evolves as a polemic against Winckelmann's *Gedanken*, Spence's *Polymetis*, and Caylus' *Tableaux*.'[42] Lessing distanced himself from Winckelmann, Spence and Caylus, who each articulated borders of art. And another trio Lessing evoked in *Laokoon* was that of Alexander Gottlieb Baumgarten, his student Georg Friedrich Meier, and Moses Mendelssohn, as David Wellbery noticed.[43] What makes Lessing's approach different from all the others is, for example, the following observation:

> According to the limits of the visual arts, all figures are motionless. The life of motion which they seem to have is the supplementation of our imagination; the art does nothing except stir our imagination. – We are being told that Zeuxus painted a boy carrying a bunch of grapes and in these art had become so close to nature that the birds flew towards them. But Zeuxus was annoyed with himself by this. I have, he said, painted the grapes better than the boy. Had I finished his image completely, the birds would have been more reluctant to approach because of him... The eyes of animals are harder to deceive than the human ones; we are seduced by imagination so that we believe we see what we actually don't.[44]

While experimenting with the tradition of *ekphrasis*, Lessing became aware of the distinction between *similitudo*, which may be the goal of mimetic realism, and on the other hand the excellence of a painting. He also noticed a split between signs and signifiers and the flexibility of 'interpretants', a notion I borrow from the semiotics of Charles Sanders Pierce and Umberto Eco.[45] Lessing shifted attention from the intention of the artist to the interpretation by the viewer, whether bird or human. The latter seems more actively involved in the construction of meaning. Lessing emphasized the productive power of imagination in the understanding of the plastic and performing arts, although they can present 'bodies' in space apparently much more readily than the verbal arts can. But this sensuousness or corporeality in visual representation is only one

aspect that marks their difference from the verbal and it could be seen as a possible advantage of painting over poetry. But there are other aspects as well.

As Lessing's subtitle, 'Über die Grenzen der Malerei und Poesie', suggests, *Laokoon* is to a large extent about differences between the plastic arts and poetic language. While Lessing neglected important distinctions between sculpture and painting and used the term 'Malerei' for both – which then has been translated widely as 'the plastic arts' – a clear line was drawn between what Lessing called 'Malerei' and 'Poesie'. Lessing broke with the traditional symmetry between the visual and the verbal arts as was implicit in Horace's dictum *ut pictura poesis*. Lessing pointed out that 'Malerei' uses figures and colours in space, whereas 'Poesie' articulates sounds in time. He not only drew attention to the different media used in both disciplines, their various materiality, but also how they differ in their approach to mimesis. He would therefore not believe in the translatability among the senses as it was proposed by Louis-Bertrand Castell with the invention of his ocular harpsichord in the eighteenth century.[46] Instead, Lessing would insist that untranslatable residues remain in any attempt to make the acoustic visual or the visual acoustic.

Lessing tried to explain different effects by linking the visual with the realm of figures and colours as seen in space and the poetic with sounds as heard in time. Whereas in the visual arts bodies are seen in space only from one point of view and – as Lessing argued – only at one given moment, the territory of poetic language is, as Lessing already indicated, and as Deleuze and Guattari put it later, that of 'a thousand plateaus', complex, dynamic, and rhizomic.[47] The ability to present things in process, as they evolve or change in time, as they belong to actions and entire stories, this appears to be an advantage for the verbal arts over painting and sculpture. Lessing continued to explain, however, that of course we also see movement in paintings and sculptures, but these are due to an effect that has to do with the significance of absent signs which require, as he put it, 'the supplementation of our imagination'.[48] In other words, Lessing approached both the visual and the verbal in terms of sign systems that require mental performances in the act of understanding. This is the reason why Lessing can well be understood as a semiotician.

He warned both visual and verbal artists to respect the limits of their medium and to avoid certain transgressions. He mentioned what

a terrible mistake it would be if a painter were to attempt to capture two distinct moments in history as if they belonged together and unite them in the same painting. If, for example, in the painting of the *Rape of the Sabine Women* by Parmigianino (Francesco Mazzola), there seems to be an immediate reconciliation after the violence and the women are gathered with relatives and new husbands peacefully in the same picture, this would speak of even worse than bad taste.[49] Lessing gave other examples of transgression and argued to keep painting and poetry apart.

Nevertheless, Lessing did not stop at having drawn the line between the visual and the verbal once and for all, as some readers all too quickly concluded.[50] Lessing avoided categorical thinking and explored moments that indicate that there exists more than one level of the argument. He acknowledged that the various disciplines of art, or the multiple senses involved, can nevertheless interact with each other and change in the process. Lessing may have drawn from Hogarth's technique of engraving by noticing that negative images or absent figures may be as decisive as present ones. Lessing commented on the fact that Homer does not offer us any overall image of the size of the palace in the *Iliad* (Bk.6, ll.242–250), yet in describing the gardens of Alcinous (*Odyssey*, Bk.7, ll.112–132), he made us participate in something of a walk through them and be more convinced about their beauty and the size of the palace as if these had been mentioned. The narrative has a gradual effect. Beauty is no longer a matter of objects in space that are being portrayed or described; instead Lessing becomes an advocate 'to dissolve visual attributes of bodies in motion'. He dissolved the subject/object binary in a post-Kantian fashion and developed a process-oriented approach to language and gesture while highlighting the significance of absent signs for poetic action: 'Even in Ovid the gradual paintings are the most frequent and the most beautiful ones; and that which was never painted and never could be'.[51] An observation such as this one can well be regarded, as Claudia Brodsky-Lacour has accurately noticed, as 'a kind of Baudrillardism avant la lettre'.[52] What is at stake here, is Lessing's decisive move to emphasize the importance of imagination in the construction of what is then considered reality. Lessing activated images to the point where signs can attain natural status via the constructive action of the interpreter and in the transformation of the poetic, but the signs as they were used in dominant language

are denaturalized and understood as cultural artefacts that can well be questioned in their conventionality. The poetic serves as a philosophical tool beyond the established borders of Lessing's time. It is a visionary moment in art history and critical theory that can be – as is my political move here – claimed for a kind of Western tradition that has so far not been verbalized or mobilized enough.

III

E.T.A. Hoffmann was a musician, composer, writer and also a painter of caricatures. His *Golden Pot* is a multi-level narrative containing, on one level, the story about the student Anselmus who is being initiated to the world of 'Poesy' or 'Dichtung'. In order to enter the poetic world, he must contribute to the arrival of a new age that would lift a spell that had affected himself and others around him. He must undergo several tasks before learning how to read and copy a manuscript that is assigned to him and written in a foreign language. As it turns out, it contains valuable information, even concerning his own life. If he could read this foreign text, he would be able to write out his assignment, copy the calligraphy as requested and thereby enter the poetic realm. He must listen to nature and the supernatural in order to understand what the text is about. The mystery is how the inner and outer worlds correlate, although for Anselmus they apparently clash.

The opening scene is one of an accident when Anselmus walks into the basket of an old lady at the market place and all her apples are scattered about. He is horrified by the scream of the woman and speechless when she casts a curse on him while taking the wallet he holds out in shock. The old lady's curse is something about him 'falling into crystal', a sentence he cannot fully understand but which sounds so shrill that the laughter of the crowd becomes all of a sudden muted.[53] The comical situation turns somewhat tragic, with the bystanders making pitiful remarks about 'the poor young man' which makes Anselmus even more flustered and angry. Everyone stares at him, the circle of spectators opens and the movement of decentralizing repeats itself, but this time it is not the apples which scatter but the people and, with relief, Anselmus runs away from the crowd of spectators.

Much later, Anselmus becomes a writer under the auspices of

Archivist Lindhorst. He has met Serpentina, one of three small green and gold snakes under an elder tree and will discover that she is the key for him in his efforts to enter the poetic life. Anselmus learns that she is a sign for creativity, a principle of otherness. One may notice that in Hoffmann the snake is female. The snake has been a symbol in Western culture associated with evil entering paradise, or else with maleness. These attributes do not fit here. Anselmus comes to love Serpentina much more than Veronica, the daughter of Registrary Heerbrandt, who would have liked to have captured him as a husband. The snake Serpentina in Hoffmann's narrative had quite different connotations from the snakes in the statue *Laokoon*, although in both cases they are associated with danger and beauty. In Hoffmann's text, the gaze of Serpentina causes feelings in Anselmus varying from 'supreme happiness' to 'intense pain'. (p.5) Words used in the narrative change meanings depending on their specific contexts.

Not only do *The Golden Pot* and *Laokoon* share the occurrence of snakes and the number of three (there are three figures in *Laokoon* and three snakes in *The Golden Pot*). There are other intertextual moments. There is, as already indicated, the breaking of circles. Whereas in *Laokoon* a circle gets broken by the snakes drawing closer and closer together in their attempt to strangle the three humans, in *The Golden Pot* a circle gets broken by scattering apples out of their container ('Anything that luckily avoided being squashed was scattered all over the pavement', p.1) and the circle of the crowd opens up for Anselmus, an outsider. It is also historically significant for Hoffmann to begin his narrative with such a powerful comment on a world in dissolution and disorder.

The story takes place in Dresden and was written there between November 1813 and February 1814. The city and the surrounding districts of Saxony were occupied by French and Russian troops in their campaign against Prussia. The city was held by the French until they capitulated to the Prussian besiegers on 11 November. Much of the city, along with its parks, which had been famous for their beauty, was largely destroyed. Hoffmann himself was grazed by a bullet.[54]

We should note that in the beginning Anselmus, the aspiring protagonist as writer, is socially a marginal character of the story, if not an outcast. Like Lessing's *Laokoon*, Hoffmann's narrative reveals gaps and silences as part of the action. Notions of natural and arbitrary language coexist. Anselmus does not see the snakes at first,

it is a sound which first attracts his attention. And the sounds of nature become instructive for the poetic:

> Anselmus's self-communings were interrupted by a strange rushing, swishing sound which started in the grass just beside him but soon slid up into the branches and foliage of the elder-tree arching over his head. At one moment it sounded as though the evening breeze were shaking the leaves; at another moment it sounded like birds billing and cooing in the branches, playfully fluttering their little wings. Then a whispering and lisping began, and the flowers seemed to tinkle like tiny crystal bells. As Anselmus listened more and more intently, the whispering and lisping and tingling somehow turned into faint words, trailing away in the breeze:

> 'Through the trees, through the leaves, through the swelling blossoms, we slip and slide and slither – sisters, little sisters, slither through the shimmering sunshine – up and down – the evening sun shoots its beams, the evening breeze breathes and stirs the leaves – the dew descends – the blossoms are singing let's raise our voices, and sing with the blossoms and the breeze – soon stars will be shining – we must descend – through the trees, through the leaves, slip and slither little sisters'. And so it went on, bewilderingly. 'It's only the breeze' thought Anselmus, 'though this evening it almost seems to be uttering intelligible words.' But at the moment a trio of crystal bells seemed to peal out above his head; he looked up and saw three little snakes, gleaming in green and gold, coiled round the branches and stretching their heads towards the evening sun. Then the whispering words began again, and the snakes slithered... (p.5)

Hoffmann's story reads on one level as that of terrible alienation, and on another level as that of the redundancy of repetitive patterns. This young man almost loses any sense for reality when he gets drawn to these elements of nature and the supernatural. He gets a job offer to do some writing for the Archivist. When he is just about to enter the Archivist's house, he has a strange encounter that evokes the earlier experience at the market place:

> Standing there, he looked at the fine big bronze door-knocker; ... and as he was to seize hold of the door knocker, its metal features were hideously obscured by fiery blue rays and contorted

into a grin. Alas! it was the apple-woman from the Black Gate! Her pointed teeth were rattling in her loose mouth, and their rattling said 'You gr-r-reat gormless fool! Just you wait! Why did you run through the gate? You fool!' Anselmus reeled back in horror; he tried to hold to the doorpost, but his hand grasped the bell-pull and tugged it; the bell rang more and more loudly in jarring discords, and its mocking echo could be heard throughout the deserted house. 'Into glass you must pass!'

Such terror gripped Anselmus that a convulsive shudder ran through his every limb. The bell-pull sank to the ground and turned into a transparent boa constrictor which coiled itself around him and squeezed him ever more tightly in its folds, until his limbs were crushed to pulp and the blood spouted from his veins, seeping into the serpent's transparent body and dyeing it red... When Anselmus regained his senses, he was lying on his wretched pallet; but Sub-Rector Paulmann was standing before him saying: 'In Heaven's name, my dear Anselmus, what on earth have you been up to!' (pp.13–14)

Some readers of Hoffmann's *The Golden Pot* have argued that it is a story of a mental illness, which is signalled by ambiguous signs, unstable meanings, and techniques such as ellipsis, ekphrasis, compression, and metaphoric displacement.[55] Hoffmann's narrative reads on another level, however, and perhaps in contrast to his later fiction, as a process of becoming a writer and of entering the poetic realm. The realm of the poetic is associated with the beauty of an inner world where everything could be meaningful and connected. It is a story of crisis, transformations, and rescues.

Serpentina is an interactive force connecting many figures in the plot surprisingly. Archivist Lindhorst tells Anselmus about the context of the golden pot, an object of desire associated with the lily, recovery, and rebirth in another life:

Serpentina loves you, and a strange destiny whose fateful threads were spun by malign powers will be fulfilled when she is yours and you receive the golden pot, which belongs to her, as an indispensable dowry. But your happiness in a higher life can only be born from struggle. You are beset by malign forces, and only the inner strength with which you resist their attacks can save you from disgrace and perdition. By working here you will pass your

apprenticeship; and provided you persevere in the task you were obliged to begin, faith and insight will lead you to your goal, which is close at hand. Carry her always in your heart – Serpentina, who loves you – and you will behold the magnificent wonders of the golden pot, and be happy evermore. (p.42)

Anselmus learns about the lost territory of Atlantis where language was a matter of natural signs and where humans were once in harmony with nature. This harmony was lost after the Lily had fallen in love with Phosphorus, which caused her destruction.[56] Everyone in this story must participate in a struggle that is textualized in terms of the Salamander's fight against the same destructive forces that Anselmus has also encountered, for example in that moment when he walked into the apple-woman's basket in the market place in the opening scene. He thinks her face appears again when he sees the doorknob upon entering the house to go to his new writing job. And the bell-pull turns into a boa-constrictor almost strangling him. While Serpentina and the three snakes Anselmus met under the elder tree have nothing in common with this apparent snake, the same character in the story may appear in more than one figure. For example, the Archivist is also the Salamander and must win a battle against the apple-woman and against the dragon. Many incidents are integral to this fight on several levels of the plot. Anselmus gets drawn into this multi-level battle as a participant.

After a series of attempts not to spill ink in the writing process and to copy precisely the hieroglyphs of a text on a parchment roll written in a foreign language strange to him, Anselmus enters another level of the poetic where signs are transitory. Serpentina has, and this is the principle she stands for, more than one meaning. When Anselmus is still not aware that it was himself who in a forgetful state must have actually copied the text as requested by the Archivist and with the magic of Serpentina, Hoffmann's own narrative challenges the notion of authorship. At one moment:

[t]he clock struck six and he realized with a shock of remorse that he had not copied a single stroke; full of concern at what the Archivist may say, he looked at the sheet, and, wondrous to relate, the copy of the mysterious manuscript was complete and flawless, and as he looked more closely at the characters, he was sure he had copied out Serpentina's story about her father,

the favorite of Prince Phosphorus in the wondrous land of Atlantis. (p.57)

As illustrated here, knowledge operates on more than one level and the world of described visibility is only a small fragment of the so-called real world. What makes Anselmus successful here is that he forgets what authority, or the Archivist, would say. He takes these coexisting figures operating on various levels of the familiar, unknown, or remote worlds for equally real. Hoffmann's story is complex and one that unfolds slowly in time. Anselmus has entered an inner world where, for example, onomatopoetic sounds, whispers of leaves and of snakes become meaningful to him. The poetic world is to be found in the world of the mundane where also natural and supernatural forces interact and coexist closely next to each other, sometimes interwoven and indistinguishable from each other. Anselmus created the text he had to write not just by focusing on the script nor by looking at things around him. Neither logo- nor imagocentrism were the answers to his search. He acknowledged that anything could become alive, that animals may actually be humans, that humans may be governed by bewitched forces, but that one must participate in the construction of meaning without excluding the invisible. Anselmus entered the poetic realm after communicating with what seemed to him strange creatures at first. He learned to interact with the salamander, the screech owl, the parrot, not just the snakes, before he was able to break the spell.[57] A fiery lily will eventually grow again from a golden pot.

IV

Paul Klee suggests a type of visuality that is reminiscent of 'Serpentina' and of the snakes in *Laokoon*. One of his paintings is called *Still Life with Snake* [#3575 (1924.203)].[58] Its colours are mostly tones of green and yellow. Klee often uses dividers and grids to separate fields in his paintings from one another and to visualize dynamic forces in his works. He brings the inner and the outer worlds together in unexpected and often immediate and subtle ways and is obviously drawn to nature, to the human, the plant and the animal worlds. He presents emotions by the use of colours, lines and motifs, while avoiding, however, any narrow kind of mimetic fixation. His

paintings are, as Klee explained in his diary, necessarily abstract (see note 23). As he explained, abstraction is needed in an era of transition – as he understood the present – at a time which is definitely not characterized simply by a 'happy world of the here and now'. Other pictures by Klee are titled, for example, *Tree-Man Dialogue* (1939.403),[59] *Tropical Twilight with the Owl* [#2720 (1921.129)], *Ad Marginem* [#5328 (1930.210)], *Growth in an Old Garden* [#2233 (1919.169)] and *Dwarf (Fairy Tale)* [#3937 (1925.255)]. But it would be reductionist on my part if I were to claim the Klee-Hoffmann-Lessing triangle as any dominant explanatory model for the deeply complex and truly innovative works. It is not my intention to claim, for example, a one-to-one mirror relation between Klee and Hoffmann, or to limit my reading of Klee's images only to influence studies. However, intertextual references between these artists are definitely there and have long been ignored in scholarship; they may be themselves marginal for a comprehensive interpretation of Klee's works yet they may help towards a better understanding in some respects.

As far as the images with the above titles are concerned, *Tree-Man Dialogue* shows the tree in much larger proportion than the man who seems to be falling backwards, overwhelmed with the message of the tree. It could well be seen in the light of Hoffmann's Anselmus under the elder tree when he first hears the whispering of the leaves and meets the three snakes, especially Serpentina. The *Tropical Twilight with the Owl* could be understood in reference to Archivist Lindhorst's studio with the screech owl and the poetic realm in the 'twilight' between real and imaginary, with creatures that are actually something else and must be liberated from the horrible spell that has bewitched them all. *Ad Marginem* shows a process of decentralizing, birds are walking upside down as if on a ceiling on the top margin of the image, there are centrifugal powers that seem to work against the habitual magnetism of the earth thus shattering the traditional assumptions of a world in order. Things tend to move away from the present world into other more remote worlds, a process Klee also called 'abstraction'.

Such a dynamic is similar to Hoffmann's highly symbolic notion of the apples falling out of the basket and running in all directions. *Growth in an Old Garden* is a palimpsest, a multi-layered combination of an underlying script or its letters that are illegible since they are under a layer of flowers, or just images of fragments of them with stems, leaves, overgrown weeds, life or fossilized organisms. The

mixture suggests an intertwining between the verbal and the visual, the old and the new. The colours are subdued and darker on the surface but underneath it is glowing and life comes to the fore under scrapings and scalings. This process is also reminiscent of Anselmus' relation to the script he must deal with, a text that comes to life and has liberating power in the context of the fairy tale which gets ironically real but reversed once he listens to the messages he gets from nature for his writing. And the *Dwarf (Fairy-Tale)* could very well illustrate that doorknob reminding Anselmus of the shrill-shouting face of the apple-woman at the market place when he first enters the Archivist's studio for his writing job. It is done in yellowish, golden and bronze colours and it shows a grin. It could also be a reflection of the person looking at it, thereby being a distorted image of the self in doubt, as would also be accurate for the case of Anselmus.

A Klee-Hoffmann study may be worthwhile, although it should not limit but rather enhance the understanding of Klee's paintings. My approach of intertextual verbal-visual studies seems justified – with the limitations I admit – particularly in the context of three paintings by Paul Klee which he explicitly devoted to Hoffmann. So far only Jürgen Walter's 1968 article deals with the connection between E.T.A. Hoffmann and Paul Klee.[60] The three Klee paintings I want to comment on in the light of Hoffmann all share the same motifs and may be considered consecutive steps in a development.

The first one is a pen and Indian ink sketch of 1918, which Klee called *Hofmannesces* [sic] *Scherzo: Im Geiste Hoffmanns* [#2029 (1918.182)]. It shares with the consecutive pictures the triplet structure of three distinct panels with the one on the left reminiscent of the beginning of Hoffmann's story, the one to the right with the writing figure and the clocks of the middle part and the centre with the lily referring to the end of Hoffmann's *The Golden Pot*. This sketch already shares with the other pictures by Paul Klee devoted to E.T.A. Hoffmann the basic motifs of a lily slightly off the centre to the left with a heart and three piercing sticks. The lily seems to grow from a triangle which may symbolize the golden pot. Compared to the other motifs, this one is not a dominant one and 'the pot' would be a triangle, different from what we may expect. Right under the lily seems to be the abstract figure of two people about to embrace on a small ladder, a composition which calls to mind the closing scenes of *The Golden Pot* when Serpentina appears with the golden pot and

while 'Anselmus embraces her with the ardour of intense passion, the lily burns above his head in flaming rays of light'. (p.82) There is a clock next to a figure to the right in a sitting position. This may be Anselmus in the Archivist's studio, surrounded by many non-parallel sticks expressing dynamics, tension, perhaps also his obstacles in the process and the powers he must deal with. It seems that the same figure, Anselmus, is shown in various positions at the same time but in various distinct portions of the image which are dynamically related but clearly distinct from each other. Above this figure in the upper right corner is another clock with pointers that are longer than the face of the clock. They show beyond the expected limits of time. There is an abstract sign of a bird right above it in the upper right corner. In the lower left corner, a human figure with face upwards seems bending backwards under a tree or a similar plant structure indicating growth. This motif is reminiscent of Anselmus under the elder tree when he first hears the whispers of the snakes and meets Serpentina. A spiral connects to this figure's face which may be a sign of dizziness, lack of control, being thrown into the hands of nature, as Anselmus similarly experienced. The spiral connects this figure with the two other panels in the picture; it runs from the face of the figure upwards to the right, across the lily in the middle and into the area where the tension is also most notably located adjunct to the writing person. It thus connects all parts of the story and has an upward motion correlating various spheres of consciousness and multiple levels of time.

The second picture of 1921 is an oil transfer and watercolour painting with various layers belonging to Klee's first Bauhaus folder titled *Hoffmanneske Geschichte* [#2609 (1921.18)] (plate 13). It has cheerful light colours in yellow, light blue, green, pink. The colours are not simply added to fill the spaces as apparently already outlined in the early 'scherzo', they have a dynamic that is equally powerful as the lines. They create something of an ironic fairy-tale mood, spaces of translucent light consisting of layers, rectangles, and segments of panels that do not superimpose each other but instead create a sense of three-dimensionality and of opening imaginary spaces. While still consisting mainly of three distinct panels, these are now not the most dominant structures in place. The figures are still sketchy, similar to caricatures, abstract. Also, though they are recognizable, the tree, the lily and the bird are depicted as if seen from afar. The pointers of the two clocks

have different positions thereby indicating the simultaneity of various time-frames. And again, these indicators of the time exceed the clocks. It is a painting which clearly does not copy nature as it is seen in any naturalistic scheme and which is also not any kind of representation

Plate 13. Paul Klee, *Hoffmanneske Geschichte*, 1921; The Metropolitan Museum of Art, The Berggruen Klee Collection; copyright DACS, photograph Metropolitan Museum of Art, New York.

of Hoffmann's fairy tale. There is no hierarchy between images, texts, art, or nature. They are all energized, as is the lily in the golden pot, by creativity that does not exhaust itself with any one given notion of reality. Instead, all these multiple realities have the same source as the lily in Hoffmann's story, the realm of the poetic, where things mean one thing but yet another, etc. It is a painting which is related to Hoffmann's text as if operating from the same distance to the world of normality, from the same connectedness of all creatures, and from the same imagination of a crystal where the past, the future, the present, and notions of Atlantis intersect. They are all connected by irony or, as Klee called it, 'cool Romanticism'.

The third one is a colour lithograph, also done in 1921 and called *Hoffmaneske* [sic] *Märchenscene* [#2714 (1921.123)]. It is much darker in tone. The colours are purple, violet, beige and brown, with several empty white spots in between. Like the other two it is divided by black lines mainly into three distinct panels, yet this third version has patches of darker and lighter rectangles that are structuring the image in a more noticeable way than in the second just mentioned. All three images are characterized by horizontal and vertical lines that give a sense of rhythm. They could be distinct rooms, houses, or even worlds, separate from each other and with various measurements. The motif of a recurrent ladder indicating a notion of progress, change, multiple levels upwards also seems important. Human figures are shown in various positions that appear as falling, gliding, or hanging. What is significant in these images devoted to Hoffmann is a reversal of expected proportions between humans, plants, and birds. The human figures seem very small in comparison to the plants and the bird in the upper right corner, while the lily slightly off the centre occupies by far the most dominant space. Klee teases us also about the unreadable clocks, one indicator pointing to the left and longer than the circle of its faceplate, the other pointing up as if it were shortly after midnight or noon. The other clock has its pointers down in apparently reversed order and also with the pointers longer than the clock's circle. Jürgen Walter has commented on the *Hoffmaneske Märchenscene* with emphasis on its unique colour transparency. He perceptively wrote:

> The colour-plane of the picture is being generated as a crystalline construction of colour-faces. The plane is graduated light-dark

in itself and broken down rectangular-rhythmically into an autonomously ordered space, whereby this space does not appear fixed in terms of three-dimensional perspective, but it only comes into being via the transparency of the colours. In the translucent, light-dark gradation of the colour-foundation, a mobile colour-space opens itself up in the transition from one nuance of colour to another, the appearance of which lies in a continuous crossing of borders, in a continuous transcending of colour-faces. In a colourful transparency appears a colour-space, which remains in flux, so as to speak; it is not fixed into three dimensions, but comes into being from a motion which continually crosses and glides across borders.[61]

In this sense, the entire picture offers insights into the formation of a crystal, into the transforming power of light as it is associated with the Lily and Phosphorus in Hoffmann's text and with the process of entering the poetic realm. Klee's brilliant image is therefore intimately linked with Hoffmann's text, particularly regarding its dynamic and semiotic features drawing the reader/spectator constructively into the creative process. By creating a 'temporal-space', it also offers an answer to the problem raised in Lessing's *Laokoon*, but an answer that again will have to rely on us, the viewers.[62]

Klee refers not only to Hoffmann, but also to Lessing, something which seems to have been completely overlooked. He mentions *Laokoon* as a work he spent time with in his youth and which triggered thought-experiments.[63] He seems to make fun of the experiment to keep the temporal out of the visual or, as *Laokoon* seemed to imply, to find the most fruitful or action-packed moment for the painting and adds: 'Even space is a temporal term.' In making this statement, Klee did not really object to Lessing but took his initiated thought-process one step further. Klee then used the parable of a tree to illustrate his particular process-oriented approach to mimesis that is still related to that of Lessing and Hoffmann:

> Nobody would expect a tree to form the crown like the root. Everyone will understand that there cannot be an exact mirror relation between below and above. It is clear that the various functions in the various elementary regions have to produce vivid deviations. But it is precisely the artist who, at times, is not admitted these deviations from the models (Vorbilder) that are

already necessary in terms of the medium of painting. One even went hastily so far as to scold the artist for inability and intentional deceit. And he, at the place assigned to him near the stem, does nothing else but collect that which comes from the depth and to mediate it. Neither to serve, nor to govern, just to mediate. He truly takes a modest position. And the beauty of the crown is not himself, it has only gone through.[64]

Klee takes the notion of the medium further than Lessing. The artist or the painter Klee is referring to in this citation, is not the dominant protagonist of action. He is not in control but instead has become part of a larger process including him. He is only an element of nature making the language of nature his concern. There are no hierarchies any more. And there is also no symmetry between the roots and the crown of the tree or between the inner and the outer. They come in different proportions although they are linked by the stem. Certain mimetic expectations are no longer applicable. The moment shown is only one in a process, yet, in response to Lessing, Klee asserts that there is no moment that is superior to the other moments in the flux of time.[65] All moments are therefore potentially fruitful or pregnant and deserve to be shown in the painted image. And he also leaves blanks or empty spots indicating, as Lessing did, the relevance of absent signs. In a similarly anti-hierarchical move, Klee became interested in the paintings of children with just the same amount of interest he had for the great artists in history. Klee insists that time affects the painting as much as the poetic and that space is temporal and belongs, in a sense, to the 'rhythmic arts'. When Lessing noted that time has a powerful role in the construction of meaning, at least when referring to poetic language, he did not go far enough. Many critics have scolded him for it. But the fact that the poetic has spatial qualities as well was a message Hoffmann and Klee in their own ways added to the *Laokoon* debate. Klee wrote: 'In the past, one wrote things that were to be seen on earth, which one enjoyed seeing or would have liked to see. Now the relativity of visible things is becoming obvious and the conviction that, in relation to the entire world, the visible is only an isolated example is being affirmed and other truths are latently in the majority'.[66]

V

Friederike Hassauer has written about the loss of written culture (*Textverluste*), others have argued for images as texts, or about textualizing images in the process of understanding.[67] The spectrum is wide. A case was made for architecture to be understood as a non-verbal 'language' by Fernande Saint Martin in *Semiotics of Visual Language*.[68] Terminologies change and 'texts' and 'images' interact with each other in numerous ways. They may differ, overlap, interfere, interact, but I would like to assert that they do not entirely absorb or erase each other.

It could well be a sign of arrogance if the works of thinkers of the past were consumed, positioned and absorbed by thinkers of the present. Those that are dead are silent and it is far too easy to speak against them. Just because Aristotle did not know what eighteenth-century Lessing knew should not make Aristotle any the less interesting than Lessing. Or, by the same token, just because Lessing did not have all the insights of our present visual culture, this should not make him a fool or an outdated verbalist.[69] While critical theory began with an awareness for history and for situated knowledge in time, I find that in recent years some strands of theory and history have entered into a kind of unnecessary dualism. This goes so far as to make a thinker such as Lessing who was a great innovator of his time, into a scapegoat for the contemporary visual-verbal divide. Hoffmann and Klee have, as shown here, critically engaged with the work of Lessing and came up with innovative responses that leave room for thought.

To link these case studies to current debates in theory and political issues, Mitchell apparently has taken the side of the 'visualists' in their move to speak up for themselves, but in the process has perhaps gone one step too far, that is he has in fact established a new hierarchy, or perhaps he has gone one step not far enough, by ignoring the power relations implicated in his own methodology. He has tried to establish the superiority of the visual over the verbal and to base this claim on the author Lessing. By relying on *Laokoon*'s dominant reception rather than on a careful process-oriented reading of the text itself and on critical readings from the margin or against the grain, he has concluded, as I have challenged in this paper, that Lessing should be made responsible for the silencing of images. Not

so. And there is another aspect to the notion of 'pictorial turn' which also needs reconceptualizing.

In *Picture Theory*, Mitchell claimed that our post-modern era is characterized by this 'pictorial turn', a notion that is both interesting and provocative in the complex visual-verbal debate. Mitchell defined it in response to what Richard Rorty had called 'the linguistic turn', that is the replacement of images by words. Rorty argues that there is an increasing prevalence of words over images in our time and that this implies a loss of visibility, not to mention tangibility. At an earlier stage in history, he pointed out, there was a similar paradigm shift that replaced things/objects with ideas/images. Rorty makes the following remark in favour of what he has termed 'the linguistic turn':

> The picture of ancient and medieval philosophy as concerned with *things*, the philosophy of the seventeenth through the nineteenth century as concerned with *ideas*, and the enlightened contemporary philosophical scene with *words* has considerable plausibility.[70]

Mitchell responded to Rorty by arguing instead for a 'pictorial turn' and argued that this notion resists theorizing to a certain extent and must be associated with a sense of discomfort:

> What makes for the sense of a pictorial turn, then, is not that we have some powerful account of visual representation that is dictating the terms of cultural theory, but that pictures form a point of peculiar friction and discomfort across a broad range of intellectual inquiry. The picture now has a status between what Thomas Kuhn called a 'paradigm' and an 'anomaly,' emerging as a central trope of discussion in the human sciences in the way that language did: that is, as a kind of model or figure for other things (including figuration itself), and as an unsolved problem.[71]

While Mitchell opened a debate by drawing attention to the picture as an 'unsolved problem', at the same time he attempted to silence a closely related debate by attaching the notion of 'iconophobia' to those who apparently put more emphasis on the verbal than the visual. He finds that Rorty has a fear of the image and similarly interprets Wittgenstein as anti-visual when he wrote: 'A *picture* held us captive. And we could not get outside of it, for it lay in our language

and language seemed to repeat it to us inexorably'.[72] Mitchell viewed this as an expression of 'Wittgenstein's iconophobia' and linked Rorty's concern with a 'linguistic turn' and Wittgenstein's critical comment on the repetition of images both as similar attempts 'to get philosophy over its infatuation with epistemology'. Mitchell noticed that for Rorty 'the mirror' in particular had negative connotations, such as a temptation of scientism and positivism.[73] Mitchell viewed Rorty's 'linguistic turn' as a defence against the power of the visual, or as an attempt to restrict, or to erase images via words. Mitchell in response asserted the primacy of images over texts by calling for 'The Pictorial Turn'.

In the same vein, Mitchell is critical of the 'semiotic turn' proposed by Mieke Bal and Norman Bryson, who, in using this term, shifted emphasis from the intrinsic aspects of the work to the more external process of reception.[74] Mitchell commented: 'Bal and Bryson argue that semiotics goes beyond the linguistic turn to achieve a transdisciplinary theory that will avoid the bias of privileging language in accounts of visual culture'; he added:

> I am skeptical about the possibility both of a transdisciplinary theory and of avoiding 'bias' or achieving neutrality in the metalanguage of representation. Although I have great respect for the achievements of semiotics, and draw upon it frequently, I'm convinced that the best terms for describing representations, artistic or otherwise, are to be found in the immanent vernaculars of representational practices themselves.[75]

It is not a matter of 'neutrality in the metalanguage of representation'. It is a need for abstraction which makes the efforts by Mieke Bal, Norman Bryson, and others, including the contributors to this volume, necessary in the attempt to get beyond what is culturally imposed on us. We must outgrow traditional hierarchies and binaries by drawing attention to language as well as images. I agree with Bal that we must approach such terms as 'rhetoric, reading, discursivity, visuality – as aspects rather than essences, and to consider each art's specific strategies to deal with these aspects as modes rather than systems'.[76] We can get beyond the image-word opposition that has kept scholarship on visual art and literary studies apart. This has consequences also for gender studies, for the integration of post-colonial discourses and for a more accurate understanding of the so-

called 'Western world view' which itself turns out to be so much more interesting, fragmented, and complex than often assumed. The Lessing-Hoffmann-Klee triangle shows that certain images survive and that the intricacies of their surrounding stories are not at all superfluous. They deserve to be ignored no longer. We live in a new era of 'visual culture' and cannot claim a monopoly on images. Nor can we do without verbalness. As my case studies should have demonstrated by now, this is not the time to build any more new hierarchies, or to claim one general overarching 'pictorial turn' against any 'linguistic turn'. We should no longer get stuck in any such dualistic pattern. Instead, I support the liberating, inclusive, and pluralistic notion of multiple 'semiotic turns' that also allows for abstraction and qualitative change.

Notes

1. Fredric Jameson, *The Prison-House of Language: A Critical Account of Structuralism and Russian Formalism* (Princeton & Oxford: Princeton University Press, 1972).
2. Barbara M. Stafford, *Body Criticism: Imaging the Unseen in Enlightenment Art and Medicine* (Cambridge and London: MIT Press, 1991), pp.1-7.
3. See Jeremy Bentham, *The Panoptic Writings*, ed. Miran Bozovic (London & New York: Verso, 1995), p.45.
4. See Barbara M. Stafford, 'A Constructivist Manifesto', in *Good Looking: Essays on the Virtue of Images* (Cambridge: MIT Press, 1996), pp.3-17.
5. Paul Messaris, *Visual Literacy: Image, Mind, and Reality* (Boulder: Westview Press, 1994).
6. See Martin Jay, 'Scopic Regimes of Modernity', in *Force Fields: Between Intellectual History and Cultural Critique* (New York & London: Routledge, 1993), pp.114-133.
7. Hans Blumenberg, 'Paradigmen zu einer Metaphorologie', in Anselm Haverkamp (ed.), *Theorie der Metapher*, Wege der Forschung 389 (Darmstadt: Wissenschaftliche Buchgesellschaft, 1983), pp.285-315, p.290.
8. See Winfried Menninghaus, *Schwellenkunde: Walter Benjamins Passage des Mythos* (Frankfurt am Main: Suhrkamp, 1986); Azade Seyhan, 'Visual Citations: Walter Benjamin's Dialectic of Text and Image', in Beate Allert (ed.), *Languages of Visuality: Crossings between Science, Art, Politics, and Literature* (Detroit: Wayne State University Press, 1996), pp.229-241.
9. Audre Lorde, 'The Master's Tools Will Never Dismantle the Master's

House,' in C. Morraga and G. Anzaldúa (eds), *This Bridge Called my Back: Writings by Radical Women of Colour*, 2nd ed. (New York: Kitchen Table-Women of Colour Press, 1983), pp.98–101.

10. See Gemma Corradi Fiumara, *The Metaphoric Process: Connections between Language and Life* (London & New York: Routledge, 1995).

11. See Andrew Goatly, *The Language of Metaphors* (London & New York: Routledge, 1997), pp.26–28; Beate Allert, 'Theorizing Visual Language in George Berkeley and Jean Paul', *Studies in Eighteenth Century Culture*, 27 (1998), pp.307–342.

12. Elena Makarova, *Friedl Dicker-Brandeis. Ein Leben für Kunst und Lehre* (Vienna: Christian Braunstätter, 2000), pp.17–18. On the children's art of Terézín, see Hana Volavková (ed.), *I Never saw another Butterfly: Children's Drawings and Poems from Terézín Concentration Camp*, Expand. 2nd ed. (New York: Schocken Books, 1993); and Helena Weissová, *Zeichne, was Du Siehst: Zeichnungen eines Kindes aus Theresienstadt/Terézín* (Göttingen: Wallstein, 1998).

13. See the recordings by the Hawthorne String Quartet: *Chamber Music from Theresienstadt 1941–1945*, Channel Classics CCS 1691 (1991); and *Silenced Voices: Victims of the Holocaust*, Northeastern Records NR 248-CD (1994).

14. For more detail on the twentieth-century reception of Lessing's *Laokoon*, see my article, 'Lessing im Kontext kunsttheoretischer Debatten', *Lessing Yearbook*, 33 (2001).

15. See Norman Bryson, 'Intertextuality and Visual Poetics', in *Style*, 22 (1988), pp.183–193; Jeoraldean McClain, 'Time in the Visual Arts: Lessing and Modern Criticism', in *The Journal of Aesthetics and Art Criticism*, 44, 1 (Fall 1985), pp.41–58.

16. See Gotthold Ephraim Lessing, *Laokoon oder über die Grenzen der Malerei und Poesie* (1766), in *Werke und Briefe*, 12 vols, vol. 5/2, *Lessings Laokoon: Werke 1766–1769*, ed. Wilfried Barner (Frankfurt am Main: Deutscher Klassiker Verlag, 1990), pp.9–321 and 627–916.

17. See Peter J. Burgard, 'Schlangenbiß und Schrei', in Wolfram Maußer and Günter Saße (eds), *Streitkultur: Strategien des Überzeugens im Werk Lessings* (Tübingen: Niemeyer, 1993), pp.194–202.

18. See W.J.T. Mitchell, 'Space and Time: Lessing's Laocoon and the Politics of Genre', in *Iconology: Image, Text, Ideology* (Chicago: University of Chicago Press, 1986), pp.95–115; Simon Richter, *Laocoon's Body and the Aesthetics of Pain: Winckelmann, Lessing, Moritz, Goethe* (Detroit: Wayne State University Press, 1992).

19. Sigmund Freud, 'Das Unheimliche', in *Werke*. Studienausgabe vol. 4 (Frankfurt am Main: Suhrkamp, 1970), pp.241–274.

20. E.T.A. Hoffmann, *Sämtliche Werke*, 6 vols, vol. 2/1, *Phantasiestücke in*

Callot's Manier, Werke 1814, ed. Hartmut Steinecke et al. (Frankfurt am Main: Deutscher Klassiker Verlag, 1993), pp.229–321. The English version cited here is Ritchie Robertson (ed. and trans.), 'The Golden Pot: A Modern Fairy Tale', in *E.T.A. Hoffmann, The Golden Pot and Other Tales* (Oxford & New York: Oxford University Press, 1992), pp.1–83.

21. Jürgen Glaesemer, 'Klee und Jacques Offenbach', in Ole Henrik Moe and Thomas Adank (eds), *Klee og musikken* (Høvikodden: Sonja Henies og Niels Onstads Stiftelser, 1985), pp.48–64 (Norwegian text with illustrations), pp.292–305 (German text). On Klee and 'Hoffmanns Erzählungen', see pp.293–295.

22. See also Jürgen Glaesemer, 'Klee and German Romanticism', trans. Renate Franciscono, in Carolyn Lanchner (ed.), *Paul Klee* (Boston: Little, Brown, 1987), pp.65–81.

23. *The Diaries of Paul Klee 1898–1919*, ed. Felix Klee, trans. Pierre B. Schneider et al. (Berkeley: University of California Press, 1964), entry number 951, p.313. The original text is in Paul Klee, *Tagebücher 1898–1918*, ed. Felix Klee (Köln: Dumont, 1957), p.323.

24. In substituting 'glass' for 'crystal', Robertson's translation loses something important (cf. p.1). On Klee's 'cool Romanticism', see Glaesemer, 'Klee and German Romanticism', pp.66–69.

25. See David Wellbery, *Lessing's Laocoon: Semiotics and Aesthetics in the Age of Reason* (Cambridge & London: Cambridge University Press, 1984); Beate Allert, 'About a Burning Building in Eco and Lessing, or: How to Process Messages', in *Lessing Yearbook*, 29 (1997), pp.57–86.

26. Gilles Deleuze, *Foucault*, trans. Séan Hand (Minneapolis & London: University of Minnesota Press, 1988).

27. Aristotle, *Poetics*, with the Tractatus Coislinianus Reconstruction of Poetics II, trans. Richard Janko (Indianapolis: Hackett, 1987), pp.1 ([14]47a 14–20), 37 ([14]60b 8). See also Gotthold Ephraim Lessing, *Laocoön: An Essay on the Limits of Painting and Poetry*, trans. Edward Allen McCormick, 1984 (Baltimore: Johns Hopkins University Press, 1996), p.xii.

28. See Stephen Bann, *The True Vine: On Visual Representation and Western Tradition* (Cambridge: Cambridge University Press, 1989), p.29.

29. Lodovico Dolce, *Dialogo della Pittura intitolato l' Arentino* (Venice: Gabriel Giolito d' Ferrari, 1557). According to McCormick the edition Lessing used appeared in Florence in 1735 with an introduction and in a French translation by N. Vleugels.

30. Jean-Baptiste Dubos, *Réflexions critiques sur la poésie et la painture: ut pictura poesis*, 2 vols (Paris: Jean Mariette, 1719).

31. See Jean Baudrillard, *Simulacra and Simulation*, trans. Sheila Faria Glaser (Ann Arbor: University of Michigan Press, 1994), p.1.

32. See McCormick, p.xvii.
33. Johann Jakob Bodmer and Johann Jakob Breitinger, *Discourse der Mahlern*, 4 parts (Zürich: Gesellschaft der Mahler, 1721–1723), reprint (Hildesheim: Olms, 1969).
34. See Lessing, *Laokoon*, ed. Wilfried Barner, p.737. Barner explains that the marble group that was created one century before Christ by Rhodian artists, had been rediscovered in 1506 in Rome in the 'Golden House' of Nero and then placed in the Vatican. The false reconstruction of Laokoon's right arm was corrected in 1960 (Barner's 1860 is a misprint).
35. Johann Joachim Winckelmann, *Reflections on the Imitation of Greek Works in Painting and Sculpture*, trans. Elfriede Heyder and Roger C. Norton (La Salle, IL: Open Court, 1987) (with the German text, *Gedanken über die Nachahmung der griechischen Werke in der Malerei und Bildhauerkunst*, 2nd enlarg. ed., 1755).
36. Sergei Eisenstein, *The Film Sense*, trans. Jay Leyda (London: Faber and Faber, 1943). See Oskana Bulgakowa, *Sergei Eisenstein – drei Utopien: Architekturentwürfe zur Filmtheorie* (Berlin: Potemkin Press, 1996), p.157. On Brecht and Eisenstein, see Roland Barthes, *Image-Music-Text*, trans. Stephen Heath (New York: Noonday Press, 1977), pp.52–78. See also Astrid Guderian-Driesen, *Die Stimme in der Kunst: Schweigen ist Silber, Reden ist Gold* (Ebringen: Bannstein, 1989), pp.86–107.
37. McClain, 'Time in the Visual Arts: Lessing and Modern Criticism', p.45. The term 'pregnant moment' in *Laokoon*, bringing the visual and the verbal disciplines of art together, is Lessing's most avant-garde move and is at the core of his aesthetic theory.
38. See Gwen Raaberg, 'Laokoon Considered and Reconsidered: Lessing and the Comparative Criticism of Literature and Art', in Alexej Ugrinsky (ed.), *Lessing and the Enlightenment* (New York: Greenwood Press, 1986), pp.59–67.
39. See, e.g., Mieke Bal, *Reading Rembrandt: Beyond the Word-Image Opposition* (Cambridge: Cambridge University Press, 1991).
40. Gaston Bachelard, *The Poetics of Space*, trans. Mario Jolas, 1964 (Boston: Beacon Press, 1969).
41. Lessing, *Laokoon*, in *Werke*, vol. 5/2, p.117.
42. Carol Jacobs, 'The Critical Performance of Lessing's *Laokoon*', in *MLN*, 102: 3 (1987), pp.483–521. E.H. Gombrich, in *Art and Illusion* (Princeton: Princeton University Press, 1956), p.139, first noticed that Lessing's *Laokoon* essay is structured as a 'tournament played by a European team. The first round is against Winckelmann, the German, the second against Spence, the Englishman, and the third against Comte de Caylus, the Frenchman'. For Winckelmann, see note 35

above; Joseph Spence, *Polymetis: or, An Enquiry Concerning the Agreement between the Works of the Roman Poets, and the Remains of the Ancient Artists* (1747); Anne Claude Philippe, Comte de Caylus, *Tableaux tirés de l'Iliade, de l'Odyssée, d'Homère et de l'Énéide de Virgile* (1757). See also Mitchell, *Iconology*, p.105.

43. Wellbery, *Lessing's Laocoon*, pp.43-98. For the relevant texts, see Wellbery, pp.248-249, including: Alexander Gottlieb Baumgarten, *Aesthetica* (1750-1758); Georg Friedrich Meier, *Anfangsgründe aller schönen Künste und Wissenschaften* (1748-1750); *Betrachtungen über den ersten Grundsatz der schönen Künste und Wissenschaften* (1758); Moses Mendelssohn, *Über die Empfindungen* (1755).
44. Lessing, 'Paralipomena', 21, *Werke*, 5/2, pp.296-97 (my translation). On this famous episode, see Norman Bryson, *Vision and Painting – The Logic of the Gaze* (New Haven & London: Yale University Press, 1983), pp.6-35; and Bann, *The True Vine*, pp.27-40.
45. See Umberto Eco, *A Theory of Semiotics* (1976, Bloomington: Indiana University Press, 1979), pp.68ff.; Charles Sanders Pierce, *Collected Papers of Charles Sanders Pierce*, ed. Charles Hartshorne et al., 8 vols (Cambridge: Harvard University Press, 1931-58), vol. 1, p.339, vol. 4, pp.473-92.
46. See Joachim Gessinger, 'Visible Sounds and Audible Colours: The Ocular Harpsichord of Louis-Bertrand Castel', in Allert (ed.), *Languages of Visuality*, pp.49-72.
47. See Gilles Deleuze and Felix Guattari, *A Thousand Plateaus*, trans. Brian Massumi (Minneapolis: University of Minnesota Press, 1987), pp.3-25, 111-148.
48. cf. note 44 above.
49. Lessing, *Laokoon*, in *Werke*, vol. 5/2, p.228.
50. e.g. Martin Jay, *Downcast Eyes: The Denigration of Vision in Twentieth-Century French Thought* (Berkeley: University of California Press, 1993), pp.183-84. See also Mitchell, *Picture Theory*, p.154, and *Iconology*, p.151.
51. Lessing, *Laokoon*, 'Paralipomena', 19, XLIV, *Werke* 5/2, pp.294-295.
52. Claudia Brodsky-Lacour, 'Is that Helen? Contemporary Pictorialism, Lessing, and Kant', in *Comparative Literature*, 45, 3 (Summer 1993), pp.230-257, p.244.
53. See note 24 above.
54. Ritchie Robertson, *The Golden Pot*, pp.xii-xiii.
55. e.g. Maria M. Tartar, 'Mesmerism, Madness, and Death in E.T.A. Hoffmann's *Der Goldene Topf*', in *Studies in Romanticism*, 14, 4 (1975), pp.365-389.
56. On Lily's destructive love for Phosphorus and her rescue in another

life, see Hoffmann, *The Golden Pot*, pp.15-16.
57. Claudia Liebrand, *Aporie des Kunstmythos: Die Texte E.T.A. Hoffmanns* (Freiburg im Breisgau: Rombach, 1996), pp.112-113. The falling 'into the crystal', suggestive of stasis, or the spell associated with Anselmus' writing task, recalls Hoffmann's protest against categorical language and dualistic thought-patterns, as also challenged by other German Romantic writers and by Klee in his own paintings in the spirit of 'cool Romanticism'.
58. Klee's works are cited according to the *Catalogue Raisonné*, ed. Paul Klee Foundation, 9 vols (London & New York: Thames and Hudson, 1998-). Each work is identified with a number plus the date and order of composition, e.g. *Mit der Schlange* [#3575 (1924.203)].
59. cf. Ernst-Gerhard Guse (ed.), *Paul Klee: Dialogue with Nature* (Munich: Prestel, 1991), p.151.
60. Jürgen Walter, 'Hoffmanneske Märchenszene–E.T.A. Hoffmann und Paul Klee', in *Antaios*, 10, 5 (1968), pp.466-482.
61. Walter, 'Hoffmanneske Märchenszene', p.466 (my translation).
62. Walter, 'Hoffmanneske Märchenszene', p.473.
63. Paul Klee, 'Schöpferische Konfession', in *Kunst-Lehre: Aufsätze, Vorträge, Rezensionen und Beiträge zur bildnerischen Formlehre*, ed. Günther Regel, 3rd ed. (Leipzig: Reclam, 1995), pp.60-66, p.62.
64. Klee, 'Über die Moderne Kunst', in *Kunst-Lehre*, pp.70-85, p.72 (my translation). Klee also refers to *Laokoon* in the reviews he wrote for the periodical, *Der Alpen*, published in Berne, e.g. vol. 6.3 (November 1911), cf. *Kunst-Lehre*, p.38; and vol. 7.4 (December 1912), cf. *Kunst-Lehre*, p.49.
65. Klee, 'Schöpferische Konfession', in *Kunst-Lehre*, p.62.
66. Klee, 'Schöpferische Konfession', in *Kunst-Lehre*, p.63.
67. Friederike Hassauer, *Textverluste. Eine Streitschrift* (Munich: Fink, 1992). See, e.g., Claude Gandelman, *Reading Pictures, Viewing Texts* (Bloomington & Indianapolis: Indiana University Press, 1991); Peter Wagner (ed.), *Icons – Texts – Iconotexts: Essays on Ekphrasis and Intermediality* (Berlin & New York: De Gruyter, 1996).
68. Fernande Saint Martin, *Semiotics of Visual Language* (Bloomington: Indiana University Press, 1987).
69. Mitchell, *Iconology*, pp.95-115.
70. Richard Rorty, *Philosophy and the Mirror of Nature* (Princeton: Princeton University Press, 1979), p.263.
71. Mitchell, *Picture Theory*, pp.11-34, p.13.
72. Ludwig Wittgenstein, *Philosophical Investigations*, trans. G.E.M. Ascombe, 2nd ed., 1958 (Oxford: Blackwell, 1998), Part I, § 115, p. 48e (quoted in Mitchell, *Picture Theory*, p.12).

73. Mitchell, *Picture Theory*, pp.12–13; see Rodolphe Gasché, *The Tain of the Mirror: Derrida and the Philosophy of Reflection* (Cambridge: Harvard University Press, 1986).
74. On 'visual textuality' see Bal, *Reading Rembrandt*, p.19.
75. Mieke Bal and Norman Bryson, 'Semiotics and Art History', in *Art Bulletin*, 72,2 (1991), pp.174–208, p.175; Mitchell, *Picture Theory*, pp.14–15.
76. Mieke Bal, 'Light in Painting: Dis-seminating Art History', in Peter Brunette and David Will (eds), *Deconstruction and the Visual Arts: Art, Media, Architecture* (Cambridge: Cambridge University Press, 1994), pp.49–64, p.59.

practice as thinking

toward feminist aesthetics

marsha meskimmon

I

During the course of 1993 and 1994, Jenny Holzer embarked upon *Lustmord*, her text-based project in response to the Bosnian War and, in particular, to the systematic rape and murder of thousands of women in the brutal regime of 'ethnic cleansing'. The project is complex and thought-provoking, not least because its texts, images and objects call to observers' own bodies, insisting that they participate in the work rather than stand outside it. Thinking about the implications of this project, its strategies and modes of making 'history', will concern me throughout this essay, but a few introductory comments by way of description are necessary first.

The texts of *Lustmord* were shown in a number of different formats, each specific to their venue and yet faithful to the project. In the commissioned artist pages for the *Suddeutsche Zeitung* (19.11.1993), for example, Holzer reproduced close-up photographs of the texts, handwritten in blue, black or red-black ink on skin (plate 14). These were printed with 'bleed' so that each text appeared as if on a sheet of human parchment. As Joan Simon noted astutely, the images recalled both butchers' marks and the identification tattoos used in concentration camps.[1] These 'skin texts' subsequently appeared in a number of other publications in the same format, such as the four-page spread shown in the October/November 1995 edition of *Creative Camera*. Additionally, they were exhibited in installations as photographs in their own right, printed in colour and again with 'bleed', so that the skin was not contained by a framing device. In the space of the gallery, these photographs were placed together with objects also inscribed with the texts of the

Plate 14. Jenny Holzer, *Lustmord*, 1993–4; courtesy of Jenny Holzer; copyright DACS.

project, such as metal tags attached to bones, a silver ring in the form of a snake and LED displays.

In the 1994 installation at the Barbara Gladstone Gallery in New York, the centrepiece of the exhibition was a constructed 'house', whose walls were sheets of leather, marked by the hand-scripted texts. This 'house' referenced the images of the former Yugoslavia gathered by airborne cameras (which Holzer had seen when researching the project) and also evoked the ideals of domesticity, hearth and home perverted by the rape and murder of female civilians in warfare. The *Lustmord* texts thus might be experienced by viewers in situations varying from reading the Sunday supplement in their own homes to standing within a fictionalized house in a museum or gallery, surrounded by the corporeal signs of mortality. The texts might also have been heard, since they were spoken by Holzer in the virtual companion to *Lustmord*, *World II*. Hence *Lustmord* cannot be conceived as a singular work of art whose meaning resides within it as an object would *contain* an idea. *Lustmord* is a mutable place of meanings, confrontations and reconceptions and it is understood throughout this essay to be in process, materializing a range of possible narratives across different spaces.

Textually, *Lustmord* describes the rape and murder of a woman in three voices: that of the woman experiencing the torture, the male perpetrator of the crime and a more gender-neutral witness to the event. These 'first-person' accounts are explicit, painful and clearly perspectival; they describe positions from which this act can occur and be read:

> With you inside me comes the knowledge of my death.
>
> I find her squatting on her heels and this opens her so I get her from below.
>
> I want to brush her hair but the smell of her makes me cross the room. I held my breath as long as I could. I know I disappoint her.

The distinctive, 'first-person' voices of these texts differentiate them from the main body of Holzer's textual *oeuvre*, in which the voice has tended to be rendered as anonymous. For example, in her early work, *Truisms*, the enunciative position is generalized to the point where the passages appear to have no individual origin and thus the conflict between idiosyncratic content and 'universal' form calls all naturalized truisms into question. The strategies of the polyphonic *Lustmord* texts are different; the insistence upon the voices of these 'others' (the suffering victim, the killing rapist, the ineffectual spectator), inscribed in, on and of 'flesh', refuses us a refuge. There is no place from which these texts may be consumed comfortably by their audience. In the first-person reading, we all take up one or more awful places within an act of extreme violence, an act of violence common to modern warfare which, while in the safety of our homes and galleries, we choose to ignore.

By the time Holzer was engaged with the *Lustmord* project, she was an established international practitioner known for her challenging, declarative textual interventions in both galleries and public sites such as billboards, bus shelters and in the published mass media. Holzer was associated explicitly with feminist conceptual practice and a definitive political stance; she was, for example, one of the artists commissioned by the Liz Claiborne company in 1992 to undertake a public awareness campaign against domestic violence.[2] This access to public spaces and to critical commentary ensured that *Lustmord* was seen and discussed in many fora, bringing attention both to the horrors of 'ethnic cleansing' and to the treatment of

history, trauma and memory in and through art. Not surprisingly, *Lustmord* attracted both kudos (winning the Gold Medal from the Art Director's Club in Germany in 1994, for example) and controversy. Interestingly, the negative commentary implied that Holzer's work was somehow too visceral or too literal – 'too sensational', 'repulsive and absurd'.[3] With these comments in mind, it is instructive to step back and explore the two most 'literal' reference points for the *Lustmord* project: the iconographical trope of the *Lustmord*, which came to prominence during the early years of the Weimar Republic in Germany, and the historical fact (and mythic device) of violence against women in modern warfare.

The iconography of the *Lustmord* (which translates roughly as 'sex murder' or 'rape slaying') became extremely popular with male artists in Germany between 1918 and 1923.[4] Principally on the left of the political spectrum, these artists included such notable figures as Otto Dix, George Grosz and Rudolf Schlichter. The imagery was brutal: typically, the works focused upon the figure of a raped female corpse, shown mutilated, disembowelled and/or dismembered. These female figures were generally read as 'prostitutes', and their depiction, murdered in filthy beds in dingy urban rooms, certainly tended to distance them from typical tropes of the 'wife' or 'mother'.[5] For example, in Dix's *Lustmord* (1922),[6] the female figure is shown mutilated, with her throat cut, in a mass of bloodstained sheets on the floor of a bedsit. The bed has not been used and the figure, despite being pictured with a completely naked and visually accessible torso (legs spread and breasts uncovered), is seen still wearing her stockings and boots. The rapidity and brutality of the murderous sexual encounter is emphasized by these details, even while they imply the banal and impersonal commodity exchange between prostitute and client.

Occasionally, the figure of the rapist/murderer was also present within the image, perhaps most shockingly in the *Self-Portrait as Sex Murderer* (1922) by Dix, in which his likeness stands centrally, grinning and wielding a huge knife amidst the body fragments of a dismembered female figure. Whether the perpetrator of the *Lustmord* was shown or not, the stylistic treatment of the theme reiterated the act of violence through lurid colour, excessive detail of the mutilations and roughly handled, crude mark-making. This visceral visual language makes the works simultaneously attractive and repulsive; even while shocked by the literal imaging of the aftermath of rape

and murder, sex and brutality, viewers are compelled to explore their voyeuristic display.

Violence against women rose sharply during the crisis years of the early Weimar Republic, before the investment of US capital through the Dawes Plan in 1924 stabilized the socio-economic climate more generally. Women were battered within the home and attacked on the street, being subject to mugging, rape and, of course, murder. While the phenomenon of violence against women may have been magnified to enhance the sales of a widespread and temporarily uncensored tabloid press, it was also a fact of grave concern to women and men across the political spectrum. Social commentators took it seriously as an indication of the failure of defeated German soldiers to reintegrate into the community, a sign of destabilized gender and sexual roles and a mark of socio-economic collapse figured through the disintegration of the 'family' and its values. Hence the *Lustmord* was both a sensational image and one designed to provoke political polemic.

Holzer's explicit quotation of this iconography in relation to the Bosnian war drew upon these histories to revive a sense of horror and outrage at the treatment of women in moments of extreme political upheaval and crisis. But her references, and the issues raised by the *Lustmord*, go far beyond histories of art or the particular circumstances of the Weimar Republic and address the manifold abuse of women in modern warfare. For example, soldiers having perpetrated and experienced extreme brutality, returning to their homes neither as heroes nor as victors, being unable to reintegrate into civilian life and finally committing senseless acts of violence, cannot but reference the Viet Nam experience for a contemporary Western audience and certainly for any politically aware viewer of Holzer's own generation. And this is by no means all. The scandal of enforced 'prostitution' in military brothels became public knowledge during the years of the Weimar Republic, damaging the reputation of the whole military establishment and colouring the debates taking place around the phenomenon of the *Lustmord*. The state was seen to have promoted sexual violence against women and was hard-pressed to prove otherwise.

Over the past half-century, the relationship between the military, 'prostitution', rape, torture and war has become further exacerbated, particularly with increased public knowledge of the systematic use of rape and murder as a strategy of 'ethnic cleansing'. A few examples suffice to remind us of the unspeakable traumas Holzer's *Lustmord*

voiced. Two terrible euphemisms come first to mind: the 'Joy Divisions', those sections of Nazi concentration camps in which incarcerated women prisoners acted as sexual servants to guards and officials and the 'Comfort Women', the tens of thousands of Korean women kidnapped by the Japanese army, located in military 'brothels' in China and used to service the troops. Many of the stories of the surviving 'Comfort Women', which only came to light a few years before Holzer began the *Lustmord*, are particularly shocking, such as the case of one survivor who testified to being raped continually some 50 times per day until her body could take no more and then being used as a living blood transfusion bag for soldiers brought to the infirmary.[7] The recent and horrific use of rape as an explicit military tactic in Rwanda (frequently in the hope of spreading the HIV virus as a side-effect) suggests clearly that the connections between sexual violence against women and the strategies of modern warfare become more devastating as and when genocide is the final goal of the conflict. In this climate, 'woman' becomes less the treasure taken by the victors as a part of the spoils and more the object of extreme hatred as the potential mother of the despised 'other'. Because of this equation, women who find themselves enmeshed in these conflicts become sexualized targets and inhuman bodies; these conditions cannot but breed atrocity.

The symbolic destruction of 'woman' is yet another element of the *Lustmord* trope, and one which has come to speak of military and revolutionary exchanges between men in Western culture. The rape of the Sabine women and the 'capture' of Helen of Troy, so frequently depicted in Western fine art and used as metaphors in literary contexts, each cite the beginning of great wars with the sexual conquest of woman. These metaphors became all the more devastating in the period after the bourgeois revolutions in Europe, where the 'prostitute' or the 'whore' became associated with revolution and the uncontrollable masses and the concomitant destruction of the 'whore/revolutionary' was the necessary enactment of state power. Thus it was that Victor Hugo invoked the start of the 1848 revolution in France with this story of the confrontation between the National Guard and revolutionaries on the barricade at Porte St. Denis:

> [A] woman appeared on the crest of the barricade, a young woman, beautiful, dishevelled, terrifying. This woman, who was a public whore, pulled up her dress to the waist and cried to the

guardsmen... 'Cowards! Fire if you dare at the belly of a woman!' Here things took an awful turn. The National Guard did not hesitate. A fusillade toppled the miserable creature. She fell with a great cry... Suddenly, a second woman appeared. This one was younger and still more beautiful; she was practically a child, barely seventeen. What profound misery! She too was a public whore. She raised her dress, showed her belly and cried: 'Fire you bandits!' They fired. She fell, pierced with bullets, on top of the other's body. That was how this war began.[8]

Klaus Theweleit's famous study of rightwing mercenaries in the period following the First World War, *Male Fantasies*, reiterated the mythic structures surrounding counter-revolutionary action and the brutal destruction of woman – particularly figured as the 'whore of Bolshevism'.[9] The symbolic construction of despised difference as a devouring female whore asking for the violent sexual torture and mutilation she deserves had extraordinary repercussions in real terms in military conflicts throughout the twentieth century. Whether the enemy was ideological (communists, Viet Cong) or 'racial' (Jews, Gypsies, Muslims, Slavs, members of other tribes and clans), the effect of the symbolic construction of difference in sexual terms has been to enforce 'prostitution', rape and the murder of women (mainly civilians) as a military strategy. When documentary photographs of prisoners' camps began to filter out of Bosnia in the first years of the war, foreign journalists quickly noted the near-complete absence of women between the ages of 15 and 35 in the pictures. The strategies against the female population could not be effaced.

It is no surprise then that Holzer's *Lustmord* should be shocking and cause discomfort and controversy among its viewers given the subject it tackled. But how could it be seen as 'too sensational' or 'repulsive and absurd'? The art-historical iconography which it referenced was far more direct and sensationalized, literally drawing upon the new genre of popular crime magazines for its visual language. Holzer never produced figurative representations of murdered and mutilated women. Nor could she have competed with the facts of women's abuse in modern warfare for sensational effect; or, perhaps this barbarism against women is itself just 'absurd' and not deserving of public attention.

I would argue along a slightly different line, that Holzer's work made skilful use of a tradition and yet differed from it such that it

became impossible to subsume the *Lustmord* into the mainstream. That is, the Weimar *Lustmord* iconography, the mythic and symbolic destruction of woman as the 'othered' whore and the actual violence perpetrated against despised women all reinforce a conventional Western logic premised upon mind-body dualism. Within this paradigm, a distanced and gendered ordering takes place and the privilege of the 'one' is bought at the expense of the 'other' – woman, for example, becomes the ubiquitous marker of difference (sexual, racial, ideological, national, etc.) while women, as embodied subjects with voice and agency, are effaced. Holzer's project operates otherwise. It participates in the violent histories it references, never shirking their force, yet refuses simply to render woman as the object of symbolic and material violence upholding the privilege of the centre. Instead it places violence against women into this very centre, giving voice to the victims, locating the brutality within a time and space and calling to the embodiment of the viewers through corporealized texts and objects. These strategies refuse us the position of the distanced observer contemplating violence against objectified others, thus engaging with histories without merely repeating their logic.

II

During the course of the past decade, much Western feminist theory has been concerned with the articulation of difference beyond the logic of mind-body dualism. The dualist paradigm effaces difference in order to universalize the logic by which masculine subjects assume the status of the transcendent 'I' while female subjectivity is rendered as the mute, unknowable other, locked within the confines of the body and its deterministic biology. Enacting the privilege of mind over body, man over woman, rational knowledge over sensual experience and, of course, empowered Western cultures over subordinated non-Western others, negates heterogeneity and alterity. However, it is not sufficient merely to point to the inadequacy of dualism, nor to reverse its terms, placing 'body' over 'mind' for example; these strategies paradoxically reinforce the power of the centre by suggesting that binary logic underpins all thinking practice by necessity. Articulating radical difference dismantles this 'economy of the same' and empowers non-dualist conceptions of subjectivity, agency and knowledge.

Thinking difference differently underlies many fascinating feminist interventions into critical theory. Explorations of subjectivity, for example, have moved away from the dominative logic of fixed and rigid boundaries between subject and object, emphasizing the fluidity of identity and the processes involved in moving through subject positions. Rather than seeking to locate a pre-formed and unified core of identity prior to the manifestation of agency in the world, processual models stress the performative acts which constitute as their effect the sense of a subject, itself in perpetual change. These models of subjectivity enable difference to be articulated rather than marginalized, since they acknowledge both multiplicity and location, not to mention the significance of intersubjective encounters with 'others' in the formation of the multifaceted 'I'. Exploring identity as mutable and in process is, of course, not only significant for reworking models of female subjectivity. Performativity has been crucial in reconceiving gay and lesbian identities beyond a heterosexual economy of desire and the strategic enunciation of multiplicity and hybridity have enabled critical deconstructions of racist paradigms which marginalized 'non-white' subjects.

Clearly, these ideas reject the proposition that there exists a generic subject or disembodied 'I'. Asserting the significance of embodiment and location in the construction of subjectivity also refutes universal claims to abstract knowledge and truth, emphasizing perspectival knowledges dependent upon the situated activities of many, diverse thinkers. Feminist critical theory itself has developed simultaneously across a number of disparate, yet interconnected, fields of thought and activity. Not surprisingly, non-traditional modes of articulation – such as poetry, performance and art – have provided feminist theory with a unique voice determined by their processual practices, their insistent materiality and their call to the bodies of their makers and readers/viewers. Feminist art practice is not divorced from 'theory' in its critique of mind-body dualism or in articulating alterity through visual and material interventions which move beyond its static binary logic.

Feminist art practices exploring difference invoked manifold visual and material strategies ranging from playing with the histories of art and sensory hierarchies to evoking sensual pleasures and excess, while working with spatial, temporal and proprioceptive effects produced in conjunction with the bodies of viewers. Feminist artists, working

across a wide range of international and cultural contexts, used a multitude of different strategies and media to develop a rich vein of practice through which they negotiated embodiment, alterity and heterogeneity. The knowledges made by art, and the specific contribution of feminist art praxis to the articulation of radical difference, should not be underestimated or subsumed under the aegis of textual theory either; these works are more than the mere illustration of pre-determined ideas, they provoke new knowledges.

Countering the logic by which pleasure, matter and the body were assigned negative roles as the antithesis of abstract, rational thought, focuses on revitalizing aesthetics as sensory cognition in the fullest sense. Thinking aesthetics in this way challenges a reductive resolution of the paradoxes of sensory cognition and refutes a definitive intellectual/sensual split within the subject; there is neither just a wholly rational (disembodied) nor wholly sensual (physiological) means through which we 'know'. There are always, inextricably both. These aesthetic practices imply a notion of sensual desire which does not reside in the satisfaction of lack, but can maintain difference in process. The active generation of ideas between materials and practices places them in contact with each other but does not reduce their difference to sameness. The interval which this opens through its excessive play of irreducible differences can also lend itself to counter-hegemonic political interventions, since it engages with alterity rather than resorbing it into the one.

Carrie Mae Weems has explored this very move toward politicized heterogeneity in her practice and it is useful to discuss one facet of this here. Weems is a contemporary African-American artist whose photographic projects consistently image African-American subjects in a wide variety of places and roles, some with accompanying text. Frequently, however, the diversity of her practice is neglected in favour of readings completely focused upon the representation of race as a unified field. As Weems said in an interview with bell hooks:

> Historically, it has been absolutely impossible for the vast majority of critics, of white audiences, and even of black audiences to come to the work and not first and foremost fixate only on the blackness of the images. As soon as blackness becomes the all-important sign, audiences assume that the images are addressing victimization...[10]

The prevalence of the sign of race homogenizes the subject and, therefore, the meanings; in this way, African-Americans cannot be diverse, they can only have a singular position and one which is determined in relation to the dominant European-American structures of understanding. The expressions of alterity and multiplicity in Weems's work runs counter to this logic, dismantles this crude economy of the same (one which homogenizes all marginal identities in relation to the centre) and thus evinces a powerful counter-hegemonic politics. Weems has produced photographic work on themes as diverse as her own family history (*Family Pictures and Stories*, 1978–84), African retentions in the Georgia Sea Islands (*Sea Island* series, 1992) and, like Holzer, against domestic violence for the 1992 Liz Claiborne commission. In images such as *Untitled* from the *Kitchen Table Series* (1990), where two women are seen at the table, enjoying a drink and a smoke and each other's company, one combing the other's hair, the simplistic message of victimization is so reductive as to be almost laughable. These figures are not displayed to us as objects, instead, the photographs emphasize tactile pleasure and the inwardness of the figures' looks beyond any colonizing view. They voice alternative subjects differently.

However, disrupting the dominant conventions of viewing 'others' can induce anger, disbelief and incredulity, as evinced by the story Weems tells hooks in the interview cited above. One particular European-American woman patron was outraged by new works by Weems saying: 'But this work is not making me feel guilty.' As Weems argued: 'She wants me to tell her how to respond to the work because she assumes that the only legitimate response is guilt in the face of perceived rage.'[11] This dialogue between hooks and Weems stresses the fact that the manifold operations of colonial power and post-colonial disintegration have interpellated heterogeneous subjects. Yet praxis, whether textual, material or performed, has been slow to address this. The anger and confusion of the patron can only be understood as a manifestation of the power still exercised by the centre over its others, doggedly refusing to acknowledge their diversity or their agency. Like the anger expressed over *Lustmord*, we are witnessing here the effects of a critical challenge to the *status quo*.

Holzer's *Lustmord* attracted its most controversial notice when it appeared as the fourth set of commissioned artist-pages run by the *Suddeutsche Zeitung* on 19 November 1993. The project appeared as

a 30-page colour supplement with the Sunday edition of the paper; the pages consisted of the photographs of the texts handwritten on skin, printed with 'bleed'. To each fleshly book was attached by hand a small, two-fold invitation card, on which were printed three of the texts. On the outside of the invitation, the voice of the female victim framed the whole work in red-black ink: 'I am awake in the place where women die'. Paired within, in black, the voices of the perpetrator and witness: 'The colour of her where she is inside out is enough to make me kill her', 'She fell on the floor in my room. She tried to be clean when she died but she was not. I see her trail'.

In many ways, it was this trail which gave Holzer's work its undisputed power and made it a chilling testimony to the suffering of women, constructed around the limits of corporeality and text, body and excess. To examine the colour supplement, readers were obliged to handle the pages and the invitation card. Only after doing this could readers find that the victim's text on the invitation was printed in a mixture of ink and blood – blood donated by German and Yugoslavian women for the project. Scandal ensued, with readers outraged at having 'touched' the blood of these women and the tabloid press running completely erroneous scare stories about the transmission of diseases (particularly AIDS and STDs) through the card.[12]

This knee-jerk reaction pointed to the abuse of women and woman all the more clearly. It was not problematic for the readers of the *Suddeutsche Zeitung* (or other shocked critics) to consume texts and images centred upon the brutal rape and murder of a woman. No terrible mass outcry followed the revelations of the extent of rape and murder actually occurring to women in the former Yugoslavia as a result of the war and the genocidal policies of the military. And, of course, little attention has been paid to the belated revelations of the rape, torture and murder of female civilians throughout this century. But to have their blood on our hands, to be unable to maintain the requisite distance of the empowered subject devouring the object of its gaze, was truly beyond the limits of conventional understanding. The full-page prints of skin, the first-person narratives and the 'handwritten' texts, when combined with the materiality of women's blood, destroyed the sharp barriers between subject and object, interior and exterior, voyeuristic attraction and corporeal revulsion. As a work dependent upon participant observation, *Lustmord* challenges a gendered logic of containment premised upon the

asymmetrical placement of woman and man in relation to text, art, creativity and body. Within this logic, male artists such as Pablo Picasso and Auguste Renoir can speak easily of 'painting with their pricks' and the philosopher Jacques Derrida can reference the ink of his writing pen and semen in one breath, since these uphold the privilege of a masculine creative virility. But the association of woman with body, fluidity and base matter is overdetermined; Holzer's strategic combination of blood and ink, skin and text, with the voice of woman, articulated that which is ordinarily kept silent to maintain the disembodied objectivity of the masculine viewer and his position.

III

The conventional logic of mind-body dualism, as it has operated within art history and criticism, renders woman ubiquitous as the object of art and all but invisible as its subject. Despite vast evidence to the contrary, most mainstream sources perpetuate the falsehood that the woman artist is a rare and derivative phenomenon, relevant only in relation to the masculine canon, held as a fixed standard of value. Even many feminist scholars of women's art reiterate dualist logic through reversal, describing women artists as anomalies, unusual instances or special cases of greatness in which women acceded to the masculine role of 'artist'. Few genuine challenges to the canon or the universal status of the male artist can be waged while the logic of woman as other is maintained. Thus it is imperative for me, as a feminist art historian and critic whose work centres almost exclusively upon the manifold art practices of historical and contemporary women artists, to find the means to explore their art otherwise. On the one hand, it is necessary to understand how exclusive and exclusionary histories marginalized women's artistic interventions and, on the other, it is crucial not to remain within that very logic. Clearly, feminist strategies centred upon non-dualist constructions of history, subjectivity and aesthetics are significant to this reconception.

Moving beyond the stalemate of the subject/object divide, where women's art is reduced to a category of object, emphasizes the processes through which women's art comes to be produced and consumed. That is, the questions shift from what women's art is or was to what women's art does or did. This move confronts limiting

paradigms which imply either that there is some sort of universal 'woman-ness' contained within works of art or that there is a singular meaning in each work, determined by the origin point of its author's self, a complete self preceding its articulation in practice. Both of these paradigms reinforce homogeneous models of woman and universal, 'feminine' essence beyond and before their manifestation within the world. In an important sense, processual models of aesthetics which enable differences to be voiced and help to establish powerful models of feminist, embodied knowledges should not be confused with the quest for a unified feminist or feminine aesthetic. Written in the singular, these terms establish fixed parameters around practice and meaning, some of which go so far as to define 'proper' modes of representation, subject matter and materials to be used in producing the ideal work of feminist or feminine content. Such pre-determined models of praxis are utterly divorced from explorations in feminist aesthetics mobilizing radical difference.

Thinking of what women's art does or did describes the activity of artworks in an intersubjective frame. The works are taken to be moments of articulation, sites of meanings in flux, capable of change and reinscription through activities in the present. This, however, does not imply that they have no meaning or merely any; the works negotiate identities and ideas through particular materials and images, made and read by embodied subjects in specific locations. These constellations of subjects, locations, materials and concepts constrain the meanings available, but never contain them. Processual aesthetics of this kind takes risks – the risks of acknowledging the role and activity of the critic as part of the process of making meaning and of recognizing the fluidity of the meanings themselves.

The kind of critical activity these ideas describe is permeable and open to the multiple material and contextual differences it encounters in and through the body, it is dialogic and intersubjective, aware of its own actions in a coextensive encounter with images, objects, texts and ideas from other sites and systems. However, unlike most theoretical positions, it does not have a prior programme, a definition of its content, a list of fixed strategies or features – it risks its own changing status as 'theory' in negotiation with 'practice'. Refusing to pre-determine a set of rules for the application of a critical formula to works of art, does not imply that there are no guiding insights and ideas operating in thinking feminist aesthetics against the grain. In

fact, what is fascinating about this work is that it expresses the dynamics of knowledge, voiced eloquently by Elizabeth Grosz when she wrote: 'Knowledges are practices, they are activities and not contemplative reflections.'[13]

If we think of critical practices as voices which have moved from contemplative reflection to active engagement, we are reminded of the important role which the term 'dissonance' played within feminist theories of difference throughout the 1990s. It is not merely coincidental that 'dissonance' was used to problematize the model of contemplative sameness, or consonance, propounded by universalizing theories of subjectivity.[14] Strategically, dissonance disrupted the complacency fostered by an economy of the same, dispelling the seamless narrative of the one with a strong and distinct oppositional voice. 'Dissonance' defied reductive consonance, simplistic concord, agreement and contractual relations based upon the inherent stability and supremacy of the centre. The strategies of dissonance were effective in deconstructing the normative centre and in making suggestive claims for difference as a mode of thinking itself, rather than as a characteristic of marginalized categories of objects and others. Moving forward with the project of voicing difference asks that we disperse the binary of consonance/dissonance even further, exploring non-dualist connections and soundings.

Significantly in this framework, the *Oxford English Dictionary* citation for 'resonance' contains the following lines:

> 1. The reinforcement or prolongation of sound by reflections, or *spec*. by synchronous vibration... b. Path. The sound heard in auscultation of the chest while the person is speaking, or that elicited by parts of the body.[15]

Resonance brings together different voices, reinforcing them at a synchronous moment without making them the same. Scientifically, resonance refers to wave motion or vibration, notions always problematic within physics since they describe both particles (matter) and light or sound, in flux. The means by which we come to know of wave motion are never singular, rather, they require the coordinated study of irreducible differences (matter and process) and, as the reference to the body within the dictionary definition reminds us, we are part of this multiple phenomenal experience. Our bodies experience resonance all the time – when your muscles twitch, it is because

your cells' constant, variable vibrations have corresponded at that point, they are resonant there. With resonance, our bodies are connected to the world, but not through a reductive logic of the same, through mobile contact with different materials, objects and actions.

It would be impossible to speak of resonance and physics without pointing out the most memorable feature of resonance, namely, its ability to shatter what had been thought to be solid. When bridges and buildings find their massive forms shaken to pieces through the introduction of an inaudible frequency, we see the power of resonance. This power is the self-same power that erupts intellectually when diverse concepts come into connection and shatter our complacent knowing, when our skies and maps meet the evidence of those who have travelled *around* the flat globe, or when, on a more intimate scale, we *recognize* something which we have never seen or understood before. If consonance presumes assimilation into one and dissonance disrupts that simplistic logic by voicing the effaced other, then resonance enables us to conceive the power which differences can have when they connect and harmonize. The 'synchronous vibrations' which resound are not the same, they do not become one. Instead, it is because they meet at coincident points while maintaining their difference that they can act in the here and now, that they can resonate.

It is the logic of resonance that I would put forward as a feminist political strategy for art historical and critical praxis, precisely because the differences which can coalesce powerfully in one context need not be determined once and for all by that singular address. A resonant criticism is fluid and permits reconfigurations with other differences, temporally, materially and spatially. This reworks conventions of theory and practice through attentive explorations of time, matter and space within the nexus of the critical act. Moving beyond the remit of dissonance in intellectual and political terms, resonance does not just point to that which is occluded within a consonant mode and reverse its terms while reinforcing its negative power. It is a positive action of difference, a way to think multiply instead of through binary codes.

Exploring critical and interpretive acts as processual encounters with difference implies a temporal shift away from linear, progressive narratives of history and teleological models of theory. Two important insights are derived from rethinking the temporality of resonance: that there is no fixed goal or endpoint to the critical act

and that its relationship to the past is dynamic and creative. If the outcome of critical acts cannot be pre-determined, they can be seen as productive experiments in the present, working through short-term strategic interventions toward long-term gains, the precise nature of which is not yet determined. Their power does not reside in replacing one hegemonic meta-critical system with another, but in their ability to reveal the myth of hegemony as an effect of the naturalization of the centre. In doing this, experimental interventions take calculated risks. Assimilating material into a singular system of meaning and value is safe but it continues to reproduce the knowledge already known. By contrast, exploring multiple connections by bringing diverse materials together to exploit their resonance, risks creating connections which are either unproductive or, indeed, counter-productive. Yet the very act of making connections across difference reveals knowledge to be a practice, the effect of manifold intellectual activities over time, and permits new relationships with histories, sources and concepts to be forged.

For feminists, forging a productive relationship with past histories and ideas has always been problematic since most of those histories and ideas enshrined masculine-normative values and supported the material empowerment of men over women. Yet there is no place 'outside' or beyond history from which to develop an untainted, woman's theory or practice. Exploring the uneasy situation of feminist scholarship within the traditional limits of academic theory (scientific discourse particularly), Sandra Harding refigured the activities of feminist thinking as 'riffing': 'We [feminist scholars] need to see our theorising projects as illuminating "riffing" between and over the beats of patriarchal theories, rather than as rewriting the tunes of any particular one.'[16] This is a dynamic and resonant approach to history through which coincident ideas and activities are able to amplify one another and change the static shape of what had been fixed before – just as Jenny Holzer's *Lustmord* played its riff between and over the histories of art, war and violence against women, without ever merely rewriting their tune.

Histories are not objects which exist in the past, awaiting excavation in their wholeness to explain events, they are temporal practices through which the present is formed and the future is opened to change. Such ideas are clearly reminiscent of Walter Benjamin's politically acute conception of historical agency:

> The past can be seized only as an image which flashes up at the instant when it can be recognized and is never seen again... Historical materialism wishes to retain that image of the past which unexpectedly appears to man singled out by history at a moment of danger. The danger affects both the content of the tradition and its receivers.[17]

The image which flashes up is recognized when it resonates within the here and now – when it illuminates our present and body.[18] The kind of activity described by thinking histories and knowledges in this way is creative, strategic and interventionist. The subject interpellated by these activities is embodied and in process, an intersubjective agent in the world. In thinking theory as processual, Rosi Braidotti conceived feminist agency thus: 'The feminist theoretician today can only be "in transit", moving on, passing through, creating connections where things were previously disconnected or seemed unrelated, where there seemed to be "nothing to see".'[19]

It is not difficult to understand that these theoretical moves might have powerful implications for critical work on art practices which themselves are exploring combinations of materials, histories and ideas where there had been 'nothing to see'. The work of Cornelia Parker, for example, places various objects, actions, sites and texts together to enable multi-stranded histories to emerge through correspondences with material specificity.[20] So, an abstract photogram appears on the wall of a gallery, itself beautifully produced and framed, and recalls in its physicality the histories of avant-garde photography and the aesthetic strategies of modernism. But the photogram is not the 'complete' work; other photograms appear and all of these are exhibited with titles and texts, the combinations of which place other contexts into the frame: *Negatives of Sound: Fluff and Dust Collected from the Whispering Gallery, St Paul's Cathedral, London* or *Negatives of Sound: Grooves in a Record that Belonged to Hitler (Nutcracker Suite)*. In the *Negatives of Sound* series (1996), the titles of the series and the individual photograms, the sites, objects and actions described through the sub-texts (collecting the dust, making the photogram from it, etc.) and the final images and other objects Parker locates in the installations resonate with one another without ever becoming one. Hence, they admit of the continuing action of reconfiguration in making meanings – the photograms from *Negatives of Sound* not only had a place within the gallery, some also appeared in the pages of *Nature* for five issues

in 1997.[21] In *Nature*, they were placed next to articles, with their descriptive texts rendered in the journal's house style and without Parker's authorial signature to define them as 'artworks'. The photograms do not simply have a single meaning locked within them and their purposeful deployment in various contexts shifts the structure of interpretation from definition to dialogue.

Parker's multi-sensorial practice locates aesthetics, as sensory cognition, within the centre of interpretation. There is no singular mode of access to these works; the texts are not privileged over the images and objects with which they are connected, the works are visually striking, but their material specificity (and all of the tactile, aural and olfactory properties these entail) are crucial to their articulation. Nor are their material properties fixed – many of the texts expand upon processes through which physical transformations occur, from tarnish to explosion. The meanings that they suggest are known through the body, subject to change and redefinition and, crucially, reworked by the bodies which explore them. Hence, when asked to decipher what her work was about, Parker shifted the debate to space: 'it's no more religious or geographical than it is scientific. I always feel that my work is about the space for projection within the work.'[22]

If process-based feminist critical modes explore non-linear experiments with time and anti-hierarchical conceptions of materiality, then they also question static constructions of space. The questions posed for thinking spaces differently are two-fold: what sort of space is described when differences coalesce without effacement and how can these spaces be made productive within the here and now? Answering the first question implies thinking of spaces as aesthetic in the fullest use of that term. That is, constructing spaces which admit of productive desire (rather than unfulfilled lack), coextensive difference (rather than assimilation) and becoming (rather than being), describe a spatio-temporal frame of cognition which is corporeal, multi-sensory and non-teleological. However, if this aesthetic space remains merely within the realm of abstract, utopian, theoretical possibility, it loses its potential to act politically in the present as a mode through which alterity might be voiced. At this point, the spaces described by a feminist aesthetics of radical difference meet those envisaged by a feminist, non-juridicial ethics.

Rosalyn Diprose, in her pivotal work on an ethics of sexual difference, critiqued the self-same logic of mind-body dualism and

the concomitant structures of universal, first principle ethics. By contrast, she moved toward models of process, ethical agency and located practices, reiterating the significance of the spatio-temporal frame of the subject. Her fascinating work drew on the double meaning of *ethos* (from which we have derived 'ethics') as the noun 'dwelling' and the verb 'to dwell', concentrating on the activity of dwelling or taking up a position as the critical component of ethical action.[23] This is not simply abstract theory about position, it relates directly to the spaces of material subjects and their places within the world in ways which reference the situated perspectives on history and past conceptual structures discussed above. As subjects, we are both positioned on the map and makers of that map, we are both located and in perpetual negotiation with our locations. This conception of dwelling as agency situates subjects as constrained, but never fully contained, by the histories within which they act.

These connections between histories, sexed and situated subjects and a processual, experimental ethics based upon the logic of becoming, rather than being, were explored further in a closely argued text by Moira Gatens.[24] While the details of her work, like that of Diprose on feminist ethics, may seem very far removed from feminist art history, criticism and scholarship on women's art, her insights provide a valuable link in thinking difference differently without simply succumbing to the desire to pose apolitical, utopian aesthetics. The link between feminist aesthetics, as the experimental action of subjects against the grain, and an ethics of sexual difference, which locates the social and political potential of those actions, may rest upon the way in which 'becoming' is thought. As Gatens observed, while the potential to become never specifies a final outcome and permits limitless configurations and reconfigurations of ideas, concepts, subjects and objects to occur, actual becomings are always specific, corporeal and located. Hence, becoming is open-ended, experimental and utopian, but able to act within specific contexts; becomings can change the world. So, for example, an open-ended critical configuration between particular works of art, historical data and theoretical texts may move in many different directions and cannot be limited to a pre-determined destination, but it will take some directions, produce some insights and arrive at some point, if only temporarily. These, in turn, will bear a material relation to the specific elements which were brought into contact – the critical act

does not simply emerge from the ether and it does not remain an abstract ideal. It makes anew.

This makes the critic all the more accountable for her position; it is not for me to hide my investment in my own praxis or my theoretical, methodological or political perspectives behind a mask of 'objectivity' when I explore the work of historical or contemporary women artists. Rather, engaging with the practice of a feminist aesthetics locates me within an ethical project, an explicit positioning of myself and my actions within my work. The strict boundaries maintained between subject and object in art historical and critical work premised upon 'objectivity' and a distanced, rational mode of observation, produced the authority of the critic through a conceit. The conceit implies either that the critic knows, in advance, the meaning of art and thus applies theory to illustrate this point or that a unified truth resides within works and is brought to the fore by their objective reading. The loss of the transcendent authority of these critical modes, with their monolithic, objective and distanced truth claims, need not be accompanied by a move to radical relativism or a nihilistic subjective stance in which anything might be said and no arguments can be made for the efficacy of an interpretation. Rather, acknowledging the creative, productive activity of the critic/theorist as a participant in the project of an experimental feminist aesthetics, emphasises the strategic value of the questions raised, the material explored, and the constellations of sources, histories and ideas produced in interpretation. It is located and responsible for its results – it acts in the here and now.

This is not, therefore, an essay *about* the work of Jenny Holzer, Cornelia Parker or Carrie Mae Weems. Nor does it replace the complex aesthetic spaces which their work constructs for participants. Nor is it about the work of feminist philosophers, the inscription of violence against women as a structural necessity in modern warfare or the politics of race and ethnic cleansing. It is itself a critical space for thinking differently by making connections where things had not been connected before. When you read about art practices, you do not enter the aesthetic spaces produced by the artists, you enter those made by the critic; the configurations of objects, materials, images, texts, concepts here developed are coextensive with practice, they do not define it or posit its 'real' meaning. I produce this essay as a participant in an aesthetics of radical difference and I hope that the

constellation which I have constructed will indeed be resonant. The wider project is one of community and communication, of having an aesthetic dialogue with artworks, texts, histories and ideas which cannot be reduced to sameness. As dialogic, this reconception can only move toward a new ecology of knowledge through the responses and activities of others, as it is read in the present and itself reconfigured in the future.

Notes

A shorter version of this piece appeared in *n.paradoxa*, vol.6: *Desire and the Gaze*, June 2000, pp.12-21 as 'Jenny Holzer's *Lustmord* and Resonant Critical Praxis'.

1. Joan Simon, 'No Ladders; Snakes: Jenny Holzer's *Lustmord*', in *Parkett*, no.40/41 (1994), pp.79-97, p.83.
2. Other well-known women artists in the US, such as Carrie Mae Weems and Barbara Kruger, were involved in the Liz Claiborne project. The horrific accounts of domestic violence which the artists heard during project discussions also came into play with *Lustmord*.
3. Simon, 'No Ladders; Snakes', p.82.
4. Beth Irwin Lewis, '*Lustmord*: Inside the Windows of the Metropolis', in Charles Haxthausen and Heidrun Suhr (eds), *Berlin: Culture and Metropolis* (Minneapolis & Oxford: University of Minnesota Press, 1990), pp.111-40.
5. See Meskimmon, *We Weren't Modern Enough: Women Artists and the Limits of German Modernism* (London: I.B.Tauris; Berkeley, University of California, 1999).
6. There are many works by Dix merely entitled *Lustmord*; here I am discussing the one housed in Vaduz, in the Otto Dix Stiftung.
7. Kristine Stiles, 'Shaved Heads and Marked Bodies', in Nancy Hewitt et al (eds), 'Representations from Cultures of Trauma' in *Talking Gender: Public Images, Personal Journeys and Political Critiques* (Chapel Hill, NC: University of North Carolina Press, 1996), pp.36-64, p.41.
8. Victor Hugo, *Chose Vues*, reprint 1985, p.163, cited in Kaja Silverman, 'Liberty, Maternity, Commodification', in Mieke Bal and Inge E. Boer, *The Point of Theory: Practices of Cultural Analysis* (Amsterdam: Amsterdam University Press, 1994), pp.18-31, p.28.
9. Klaus Theweleit, *Male Fantasies*, Volume I: *Women, Floods, Bodies, History* (Minneapolis: University of Minnesota Press, 1987). See especially the section 'Attacks on Women', pp.171-82.
10. bell hooks, 'Talking Art with Carrie Mae Weems', in *Art on My Mind:*

Visual Politics (New York: The New Press, 1995), pp.74-93, pp.78-9.
11. *Ibid.*, p.79.
12. Simon, 'No Ladders; Snakes', p.82.
13. Elizabeth Grosz, 'Bodies and Knowledges: Feminism and the Crisis of Reason', in *Space Time and Perversion* (London: Routledge, 1995), pp.25-44, p.37.
14. Rosalyn Diprose and Robyn Ferrell (eds), *Cartographies: Poststructuralism and the Mapping of Bodies and Spaces* (Sydney: Allen and Unwin, 1991); Catriona Moore, *Dissonance: Feminism and the Arts, 1970-1990* (Sydney: Allen and Unwin, 1994); Hilde Hein, 'The Role of Feminist Aesthetics in Feminist Theory', in Peggy Zeglin Brand and Carolyn Korsmeyer (eds), *Feminism and Tradition in Aesthetics* (State College, PA: Pennsylvania State University Press, 1995), pp.446-63; and even quite recently in Griselda Pollock, *Differencing the Canon* (London: Routledge, 1999).
15. *The Shorter Oxford English Dictionary, on Historical Principles*, Third Edition (Oxford: Clarendon Press, 1973), p.1808.
16. Sandra Harding, 'The Instability of the Analytical Categories of Feminist Theory', reprinted in Helen Crowley and Susan Himmelweit (eds), *Knowing Women: Feminism and Knowledge* (Oxford: Polity Press in association with the Open University, 1992), pp.338-54, p.341.
17. Walter Benjamin, 'Thesis on the Philosophy of History', in *Illuminations*, edited and introduced by Hanna Arendt, translated by Henry Zohn (Hammersmith: Fontana, 1992), pp.247-8, nos. v, vi, vii.
18. *The Shorter Oxford English Dictionary, on Historical Principles*, Third Edition (Oxford: Clarendon Press, 1973), p.1808.
19. Rosi Braidotti, 'Toward a New Nomadism: Feminist Deleuzian Tracks; or, Metaphysics and Metabolism', in Constantin V. Boundas and Dorothea Olkowski (eds), *Gilles Deleuze and the Theater of Philosophy* (New York & London: Routledge, 1994), pp.159-85, p.177.
20. For readers wishing to explore Parker's work in more depth, please see Cornelia Parker, *Avoided Object* (Cardiff: Chapter Ltd, 1996).
21. Elizabeth Mahoney, 'Natural Science' (review of Cornelia Parker), in *Art Monthly*, no.3, 1998, pp.33-4.
22. Elizabeth Mahoney, 'An Ounce of Gold Around the World' (interview with Cornelia Parker), in *Make: The Magazine of Women's Art*, no.79, March-May 1998, pp.22-3, p.23.
23. Rosalyn Diprose, *The Bodies of Women: Ethics, Embodiment and Sexual Difference* (London & New York: Routledge, 1994), pp.18-19.
24. Moira Gatens, 'Sex, Gender, Sexuality: Can Ethologists Practice Genealogy?', in *The Southern Journal of Philosophy*, vol.XXXV, Supplement, 1996, pp.1-19.

index

This index lists concepts and issues relevant to the practice of Reconception

action 2, 79-80, 130, 166, 171, 198, 236, 238, 242
aesthetic(s) 3, 22, 28*ff*, 52, 130, 161, 194, 232; contemplation 150; of difference, 243; experience 152; feminist 223*ff*; production 189; spaces 241*ff*
agency 2, 115-16, 145, 230, 242
alterity 230
analysis 24; anthropological 62*ff*, 68, 77; deconstructive 40
anthropologist, anthropology 2, 15-6, 55, 61*ff*, 129, 131, 143-4, 157
art, artists, arts 2, 4, 22, 28-9, 36, 43, 47, 50-2, 79, 82, 86, 90, 129*ff*, 165, 173, 177, 187*ff*, 223*ff*
articulation 1, 21, 45, 116, 171, 176, 197, 230-1, 236
authority 11, 26, 64, 86, 110, 115, 136, 205, 243
avant-garde 129-30, 187, 189, 240

becoming/being 36-8, 41-4, 48-9, 52, 171, 203, 241-2
behaviour 2, 11, 13, 21, 27, 30, 63-4, 73-5, 80, 138, 173, 177
binary 189, 199, 237-8; logic 41, 230-1; thought-patterns 188
borders/boundaries 1, 43-45, 50, 55, 62-4, 82, 176, 192-3, 200, 211, 231, 243

censorship 17, 187, 227

charlatan/shaman/trickster/magician 86, 115, 118, 137, 179, 183, 204
cognition/cognitive 9, 14-16, 21, 27-30, 39, 182, 232, 241
commitment 2, 20, 55, 74, 161*ff*
commodification 2, 4, 11, 24, 43, 56, 70, 226; commodified knowledge 5, 13; commodity thinking 15, 23-4,
contingency 1, 10, 28,
cultural 2, 16, 20, 38, 48, 62-4, 72, 80-1, 133, 142, 144, 157, 214; counter- 189; environment 12, 21, 26; production systems 4-5

dance 47, 107, 135-6, 140-1, 142, 161*ff*
dialogue 1, 52, 82, 170, 206, 236, 241, 244
difference 2, 74, 188, 198, 229-32, 236-8, 242,
discipline/(inter)disciplinarity 1, 3, 10-2, 21, 25, 36*ff*, 63, 82, 181, 190, 193, 199, 215
domain thinking 51, 62*ff*, 188

ecological 4, 5, 10-12, 18, 24*ff*, 37, 54, 62, 80; awareness 177; materialism 13; propriety 15-17; systems 53, 178
ecology 4, 53-4; of images 190; of knowledge 3-4, 9*ff*, 187, 193, 244; environmental constraints 80

epistemology 4, 9, 27, 62-3, 132, 215
ethics/morality 1, 3, 14, 19, 28, 55, 72, 157, 185, 241
ethnographer, ethnography 1, 62, 75, 82, 129*ff*
experiment, experimentation 49-52, 68, 72, 132, 143, 196, 211, 239, 241-3
expert, expertise 4, 11, 19, 21-4, 27, 72, 187

feminism/t 9, 187; aesthetics 223*ff*; art history 235; art practice 131, 225, 231; criticism 196, 241; philosophy 49, 243; politics 131, 238; theory 230

gender(ed) roles 225, 227; studies 191, 215; logic 234; ordering 230

history 2, 10, 22-3, 40, 47-9, 62, 82, 102, 107, 113, 119, 223, 230, 238-9
honour 55, 136, 147, 156, 161*ff*
humanities 3, 4, 21-4, 26, 39, 82; human sciences 214

identity 37-8, 55, 65, 94, 113, 131, 142, 167, 171, 231, 236; identification 27, 121, 152; identify[ied as] 46, 174, 183-4
ideology 13, 25, 62-3, 69, 72-5, 81, 229
institutions 1, 17, 27, 37-40, 55-6, 98, 131, 143, 181, 184
intellectual 1, 9, 238; autonomy 20; development 132; ecology 4, 10*ff*; enquiry 214; /sensual 232
intertextual(ity) 192, 201, 207

knowledge 1, 3, 9*ff*, 38-9, 42, 45, 50, 52, 82, 118, 132, 143, 172, 205, 225; already known 9, 11, 17, 27, 239; economy 18-9; embodied 230-1, 236; production 2, 11, 24; situated 2, 213; structure/system 5, 167

linguistic-symbolic 16, 62-3, 75, 80; linguistic turn 214

machine/mechanical 16, 52, 61-4, 78, 67, 85, 86, 99, 102, 108-10, 119, 182
marginal(ity/ization) 2, 13, 41, 130, 134, 145, 147, 187, 195, 201, 206, 231, 235, 237
material 12, 19, 28, 44, 103, 118, 192, 232-3, 241; culture 135, 141
materiality 194, 198, 231, 234; of knowledge 1; of thought [materializing] 48, 52, 224
meaning 17, 63, 80-1, 133, 139, 166, 194, 203, 236, 243; construction of 26, 197, 212; negotiation of 1, 65; production 2, 10
memory 27, 29, 101, 109, 150, 167, 113, 226
mind-body 4, 15, 26, 28, 107, 173, 230, 235, 241
modernism 130, 240
multiculturalism 17, 19, 27

narrative 1, 48, 131, 189, 199, 201, 234, 237
negotiation 1, 63-5, 80, 81, 86, 193, 236, 242

object/objective/objectivity 10, 14, 19, 27, 39, 42, 82, 86, 107, 113, 116-8, 143, 150, 179, 199, 214, 230, 235, 243

paradigm 37, 42, 107, 134, 149, 166, 167, 214, 230, 236
percept(ion) 14, 29, 50, 54, 129, 178, 191
performance 134, 140, 196

performativity 166, 231
philosophy 2, 9, 13, 23-4, 35*ff*, 107, 131, 200, 214, 243
pluralism 132
poet(ic/ry) 132, 166, 178, 188*ff*, 231
post-colonialism 9, 187, 215, 233
post-modernism 9, 13, 24, 28, 132, 214
post-structuralism 9, 187
practice 20, 26-8, 39, 42-3, 46, 53, 95, 119, 131, 135, 152, 156, 179, 182, 215, 223, 236; aesthetic 232; creative 4; knowledge 5, 237; intellectual 3, 10, 13; material 12
process(ual) 1, 3, 13, 16, 24, 37, 40, 43-4, 49, 51-2, 63, 80-1, 143, 150, 170, 190-1, 198, 204, 206, 211, 224, 231, 240
profession(alism) [see expert] 4, 39, 108

reconception 1-5, 10, 25, 30, 52, 63, 187, 189, 214, 224, 235, 244
reflection 3-5, 9-13, 17, 20*ff*, 40, 42, 130-1, 170, 188, 195, 237; reflective consciousness 23; reflective practice 20, 26, 28, 30; reflective reason 15
reflexive 3, 5, 10, 13, 15, 26, 175
repetiti[on/ve] 29, 85, 106, 116, 119, 151, 167, 202, 215
representati[on/ve] 16, 26, 27, 30, 148, 152, 181*ff*, 193, 214-5, 236; self- 132
resistance 2, 5, 15, 25, 54, 64, 75, 137, 178, 185, 203, 214
resonance/dissonance 3, 237-8

sceptic(al/ism) 5, 13, 18, 23, 24, 27, 30
science/scientism 19, 25, 50-1, 54, 86, 91, 108, 117-8, 119, 181, 182, 189, 214, 215, 237, 239, 241
self-conscious(ness) 9, 10, 23, 170-1, 174; defeating 17, 53; deluded 17, 179*ff*; determination 131, 157; examination 132; image 66; interest 19; orientation 4, 5; referential 130-1; reflect(ion/ive) 131, 195; regulating 40, 104
semiotics 16, 25, 54, 190, 194, 197-8, 211, 215
sense(s) 168, 191, 198, 203; sensory 161, 231; multi-sensory 191, 241; sensu[ous/al] 14, 140, 197, 230, 232
specialization 11-2, 19, 23-5, 40, 51, 69, 92, 111
subject/subjective/subjectivity 13, 14, 28, 45, 51, 82, 143, 199, 230-1, 233-6, 242,
symbol(ic/ism) 16, 26, 62, 69, 75, 98, 113, 117, 134, 155, 201, 206; destruction 228, 230; form 4, 24; (re)sources 29, 79, 80; system 2, 182

technology 12, 85, 91-2, 113, 115, 185,
theory 12, 29, 52, 62, 69, 82, 118, 134, 144, 200, 213, 215, 230, 236, 243
thinking/thought 1, 4, 9, 10, 13-7, 23-4, 30, 38, 41, 42-5, 51, 53, 62, 82, 111, 116, 166, 188, 199, 211, 223, 230, 239
torture 2, 4, 150, 152, 184-6, 227, 234
trauma 22, 226
trope 27, 28, 134, 214, 226

values 5, 13, 17, 22, 39, 74, 80, 130, 135, 239
veracity 16, 20, 174, 183
violence 199, 225, 230, 233, 239; sexual 227
visual(ity) 29, 187*ff*, 231; arts 52, 141, 146, 188; visualists 187, 189, 213
voice 2, 3, 47, 50, 131, 164, 175, 187, 225, 237